A Culture of Stone

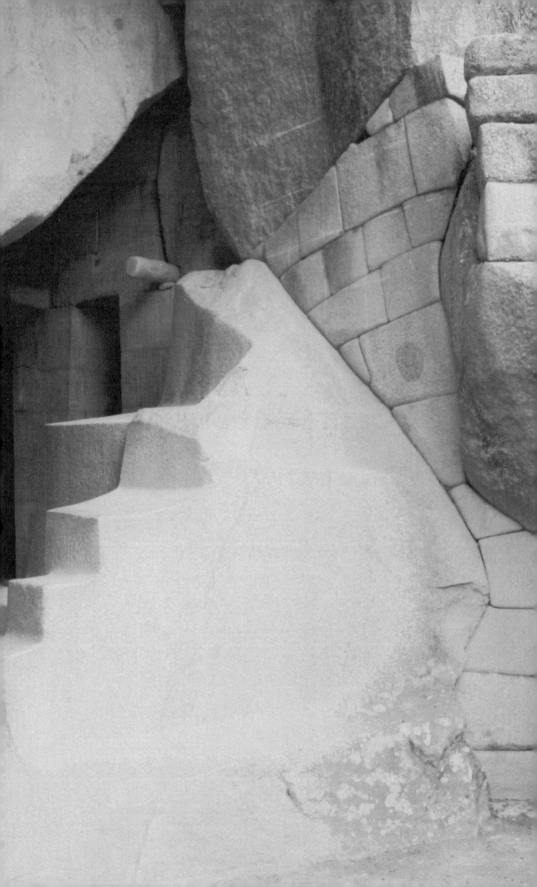

CAROLYN DEAN

·⟨⟩·

A Culture of Stone

INKA PERSPECTIVES ON ROCK

Duke University Press / Durham and London / 2010

© 2010 Duke University Press
All rights reserved
Printed in the United States of America on acid-free paper ♾
Designed by C. H. Westmoreland
Typeset in Monotype Fournier by Tseng Information Systems, Inc.
Library of Congress Cataloging-in-Publication Data appear on the
last printed page of this book.

Duke University Press gratefully acknowledges support for the
publication of this book from the Arts Research Institute
at the University of California, Santa Cruz.

·⟨⟩·

TO CECELIA F. KLEIN

·⟨⇆⟩·

Contents

·⇌·

Illustrations

All photographs by the author unless otherwise indicated.

·⇌·

Acknowledgments

Initial phases of this research were carried out in my spare time on weekends and other days when the regional archives at the Universidad Nacional San Antonio Abad in Cuzco were closed. This book was born during the hikes and outings that, at the time, were considered distractions from my "real" work of researching aspects of Cuzco's viceregal history. Nevertheless, those who funded my historical research helped nourish this project as well; in particular, a grant from the Pew Charitable Trust supported several trips to the Andes. Research for this specific project was generously funded by the Arts Research Institute and by several faculty research grants from the University of California, Santa Cruz.

During the decade in which I have worked on this project, I have received the support of numerous individuals, especially the staff and faculty of the History of Art and Visual Culture Department and the Arts Division at UCSC. I am grateful to those who have assisted me in the Andes and beyond: Tom Atkinson, Kathryn Burns, Washington Callapiña, Moisés Callapiña, Darwin Camacho Paredes, Terence D'Altroy, Esther Dean, Robert Dean, Sharon Dean, Jean-Jacques Decoster, Peter Frost, Paul Goldstein, Margaret Kieckhefer, Joanne Pillsbury, Janet Stephens, and Marie Timberlake. To those who have read drafts of my text and generously offered helpful advice and suggestions — Elisabeth Cameron, Constance Cortez, Shelly Errington, Stella Nair, and Catherine Soussloff — my heartfelt thanks. Singled out for special mention is Steve

Chiappari, an exceptional individual who has not only lugged my camera equipment (and other sundry items) around the Andes but read every word of the manuscript and offered me unflagging support. Finally, this book is dedicated to my mentor and friend Cecelia F. Klein, who — apart from my mother — is the wisest woman I know.

·(⇄)·

Note on Orthography

From the time the first Spaniards recorded the word *Pirú* (later Perú), not comprehending what indigenous Andeans said to them, spelling native words has been nothing if not difficult. Quechua (Keshwa, Quichua), the language of the Inka as well as many other Andean peoples, has had an especially vexed orthographic history. What started as *Inga* became *Inca* and then *Inka*. The latter orthography reflects modern efforts to introduce consistency, as well as to spell words in Quechua, a language unaccompanied by its own writing scheme, without reliance on the particulars of Spanish pronunciation. However, the pronunciation of Quechua was not consistent throughout the Andes in pre-Hispanic times, nor is it constant today. Rather than a note on orthography, this might better be characterized as an explanation of unavoidable *heterography*.

I have elected to spell most Quechua words following Rodolfo Cerrón Palomino's dictionary of southern Quechua (1994). Where alternate spellings might be more familiar to some readers, I have listed them in parentheses upon the first usage. When reference is made to a particular historical source, the original spelling is retained with alternate spellings provided in parentheses. Site names are spelled according to common practice. In cases where there appears to be no agreement (as in Pisac/Pisaq or Sacsahuaman/Saqsaywaman), I have selected the spelling that seems to be most commonly used at present; again, alternate spellings are provided in parentheses in an effort to minimize confusion. In particular, Cuzco, the Inka capital, was spelled both Cusco and Cuzco by early

Spaniards. In 1990, *Q'osq'o* became the city's official spelling, but many residents prefer *Cusco*. Because *Cuzco* is the standard spelling in English, I will follow the convention likely to be more familiar to readers.

Finally, the plural case of Quechua nouns is indicated by the suffix *-kuna*. Unfortunately, using the Quechua plural proves confusing for many readers. Rather than adding an *s* at the end of a Quechua word, thereby creating an awkward bilingualism, I have elected to maintain Quechua words in their singular form regardless of whether they are singular or plural.

The stone is normally no work of art while in the driveway,

but may be so when on display in an art museum.

—NELSON GOODMAN, *Ways of Worldmaking*

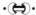

INTRODUCTION

Coming to Terms with Inka Rocks

In the South American Andes, in the fifteenth and early sixteenth cen-
turies, the Inka (Inca) framed, carved, sat on, built with, revered, fed,
clothed, and talked to certain rocks. This book is about some of these
rocks, and what they meant to the people who forged various kinds of re-
lationships with them. Here we reckon primarily with pre-Hispanic Inka
perspectives on stone, as they are articulated in and through the rocks
themselves, as well as in Andean stories about stone.[1] Even so, as an art
historian I am mindful that much of Inka rockwork — extant since the fif-
teenth century and still sitting in plain view — has just recently been rec-
ognized and talked about as "art" (plate 1). Although many readers will
concur that the rocks discussed here are indeed prodigious works of art,
and I would not argue against them, this book is not about Inka rocks *as*
art, for the Inka's culture of stone was not guided primarily by aesthetic
criteria. However, changing assessments of Inka rockwork, from Spanish
colonization to the present, and the implications of those changing as-
sessments influence our present considerations. Thus, while I devote the
most attention to the meaning of stone within Inka signifying systems, I
also note the non-Andean notions that have shaped current understand-
ings of Inka rockwork.[2]

Like Andean indigenes today, the pre-Hispanic Inka knew well, named,
and communicated with many natural topographic features.[3] Mountains,

rivers, lakes, boulders, outcrops, caves, and springs were (and still are) kratophanic. They were sacred places where humans encountered and interacted with powerful numina.[4] Such places were regarded as *waka* or *huaca*, a word in Quechua (or Runa-simi), the language of the Inka and many other Andean peoples, that has no exact equivalent in other languages.[5] It may be provisionally defined as a sacred thing, landscape feature, or shrine; it can be natural or artificial or a combination of the two. In the mid-sixteenth century, a Spanish colonial official who studied Inka religion to curb its influence observed that native Andeans counted among their waka "idols, ravines, boulders or large rocks, hills, mountain peaks, springs, fountains, and finally whatever natural objects that seem notable and are differentiated from the rest."[6] Waka are thus both extraordinary and sacred things. In pre-Hispanic times, they commonly received offerings of shells, textiles, leaves of the coca shrub, feathers, and *chicha* (known in Quechua as *aqha*, a fermented maize drink). Some received sacrificed llamas and figurines of shell, stone, silver, and gold. A few were offered children.

When Roman Catholic Spaniards first contacted the indigenous peoples of what are now called the Americas, they were predisposed to understand most Andean waka as idols.[7] They exhibited great consternation because of the incongruity between their expectations for what idols should look like and the reality of what waka actually were. According to early modern European thought, idols ought to be man-made, anthropomorphic or zoomorphic, and composed of precious materials or finely crafted.[8] What Spaniards found in the Andes were boulders, lakes, caves, mountains, mummified bodies, and so on. Indigenous Andeans did not often locate the numinous in representational statuary, for waka were normally unshaped or slightly shaped natural substances; they were the preserved bodies of ancestors and natural formations in the Andean landscape. Waka could not readily be identified by appearance, material composition, or location. As the seventeenth-century Jesuit Bernabé Cobo said with regard to one stone waka of great importance, Spaniards "paid no attention to the idol, because it was, as I have said, a rough stone."[9] A European artist charged with illustrating Pedro de Cieza de León's early chronicle of a Spanish conquistador's experiences in the Andes, a place the artist had never visited, imagined what Inka "litholatry" might have looked like (figure 1).[10] He depicts an Inka, cloaked in a toga in the manner of ancient Rome, elevating an egg-shaped rock so that it might be

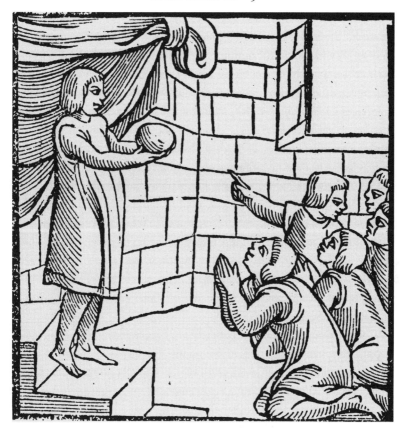

1. "Indians worshiping a stone as a god." *Crónica General del Perú*, by Pedro de Cieza de León, fol. 63r, 1553. Photograph provided by the Library of Congress.

revered by a throng of devotees. Unlike most sacred rocks in the Andes—located outdoors and frequently placed, or more often left, in natural or quasi-natural settings—this imagined sacred rock is housed indoors. The artist borrowed from familiar scenes of already known religious worship, replacing the customary figurative idol with a smallish rounded stone. It would seem that reverence for mighty, unhewn rocks that were worshiped in the open air—what the Inka thought of as "natural temples"—was beyond imagining and, as a consequence, beyond imaging.[11]

For Europeans in the Andes who encountered waka face-to-face, the matter was apparently just as baffling.[12] Even Juan Polo de Ondegardo, the magistrate of colonial Cuzco in the second half of the sixteenth century, a man who gained great familiarity with Andean religious practices,

was stymied by the multifarious natural objects of Andean reverence. He finally abandoned his long list of things that Andeans worshiped by concluding that one could best identify idols not by what they looked like, what they were made of, or where they were located but by the fact that they received offerings.[13] In other words, the only sure way he found to recognize sacred things was by the way the Inka and other Andeans responded to them. Polo's observation is a critical one and bears repeating: to the Inka, what something looked like did not often reveal its inherent value. As an example, the Inka employed a word for the decoration of surfaces regardless of media; whether painting, engraving, or embroidery, all superficial decoration was referred to as *qillqa*.[14] Because qillqa could describe a painting or a carving, it might be taken to describe things of aesthetic value, that is, things that have been rendered more visually appealing. Early in the Spanish colonial period, however, the word *qillqa* was readily used to describe writing on paper, something not used in the pre-Hispanic Andes and not esteemed for its aesthetic merits when it was introduced to the region.[15] The word *qillqa* indicated only that the thing to which it referred had some superficial decoration, and did not convey any particular sense of value as a consequence of that decoration. Qillqa, superficial marking, did not affect value, for it did not impact the inherent worth, the essence, of the thing so adorned.

This basic principle of categorization by the essence of what things are has troubled those who have sometimes sought to categorize Andean material culture primarily by what things look like. From an Inka perspective, what the eye perceives (a thing's surface appearance) was important, but nearly always less significant than what the mind conceives (a thing's substance or essence). As a corollary, process—an emphasis on working with the substance of a thing—was often valued over the end product, its "finished" appearance. For the Inka, sacredness was embedded in the material of the thing rather than in its form. Thus the Inka identified sacred essence in a variety of hosts, and any particular essence was not necessarily reflected in its external form.[16] Several scholars have discussed the notion of *kamay* (*camay*), which is often translated as "essence." The art historian Tom Cummins, for example, explains how the sand used by the Inka to cover the central plaza of Cuzco, their capital city, contained a sacred essence that was specific to itself.[17] Although the Spanish authorities, finally recognizing that the sand of the plaza was held holy by the indigenous residents of the city, ordered its removal and used it to make

mortar for the construction of the cathedral, they could not separate the kamay from the sand. Regardless of the shape it took or how it was used, it was invested with its own essence. Essence was transubstantial, and so its significance was independent of form.

With this foundation and cautionary note, it is appropriate to introduce what I will be calling throughout this book the Inka's culture of stone, that is, the broad array of stories, beliefs, and practices that both constitute pre-Hispanic Inka perspectives on, and are articulated in, stone. Stories, both pre-Hispanic and contemporary, record the actions of the once and future animate Andean topography. In many of these stories, life-forms—both humans and animals—turn into rocks, while in others, stones animate. Thus in the Inka mind, stone, like the sand of Cuzco's main plaza, was transubstantial. Appearances might vary, but its essence was stable. Petrifaction signaled the suspension of, but not an end to, life. Given Andean notions about the ideal structure of the cosmos, a composition of conjoined complementary pairs (to be discussed further in chapter 2), we may recognize that stone often complemented biological matter. Not subject to death and decay, stone was life immobilized. It was animacy "paused" for an unspecified period. The challenge here is to understand rocks not as mineral matter of variable composition that the Inka and other Andeans mistakenly (or even charmingly) endowed with life force, but as ancient Andeans saw them—potentially animate, transmutable, powerful, and sentient. However, if rocks to the Inka were the stuff of gods and culture heroes, they were also the stuff of houses, terrace walls, and llama corrals. Rocks were therefore simultaneously both normal and numinous. Thus, in spite of their reverence for certain rocks, pre-Hispanic Inka cannot accurately be labeled litholators. That is, they did not worship *all* rocks, nor did they worship rocks *as* rocks. My subject of study, then, is not the whole range of rocks employed by the Inka. I will not catalog every rock artifact produced, and classify each form. Rather, I will consider rocks that the Inka recognized as something beyond mineral composites, rocks that were revered or had symbolic import because they were at once rocks and more than rocks. While a few of the rocks to be discussed here are very well known, most are barely recognized or incompletely understood examples in which the fact that the Inka believed the rock in question to be much more than rock has been forgotten, overlooked, or not fully explored. Here I offer fresh perspectives and new interpretations of petrous forms based on Inka notions, practices, and

values. How we recognize the significance of such stones, which to us have little readily apparent meaning, is both a measure of how we value perspectives that are not our own and a measure of our hermeneutic limitations.

"I like that boulder. That is a *nice* boulder." This was Donkey's response after spying the ogre's squalid living conditions in the popular animated movie *Shrek* (2001). His utter inability to find anything nice to say about Shrek's abode was emphasized when Donkey paid the compliment to a clearly inconsequential rock. Rocks, in Western culture, are generally things not to be noticed, and certainly not to be praised or worshiped. Indeed, in stark contrast to the Inka's perspective, Europeans have historically associated the veneration of sacred stones with primitive superstition. Ancient Greeks revered *argoi lithoi*, which were unworked stones, as well as black meteoric stones known as *baitulia* or *lithoi empsychoi* (animated stones).[18] From the earliest recorded times, such rocks were anointed with olive oil and spoken to by devotees. Such practices were later derided as superstitions by those who believed that anthropomorphic statuary was the proper focus of worship, and apparently the more "realistic" the better.[19] Because the Greeks moved from unworked rocks to imagistic stones, heirs to some of their traditions (such as early modern Spanish conquistadors, as well as many modern scholars) too often assume that such was the natural course of things. These assumptions then color the perception of the rockwork of other cultures, including that of the pre-Hispanic Inka. A brief consideration of varying perspectives on the nature of stone may help us approach Inka rockwork with minds open to new and different possibilities.

Around the world, societies can be found in which rocks are recognized and celebrated as extraordinary, as embodiments of some thing or idea beyond the stone of which they are made. The Ojibwa language of North America, for example, distinguishes between animate and inanimate objects; stones are grammatically animate, and Ojibwas sometimes speak to stones as if they were persons, recognizing the potential for animation in particular rocks under certain circumstances.[20] On the other side of the world, in Vanuatu, stones called *navat mbarap* represent ancestors and ancestral places. As parts of nature, stones are recognized as metonymic surrogates for the land. Throughout the Pacific, living people establish relationships with stones as embodiments of particular places and the past people who inhabited those places, much as they were and

are in the Andes.[21] Almost universally, the possession of certain rocks is equated — by metonymic associations — with claims to territory and contact with the ancestors who lived there.[22]

Unhewn rocks have long been regarded as culturally significant in the Far East. Rocks have held a special role in Chinese oral and visual culture for over two thousand years. According to a cosmogonic story, the sky is a great cave; mountains were formed by fragments that came loose from its vault and fell to earth. As they fell, they were charged with cosmic energy (*qi* or *ch'i*). Mountains and rocks, their microcosmic manifestations, are charged with the *yang* energy of the heavens and, in this sense, complement the *yin* of earth and water. My colleague John Hay derived the title of his highly regarded monograph *Kernels of Energy, Bones of Earth* (1985) from an eighteenth-century Chinese encyclopedia that uses these phrases to describe rock. The same encyclopedia also indicates that rock is the "essential energy of earth." While all rocks might be significant, historically in China rocks of unusual size or shape have been treated as special conduits of qi.[23] Rocks came to play important symbolic roles both in representation, particularly in painting, and in reality, especially in gardens. When set apart in gardens, they are both objects of aesthetic appreciation and reservoirs of qi. Thus the placement in gardens of rocks, which are sometimes natural and sometimes shaped to enhance their appearance, is as important in China as the placement of plants. Indeed, rocks were considered essential elements of Chinese gardens from very early times.[24]

Perhaps no rock gardens are as well known as those created by Zen Buddhists in Japan. There the Chinese Buddhist regard for rock conjoined with preexistent Shinto notions that the natural world is animated and pervaded by spirits. Rocks in particular were thought to be inhabited by various *kami*, or divinities.[25] The term *karesansui* (dry landscapes) appears for the first time in the eleventh century in the oldest existing treatise on the art of gardens in Japan, where it is defined as "a place without a pond or a stream, where one arranges rocks."[26] In these dry gardens of rocks and sand, nature, stripped down to its essential components, aids in the revelation of the true self when contemplated by human beings. The rocks were seldom altered in form, and, in fact, while the making of a garden involved moving rocks, their natural position was to be respected such that a rock found lying horizontally was not to be placed upright and vice versa.[27] In East Asia, as in the Andes, stones housed vital

energies and were on a continuum of animacy along with plants, animals, and human beings. Comparing Inka understandings to those of other cultures can help counter pervasive Western notions that have historically clouded scholarship on Inka rockwork.

Unlike those just discussed, Western tradition does not generally recognize a "continuum of animacy," what Graham Parkes calls "panpsychism."[28] Denying the constant (though imperceptible) changeability of rocks, Western thought has most often identified stone as the binary opposite of, rather than a complement to, things recognized as animate. Andean perceptions of stone's transmutability run contrary to traditional Western thinking. Aristotle, for example, denied that inanimate nature, such as rocks, possessed a "soul," unlike plants and animals, which he recognized as animate. Maintaining this basic Aristotelian division, the eighteenth-century Catalan writer Nicolas Felieu de La Penya asserted that "inhabitants comprise cities, not stones."[29] In the ancient Andes, however, stones were often perceived *as* inhabitants of settlements; in fact, they were believed to be the original owners of certain territories, and they were often the most important residents of particular places. They were clothed, fed, and conversed with. Rooms were built to house them, and structures were carefully located around them (figure 2). Relationships, as real as those between sentient beings, were established with rocks.

While throughout Western history, with the exception of a few Renaissance-period philosophers, most thinkers have excluded rocks and minerals from the realm of animacy, this does not mean that rocks have not been seen as sources of great inspiration. Goethe's essay "On Granite" praises the ability of natural rock to awe and inspire; Emerson, Thoreau, and other American transcendentalists understood that the contemplation of natural rock yields great insights, so that it can be perceived with admiration and even affection. It might be observed that heirs to this tradition include the residents of, and visitors to, New Hampshire (the Granite State) who had over many years attached personality to, and grew very fond of, the natural rock formation known as the Old Man in the Mountain. The rock was featured in the short story "Great Stone Face" by Nathaniel Hawthorne and appeared on the license plate of New Hampshire. To the dismay of many, it came crashing down in early May 2003. In television interviews, the state's governor compared its tragic demise to a death in the family. While the recognition of personality and

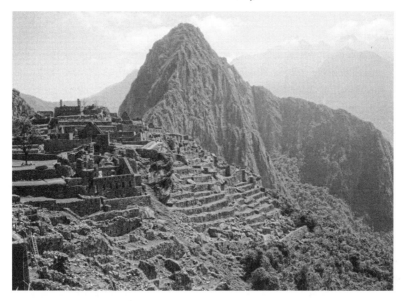

2. Structures arranged around crags, Machu Picchu.

life in an esteemed rock would seem to bring diverse cultural perspectives close, it is important to note that those who loved the Old Man required imagism to see him. Manifesting what Simon Schama has called "anthropocentric fixation," they needed the craggy rock to look like an elderly gentleman.[30] Imagism was something not required by the Inka or needed in the Andes today. Anecdotal evidence supporting this assertion may be found in a Quechua song, collected in 1975 in the Ayacucho region of central Peru, that laments the "poor rocks" and "poor boulders" that must be pulverized by dynamite for a new highway to be built.[31] The song does not bemoan the devastation of a beautiful landscape but mourns the destruction of rocks regardless of their form or setting.

Since Spaniards first set foot in the Inka realm, rocks, and Andeans' regard for them, have bewildered Western observers. The early stages of this awkward history of misapprehension will be charted in the final chapter. Here, however, I would like to focus on more recent history with particular attention to changing perceptions of the aesthetic value of Inka rockwork. Not long ago the philosopher Nelson Goodman concluded that "What is Art?" is the wrong question and ought to be replaced by "When is Art?"[32] For Inka rocks, the "when" is the latter half of the twentieth century, making them a very late entry into the ledger

of world art. While in 1957 the historian J. Alden Mason concluded that stone sculpture "was entirely missing" from Inka material culture and made no mention of their carved or framed boulders and outcrops in his study of pre-Hispanic Andean societies, just five years later the art historian George Kubler, in *The Art and Architecture of Ancient America*, does note, albeit briefly, the Inka's "intricate non-figural carvings on the surfaces of caves and boulders." [33] Since that time, discussion of Inka rock carving has been mostly on the rise. [34] The anthropologist Shelly Errington helps us address why that might be in her article "What Became Authentic Primitive Art." [35] She observes that what was initially recognized in the West as "art" from outside the European tradition was, in essence, driven by the needs and expectations of the modern Western art market. In part, what became art in the twentieth century was what had been and could still be collected and displayed in the manner to which art had become accustomed; its iconicity (imagism or optical realism) and perceived ritual function were also critically important. That most numinous Inka rocks, being outcrops or large in size, are not portable — and therefore not subject to collection and display except through photography and modern touristic practices — militated against early recognition of their aesthetic merits, as did their dominant aniconicity.

Esther Pasztory, in an insightful essay on Andean aesthetics, points out that the twentieth-century turn to abstraction in western Europe and America encouraged a midcentury reevaluation of abstract Inka forms, especially their treatment of large rocks and outcrops. [36] In this observation, she echoes an essay written in 1953 by Meyer Schapiro, who concluded that "the values of modern art have led to a more sympathetic and objective approach to exotic arts than was possible fifty or a hundred years ago." [37] It would seem that we have Western artistic movements, from the earliest experiments in abstraction to Land Art of the 1960s and 1970s, to thank for our ability (or willingness) to value what the Inka wrought in rock. [38] Certainly Frank Lloyd Wright's belief that houses ought not be on hills, but of and belonging to hills, was comparable to that of fifteenth-century Inka architects who commonly integrated rock outcrops into the foundations of their stone walls (figure 3); such perspectives will be explored further in later chapters. For now, suffice it to say that many of the rocks that the Inka valued so highly were not much valued beyond the Andes until after the mid-twentieth century, when the widespread use of photography made them collectible, and an apprecia-

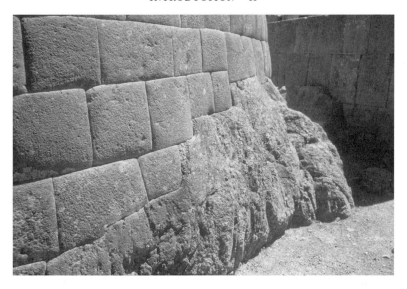

3. Outcrop integrated into a masonry wall, Pisaq.

tion of abstraction rendered them aesthetically appealing. My discussion of Inka rockwork must necessarily reflect on their reception outside the Andes to understand the fragmentary nature of the records on which we now rely.

In what remains of the pre-Hispanic Inka world, we find few if any likenesses of the numinous. Finely crafted images of deities in precious metal were melted down for Spanish coffers, while others were hidden away, lost, and forgotten.[39] In contrast, numerous natural waka still exist; many of them were likely far more significant than the Inka objects collected by the Spaniards and recognized as having aesthetic value in European terms. The art historian Cecelia F. Klein observes that "in [non-Western] cultures the most important values and most profound ideas are sometimes expressed through forms that are not [human-made], are not imagistic, and/or are not executed with the materials and 'care' that we expect of 'great art.'"[40] Of course, the Spaniards who first colonized the Andes were not looking for "art," since the concept of art as something valued primarily for its aesthetic qualities did not come into being until the eighteenth century in western Europe.[41] However, the notion of what was aesthetically pleasing clearly influenced what they collected, preserved, contemplated, and described. Some Spaniards concluded that Andean "idols" were ugly. The sixteenth-century Jesuit José de Acosta,

for example, wrote, "In Peru, they [their idols] were called *huacas* [waka], and ordinarily these were ugly and deformed in appearance; at least all the ones I have seen were so. I believe there is no doubt that the devil, in whose veneration they were made, liked to be worshiped in ill-featured figures."[42] Because Acosta expected the highest order of sacred objects—those that conveyed the presence of the holy—to be not only imagistic but optically "realistic," he maligned the appearance of Andean sacred objects, thinking that they were meant to be representational, but just very poorly formed. To the Inka and other Andean peoples, of course, optical realism did not mark the presence of the holy.[43]

Spaniards, whether searching for idols or treasure (or both), tended to focus on objects of gold and silver. In some ways reminiscent of the Spanish focus on precious metals, modern scholars have too often supposed that many sacred rocks must once have been covered in gold, silver, and jewels.[44] Klein points out, however, that many societies value natural, unworked substances over finely crafted images of precious materials; while the latter are beautiful demonstrations of human creative abilities, the former are numinous just as they are.[45] Certainly, it seems to be the case that the Inka frequently privileged naturally numinous materials over crafted representations of numina. So while statuary of precious metal was seized and melted, much of Inka sacred visual culture remains in stony ruins and the seemingly natural landscape, both of which are dotted with ostensibly innocuous outcrops and boulders—waka that once were and might again be alive. Contact and interaction with other societies, their beliefs and practices, have caused many in the West to question some long-held notions, including what gods, deities, and numinous beings ought to look like. Yet the idea that gods have fixed, recognizable forms and that these forms are represented in an optically realistic way has long endured and too often colored the ways Westerners look at—or what they look for—in objects revered by non-Western others.

Because it is the potential animacy of rocks rather than their artifice that renders them significant, the question of whether they are "art," an ambiguous term at best, seems particularly irrelevant. As I've argued elsewhere, although the pre-Hispanic Inka, like people everywhere and across history, made aesthetic distinctions between objects and sometimes valued certain things above other things owing precisely to these aesthetic distinctions, they did not recognize art as a special category of things and practices composed of subcategories defined by media,

function, geographic provenance, value, and so on.[46] To many, the long overdue aesthetic recognition of an overlooked aspect of Andean visual culture will seem a step to be celebrated. Certainly, many students of non-European cultures have pleaded for recognition and an end to the perceived second-class status of their subjects.[47] The Argentinian artist César Paternosto, for example, whose insights regarding carved Inka rocks I discuss later, bemoans the failure of researchers to acknowledge Inka carved stones as "sculptures" even though he recognizes that other terms and categories borrowed from Western ways of speaking about art are misleading and ill-fitting.[48] While we might well be disappointed in how long it has taken art historians to recognize and seek the meanings of Inka rockwork, we should be wary of how categorizing Inka rocks in non-Inka ways affects their significance. We should understand that "art" is but a subset or category of things and is ultimately inseparable from things not called art.[49] Further, as a cultural construct, it is not a universal category. Indeed, Errington has aptly observed that "the notion that art is a panhuman universal is a pernicious idea, which has on balance done more harm than good."[50] Too often the term *art* is bestowed and then defended as though, in so doing, we were granting other cultures a favor, recognizing their (to us) strange objects as akin to a notion that we find indispensable to the concept of culture. That some Inka rocks are now called art, however, can be seen as an attempt to reconstruct Inka visual culture in the image of the colonizing West, only different in ways that render it somehow insufficient.[51] Twentieth-century abstraction may ease or even compel our recognition of the aesthetic value of fifteenth-century Inka rockwork, but it does not reveal the fullness of the meanings attached to rocks by the Inka. Nevertheless, prevailing Western categories and the values assigned them influence what Inka rock artifacts have been considered and how they have been considered. In particular, the notion of craft and the modern belief that art ought not to be obviously utilitarian have often colored perceptions and interpretations of pre-Hispanic Andean rockwork.[52] As will be seen in later chapters, the utility of any particular rock had little impact on its perceived numinosity.

One of the chief problems created when the notion of art is introduced to a consideration of Inka rockwork is that in the West, art is historically and often still seen in opposition to nature. While this is a broad and much-debated topic, I raise it here to make a single brief point. From

Plato, who concluded that art was inherently inferior to nature, to his student Aristotle, who in *The Poetics* argued that art can accomplish much more than literal (physical) imitation and can convey the essence of what is represented, Western philosophers have most often regarded art and nature as competitors.[53] Consider the words of the French essayist Michel de Montaigne, written in 1580: "It is not reasonable that art should *win* the place of honor over our great and powerful mother Nature."[54] This fundamental and often still operative precept of Western thought, that art not only originally imitated but always competes with nature, is inherently at odds with ancient Andean beliefs and assumptions. Stone in the Andes was both nature and culture, both part of the earth and part of human society.[55] What's more, the Inka often valued rock precisely for its ability to participate in natural and cultural environments simultaneously. That rocks were often places where complementary orders conjoined, enhanced their significance.

While I have focused on the term *art* in relation to Inka rockwork, many of the ways we traditionally think about and categorize visual culture conflict with Inka (and more generally Andean) notions. Recent studies of Inka rockwork, for example, have tended to separate carved stone from other kinds of Inka rocks, a distinction that is inconsistent with Inka perspectives. Carved rocks are the specific focus of the important book *Piedra Abstracta: La Escultura Inca, una Vision Contemporánea* (1989), by César Paternosto.[56] One of Paternosto's foremost objectives was to establish a temporal sequence of carved rocks, which he proposed progressed over the hundred-year period of the Inka imperium (traditionally dated 1438–1532) from partially imagistic and effusive, as at Kenko Grande and on the Saywite monolith (plates 2–3), to abstract, like the Third Stone of Saywite (plate 1), and "minimalist," as seen best on the carved megaliths of Ollantaytambo's unfinished temple (figure 4).[57] Much of Paternosto's language is derived from Western discourses on art and aesthetics. This is perhaps not surprising, since Paternosto is himself an artist who brings his keen eye to the appreciation of Inka forms *as* art. Although my book takes another course, we can learn much from Paternosto's subtle observations. Also focusing on carved rock is the work of anthropologist Maarten Van de Guchte, whose dissertation, "Carving the World," considers the meaning and significance of outcrops in the region around the Inka's capital of Cuzco. Van de Guchte describes the carving of specific rocks in detail and attempts to identify those carved rocks that

4. Detail of abstract design carved into megalithic wall, Ollantaytambo.

were waka. His work is complemented by that of Brian S. Bauer, who identifies waka, many of which are rocks, in and around Cuzco.[58] Rock waka could be carved or uncarved; although today these are often treated as separate—though clearly related—topics, the Inka used a variety of visual cues, identified in the following chapter, to signify the importance of certain rocks, whether carved or not. In fact, carving will be seen to be just one of a number of ways the Inka designated numinous rocks. Thus studies of carved rocks, although highly significant and extremely useful for other reasons, unfortunately fragment the Inka's culture of stone in very un-Inka ways.

Studies of rock waka, both carved and uncarved, have also tended to be distinct from the considerable body of research on Inka masonry architecture. All students of Inka masonry owe a debt of gratitude to John H. Rowe, who in 1944 wrote the seminal study on Inka architecture. More than three decades later, in 1977, Graziano Gasparini and Luise Margolies authored a book-length study of Inka architecture that was translated into English in 1980. Other contributions to the study of Inka architecture will be discussed in subsequent chapters. For now, let us note that studies of Inka stonemasonry structures have historically focused on technology, emphasizing engineering feats and extraordinary craftsmanship, as well as form, volume, and spatial arrangement. This work continues to be important. However, it is also useful to consider what the Inka's engineering feats (the moving of stone) and their craftsmanship (the cutting and fitting of stone) represent in light of the Inka's beliefs about the potential animacy of rock. Unfortunately, too many have apparently agreed with Gasparini and Margolies, who concluded that "the deeply rooted cult of the rock, whether the rock was natural or modified in multiple ways by the stone carver, represents an area of investigation apart from architecture."[59] It should be noted, however, that the same authors also asked, "Why should they [the Inka] incorporate an existing boulder in to the wall of a house . . . ?"[60] To even begin to answer this question (which I do in chapter 2) requires an exploration of what stone, particularly natural stone, meant to the Inka, as well as an examination of the cultural mechanisms through which the Inka invested rocks with particular meanings. It requires us to attend to what the architectural historian Dell Upton describes as the "cultural landscape," a term he coined to describe the "fusion of the physical with the imaginative structures that all inhabitants of the landscape use in constructing and construing it."[61] In other

words, it calls for us to reckon with the Inka's culture of stone in all its fullness and complexity, something that has not yet been done to any great extent.

This is not to say, however, that others have not blazed important trails in the study of the Inka's culture of stone. In *Monuments of the Incas* (1982), the historian John Hemming and the photographer Edward Ranney attempt a brief but integrated study of Inka rockwork—both as freestanding sculptural monuments and as parts of architecture. Archaeologists and others who have focused on site planning have also attempted integrated studies of the Inka built environment. The work of John Hyslop, who studied Inka site planning throughout the empire, has been most significant in this regard; he observes that "to ignore the subject of outcrops and boulders in Inka architecture is to neglect its fundamental Andean roots." [62] Also important is the research of scholars who have focused on site planning in particular locations: Margaret Greenup MacLean, who considers the integration of rock outcroppings within Inka landscaping in her dissertation on Machu Picchu and seven nearby sites; Stella Nair, who studies the Inka royal estate at Chinchero with specific attention to the nonutilitarian aspects of landscaping; and Susan Niles, who has established a model for scholarship on the Inka built environment by considering entire settlements, including structures, terraces, outcrops, boulders, and open spaces. [63] My present inquiry follows in the footsteps of, and is inspired by, all these authors, for the Inka's culture of stone placed value on rocks of all sorts, whether they were carved or not, or integrated into masonry walls or not. To separate out carved stone as worthy of special attention, or to separate out for study stones in architecture while ignoring stones apart from it, is to prioritize non-Inka understandings of rock. It is to take those rocks that most closely align with "sculpture" and monuments that most closely align with "architecture" and extract them from the Inka's culture of stone, awkwardly cropping the picture of Inka visual culture.

Because non-Andean perspectives have clearly had a pervasive, if often subtle, influence on what of Inka rockwork has been studied, and how, I endeavor here to maintain a reflexive view on both scholarly and popular modes of interpretation. While many archaeological studies have necessarily focused on particular sites, geographic areas, or discrete economic, religious, or political systems, the Inka's use of rocks spans the boundaries artificially created by many disciplinary approaches and methods.

This study, the first of its kind by an art historian (which is to empha-
size culture-specific ways of seeing and interpreting the visual), is not
intended to supplant the indispensable kinds of studies listed earlier, but
rather hopes to augment them by attenuating linkages, combining ap-
proaches, and limning overarching belief systems that gave meaning to
Inka rockwork.

Those who study visual culture often use the term *visuality* to refer to
historically and culturally conditioned ways of seeing and interpreting
what is seen.[64] Because Inka and more generally Andean visuality has
been decentered since Spanish colonization by other, non-Andean visu-
alities, I will seek to recenter pre-Hispanic Inka ways of seeing and in-
terpreting rockwork, which can be, in some measure, accessed through
examinations of the treatment of rock and indigenous categories of rock-
work, as well as through Andean stories told about rock. In my con-
sideration of Inka visuality, I will necessarily consider those non-Andean
ways of seeing that have shrouded, disregarded, and mystified indige-
nous signification. At first contact, Spaniards sought easy equivalences
between new Andean things and things with which they were already
familiar. Llamas and alpacas were "sheep," and Andean places of wor-
ship were "mosques" or "temples," aligning them with already-known
non-Christian religions. Earlier we noted that Spaniards defined *waka*
as "idol." The Andeanness of such things was occluded by terminology.
Now perhaps we begin to see that *architecture*, a term that distinguishes
built from unbuilt areas, blinds us to the fact that the Inka built environ-
ment includes unworked and partially worked crags and boulders. To the
Inka, we are told, the stones of the temple walls were as sacred as what
the Spaniards would later call the statues or idols inside.[65] To sort Inka
visual culture according to non-Inka concepts—as when separating dis-
cussion of sculpture from that of architecture—is to re-create it.

This does not mean that I dismiss non-Inka perspectives as irrelevant
or unimportant, and certainly I can make no claim to "telling it as it really
was" for the pre-Hispanic Inka.[66] On the other hand, I believe we can
take cues from the Inka themselves—from their own words as well as
their practices—about how to understand rocks other than in Western
ways. While we cannot fully apprehend Inka visuality, we can be aware of
how, since Spaniards first invaded the Andes, non-Andean precepts have
been prioritized. We can also resist the temptation to re-create the ancient
Inka in our own image, as though our aesthetic values and perceptions

were universally valid. The concluding chapter will pursue these notions further.

What I am attempting here is to approximate Inka visuality with regard to stone as it is revealed in rocks themselves and recorded in both colonial-period accounts and contemporary stories told by the descendants of the Inka and other Andean peoples. Thus I am relying primarily on evidence from three kinds of sources in addition to prior scholarship on aspects of Inka rockwork. First there are the rocks themselves, how they are situated in and related to both the natural and built environments around them. Second there are colonial-period accounts of Inka rockwork, from the first Spaniards to enter the Andes to later colonial government officials, and the extirpators of "idolatries" with their Christianized indigenous assistants.[67] Especially important in this group of colonial-period works are early Quechua-Spanish dictionaries. Those by Domingo de Santo Tomás (1560), an anonymous author (1586), and Diego de González Holguín (1608) give us a vocabulary with which to speak about stone in indigenous terms.[68] Also important are eyewitness testimonies that, in general, can be given more weight than those of authors who learned of something second (or third) hand. I am also particularly wary of the problem of what we might call "cultural illiteracy," the inability of European observers to fathom what they saw or to understand what they were told by indigenous informants. Colonial sources can prove useful if they are employed with caution and a critical awareness of how cultural precepts may have influenced not just perceptions and interpretations but also what was written about to begin with.

Third among available sources, and worthy of a more lengthy discussion, are contemporary ethnographic and folkloric studies — the thoughts of indigenous Andeans today. Recently, the notion of cultural continuity between the pre-Hispanic past and the present has been vigorously questioned. The paradigm of what is called *lo andino*, meaning Andeanness, a shared indigenous Andean culture that has survived from the pre-Hispanic world until the present time, has been rejected by many as a romantic and essentialist fiction.[69] However, the recognition of a profound reverence for ancestors, a belief in the basic complementary structure of the cosmos, and a fundamental reliance on reciprocity, for example, do not require us to deny the upheavals that have occurred as a result of political, economic, and religious changes and have altered people's lives dramatically over the centuries.[70] Lawrence A. Kuznar, an

ethnoarchaeologist, demonstrates how ethnographic work can aid and support archaeology in identifying and interpreting religious sites and practices, and the ethnographer M. J. Weismantel observes that indigenous Andeans often consciously retain what they view as particularly Andean cultural practices as part of self-identification.[71] Thus it would be folly to reject out of hand the contemporary insights of indigenous Andeans, many of whom have a firm sense of their own culture and its history.[72] While modern stories about the ancient Inka and their relationships with rocks cannot be taken literally, they will be taken seriously here. Chapter 2, in particular, tests the boundaries of contemporary storytelling by looking for continuities between ancient Inka practices and modern Quechua stories about them.

As I researched the Inka's culture of stone, looking at many of the rocks the pre-Hispanic Inka left behind, and listening to the ways Andeans of yesterday and today talked about rocks, it became clear that many of the categories of things and ideas that I had packed into the Andes, like so much photographic film and altitude-sickness pills, notions like art or litholatry, or a dozen others I could name, are inadequate to describe Inka concepts. It became clear that the West has literally never come to terms with Inka rocks. We have no language to describe what they perceived. Therefore what is required is attention to Inka terms and concepts in the Quechua language, not all of which are clearly defined or well understood. Quechua terms will not be used here for their own sake; what can be translated in a straightforward manner will. However, many terms are not easily or not at all able to be translated without skewing meaning. Thus, while so many unfamiliar and even ambiguous terms may be challenging, they are essential. Recently, the art historian James Elkins, in his review of David Summers's global art history text *Real Spaces*, objected to what he characterized as the overuse of critical concepts and vocabulary indigenous to the cultures studied, saying, "Too many unfamiliar terms and the text may no longer feel like art history."[73] So be it. This study may not feel so very much like art history, at least not Elkins's art history, but then, as I indicated earlier, it was never intended to be about art.

The first step in understanding rocks from an Inka perspective is to look at Inka categories of rock rather than trying to fit Inka rocks into established Western categories. Accordingly, chapter 1, "Rock and Remembrance," discusses the ways the Inka distinguished sacred and

potentially animate rocks, those stones to which offerings were made, from mundane rock. I characterize these sacred rocks as "remembered rocks" because Inka oral and performative culture kept them alive and potentially animate in the memories of those who encountered them. The chapter also focuses on named types of rocks that the Inka venerated. These include the rulers' stone brothers, petrous guardians of territory, petrified warriors, rocks that embodied periods of time, and those that embodied quarries and sacred mountains. I argue that the Inka prioritized the transubstantial essence of stone over its superficial appearance. Thus the imagistic carving of stone, although important, will not be the focus of my discussion.

With the aid of a contemporary Quechua story, chapter 2, "Rock and Reciprocity," suggests that the pre-Hispanic Inka conceived of the untouched natural environment as fundamentally complementary to their built environment. Further, they understood building in stone as one of the processes through which they ordered unordered nature, converting untamed spaces into domesticated Inka places. I focus on the elements of the Inka built environment where the order of Inka civilization meets unordered nature, and the significance of stones that occupy such interstitial zones. Specifically, I will examine the following: terrace walls as symbols of nature organized for the benefit of human inhabitants; dressed-stone masonry as domesticated rock; and rock outcrops that Inka builders integrated into masonry walls. Integrated outcrops married the natural environment to the built environment and so symbolized the union between the earth and Inka.[74] Further, certain practices, places, and rocks enacted a tangible colloquy between the Inka and the powerful spirits associated with the land and its topography.

Building on these ideas, chapter 3, "Rock and Rule," looks at the Inka built environment as a symbol and actuation of the Inka civilizing mission (perceived by other Andean peoples as Inka imperialism). The Inka's culture of stone was fully mobilized in support of the state's imperial agenda and reached its fullest expression both by building on pan-Andean beliefs and reverential behaviors regarding rock and by introducing new forms and practices. My discussion focuses on place making, place taking, and place holding, specific strategies through which the expanding Inka state converted land into territory and bolstered their claims to it. The Inka's distinctive style of architecture converted space into place. Traces of labor, the visible marks of fitting and setting stones

into specific locations, also functioned as place makers. Sacred sites, in particular, were marked in ways that familiarized them and brought them into the Inka's waka network. Oral histories claimed and held places for the Inka as they not only remembered specific rocks but recalled Inka actions on — and so possession of — those rocks and the landscape of which they were a part. The chapter also considers the occupation of lithic seats from which oversight of specific territories was often exercised. Such seats both commemorated and naturalized Inka governance of newly acquired lands, placing those who occupied elevated lithic seats on a continuum of numinous Andean overseers.

Chapter 4, "Rock in Ruins," examines the colonial destruction of the Inka built environment and the concomitant production of ruins. Ruined Inka structures — partial, tumbling walls of stone — signified Spanish colonial control as well as religious conversion. Here I ponder the meanings of Inka ruins as they have changed over time, and focus on the ways tourists today, like the Spanish conquistadors of yesterday who paved their trail, continue to impose their expectations and desires onto Inka sites and monuments. In particular, non-Andean visitors to Inka sites today are encouraged by guides and guidebooks to discern surreptitious images in aniconic Inka rockwork. Whereas the Inka valued embodied essence over superficial appearance, today it seems that appearance now trumps essence. While stones were once understood to take form of their own volition, they now take form in the tourist imagination, and the tourist has become the primary producer of meaning. We will consider the impact this has had on understanding Peru's indigenous past.

As we toil to see rocks from an Inka perspective, as we come to terms with their terms, perhaps we can learn from Andeans who once struggled to explain their world using European expressive modes. In the days, decades, and centuries following the Spanish invasion, Inka and other indigenes grappled with many new notions, including the idea that they were *indios* (Indians) who inhabited a "new" world. They confronted the strange religious beliefs and practices of Roman Catholicism; European medical, hygienic, and sexual practices; and different manners of clothing, gesture, speech, and making music, as well as myriad other expressive cultural elements. They also surely grappled with European visual representational practices. Felipe Guaman Poma de Ayala (hereafter called Guaman Poma), a native of Ayacucho in the central Andes, spoke

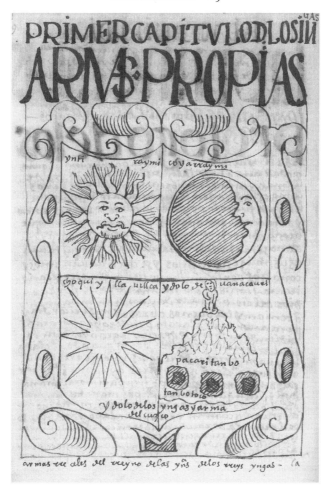

5. Coat of arms with Wanakawri as both mountain and anthropomorph.
Felipe Guaman Poma de Ayala, "Primer Capítulo de las Yngas: Armas
Propias," in *El Primer Nueva Corónica y Buen Gobierno*, fol. 79, ca. 1615.
Photograph provided by the Royal Library, Copenhagen, Denmark.

and wrote both Spanish and the indigenous language of Quechua. As a
Christian, he aided in the extirpation of indigenous religious practices,
and as a native Andean, he protested the Spanish colonial system of gov-
ernment. In the latter part of the sixteenth century and early years of
the seventeenth, he authored an illustrated chronicle, *El Primer Nueva
Corónica y Buen Gobierno*, showing linguistic dexterity with Spanish and
the Andean languages of Quechua and Aymara.[75] His images are like-

wise dexterous and bicultural, drawing as he did in imitation of European printed book illustration while using Andean codes of dress, performance, and composition.[76]

Guaman Poma may hint at the transformational qualities and transubstantial nature of stone when he shows us a drawing of an Inka coat of arms where, in the lower right quarter of the blazon, the important waka called Wanakawri (labeled "ydolo de uanacauri") is depicted both as a mountain and as an anthropomorphic figure (figure 5).[77] Wanakawri was one of the Inka's most esteemed waka, as it was understood to be the petrified brother of the founding Inka dynast. Colonial-period descriptions of the Wanakawri waka indicate that, unlike Guaman Poma's drawing, it was an unshaped tapering stone.[78] It seems reasonable to suggest that since carved rock statues were not part of Inka religious observance, the artist is trying to communicate the invisible anima of the rock formation, drawing, as it were, in two languages — a lithic shrine for Andeans, and a figurative idol for Europeans. Guaman Poma shows us the transubstantial nature of rock that was simultaneously an inert rock on a hill and the potentially animate brother of the first Inka ruler. The indigenous illustrator merges the two, anthropomorphizing the hill and lithomorphizing the figural image. In so doing, Guaman Poma's conjoined anthropomorphic figure and hill reveal the topography's kamay, or essence. The textual and visual bilingualism in Guaman Poma's manuscript suggests that certain concepts, especially (for our purposes) those concerning sacred rocks, cannot be expressed well in other languages. Translation necessarily involves revision.[79] My goal here is to read across time and cultures, as well as languages; may I be a fraction as deft as the hand that portrayed Wanakawri many centuries ago.

A Western artist uses sterile, neutral materials,

but among the Incas, the sculptural medium itself was numinous.

—CÉSAR PATERNOSTO, *The Stone and the Thread*

Many rocks were, for the Incas, just rocks.

—SUSAN NILES, *Callachaca*

·(⇄)·

CHAPTER 1

Rock and Remembrance

To the ancient Inka, as to modern speakers of Quechua, the word for rock in general is *rumi*; a boulder, an outcrop or crag, and, more generally, any significant rock formation were called *qaqa* (*caca, caka, ccaca*).[1] Like many other people, the Inka recognized the distinctive properties of which some kinds of rock were composed; for example, crystals, obsidian, and other precious stones were *qispi* (*qespi, quispe*), pumice was *khachka rumi*, limestone was *saqana*, and metallic rock was *qurpa* (*corpa*). A rock could also be distinguished on the basis of its form, as in flat stones (*p'alta rumi*), round stones (*llunphu* or *rumpu rumi*), squared-off-stones (*k'uchu rumi*), or named according to its function, as in hammer stones (*kumpana*), ashlars (*kallanka rumi*), pavers (*qallkirumi*), and so on.[2] Clearly the Inka thought about rock in a variety of ways, some of which are more familiar to us than others. As quoted in the epigraph, Susan Niles notes that although the Inka recognized the numinosity of many rocks, they did not revere all rocks. The seventeenth-century Jesuit extirpator of idolatries Pablo Joseph de Arriaga tells us that large stones worshiped by the Inka were given names, and that stories were told about them.[3] Another extirpator working in the first half of the seventeenth century, Fernando de Avendaño, indicates that many rocks held sacred by Andean peoples were deities who had petrified, and that such stones

had histories that were passed down through generations of worshipers.[4] Thus named rocks were usually large ones about which stories were told. They were rocks that were supposed to be remembered and associated with particular deeds or events. Whether we call the stories myths, legends, fables, tales, or oral histories, they recorded the meanings of, and so made meaningful, certain rocks.

I begin by looking for cues on or about large rocks still present in the Andean landscape that allow us at least tentatively to differentiate between rocks that were *just* rocks, no matter how useful, and rocks that the Inka considered to be something beyond the mundane, rocks that were named and likely had stories attached to them. I then consider aspects of Inka oral culture that converted regular rocks into remembered rocks. Many of the rocks that were worth remembering to the Inka were believed to embody (once) nonpetrous things. Most often, these rocks did not look like that which they embodied. As I have argued elsewhere, *representation* is a misleading term with regard to many different types of Inka numinous rocks, for these rocks are not substitutes for that with which they are identified, but are, in fact, those very things themselves, just in a lithic guise. Because, from an Inka perspective, such rocks make something other than stone *present*, I suggest they be thought of as "presentational" stones.[5] Because presentation and representation constitute the complementary poles of Inka material and visual culture, I conclude the chapter with a consideration of these two fundamental interpretive modes.

DISTINGUISHING THE EXTRAORDINARY

Of the many waka (sacred places or things; see the introduction) listed by the sixteenth-century priest Cristóbal de Albornoz as being in and around Cuzco, more than half were rocks.[6] According to the Jesuit Cobo, writing in the first half of the seventeenth century, approximately one-third of the waka composing a system of 328 "shrines" (*adoratorios*) in Cuzco and its environs consisted entirely or primarily of rocks.[7] A large number of these petrous waka escaped extirpation during the Spanish colonial period because they were unworked elements of the natural environment and so easily overlooked.[8] Even if recognized, they were not so simply done away with; destroying large boulders, rock outcrops,

caves, and so on is not readily accomplished, as Albornoz noted: "It is im-
possible to take from them this superstition [of worshiping boulders and
mountains] because the destruction of these *waka* would require more
force than that of all the people of Peru in order to move these stones and
hills."[9] As noted in the introduction, Polo relied on the observed behav-
ior of devotees to identify waka. While there are no pre-Hispanic Inka
left to instruct us, we can attend to some of the visual cues — framing,
distancing, contouring, and carving — that allow us to recognize some
large rocks that the Inka likely regarded as not "just" rocks, for these
strategies all single out particular megaliths from the otherwise undiffer-
entiated landscape.[10]

Framing

One readily recognizable Inka strategy for designating special rocks was
to frame them in masonry (plate 4). The rectilinear frame draws attention
to what is enclosed, and separates the extraordinary from the ordinary,
the special from the regular, and the sacred from the mundane. Some-
times the frame is low, allowing a view of what is framed, and some-
times the frame encloses the rock, housing it as human residents would
be. Some framed crags are given finely formed habitation; as Niles ob-
serves, such rocks would be "impediments to comfortable living" and so
"are not part of the house or its furnishings but are, rather, the denizens
of the house."[11] The quadrangular frame itself is a common motif in Inka
visual culture: *tukapu* (*tocapu*), for example, distinctive woven patterns
in the finest Inka textiles, are held within and distinguished by quadran-
gular frames, and the *kancha* (*cancha*), the basic unit of the Inka built en-
vironment, acts as a frame that separates specialized places from nonspe-
cialized spaces.[12] Doorways and windows in Inka architecture frequently
frame special views, separating and drawing attention to certain features
of the surrounding landscape, as will be discussed in the following chap-
ter (figure 27).

 Given the ubiquity of frames as indicia of special or specialized space in
Inka visual culture, it is not surprising to find that the early-seventeenth-
century indigenous chronicler Joan (or Juan) de Santa Cruz Pachacuti
Yamqui Salcamaygua (hereafter Santa Cruz Pachacuti) drew the three
exits from the inner world of the ancestors, from which the first Inka
emerged into this world, as nested frames (figure 6).[13] The mouth of the

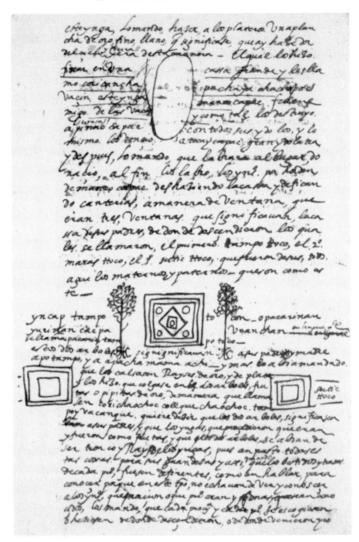

6. Ancestral caves. Juan de Santacruz Pachacuti Yamqui, *Relación de Antigüedades*, fol. 8v, ca. 1613.

cave (*t'uqu*) functions as a conceptual frame delineating the passage from one world to another.[14] Like the mouth of the cave, only horizontal rather than vertical, the masonry frame signals the encounter between specialized and regular space. In particular, the frame around an outcrop announces the emergence of the rock from the underworld or innerworld of spirits and ancestors, marking it as a place where worlds conjoin.

Distancing

Rocks in the Inka built environment can also be distinguished by their distance from other structures. Unlike the petrous waka that are framed with a visible boundary between sacred and profane space, the distanced rock is surrounded by vacancy. The void announces the approach to something significant by the striking contrast between nothing and something. This is the case, for example, with regard to many *chakrayuq*, the lithic owners of the fields or terraces where they are found. Because vacant space, as a mark of the special, depends on the distant presence of other structures or monuments, it is most commonly seen to define rocks very near or within zones of human occupation. Distancing indicates that certain rocks are both a part of and apart from the built environment. Since distanced rocks—being outcrops or boulders—could not (easily) be moved, we must conclude that the Inka determined the placement of some structures so as to purposefully contrast with the space around these extraordinary rocks.[15]

Contouring

A third Inka technique used to identify a rock that is not just a rock may be characterized as contouring. Unlike the rectilinear frame, contoured masonry traces the form of the rock, hugging its lateral surfaces. In contrast to the distanced stone, positioned apart from worked masonry, the contoured rock is integrated into the architecture that surrounds it. Curvilinear contouring signals some of the most important of sacred Inka rocks, including the so-called Intiwatana at Pisaq (Pisac, P'isaq), where fine masonry encircles two outcrops (figure 7), and the misnamed Tower (Torreón), also known as the Temple of the Sun, at Machu Picchu. Despite its exterior appearance, the Tower's upper chamber opens to reveal the room's occupant: the outcrop whose upper surface is visible in the interior (plate 5). At both Machu Picchu and Pisaq, the living rock is embraced by masonry but is also exposed. The interplay of worked and unworked stone at sites of contouring articulates the rock's liminal position as part of the natural environment and part of the built environment, a simultaneous resident of both this world and the inner- or underworld. At Chinchero the set of carved rocks known as Pumacaca (Pumaqaqa, "mountain lion crag") was even once contoured in such a way as to make

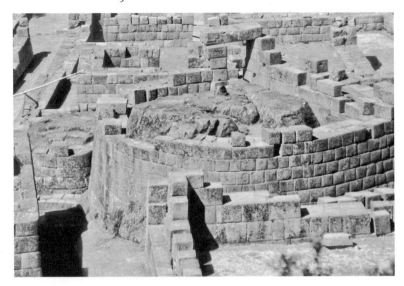

7. Contoured outcrops, Pisaq.

it appear as though parts of the bedrock were worked ashlars, deliberately confusing the distinction between masonry wall and sacred rock; this may have happened at other sites of contouring as well.[16]

It has been suggested that the curved shape of the contoured wall may itself be significant, as curvilinear walls of worked masonry embrace sacred topography at Ingapirca (Hatun Cañar), Patallaqta, Tomebamba (Tumipampa), Wiñay Wayna, and many other sites. Of all curved walls, surely the most sacred was part of the Inka's main temple in Cuzco, the Qurikancha (Coricancha), a structure that will be discussed in greater detail later (figure 44). Indeed, the Qurikancha may well have inspired other examples of curvilinear contouring masonry walls found throughout the empire.[17] Because the Spaniards built the church of Santo Domingo over its walls, placing the apse of the Catholic church close to the curved portion, exactly what the bowed wall contoured is a matter of conjecture. Gasparini and Margolies, who produced a plan of the Qurikancha based on work done after the earthquake of 1950 brought down some of the colonial-period structure, wondered whether the wall could have enclosed a sacred stone in the manner of Machu Picchu's Tower.[18] In reconstruction no outcrop was uncovered, however. According to some chroniclers, one of the original Inka brothers was petrified at the place where the Qurikancha was later built.[19] It may also be the site where

the first Inka sank a staff into the ground as a sign of Cuzco's foundation. Betanzos, writing in 1557, reports that Manco Capac (Manku Qhapaq) selected the site of the Qurikancha as the first spot to be settled in the Cuzco valley.[20] Thus the curving wall draws attention to this special place.

Terrace walls are also sometimes curvilinear, emphasizing both the natural curvature of the topography and the orderly and procreative presence of Inka occupation; this will be discussed in the following chapter (plates 10 and 12). The curved, contouring wall—whether it is hugging a numinous outcrop, embracing a sacred location, retaining an unstable slope, creating cultivable plots, or serving other purposes—inevitably draws attention to the shape of that which it contours.[21] As pointed out in the introduction, a focus on appearance (the curviness of the contouring wall) alone may be misleading; the Inka focused on what was behind the wall, encased and embraced by their masonry. The function of the curve—to draw attention to what it contours—is the key to understanding the significance of the curvilinear wall. While outcrops were just one of several things to be embraced by curvilinear masonry, when rocks were contoured, they were clearly waka.

Carving

Of all the visual cues to a rock's special status, carving has been the most thoroughly considered elsewhere. As indicated in the previous chapter, the book-length studies by Paternosto and Van de Guchte are the most detailed; Bauer, Hyslop, and others have also authored insightful considerations of Inka rock carving.[22] The following forms are most commonly found carved in stone: steps; flat places or platforms; gnomons; rectangular niches; cupules; and channels. Rarer imagistic carving, as seen on the Saywite monolith (plate 3 and figure 8) and elsewhere, includes terraces, pumas or other felines, frogs or toads, reptiles, monkeys, and birds.

On the most basic level, the carving of the stony surface, whether imagistic or not, distinguishes the rock from its natural environment, visually marking it as extraordinary. Carving separates, as Paternosto says, "the space of the sacred from its profane and nameless surroundings."[23] Thus carving, like framing, distancing, and contouring, visually distinguishes the sacred rock from its mundane setting. On another level, some of the

carving may well have been functional: the frequently carved flat places could have served as altars or places for setting offerings; some niches may have been seats; some steps may allow passage onto and across the surface; gnomons and other shapes allowed for astronomical observations or other sighting practices; and cupules and undulating channels (called *paqcha* or *paccha*), such as those at Kenko Grande which give the site its name (Kenko or *q'inqu*, meaning zigzag in Quechua), provide a way for liquid offerings such as water, *chicha*, or blood to be deposited on and flow across the stone (figure 9).[24]

Some imagistic carving may function as a form of offering, a sort of relief version of the more familiar free-standing *illa* (*ylla*), small amulets used by pre-Hispanic Andeans (and still used today) as repositories of good fortune, increased productivity, and abundance.[25] An illa is usually a small stone sculpture, often shaped like a camelid (llama or alpaca) or bird, with or without a depression for offerings.[26] When carved directly on the surface of the stone to which it is offered, the imagistic carving may have served as a permanent record of petitions to the larger petrous numina. Imagistic carving may also allude pictorially to characteristics of the place. A rich and fertile environment is suggested by the terraces, canals, and creatures symbolic of water on the Saywite monolith, a carved granite rock measuring ten feet in length, nine feet in width, and eight feet in height, located near a waterworks (plate 3). The monolith appears to be a microcosm — its upper surface altered by habitation, procreative and teaming with life; its lower portion, its underworld, unhewn and untamed.[27] The carved upper surface of the monolith, with its terraces, steps, and channels, reminds us of the ways the Inka carefully orchestrated the flow of water through their sites. Indeed, the Saywite monolith appears to have been designed for liquid to run through its channels and across its surface, spilling off the carved area at orifices along its edge where the carving ceases.[28] Flowing water visualizes the passage from and communication between under- and upperworlds. Indeed, many carved rocks signal sources of water or waterways.[29] The Inka's "culture of water" clearly and importantly overlaps and intersects with their culture of stone, as water was also a transubstantial medium symbolic of the transitions between parts of the world and diverse stages of being.

Steps, found on many carved rocks, likewise symbolize passage and may mark places of transition between worlds. As noted earlier, outcrops themselves are liminal, being both part of the underworld, from which

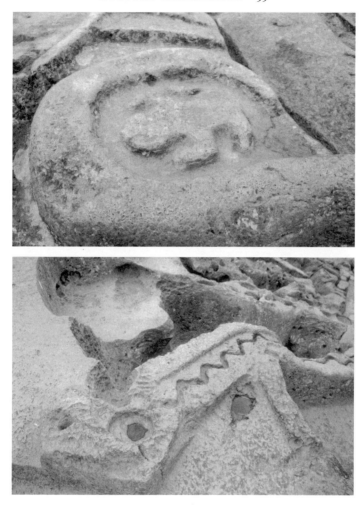

8. Carved monolith, detail zoomorph, Saywite.

9. Paqcha or channel for liquid offerings, Kenko Grande.

they emerge, and part of this world. Steps and stepped patterns are particularly important parts of outcrops associated with caves or *chinkana* (labyrinths), crevices or underground passages through the stone, as well as waterways (e.g., plates 6–7 and 11). The cave, called the Royal Mausoleum, beneath the Tower at Machu Picchu features a flight of steps leading nowhere at its entrance (plate 8); the so-called Third Stone (or Intiwatana) at Saywite is carved with both nonfunctional steps and a window, both of which signal transition (plate 1). Steps carved into many

other boulders and outcrops are likewise nonfunctional. Referring to the "little flights of stairs" carved into the outcrop at Kenko Grande, the early-twentieth-century explorer Hiram Bingham notes that they "serve no useful object so far as one can see." [30] In fact, steps at Kenko are placed near a passageway through the outcrop that the Inka modified. Similar carvings of steps near caves, crevices, passages through rock, or waterways are found at Chinchero, Saqsaywaman, Choquequilla, Intinkala, and Salunpunku (Salonpuncu, also known as Lago, Laqo, or Lacco), just to name a few. Steps or stepped patterns symbolically allude to passage between different cosmic levels; in so doing, they signal the liminality of the places they mark. [31] These are important sites where this world opened into the ancestral realm. In fact, some caves and crevices actually housed ancestral mummies. [32]

Caves, nooks in rocks, outcrops, and springs are all named as origin places (*paqarisqa, paqarina, pacarina*), liminal spots where ancestors surfaced from the inner- or underworld to populate this world. [33] In the best-known Andean origin story, the creator deity made human beings from rock in the area near Lake Titicaca and sent them in pairs underground so that they would emerge from caves, fountains, rivers, and springs in various parts of the Andes. The Inka themselves first emerged from Tampu T'uqu, the central cave of a set of three caves (figure 6). Hence caves, like other paqarisqa, were doorways between the ancestral world and this world, and they remained places of contact between realms. [34] Carvings, particularly with steps, symbolic of passage, were visible reminders of liminality, of passage through, proximity to, and communication with ancestral beings. Certain animals, such as the serpent, the puma, and the condor — animals often carved near portals — were symbols of transition and so are also appropriate marks of liminal spaces.

Framing, distancing, contouring, and carving emerge as fundamental strategies through which rocks that were part of the natural environment were visually reconceived as simultaneously participating in the Inka's cultural environment. These methods of marking were not mutually exclusive; the so-called Puma Rock at Kenko Grande is partially framed, while the surface of the rock next to it is extensively carved (plate 2 and figure 10). The so-called Funerary Rock or Ceremonial Rock (figure 29), as well as the Intiwatana at Machu Picchu (figure 42), both of which are discussed in later chapters, are both carved and distanced, as are many of the monoliths at Saywite. Inka marking, by whatever method, orches-

10. So-called Puma Rock, Kenko Grande.

trates human encounters with sacred rocks by emphasizing either or both the connectivity of the rock to the built environment (through framing, contouring, and the carving of steps, niches, and other architectonic forms) and its contrast with that same environment (through distancing and the carving of imagistic or naturalistic forms).[35] Thus these techniques for marking sacred rocks simultaneously produce connectivity to and contrast with the natural environment and so accentuate interstitiality. Additionally, the Inka draped some sacred rocks with textiles and may have adorned some of them with plates of gold and precious stones. The end result of such visual cues is liminality on several levels. Another consequence is that marked rocks were recognized as both normal and numinous, existing and participating in diverse worlds simultaneously. How rock can be both rock and more than rock at the same time is the next subject to consider.

PRESENCE IN/OF STONE

The anthropologist Alfred Gell wrote, "All that may be necessary for sticks and stones to become 'social agents' . . . is that there should be actual human persons/agents 'in the neighbourhood' of these inert ob-

jects, not that they should be biologically human persons themselves." [36] Modern dictionaries define the term *living rock* as rock in its original state or place. To the Inka as well as other Andeans, however, certain rocks were perceived as quite literally alive. Andean oral culture is replete with instances of animate beings converting to stone, as well as rock coming to life. In fact, the extirpator Arriaga estimates, with some exasperation, that there were a thousand fables of lithomorphs in Andean oral culture. [37] Andean creation stories in particular indicate that human beings were originally made from stone and, in some accounts, turned back into stone when they displeased the creator. [38] Not only was stone perceived as a substance given to animation; flesh was understood to be capable of petrifaction.

Perhaps the best-known examples of lithomorphy come from stories of the Inka's origin featuring the deeds of four brothers and their four sister-wives. Although the various accounts differ in many details, in all versions at least one of the first four Inka brothers turned to stone while on the migration to the divinely selected Inka homeland. [39] None of the original sisters was said to have petrified. While the earth itself was conceptually feminine, most rocks that are specifically named are male. Rock, in Andean thought, seems to have been mostly associated with masculinity and virility; feminized rocks are usually specifically *not* procreative. Indeed, in many pre-Hispanic stories petrifaction brings an end to a female's procreative abilities. [40] For example, in the Quechua story of Cuni Raya Vira Cocha and Caui Llaca recorded in the early-seventeenth-century Huarochirí manuscript, Caui Llaca flees the amorous Cuni Raya, running from the mountains toward the sea. At Pachacamac, on Peru's central coast, she was petrified and can be seen there today as a boulder inundated in frothy sea foam, which is *viracocha* (*wiraqucha*, sea fat) in Quechua. Although forever awash in Cuni Raya's viracocha, a metaphor for semen, the petrified Caui Llaca is impregnable and infertile. In other stories from Huarochirí, lithification is also directly associated with an end to female sexual activity. [41] Even today in parts of Peru, some outcrops, considered to be extensions of mother earth, are called ñusta (princess) and are said to house the earth's female spirit. [42] Ñusta, a title for an Inka maiden of royal heritage, refers to a female who is not yet sexually reproductive.

Sometimes petrifaction punishes women for sexual transgressions. Cobo tells of married women who, suggestively, went "walking about at

night" (*andando de noche*) and, as a consequence, were turned to stone.[43] The presence of such lithomorphs in the landscape made Andean morality both visible and material. The Mercedarian Martín de Murúa devotes two chapters of his early-seventeenth-century *Historia general del Perú* to the lengthy tale of Chuquillanto, an *aklla* (*aclla*, "chosen one," a chaste servant of the state religion), and her illicit lover, the shepherd Acoitapia (Acuytapra).[44] Fleeing from those who would punish them for their forbidden affair, they both turned to stone. The story accounts for two sacred mountains, Sauasiray and Pitusiray.[45] Although Murúa describes the lithified lovers as statues (*estatuas*), it is clear that they became one with the stony mountains. In his manuscript of 1590 (the Galvin manuscript), Murúa companions the story with five painted illustrations, the last of which shows the lovers petrifying (figure 11).[46] To the left, Chuquillanto is positioned on a vertical axis between the town of Guayllapampa (Guaillabamba) below and a hill labeled Sauasiray; to the right, "Acoitapia" appears above the town of Calca and below a twin-peaked hill labeled Pitusiray and Urcun/Urcunsiray. Both Chuquillanto and Acuytapra are half human and half stone; their bodies below the waist have petrified, and the tops of their heads merge with the rocky peaks above. Legendary lithomorphs such as these were clearly identifiable in the landscape. Pre-Hispanic Andean topography was dotted with rocks, hills, and mountains that functioned as the mnemonic apparatuses of history linking the human occupants of the land to their past. Because the Quechua word *pacha* refers to both time and the earth, it is logical that a given landscape would be associated with the past events that took place in them.[47] Rosaleen Howard-Malverde observes that today in the Andes, "stone stands at the crossroads between past, present, and future, and between inner and outer worlds, and perfectly epitomizes the merging of space and time in Andean thought."[48] For the Inka (and other ancient Andean peoples), too, landscape was a memoryscape wherein rocks and other natural and built formations were actors in known narratives. Ceremonies celebrating remembered rocks recalled specific versions of history that supported certain land and water rights. Thus many petrous *waka* were associated with particular social groups, for those *waka* embodied their collective history as well as the special prerogatives accorded them because of historical deeds or circumstances.

People from conventionally literate societies tend to think that text substitutes for oral communication; it might be assumed, by analogy,

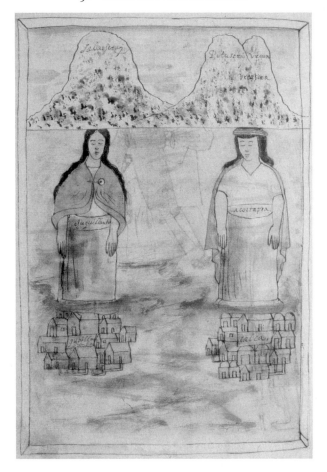

11. Chuquillanto and Acuytapra transformed into mountains. Martín de Murúa, *Historia y Genealogía de Los Reyes Incas del Perú (Códice Galvin)*, fol. 147v, 1590.

that objects—like remembered rocks—substitute for orality as well. Penelope Harvey, however, points out that the distinction between historical narrative and remembered experience is "grounded in a very specific European tradition, with all the obvious limitations for a cross-cultural application." She reminds us that there are divergent ways of remembering and recounting, and that the use of textual metaphors so common in Western cultural theory may not be useful for understanding the Andes.[49] Rather, she argues, signs validate already known histories and relationships. Thus lithic waka were not there as substitutes

for oral histories (they cannot be "read"); rather, they were evidential in nature and so validated already known stories.[50] As suggested earlier, we might think of the land, scattered with the lithic evidence of past acts, as a memoryscape. The ethnographer Thomas Abercrombie evokes Mikhail Bakhtin's concept of the chronotope to describe how some contemporary Andean stories are linked directly to specific places in the local landscape; in recalling these stories, individuals rehearse "memory-paths" to "move from the here and now backwards in time and outwards in space and, paradoxically, also towards the future."[51] Memories, of course, are subjective abstractions of human experience. Remembering one version of the past requires the forgetting or repressing of another version of that same past. Identifying historic actors—what we might think of as materialized memories—petrified in the landscape with whom future humans will interact keeps particular interpretations of history alive. At these petrous memorials, historic actors were said to have declared themselves, through petrifaction, ever present with their future actions always potential. Later chapters will explore specific instantiations of what might best be called naturalized memories and also discuss aspects of the Inka's culture of stone in which rock, metonymic of willful nature, "voluntarily" supported, enhanced, and furthered the Inka state's imperialistic agenda. For the Inka and other Andeans, state-ordained rituals mandated and validated reiterations of certain versions of the past. In telling stories—by remembering specific rocks in particular places—a certain past was made present. Petrous, named waka were both materialized memories and traces of historic events.[52]

In their sacred geography, the Inka and other Andeans encountered petrous beings from their shared history who had shaped their world and, it was believed, still had the power to do so. In and around Cuzco, for example, were the *puruawqa* (*puruauca*, *purunawka*), stones that had come to life to help the Inka defend Cuzco from a neighboring enemy and repetrified when the danger had past. Implicit in the legend of the puruawqa is the promise of reanimation. Pre-Hispanic Andeans did not perceive lithification as a necessarily permanent state; what was once rock might return to rock, and what was once animate might spring to life again.[53] Sabine MacCormack understands this idea as an expression of the Andean principle of "continuous identity," according to which "identity could be conceptualized as continuous even when its expression or representation changed."[54] For the Inka and other Andeans, stories af-

firmed the once and future animacy of certain known rocks that were associated with past or invisible personages and actions. Unlike rocks without memories attached to them, "remembered rocks" were named actors who participated in the making and remaking of culture, society, and history.

No doubt empirical observation lent credence to stories about animate stone. Someone who has seen hundreds of individuals attempting to move a megalith, as was done not long ago in the town of Ollantaytambo, might believe that stone stubbornly resists relocation, as one story claims; someone who has seen a boulder tumbling rapidly downhill, crushing whatever stands in its way, might well believe in its desire for vengeance, a theme of yet other stories.[55] Owing to rocks' potential animacy and their important roles in visualizing history, Andeans engaged with remembered rocks in a variety of ways. Offerings were (and are) the most common method of interacting with potentially animate rock and of keeping the associated stories alive. Some people, particularly members of the Inka royal family as well as diviners, were said to converse with numinous rocks. Today many indigenous Andeans still believe that the pre-Hispanic Inka could speak directly with rocks and mountains, something most of their descendants have lost the ability to do.[56]

PRESENTATIONAL STONES

In the discipline of art history, we are used to speaking of representations, as well as signs, icons, indices, and symbols.[57] All these terms imply surrogation. In his "Meditations on a Hobby Horse," originally published in 1951, E. H. Gombrich argues that all images are substitutive; significantly, he also finds that nonresemblant representations like the hobby horse are comparable to images because they are substitutive as well.[58] The Inka's remembered rocks, in contrast, were perceived as the embodiments of things or ideas. They were "presentations" rather than "representations" and were not substitutive. While representations *mediate* between absent or invisible prototypes and past events, embodiments make the absent or the past *immediate*. They do not replace or stand in for the things they are held to embody. Thus those rocks that made absent or invisible individuals, actions, or ideas materially present for the Inka and other Andeans can best be thought of as presentational stones. Presenta-

tional stones operate through a belief in shared, albeit transubstantiated, essence; the rock is perceived to be that which it embodies, regardless of its appearance. In Andean hearts and minds, presentational stones were not replacements for lost ancestors, culture heroes, past actions, or invisible concepts; they were those things themselves. They were not representations of past actions or abstract ideas; they were transubstantiated articulations of them.[59] Presentational stones also hosted the sacred essences of hills, streambeds, and canyons. In such instances the embodiment is perhaps less strange to us, since we recognize some essential similarity — a natural metonymy — between rocks and the larger topographic features they are held to embody.

Presentational stones constitute an important subset of remembered rocks that we can study in some detail, for we have a number of specific, named types recognized by the Inka. Inka presentational rocks include *wawqi*, *wank'a* (and the subcategories of *chakrayuq* and *markayuq*), *saywa*, *puruawqa*, *sayk'uska*, and *sukanka*. Some discussion of each of these presentational forms will allow us to understand the significance of lithic embodiment according to the Inka system of essential equation.

Wawqi

In Quechua, *wawqi* means "a male's brother"; it is variously spelled *huauqui*, *huauque*, *huauqque*, *huaoqui*, *huaoque*, and *guaoiqui*. Rocks that embodied the male individuals of whom they were considered brothers were also referred to as wawqi. All the Inka rulers, for example, kept wawqi that were regarded in the ruler's lifetime as the living ruler's double. After the ruler's death, the wawqi continued to be treated like the rulers to whom they belonged; they were fed, clothed, housed, and consulted on affairs of state. Wawqi owned both land and goods and had retainers to see to their needs. Betanzos says that the wawqi was "received and served by the natives of these towns and provinces as if it were the Inca in person."[60] It is clear that wawqi did not represent their flesh-and-blood brothers in the sense of temporarily standing in for them but were, in fact, perceived to *be* them.

The best-known wawqi in pre-Hispanic times was Wanakawri (Huanacauri, Guanacauri), one of the petrified brothers of the Inka founder Manku Qhapaq.[61] The other brothers who turned to stone in some origin stories would also have been referred to as wawqi and regarded as waka.

Later rulers may have had more than one wawqi as well.[62] Lesser leaders than Inka rulers also possessed wawqi, as did Inka deities. An "almost round stone" called Turuca was the wawqi of the Inka's creator deity, and the sun, the Inka's patron deity, apparently had a wawqi that was "a stone made like a sugarloaf pointed on top and covered with a strip of gold."[63] The sun's wawqi, called Inti Guauque (i.e., Inti Wawqi), was placed in the plaza of Cuzco so that commoners, who had no access to the statue of gold housed in the temple of the sun (the Qurikancha), could revere it.[64]

Unfortunately, no wawqi that we can be sure of survived the colonial era.[65] In 1559, Polo de Ondegardo, the magistrate of Spanish colonial Cuzco, in an effort to consolidate Spanish rule and end the indigenes' allegiance to their pre-Hispanic Inka rulers, tracked down royal Inka mummies that were kept and revered by indigenous Andeans. Cobo characterizes Polo as demonstrating "unusual diligence and cunning" (*extraña diligencia y maña*) in this search, in which, along with the royal mummies, he frequently found the wawqi that remained the companions of the rulers even in death.[66] The mummy was the repository of the ruler's feminine side and was associated with both crop and human fertility; the wawqi manifested the deceased ruler's masculinity and was associated with warfare (conceived of as a male activity) and an adequate water supply (as flowing water was analogous to semen).[67] Mummy and wawqi thus constituted complementary halves of the deceased ruler. They also linked this world to the ancestors' world, just as did the outcrop waka discussed earlier.

Of known eyewitnesses to the wawqi of Inka rulers, Polo is the only one to have written an account. What he has to say is therefore crucial.

> The Indians named certain statues or rocks in [the ruler's] name so that in life and in death they might venerate them. And every royal lineage used to have its idols, or statues of their [Inka rulers] which they used to carry to war and to take in procession in order to obtain water and favorable weather, and for which they used to make various festivals and sacrifices. There was a large number of these idols in Cuzco and its surroundings; it should be understood that all this has ceased, or in large part the superstition of adoring these rocks ceased, after they were discovered.[68]

Although Polo indicates that all wawqi were made of rock (at least all those he discovered), Cobo identifies wawqi (which he never saw) as

being made of gold, silver, wood, stone, and other unspecified materi-
als.[69] Other chroniclers also claim that one or more of the wawqi were
crafted of gold. None of the gold wawqi were ever documented by Span-
iards who actually saw them. As I have argued elsewhere, reports of Inka
gold wawqi were likely greatly exaggerated.[70]

Also uncertain is what wawqi looked like. Several chroniclers call them
"portraits" (retratos) or "images" (imágenes), suggesting that they looked
like the rulers they embodied. Acosta, for example, says that the relatives
of a deceased man might make "a portrait of the deceased" (un retrato
del defunto) that they honor and adore like a god. Elsewhere he describes
wawqi as "statues of stone made in the likeness [of the deceased ruler]"
(estatuas de piedra hechas a su semejanza).[71] The Spanish chronicler Pedro
Sarmiento de Gamboa, however, reports that one wawqi was a sculp-
ture of a falconlike bird, and another was a stone shaped like a fish.[72] As
does Sarmiento, Cobo describes one wawqi as pisciform. Elsewhere he
describes the wawqi of the first ruler (Wanakawri, mentioned earlier) as
being "of moderate size, without representational shape, and somewhat
tapering" (era mediana, sin figura y algo ahusada). He does not describe
any wawqi explicitly as portraits of rulers, although he says that "some
[rulers] made the statue large; others made it small; still others made it
the same size and shape as themselves" (la hacían unos mayor, otros menor,
y otros al propio de su tamaño).[73] To resolve the problem, we again rely
on Polo, our only sure eyewitness, who is careful to say that wawqi were
"rocks in [the ruler's] name" (piedras en su nombre) and also identifies
them as statues (estátuas) but does not describe them as portraits.[74] His
description, however abbreviated, calls into question those chroniclers
who did not see any wawqi for themselves but say that they were made
in the image of the ruler. Consistent with Polo, an anonymous Jesuit au-
thor, writing in the sixteenth century, calls wawqi "statues" (estátuas)
to which the Inka made sacrifices, but adds that they were not represen-
tations of the ruler's person.[75] With regard to the appearance of wawqi,
it is surely significant that those seized by Spaniards—whether treasure
hunting or extirpating idolatry—were discarded rather than being con-
fiscated and publicly destroyed or hidden away. This strongly suggests,
given established practices elsewhere in the Spanish Indies, that wawqi
did not match Spanish expectations for "idols"; that is, they were funda-
mentally not anthropomorphic and probably not intentionally figurative.
Clearly, what wawqi actually looked like is a matter of some confusion in

colonial records. The Western preference for figural imagery has so dominated interpretations of Inka visual culture from colonial times through the current day that we have trouble recognizing presentational forms.[76]

More than one chronicler indicates that wawqi contained fingernails and cuttings of hair of the ruler with whom they were equated. Betanzos reports that soon after becoming ruler, Atahualpa (Atawalpa, Ataw Wallpa) "ordered that a statue be prepared of his own nail clippings and hair, which was a representation of his person. He ordered that this statue be called Incap Guauquin [Inka Wawqi], which means the brother of the Inca."[77] The lithic wawqi could well have had small cavities or niches in which the hair and fingernails described by the chronicler were deposited. The sheddings—material metonyms of the entire body from which they came—bolstered the presentational force of the rock.[78]

Wank'a (*huanca, guanca*)

Wank'a were rocks that were understood to be the petrified owners of places, such as fields, valleys, and villages. Located in the place that it owned, the wank'a was a symbol of occupation and possession. Given the wide range of locations in which wank'a have been found, the practice clearly preceded the rise of the Inka.[79] According to records from 1660, cited by Pierre Duviols, every village in the high agricultural zone between 2,800 and 4,000 meters in altitude of the southern Andes had at least one wank'a; coastal communities may also have had them.[80] Often, while one wank'a, called the *wank'a markayuq*, was identified as the colonizer and owner of the village, the fields had another called the *wank'a chakrayuq*.[81] Markayuq (owner of the village) and chakrayuq (owner of the field) are thus two types of wank'a. To the living inhabitants of the place, both were ancestral figures. Duviols, in his classic study of wank'a, concludes that "the huanca was therefore the tangible and permanent image of colonizing heroes."[82] They were landmarks indicating that the place they occupied was possessed; in other words, wank'a marked land as territory.[83] Although the extirpator Arriaga describes wank'a as monoliths of long or oblong shape, they apparently varied in both form and size.[84] Fellow extirpator Avendaño indicates that "guanca" could be moved and placed in the midst of fields, where they acted as intercessors (*abogados*).[85]

Wank'a, like wawqi, were apparently always gendered male. There are

no reports of female wank'a, and the actions associated with these tute-lary monoliths are those of conquest and control over territory; both these activities are generally associated with males in Andean culture.[86] Duviols characterizes the wank'a, oblong in shape and planted vertically in the earth, as the phallus that plunges into the womb of mother earth, recalling male insemination during sexual intercourse.[87] Wank'a com-memorated the dual masculine activities of conquest, whether actual (the taking of land) or metaphorical (tilling agricultural fields), and of posses-sion. Since the wank'a embodied the founding ancestor of a place, every wank'a also, at least ideally, corresponded to a *mallki* (*mallqui*), an an-cestral cadaver or mummy.[88] The deceased was therefore doubled (just like the Inka leader with his stone wawqi). The wank'a was identified with the masculine virility of the deceased, while the mummy, conceived of as a seed (also *mallki* in Quechua), housed its feminized fertility. The in-organic double complemented its organic alter ego; the stone provided the permanence the human body lacks.[89] The wank'a was referred to by a different name than was the mallki, and they were looked to for different things. Generally, the wank'a was concerned with masculine-gendered issues such as drought or flood (things associated with male semination) and warfare. The mallki addressed "feminized" issues such as crop fer-tility. This was also true of the deceased ruler's body and his wawqi.

The wank'a, often a visible part of the landscape, not only kept an otherwise absent culture hero alive and present but also, like the wawqi, visibly linked this world to the world of the ancestors. While some wank'a were referred to as *piedras paradas* (motionless stones), others were ap-parently capable of animation. Duviols, for example, refers to Huari (An-cient Ancestor), a pan-valley wank'a who was said to travel throughout his realm and had many rock thrones on which to sit.[90] Wank'a were often related to *paqarisqa*, places of ancestral emergence. While some paqa-risqa are described as caves, springs, fountains, lakes, and so on, others are stones that were identified as ancestors or as the residences of their spirits. Cobo reports that each province had its own shrine, "which was the place where they thought the originators of each nation were saved [i.e., preserved]. These places were well known in each province, and they were worshiped with all kinds of sacrifices."[91] The "originators" re-ferred to by Cobo were stones—probably wank'a, although Cobo does not use that term. Since the Inka were said to have come to Cuzco from the south, they did not have their paqarisqa close at hand. Still, the iden-

tification of one or more Inka wank'a in Cuzco would have made visible their claims to possession of the valley. The historian María Rostworowski de Diez Canseco identifies the petrified Ayar Auca, a brother of the first Inka who turned to stone while on the migration to the Cuzco valley, as a wank'a, a sign of the Inka's claim to territorial possession.[92] Duviols understands wank'a as analogous to the baton said to have been plunged by Manku Qhapaq into the fertile earth when he founded Cuzco.[93] If the curving wall of the Inka's Qurikancha embraces the spot where Manku's baton originally sank or one of his brothers turned to stone, then one of the wank'a that claimed the Cuzco valley might well have been the focus of that most sacred of structures.[94]

Saywa (*sayhua, sayua, sayba*)

González Holguín identifies sayhua as a boundary or territorial marker (*el mojón de heredades, territorios, los linderos*).[95] Unlike wank'a—lithic symbols of territory—saywa embodied the boundaries between places and commemorated the act of marking territory. They were petrous embodiments of passage and transition, which is inherent in travel, and they memorialized land rights. The origin story of the contemporary community of Amaru in the district of Pisaq tells of some boundary markers, or saywa. According to the account, the old landlord ordered one of the saywa stones to be buried because he feared that with the stone as a witness, the tenant farmers would reclaim lands that were originally theirs.[96] Apparently saywa do not just mark boundaries but also bear witness to past events and so sustain certain histories. In Inka times, they received offerings as individuals passed from one territory to the next. Each act of reverence was an acknowledgment and remembrance of particular articulations of territory.

Given their wide distribution, saywa, in some form, likely preceded the Inka. Polo describes Inka "sayba" as pillars.[97] Guaman Poma illustrates a saywa that he identifies as a *mojón* (boundary stone) (figure 12); he may also have depicted saywa while working for Murúa, whose Galvin manuscript depicts a rolling landscape with one prominent hill and six saywa, shown as cut and dressed stone pillars (figure 13).[98] The gloss reads "sayhua" in one hand, and "Mojones del ynga" is written in another. Murúa credits Topa Inga Yupanqui (Thupa Inka Yupanki, the tenth ruler) with redistricting the empire and with establishing boundaries by

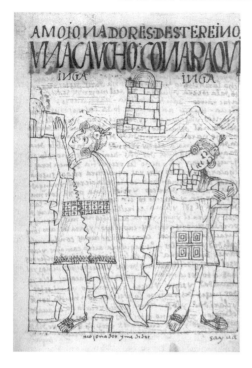

12. Specialists constructing saywa. Felipe Guaman Poma de Ayala, "Amojonadores deste Reino: Una Caucho Inga, Cona Raqui Inga," in *El Primer Nueva Corónica*, fol. 352 [354], ca. 1615. Photograph provided by the Royal Library, Copenhagen, Denmark.

means of saywa that delimited agricultural lands, mining zones, community property, and so on.[99] They were guarded, and anyone caught crossing boundaries or damaging the markers was severely punished. Other chroniclers credit the ninth ruler (Pachakuti) with the introduction of boundary stones.[100] The saywa they set as permanent reminders of their deeds may well have embodied these powerful personages who defined territorial limits.

In his list of waka in and around Cuzco, Cobo includes four saywa shrines—Collanasayba, Cascasayba, Aquarsayba, and Illansayba—that were located at the far extent of Cuzco territory.[101] He says that Illansayba consisted of "some stones to which they sacrificed for the health of those who entered the province of the Andes [Antis]."[102] He also refers to a waka called Sinayba, describing it as a large hill "at the far end of Quispicanche" (*destotro cabo de Quispicanche*); Bauer suggests that Cobo's "Sinayba" might have been meant to read "Sayhua," which is the current name of a mountain south of Cuzco.[103] It might well have defined the end of Quispicanche territory and so have functioned as a saywa. It should be noted that a number of the waka named by Cobo are located

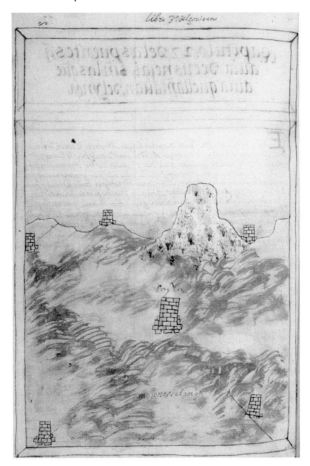

13. Saywa. Martín de Murúa, *Historia y Genealogía de Los Reyes Incas del Perú (Códice Galvin)*, fol. 79v, 1590.

at places where a traveler from the imperial capital last glimpses Cuzco (or where an incoming visitor first sees the settlement); although they are not explicitly named as saywa, some may well have functioned as such.[104] The carved granite monolith at Saywite, the name a likely derivation of saywa, is probably one of these numinous boundary markers (plate 3).[105] It is located on the border between the Inka and the Chanka, their ancient enemy. It may have commemorated the Inka victory, which defined distinct territories between the two groups, and embodied the Inka leader responsible for the defeat of the Chanka.

PLATE 1. Third Stone or Intiwatana, Saywite, and PLATE 2. Carved outcrop, Kenko Grande.

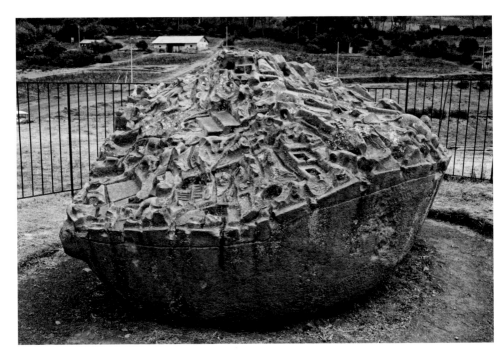

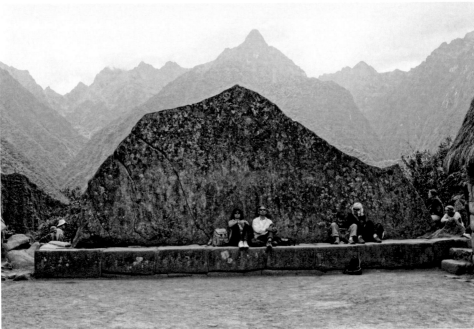

PLATE 3. Carved monolith, Saywite, and PLATE 4. Sacred Rock replicating Mount Yanantin beyond, Machu Picchu.

PLATE 5. Tower, also known as the Temple of the Sun, Machu Picchu,
and PLATE 6. Carved stone with steps and crevice, Saywite.

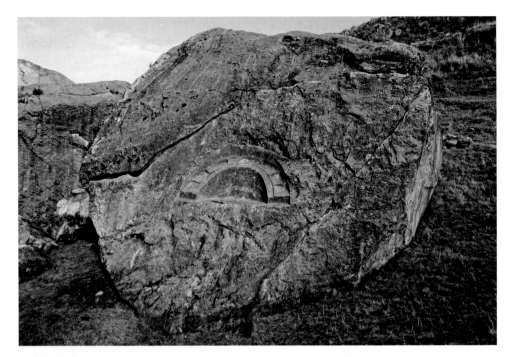

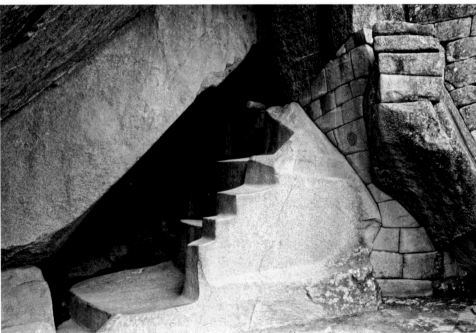

PLATE 7. Quillarumi, a carved rock located near an extensive waterworks, and
PLATE 8. Royal Mausoleum, Machu Picchu.

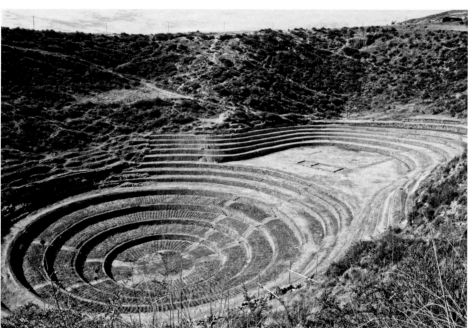

PLATE 9. Chinkana Grande, Saqsaywaman, and PLATE 10. Curvilinear terracing, Moray.

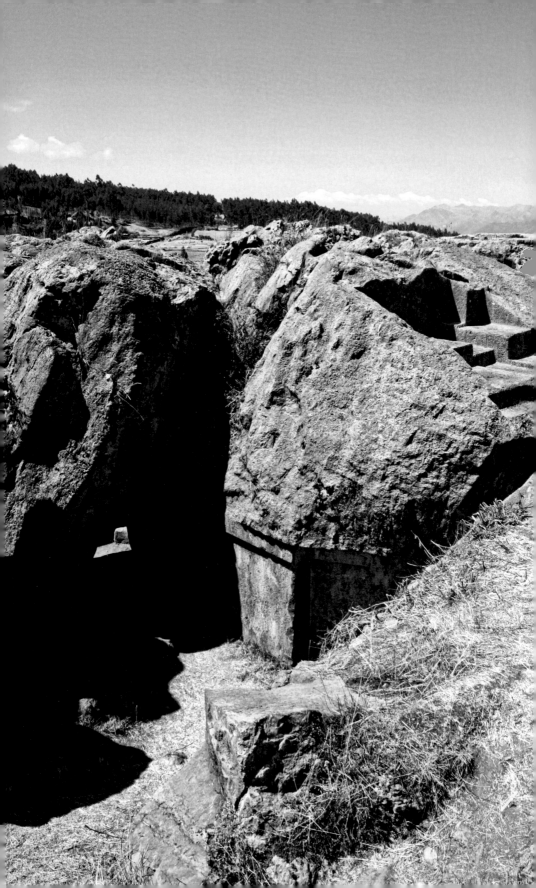

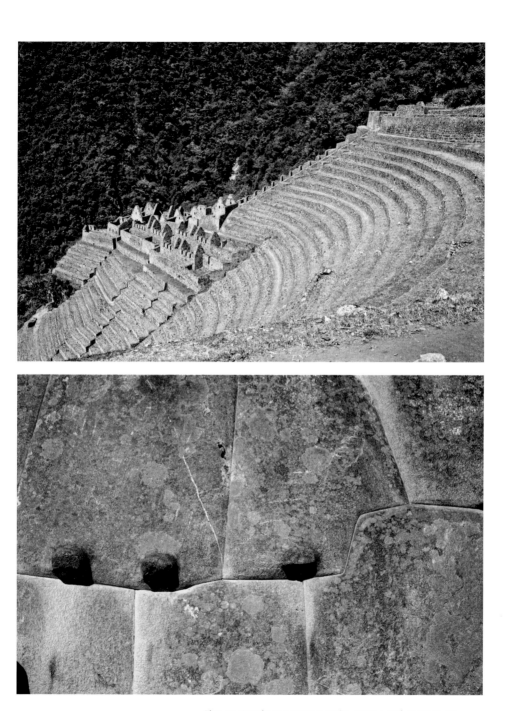

Plate 12. Curvilinear terracing, Wiñay Wayna, and PLATE 13. Masonry with protuberances, Ollantaytambo.

(opposite) PLATE 11. Carved rock passage, Saqsaywaman.

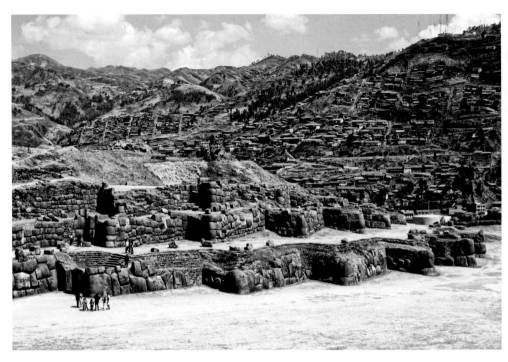

PLATE 14. Zigzag terraces, Saqsaywaman, and PLATE 15. Temple of the Condor, Machu Picchu.

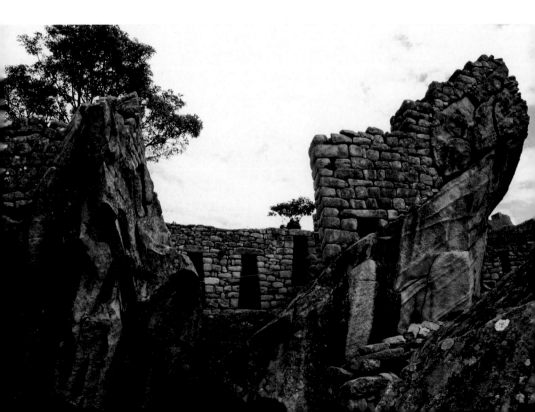

Puruawqa (*puruauca, purunawka*)

As mentioned earlier, puruawqa, also known as *purunruna*, are petrified warriors who once defended Inka Cuzco.[106] They are a specific manifestation of rock's ability to animate; as such, they are an Inka manifestation of more widespread Andean notions. There are several versions of the puruawqa story. While the Inka protagonists differ (some say it was the ruler Wiraqucha [Viracocha] who led the Inka forces; others credit his son Inka Yupanki, who later took the name Pachakuti), all agree that the armies of the Chanka were threatening Cuzco and that a miracle was needed for the Inka to emerge victorious. Some report that stones on the battlefield converted into warriors to aid the Inka, while others indicate that supernatural fighters petrified after having secured victory.[107] Santa Cruz Pachacuti claims that the puruawqa were stones dressed up to look like warriors (a ruse to confound the enemy), which then animated at the urging of the Inka leader, who himself was confused about their "reality."[108] The puruawqa stones were apparently of variable size and shape, none of them imagistic, with some being described as small and round, and others characterized as large.[109]

Cobo reports that the battle took place a league from Cuzco.[110] After the Inka's victory, the leader of the Inka forces commanded that the puruawqa stones, which he identified in the landscape, be revered with sacrifices and offerings. Many were brought to the main temple in Cuzco (the Qurikancha). Niles discusses the relocation of the puruawqa stones that were placed near the Qurikancha (especially in Inti Pampa, the plaza in front of the temple), near the main plaza of Awkaypata (Haucapata), and elsewhere in the sacred landscape of Cuzco at points emphasized in the battle itself, such as the heights of Karmenka (Carmenca), where the Chanka army was repulsed.[111] Some were venerated in groups and others singly; some, such as Catonge, Sabaraura, and Quingil, were named individually. More than twenty puruawqa dotted the environment in and around Cuzco, where they functioned to confirm oral histories recounting the Inka victory against a lethal enemy.[112]

While many puruawqa were located in and around Cuzco, some may have companioned rulers on their travels. Cobo reports that Guayna Capac (Wayna Qhapaq, the eleventh ruler) was customarily accompanied by five or six guardian "idols" (*ídolos*).[113] Since Spaniards frequently called

presentational stones "idols," and since the puruawqa were the quintessential guardians of the Inka, it is possible to suggest, at least tentatively, that the ruler Wayna Qhapaq traveled with a number of puruawqa escorts. Whether individually or in groups, they embodied numinous defenders of the Inka.

Sayk'uska (*saycusca, saicusca, saycuscca*)

Sayk'uska, meaning weary or tired in Quechua, refers to quarried rocks that were intended for use in Inka building projects but never arrived at their destinations. They were called *piedras cansadas* (tired stones) in Spanish. They are still identified along roadsides throughout the area once controlled by the Inka. Guaman Poma records a story about a sayk'uska in which a recalcitrant rock, distressed at being relocated from its quarry near Cuzco and weary from travel, began to cry tears of blood; in the drawing that accompanies the story, tears spill from the monolith that the Inka are trying to move by means of workers who pull on ropes that have been tied around the large stone (figure 14).[114] On the exhausted megalith itself, the illustrator has written, "lloró sangre la piedra" (the stone cried blood). While Guaman Poma refers to a sayk'uska being moved from Cuzco to Guanuco, Murúa tells of, and depicts, a weary stone that was moved from Quito to Cuzco (figure 15). Like Guaman Poma, Murúa credits a mighty war captain named Ynga Urcon (Inca Urco, Inka Urqu), a member of the royal family, as the force behind the great feat.[115] In the drawing, the roughly hewn stone has two eyes and is labeled *saycum callacuncho*. Cobo identifies a waka named *collaconcho* as an obdurate megalith that fell on and killed "some Indians" (*algunos indios*) who were trying to incorporate it into the structure of Sacsahuaman (Saqsaywaman) above Cuzco.[116] Echoing Murúa and Cobo, El Inca Garcilaso de la Vega, who lived in Cuzco as a child and likely heard stories from his Inka mother and her relatives, tells of a sayk'uska that was being transported to Saqsaywaman when it became tired.[117] According to all sayk'uska stories, the sympathetic Inka, recognizing the stones' anguish at being relocated and their refusal to cooperate with Inka builders, left the weary rocks where they can be found today. We might say that sayk'uska, renitent and tearful, were stones that the Inka first moved (literally), and then were moved by (emotionally).

The sayk'uska, a material metonym of the place from which it was

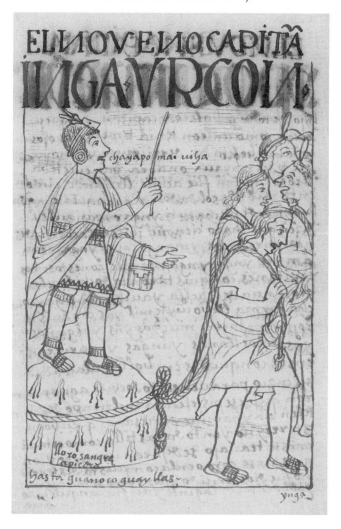

14. Inga Urcon moving a sayk'uska. Felipe Guaman Poma de Ayala, "El Noveno Capitan: Inga Urcon," in *El Primer Nueva Corónica*, fol. 159 [161], ca. 1615. Photograph provided by the Royal Library, Copenhagen, Denmark.

removed, embodies the quarry and houses its spirit. Quarries were regarded as sacred and were given offerings; Cobo, in fact, names three quarries in the Cuzco region as waka.[118] Even today, in parts of the southern Andes, stones, embodying the quarries from which they come, receive offerings.[119] Stories attached to specific "tired stones" affirm the potential animacy of quarried rocks, especially those of large size, and

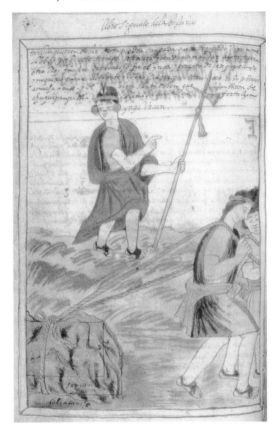

15. Ynga Urcon moving a sayk'uska. Martín de Murúa,
Historia y Genealogía de Los Reyes Incas del Perú (Códice Galvin),
fol. 37v, 1590.

underscore the relationship between rock and its place of origin. Say-k'uska, usually located in the vicinity of whatever building project they were intended for, remind all who look on impressive Inka constructions of the quarry that yielded the stones. Betanzos locates one tired stone of legend just outside Cuzco:

On the flat place behind the fortress [of Saqsaywaman] there is a very big stone. It was brought like the others from the quarries; this stone came from more [than] a league and a half from there. They put it down a stone's throw from the fortress on the flat place mentioned, and they could never move it from there. . . . Seeing this, the Inca [ruler] said that

stone had gotten tired and that it should be called the tired stone, which is the name it bears to this day.[120]

The sayk'uska of Saqsaywaman has been identified by some as the outcrop, sculpted with stairs and niches, known today as the Chinkana Grande (Chincana Grande, Chingana Grande) located a short distance from the so-called fortress of Cuzco (plate 9).[121]

Van de Guchte, in his careful analysis of six chroniclers' accounts of the weary stone legend recorded between 1553 and 1653, suggests that sayk'uska symbolize the termination of Inka building projects.[122] We may surmise that when the Inka completed a large building project, they often left a sayk'uska unincorporated to receive offerings as an embodiment of the quarry that had generously provided the stone.

Sukanka (*sucanca*)

Sukanka were stone pillars that were used to track the sun and so mark the passage of time.[123] As such, they embodied time itself, or distinct periods of time, and the movement of the sun (Inti), the patron deity of the Inka. While saywa marked the passage through space and articulations of place, sukanka marked the passage through time and its segmentation into distinct periods. The most discussed sukanka were located on the horizon of Cuzco, where they were used to determine equinoxes.[124] Polo reports that they were shrines and received sacrifices, while Cobo identifies a waka, which he calls sucanca, as a hill with two markers placed to indicate when it was time to plant maize.[125] He also identifies waka that marked other points in the agricultural cycle; these were undoubtedly sukanka as well.[126] Although Cobo mentions several markers of time in his list of waka, he also says that not all of them were part of the much-discussed *siq'i* (*ceque*) system of shrines, though all were considered sacred; Murúa similarly maintains that all the sukanka, which he describes as the pillars or landmarks around Cuzco used by the Inka to separate the solar year into lunar months, were principal shrines and were offered a variety of sacrifices.[127] Those aligned to mark the halves of the year were specially named; Pucuysucanca indicated the beginning of summer in the southern hemisphere (*puquy* meaning "ripening season"), and Chiraosucanca (*chiraw* meaning "cold season") marked the beginning of the winter months.[128]

The Inka employed landmarks of various sorts to provide fixed sighting points and so to track the movements of celestial bodies. We might imagine that gnomons, like those on the so-called Intiwatana ("hitching posts of the sun") at Machu Picchu, Pisaq, and elsewhere, were related to sukanka (figure 42). There is some doubt about whether *intiwatana* is an Inka term, however, and so the relationship between intiwatana and sukanka must remain an open question for now.[129] Some *usnu*, stone platforms with basins for offerings, were also used for astronomical observations; usnu will be discussed further in chapter 3.[130] For the present, suffice it to say that the Inka used a variety of lithic monuments for solar observation, including towers, gnomons and other carved rocks, particular arrangements of rocks, and windows or other apertures that cast light in distinct patterns on stone.[131] All of them may have been held to embody periods of time.

In all these specific instances, presentational stones made absent or invisible actors or actions (or both) present: the marking of a border, the calculations of periods of time, the quarrying of stone, a battle, a king, a founding ancestor. Further, these absent or invisible actors and actions are preserved and made visible with a promise of future reenactment every time an offering is made or a ritual is conducted. Paul Connerton, in *How Societies Remember*, maintains that ritual constitutes the most powerful source of historical knowledge in most societies. For the Inka, knowledge was acquired largely if not primarily through sight and motion — history was seen in commemorative rituals that not only reminded the participants of what had happened, or what was said to have happened, but re-presented historic actors and their actions (i.e., made them present again).[132] Storied stones performed mnemonically, but they did more than that, for they were (transubstantiated) actors in spoken histories. The distance between then and now collapsed when past or invisible actors and actions, through their lithic embodiments, pervaded the Andean present. Petrous embodiments were thus a subset of remembered rocks that the Inka valued as firsthand witnesses to significant actions.

At times various presentational stones — petrous embodiments — have been called statues, statuettes, portraits, likenesses, images, and representations though there is no good evidence to suggest that the appearance of any of the types of stones was particularly important as a measure of the relationship between the embodiment and what was embodied. Indeed, what is most striking about these categories of rock is how little

each type corresponds to the visual cues for discerning sacred rocks identified at the outset of the chapter. A wank'a, for example, might be framed, distanced, contoured, or carved; it might be draped in textiles or adorned with precious metals and jewels. The visual treatment of the rock tells us only that it might fall into one (or more) of the categories of presentational rocks, not which kind of rock it was. Ultimately it was the transubstantial properties of presentational stones, remembered and conveyed through oral culture, rather than their visual characteristics, that made the identification between embodiment and thing embodied possible.[133] To employ terms that implicitly suggest an index-prototype relationship (that is, one of substitution) is to replace Inka concepts with our own. Because essence was transubstantial and independent of form, a single stone could have served several of the functions identified here. There is nothing precluding a wank'a from also being a saywa, or a saywa from being a puruawqa. Indeed, any fixed marker may have been considered a saywa regardless of its other functions.[134] As noted, Rostworowski identifies the petrified Ayar Auca, a brother of the first Inka who turned to stone while on the migration to the Cuzco valley, as a wank'a.[135] As the lithified brother of Manku Qhapaq, he/it is also implicitly a wawqi. What a presentational stone was called depended on how it was remembered on particular occasions of use. Since function correlated only roughly with form (if at all), we cannot use the appearance of a particular marked stone to identify any singular function. The visual or aesthetic qualities of a remembered rock appear to have been especially irrelevant. This is not to say that the Inka did not make and value sizable lithic "images," however. In fact, to further explore the Inka relationship between substance and superficies, I now turn to a category of large petrous presentations that are also at least sometimes imagistic.

ECHO STONES AND APACHITA: SUBSTANCE AND SUPERFICIES

At least one type of presentational stone seems to emphasize both the equation of substance and similarity of superficies. Today such stones are often referred to as echo stones; we do not know whether the Inka had a special term for them. They are stones shaped, whether naturally or through human alteration, like the mountain peaks on the horizons

beyond them. Mountains were (and still are) regarded as *apu* (lords), powerful, masculine entities that were believed to control the weather and watched over everything within their watersheds.[136] Echo stones embody mountains that are beyond human habitation. While they host the essence of the apu and so are the same in substance and essence, they also employ visual mimesis; that is, they resemble that which they embody.

The finest examples of echo stones come from the renowned late-fifteenth-century site of Machu Picchu; the best known is the Sacred Rock standing near the northernmost extent of Machu Picchu near the trail to Wayna Picchu (plate 4). Also echoing mountains beyond is the so-called Funerary Rock (figure 29), as well as at least six other stones at the site.[137] Even the so-called Intiwatana, which may have functioned as a sukanka, echoes the Uña Picchu peak beyond. Records indicate that echo stones existed elsewhere. In the area around Cuzco, for example, was a waka called Maychaguanacauri (Maychawanakawri), which Cobo described as a stone waka "shaped like the hill of Huanacauri" (*hecha a manera del cerro de Huanacauri*); it was placed on the road to Anti-suyu, where all who passed made offerings to it.[138] Because the mimeticism of echo stones requires that they be viewed from particular vantage points, the waka Maychawanakawri must have been placed in such a way as to underscore its visual similitude with Wanakawri hill. Such small-scale lithic simulacra of mountains were perceived as diminutive incarnations or, better yet, the miniaturized petrescence of spirits associated with Andean topography.[139] The use of miniatures throughout the Andes, both past and present, is well documented.[140] Miniatures embody, on a small scale, larger entities that are generally perceived as too large to be controlled. By manipulating miniatures, Andeans of the past and present assert a measure of control over many aspects of their world, from the fertility of crops and animal herds to the well-being of society itself. In the pre-Hispanic period, echo stones, as miniature mountains, likely received offerings intended for their larger selves.

In addition to echo stones, a second category of rocks that arguably embodied mountains in miniature is *apachita* (*apacheta*), also known as *cotorayaq rumi*.[141] Albornoz describes them as a "very ordinary" (*muy ordenario*) type of waka and says that they were common throughout the Andes predating the Inka.[142] While apachita are conventionally thought to have been heaps of rock compiled over time by travelers who stack stones as offerings at dangerous or otherwise significant parts of a jour-

ney, such as crossroads, mountain passes, and flatlands, Arriaga identifies the common focus of roadside reverence as a "large stone" (*piedra grande*) that he says was normally located on a hilltop.[143] The anonymous Jesuit identifies apachita as mountaintops (*cumbres*), as do Polo and Acosta.[144] Cobo defines them as "high places and hilltops" (*los altos y cumbres de los cerros y collados*) and indicates that the cairns constituted the offerings of rocks left to the apachita by passersby.[145] In other words, he maintains that the apachita is the place—whether hilltop, crossroads, large rock, or something else—where the offerings of small rocks are left, not the small stones themselves. Illustrations in Murúa's 1590 manuscript (the Galvin) also suggest that apachita were not exclusively piles of rock. On folio 80 verso, a pyramidal structure of what looks like cut-stone masonry is labeled *apachita* (figure 16). It is located centrally in the drawing along a major road that runs diagonally across the page. Paths branch out from the road, and the landscape appears wild, with rolling uncultivated hills. Also pictured are four stone huts, one of which is identified as a house for *chaski* (long-distance running messengers) called *puytuc uasi*, constructed of piled and apparently unworked fieldstone.[146] The way the anonymous painter has carefully differentiated between types of stone construction suggests a purposeful rendering of the apachita as a mountain-shaped pyramid of cut and dressed ashlars. We must consider the possibility that apachita in Inka times could be both built masonry structures and cumulative piles of stones in their natural state.

Glossed apachita, a pillar-shaped stone surmounting a crenelated masonry platform, also appears in Murúa's manuscript of 1590 on folio 104v (figure 17). While maintaining a mountainlike shape, this apachita is more elaborately constructed than a pile of stones. It closely resembles the so-called, and surely misnamed, Puma Rock at Kenko (figure 10). The upright monolith has a rectilinear masonry framing wall, as does the Galvin apachita. In fact, as Van de Guchte has observed, bedding joints on some of the ashlars in the extant wall indicate that the barrier at Kenko was once higher, obscuring the lower portion of the vertical monolith.[147] This is precisely what occurs in the Galvin image. The Galvin's odd crenelations, which are unlike known free-standing Inka walls, might well refer to a once higher wall in a state of disrepair, as worked ashlars were removed for reuse in colonial-period structures. The Galvin painter might thus have depicted the wall as it appeared in his time, the late sixteenth century. The crenelations might also be a nod to the semicircular

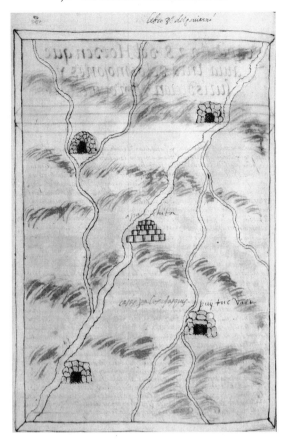

16. Apachita. Martín de Murúa, *Historia y Genealogía de Los Reyes Incas del Perú (Códice Galvin)*, fol. 80v, 1590.

amphitheater wall at Kenko, which is associated with the vertical stone. It is as though the Galvin painter has collapsed significant features of this portion of the Kenko site, as it was in the late sixteenth century, to produce this image of an apachita.

From available evidence, we can conclude that pre-Hispanic apachita assumed a variety of forms, from natural hilltops to pyramidal masonry structures (like that on Galvin folio 80 verso) to monoliths and outcrops that could be either shaped or natural (like that on Galvin 104 verso). What all forms of apachita appear to have in common is that they received offerings from travelers desiring comfort and assistance, or, as Arriaga phrases it, "to get rid of their weariness" (*se les quita el cansancio*).[148] In the drawing on folio 104v, the apachita is shown as the recipi-

17. Apachita. Martín de Murúa, *Historia y Genealogía de Los Reyes Incas del Perú (Códice Galvin)*, fol. 104v, 1590.

ent of the most precious of offerings—a child. We see a priest, labeled *echicero* (wizard), offering bundles of coca leaves and colorful feathers to the apachita in addition to the youngster. The companion text indicates that while apachita commonly received offerings of feathers, shells, chewed coca and maize, stones, and sandals worn from traveling, some were offered fine cloth, camelids, and children.[149] What Murúa's illustrator may be referring to in these drawings are state-constructed apachita, the formal version of the more common piles of stones. While common apachita received small offerings, such as a few coca leaves, apachita constructed by the state were featured in elaborate rites with copious offerings of the most valued kind.[150]

The ethnohistorical sources mentioned in the foregoing paragraph

correspond to modern ethnographic accounts of apachita. While piles of rock are clearly the most common variety, some researchers working in the Andes today find that apachita vary in form. Kuznar, for example, describes apachita as ubiquitous stone altars found along roads, at boundaries, and on mountain passes; although they most often consist of a few large stones with smaller ones stacked on top, they can become highly elaborate, sometimes having their exterior surfaces finished with mortar.[151] Modern ethnographers also engage in the debate, initiated in the sixteenth century, concerning whether the apachita is a place of reverence or the actual object of worship. While La Barre concludes that the apachita itself is a spirit to which offerings must be made, Kuznar clarifies that because apachita are located in auspicious places, they themselves are considered sacred.[152]

Whether apachita comprised worked or unworked stone, some of them, like the echo stones described earlier, formally replicated mountains. It is tempting to conclude that what we now call echo stones were sometimes related to state-sponsored apachita; the Sacred Rock is located at the northern end of Machu Picchu near the precarious path to Wayna Picchu peak, and the Funerary Rock is found at the southern end of the site near the Inka road into and out of Machu Picchu. Both are thus ideally located for passersby who might wish to make an offering at the outset or end of their journeys. Moreover, the Funerary Rock apparently received offerings of small stones of various sorts, which were found near its base, rocks being a common offering to apachita. Other apachita were themselves the summits of mountains or were otherwise identified with mountains. The Apacheta Ingañan (Apacheta Inca Road), for example, a pile of rocks that today measures approximately one and one-half meters in height and four meters in breadth and is located on the Cañar-Azuay Inka Road in Ecuador, bears the same name as the mountain located to its west.[153] While it is impossible to sort out which one was named first, the identification of this apachita with a mountain that overlooks it and the road it companions is clear. Thus we might suspect that apachita embody significant topographical features, such as hills and mountains, the great watchers of the Andes who oversee all they survey. While mountain-shaped apachita clearly form miniature peaks, a hilltop or summit crossed by a traveler is also a small portion of the larger mountain it occupies. In valleys or at crossroads the cairns made up of offered stones actually create, through the addition of rock offerings over time, the hill-shaped apa-

chita where the hill shape did not originally exist. Hence certain apachita, like the echo stones, were both representational (looking like mountains) and presentational (embodying mountains).

It is important to note that the "large stones" mentioned by Arriaga, whether or not they were actually peaklike in form, could also embody sacred mountains, as boulders and outcrops near or in villages throughout the Andes are commonly regarded as the embodiments of important hills or mountains located on the distant horizon. Albornoz, in his list of waka throughout the Andes, frequently names rocks (*piedras*) that are identified with particular peaks and share the same name as the mountain.[154] For example, he tells us that the waka Callacalla in Chachapoya territory is both a rock and a hill; in the province of Parinacocha is Sarasara, which is again both a rock and a mountain. In the Cuzco region today, small rocks are capable of embodying the powers of sacred peaks such as Mount Ausangate.[155] Similarly, in northern Chile, the anthropologist Thomas Barthel reports that the residents of the village of Socaire use a boulder in their October agricultural rituals that is named Chilique, the same name as a nearby mountain; the mountain Chilique, the provider of water for crops, is embodied at the ceremonies through the miniature Chilique boulder, to which offerings can be made directly.[156] Today, in many instances where stones embody mighty mountains, the stones are nonresemblant. Although some types of presentational stones, like echo stones and at least some of the apachita, could be enhanced through resemblance, they were fundamentally presentational. It is appropriate, then, to end this chapter with a brief consideration of the Inka use of presentational and representational forms.

PRESENTATION AND REPRESENTATION
IN INKA VISUAL CULTURE

That the Inka worked some stones to make them echo, in miniature, distant sacred mountains suggests that representation and presentation did not function oppositionally in pre-Hispanic times. Rather, the reproduction of appearance and embodiment of essence were complementary modes of Inka (re)presentation. This does not mean that they were equally valued, however. Betanzos tells us that just before dying, the ruler Pachacuti Inca Yupanque (Pachakuti Inka Yupanki) ordered that

a "golden image made to resemble him" be placed on top of his tomb; also, "he ordered that a statue be made of his fingernails and hair that had been cut in his lifetime."[157] While I suspect the "statue" of finger-nails and hair was a stone wawqi with a niche for the sheddings, neither this nor the truth of the account is at issue here. What I find interest-ing is that two "statues" were made: one, of gold, was a visual likeness, and the other, containing sheddings, was a nonresemblant embodiment. While the golden statue remained in the ruler's tomb, the presentational artifact was hoisted on a litter and celebrated in the manner of the living ruler: "When they brought it [the 'statue' made of the ruler's cut hair and fingernails] out like this, they sang about the things that the Inca [ruler] did in his life, both in the wars and in his city. Thus they served and re-vered him, changing its garments as he used to do, and serving it as he was served when he was alive."[158] This story, whatever its veracity, hints that, to the Inka, essence—embodied in sheddings (and possibly tran-substantiated in stone)—was more vital, more real, than mimetic form. In selecting essence to convey the presence of the absent ruler, the Inka valued certain materials, including aniconic rock and human sheddings, over exquisitely crafted likenesses, which they also made and used. In other words, essential connections were valued more highly or thought to be more true than were visual comparisons.

Essence, as the Inka understood it, was clearly transubstantial, and rock was a special medium of embodiment. Hills near new Inka settle-ments were not only often named Wanakawri after the wawqi of the first Inka; they *became* Wanakawri. As Albornoz explains, indigenous An-deans could transfer the essence (the *kamay*) of their waka to new loca-tions in the following manner: if the waka was a rock or a hill, they could take an actual piece of the original and, by placing the piece (a material metonym of the original) on a new rock, transform the new rock into an embodiment of the original. They could also take a textile that had touched the original waka and, by placing the textile (an indirect ma-terial metonym by virtue of having touched the original) on a stone in some new location, successfully transform the new rock into the revered waka.[159] The new waka would be addressed by the original waka's name. The Inka employed transference, carrying the Cuzco valley with them and re-creating Wanakawri at distances far from the original. Whether or not the transubstantiated rocks and hills visibly resembled the original Wanakawri waka was clearly of secondary importance. Rock embodi-

ments are thus a critically important element of Inka material culture, but one that evades quick visual identification.

It is significant that while the Inka may have carved figures onto some few megaliths, large rocks — remembered rocks — were never themselves carved into figures. Given the Inka's talent for working rock, it cannot be argued that they lacked the ability if that is what they had desired to do. Rather, it was important that boulders remain stony, that their appearance not disguise their substance, which was perceived as the quintessential transubstantial medium.[160] The argument here is not that the Inka did not appreciate or employ imagism. Certainly, they revered stones that were serendipitously resemblant.[161] The Inka also crafted figurines of humans, camelids, and other living beings in shell, gold, and silver, as well as stone, all of which functioned as visual metaphors and signified through mimesis. One interesting artifact of this sort is the illa, which, as noted earlier, was used by the Inka and is still used today as a repository of good fortune. While *illa* can refer to a small stone figurine, according to González Holguín, an illa might also be a "piedra vezar," a bezoar (a stonelike concretion found in the stomachs of camelids and other ruminants).[162] *Illa*, which can be translated "bright or shining one," also refers to shiny things or to stones that are sacred because they have been struck by lightning (called *illapa*).[163] The Inka apparently referred to a variety of small things that were associated with the bringing of good fortune as illa; the essence or good fortune of those things was also called illa.[164] Thus what they did (their essential function) or what their owners believed them to be (their essence) trumped what they looked like. So long as the focus remains on appearance, we are stuck wondering whether an illa is "really" a small imagistic stone carving, a naturally shaped bezoar, or a nonimagistic lightning-struck stone. Once we shift from appearance to essence, however, we query the following: how and when are resemblant carvings like a lightning strike or digestive processes? Does imagistic carving bring out the "essence" of the rock, marking it like lightning alters whatever it touches? Does carving away a rock's nonimagistic parts mirror or complement in some way the accretion of calculus that builds rocks in the stomachs of ruminants? While pursuing the answers to these questions would take the present discussion far off course, we can say that, in the end, categorizing Inka rockwork by appearance alone is fraught with difficulties. Studies that focus on form and appearance — as studies of the visual arts often do — may run into trouble given the nature

of Inka visual culture, in which style and shape are usually secondary to essence and function.

The Inka and other Andean peoples did not *need* resemblance to establish identity. Presentational stones, all of which were rocks meant to be remembered, were visibly distinct from their surroundings, but their form did not reveal what they embodied. Rather, remembrance conveyed each particular embodiment. It is telling that, rather than waka being forged in the image of a founding ancestor, many Andeans are said to have come to resemble physically their ancestral waka.[165] Carmen Muñoz-Bernand and Carlos Alvarez Pazos both indicate that this belief persists to the present time, reporting that in the western highlands of present-day Ecuador, ethnic Cañari are said to resemble their sacred mountains. When the mountain is small, the people are small, and when it is tall, the people are tall. If it is wild, the men are impulsive and irascible; if the mountain is tranquil, the people will be as well.[166] Rather than fashioning artifacts to resemble things in nature, Andeans have a long history of recognizing their own identity and those of their numina in their natural surroundings. The next chapter will plumb Inka perspectives on their association with the natural environment further, exploring the relationships between the earth, its rocks, and human beings.

The Spanish brought writing.

The Inkas did not know writing; they knew stonework.

—DON LUIS, Sonqo, Peru, quoted in Allen,

"When Pebbles Move Mountains"

·(⬌)·

CHAPTER 2

Rock and Reciprocity

Many stories recorded after the Spanish invasion of the Andes (1531–33) indicate that the Inka had a special relationship with stone. The Inka are often said to talk to and interact with rock that is frequently, and always potentially, animate. As discussed in the previous chapter, the Inka, like many other Andeans, understood themselves to be related to certain rocks, a belief that reflected and promoted a sense of connection with the very essence of the land. Indeed, in stories and in life, the Inka interacted with the earth and its stony extrusions in ways that underscore their commonality and interdependence, not as human beings separate and distinct from what we might call natural resources, but as codependent entities, each possessing life force. In this chapter, I focus on the ways the Inka visually articulated a reciprocal and complementary relationship with the natural environment through stone.[1] Rock was both a vehicle for and a visual articulation of a colloquy between the Inka and the lands they occupied. As Don Luis, Catherine J. Allen's perceptive friend and informant, maintained (see the chapter epigraph), although the Inka did not communicate through writing, they certainly did so through their stonework.

Throughout this book I relate many stories that speak of and to the perceived special connection between the natural environment and Andean peoples. Perhaps none addresses the relationship between earth and the

Inka as poignantly as a story Alejandro Ortiz Rescaniere recorded in Quechua in the central Andes in 1971. A portion of it reads as follows:

> Almighty God, our father and creator of the world, had two sons, the Inka and Jesus Christ. The Inka said to us "Speak" and we learned to speak. From that time on we teach our children to speak. The Inka asked Mother Earth to give us food and we learned to cultivate. Llamas and cows obeyed us. It was an era of abundance. . . . While the Inka built Cuzco completely of stone, they say Lima [the Spanish capital] is made of mud. . . . After building Cuzco, the Inka constructed a tunnel by means of which he used to visit Mother Earth. He brought her presents, and asked her for favors for us. The Inka married her and they had two very handsome babies. . . . When these were born it made Jesus Christ very angry and unhappy. He had grown up, and was young and strong, and he wanted to vanquish his older brother, the Inka. "How can I defeat him?" Jesus asked. The moon took pity on him and, saying "I can help you," sent him a page with writing. Jesus said, "Surely this will scare the Inka" and showed him the page. The Inka was frightened because he could not understand the writing. "What manner of thing could these drawings be?" asked the Inka and then he ran far, far away. . . . With the Inka gone and unable to do anything, Jesus Christ attacked Mother Earth, cut off her head, then built churches on her.[2]

This story, complex and vivid, presents thickets of meaning that could be explored at great length. It speaks of the inherent conflict between oral and literate traditions, and Christian and indigenous Andean religions.[3] It also limns a particular kind of relationship between the Inka and the natural environment: the Inka conversed with Mother Earth, brought her presents, and asked her for things in return; the Inka married the earth, and together they produced offspring. The story unfolds a burgeoning romance as the wooing with gifts leads to marriage and eventual pro-creation.

Here I am interested in how this modern story might shed light on heretofore unexplored aspects of the pre-Hispanic Inka built environment, stoneworking in particular, for implicit in the tale is a reciprocal relationship between Andean occupant and the earth, who, we know from this and other stories, is animate both in its whole ("Mother Earth") and in its parts (mountains, crags, boulders, and so on). I suggest that we can look to the physical remains of Inka occupation and find that, though it is

presently often in ruins, Inka rockwork today testifies that those aspects of the story that speak of intercourse between the Inka and the land are not merely or facilely the results of modern nostalgia. They do not so much represent the invention of a romantic indigenous past as they do a continuation of a way of thinking about Andean land and the human beings who occupy, work with, give to, and take from it. Accordingly, the sections of this chapter are devoted to one or more remnants of the Inka built environment, each readily visible today, that correspond to certain assertions made in the story. This chapter, then, is an experiment in using modern Andean stories to help interpret the stonework that the Inka knew so well, but about which non-Andeans understand so little.

In the story, Inka culture interacts with the earth through agriculture, husbandry, and architecture. All three activities involve the ordering of unordered nature to facilitate and enhance human occupation — the domestication of crops and animals, as well as the "domestication" of rock through use in construction. Setting aside husbandry, which is beyond the scope of the present discussion, I focus on the linkage of agriculture and architecture as human activities that bring order to nature. In fact, the Inka viewed these two activities as diagnostic of civilization. The terrace wall, a structure that organizes natural topography and renders it supportive of human habitation, is a visible expression of nature tamed. Indeed, terraces are often places where the twin ordering activities of agriculture and architecture come together. I focus next on the cut and fitted stonemasonry for which the Inka are renowned. In the story, stone is explicitly identified as a particularly Inka building material; stone-masonry, then, might be understood as a visible reminder of the Inka state's unique abilities to domesticate stone. Both terraces and stone-masonry are petrous expressions of pre-Hispanic Inka order through which the Inka tamed the chaos of nature and rendered it habitable.

The story outlines the ways the Inka drew the earth into intimate relations. Accordingly, I also consider the visible conjoining, the symbolic marriage, of Inka and earth by focusing on natural rock outcrops that are integrated into masonry walls. Such integration conjoins Mother Earth to Inka settlement. Since the story also emphasizes the ongoing communication and reciprocal giving between earth and Inka, I consider some places and practices through which the colloquy with the natural environment was maintained. While the story focuses on Mother Earth, I expand the discussion to examine Inka relationships with masculinized

mountains, who in parts of the Andes today are addressed as "father."[4] In particular, I take up the difficult issue of child sacrifice, for while our story stresses the gift of life bestowed by Mother Earth, occasionally the Inka returned this most precious of gifts—human life—to their stony mountain lords.

ORDER AND UNORDERED NATURE

"The Inka asked Mother Earth to give us food and we learned to cultivate."

In the story, the relationship between earth and Inka is characterized by reciprocity. In Quechua, a reciprocal relationship is described by the word *ayni*.[5] It implies an obligation to aid a partner, as well as a promise that help will be available from that partner when needed. Our storied Inka establishes reciprocity with the earth. There is a consistent give and take between the two; though the relationship is initiated by the Inka, the earth always responds. As mentioned in the previous chapter, it was accepted in pre-Hispanic times, and widely believed in Quechua communities today, that the ancient Inka conversed with the earth and its parts, particularly rock. Moreover, Inka interaction with the land is described both in this story and elsewhere in ways consistent with interactions between human beings. In the story, the earth is gendered female as a complement to the male Inka, and their relationship proceeds according to accepted norms. This reflects an Andean belief, dating from pre-Hispanic times, that the earth in general, called Pachamama (Earth-Mother), is feminine, although discrete parts of the earth, such as individual stones, outcrops, and mountains, are more often male.[6]

Like many other peoples, Andeans observe that agriculturalists engage in a special relationship with the feminized earth that, understandably and almost universally, has sexual overtones. Agricultural activity, in particular, was analogized as intercourse between human beings and the earth.[7] The female earth is opened in plowing, is impregnated in sowing, and gives birth at harvest. This reading is especially apparent in drawings of pre-Hispanic Andean agricultural practices by the native artist and author Guaman Poma. In his illustration of the Inka plowing ritual of August, the sexual metaphors are obvious (figure 18).[8] The drawing

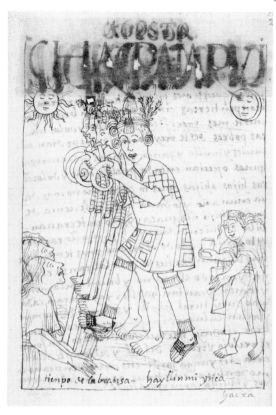

18. August agricultural ritual. Felipe Guaman Poma de Ayala, "Agosto: Chacra Iapui Quilla," in *El Primer Nueva Corónica*, fol. 250 [252], ca. 1615. Photograph provided by the Royal Library, Copenhagen, Denmark.

shows male Inka penetrating the earth with phallic foot-plows. Females kneel on the earth and are identified with it — to the point of losing their bodies into the soil — as the land is opened to receive the seed. Although the fertile earth is generally called Pachamama, the friar Murúa drew a distinction between "camac pacha," agricultural land, and "pacha mama," which was land that had yet to be brought under cultivation.[9] In his understanding, interaction with human beings in the form of agricultural activity fulfilled the creative potential of the earth.

Agricultural pursuits do not represent the sole intercourse between Andean people and Pachamama, however, for the land was also entered when architectural structures were grounded. In our story, building follows cultivation. The purposeful linkage of agriculture and architecture frequently occurs in Inka stories (and Andean oral culture of the past, as well as the present), as they are inextricably linked as human activi-

ties that order the natural world and make it comprehensible according to Andean ways of thinking.[10] According to the Inka, both agriculture and architecture (as well as animal husbandry, which is mentioned in the story, and weaving, which is not) were means of bringing order to untamed areas and peoples of the Andes. Both were more than signs of Inka order; they were the actuation of order. They are pursuits that can be paralleled as ordering processes that have left visible marks on the land and testify to a regulating presence that has altered nature for the benefit of its human occupants. In planting, the earth is prepared by plowing to receive seed. Likewise, buildings are initiated first by preparation and then by penetration of the earth. Not only do agriculture and architecture order nature, but both pursuits also modify the natural environment, in ways that sometimes imperil it, to serve human needs and desires. Both activities risk upsetting the balance between what we might call natural and cultural environments. Thus the Inka conceived of agriculture and architecture as ambivalent but necessary activities that ordered the natural course of things for the benefit of human life.

Garcilaso de la Vega, a mestizo author and native of Cuzco, relates Inka origin stories in which agriculture and architecture are not only coupled but identified as pursuits that define civilization itself. The stories tell of a time before the Inka when the world was in chaos. Human beings lived like wild animals without villages, houses, and cultivated fields. The Inka were sent by the Sun, their father, to give men laws and show them how to build villages, keep house, plant and grow crops, dress, and tend livestock. According to these accounts, apparently told to the young Garcilaso by his royal Inka uncles in Cuzco, the Inka understood themselves to be the agents of order, the civilizers of the Andes.[11] While Garcilaso, interested as he was in impressing his European readers with the many accomplishments of the Inka, may have exaggerated his claims, it is likely that his words reflect, in some measure, Inka imperial rhetoric.

To conceive of themselves as the architects of a well-ordered society, the Inka—like other "civilizers" in the history of the world—needed to identify places of disorder with which to contrast their own values, beliefs, and practices.[12] Although many of the people who were characterized as barbaric and uncivilized in Inka imperial rhetoric would surely have disagreed with such an assessment of their lifeways, the Inka promoted the notion that all contemporaneous societies lacked one or more elements of civilization until they were successfully integrated into the

Inka's realm.[13] There were, however, two places that were forever beyond the kind of procreative relationship between earth and Inka that is described in the story: the forest or *selva* (below) and the mountainous zones and high plains (above). The Inka reasoned that both places were ultimately unorderable in part because they resisted both architecture and agriculture. Some brief discussion of Inka perspectives regarding these two "undomesticable" zones is necessary before we can understand how the built environment, and particularly the terrace in which agriculture and architecture are united, signified notions of Inka civilization.

The Selva

Both the selva and its mountainous border zones, called the *ceja*, resisted Inka colonizing efforts.[14] The Inka referred to the inhabitants as Chunchu (Chuncho) and Anti and distinguished them from people of the "civilizable" zones in terms of both appearance and behavior.[15] According to colonial-period chronicles, the Inka launched a series of explorations into the forested slopes north and east of Cuzco in the decades preceding the Spanish invasion.[16] They called this region Antisuyu (Region or District of the Anti). Because of its inhospitable environment and inhabitants, Antisuyu was the least known of the four regions of the Inka empire. Ignorance characterizes colonial-period conceptions as well. Authors from the sixteenth and seventeenth centuries insist on the strange and hostile character of the Amazonian piedmont and its inhabitants.[17] Cieza, perhaps the first Spanish chronicler to rely on Inka informants extensively, characterized selva dwellers as "barbarous and warlike" (*bárbaras y muy belicosos*), and Betanzos, whose words often reflect his Inka wife's views and those of her relatives, describes them as naked, dissolute, extremely warlike, and cannibalistic.[18] Indigenous chroniclers of highland descent echo a similar refrain. Guaman Poma, for example, describes the people of Antisuyu as arrogant, deceitful, and traitorous.[19] I have argued elsewhere that the Inka (and maybe other Andean highlanders as well) imagined Anti or Chunchu people as wild, uncontrolled, and uncontrollable savages whose very existence coded the Inka as agents of civilization. Based on a few known characteristics that differed from highland traits, the people of the selva were perceived to be wholly opposite to highlanders and, consequently, wholly known as opposites. Uncontrollable and unknowable, Antisuyu was a blank slate to be written on by

the highland imagination. Thus descriptions of the Anti/Chunchu tell us more about Inka attitudes than about selva cultures — and, equally obviously, highland notions about selva dwellers are our present concern rather than the actual traits of forest cultures.[20]

In the Inka view, the Anti/Chunchu lacked proper dress and agriculture. Guaman Poma indicates that although some Anti/Chunchu people were successfully incorporated into the empire and so served the Inka, they never fully conformed to the codes of "civilized" behavior. In fact, one storied aspect of Anti/Chunchu service to the Inka state included eating non-Inka highland groups who resisted Inka domination.[21] Hence they were characterized as consistently *not* agricultural even when brought into the order of the Inka state. It is architecture, rather than agriculture, which is of interest here, however, and so it is significant that forest dwellers were also characterized as being *not* architectural. That is, they were often characterized as lacking settlements and even homes, "homes" being defined as permanent architecture in contrast to the semi-permanent, perishable dwellings of most Amazonian peoples.[22] From an Inka perspective, the uncontrollable selva was out of order and the lack of architecture was evidential.

The Higher Lands

The other necessary opposite, the other Other through which the Inka could characterize themselves as civilized, were the Qulla (Qolla, Colla) herders who occupied the barely habitable regions of higher altitudes — the *puna* (high plains) and mountainous higher lands.[23] Like the selva, the imagined higher lands were the projection of both Inka fear and desire. They were places of "pure" nature dominated by and belonging to the mountain apu (lords), the powerful and sacred mountains that affect human society by controlling weather, water, and other natural resources.[24] In the past as today, mountains are conceptually beyond human control and order. In fact, the Spanish verb *amansar*, which means "to tame," is used reflexively in parts of the Andes today to describe a mountain allowing itself to be crossed by a road or its slopes to be cultivated.[25] Mountains still resist human occupation. In Inka times they were not subject to the twin ordering activities of agriculture and permanent architecture.

Although mountain peaks (*urqu*) are generally gendered male, in contemporary Andean oral culture the wilderness above and beyond human society is sometimes personified as an old hag called Mama Huaca.[26] Like the selva, said to be inhabited by cannibals, the Mama Huaca was (and is) said to consume human beings, especially children and men whom she is able to lure with promises of great wealth.[27] She represents the precarious and dangerous relationship between human communities that depend on natural resources for their prosperity and the "pure" Andean environment that suffers exploitation—soil erosion, desiccation, overuse—and so causes human suffering as a result. Enrique R. Lamadrid, who has studied these myths extensively, writes, "In a primal sense, the Mama Huaca embodies the raw and awesome vitality of the Andes. As a monster, she represents the disjuncture between nature and culture, the subversion of the process of domestication and acculturation."[28] High and desolate, Mama Huaca represents Pachamama imbalanced and out of order, and so destructive rather than procreative.

Elsewhere in the Andes, the savage and untamed nature of the higher lands is personified in myth as Mama Qaqa (Mother Rock).[29] Unlike Pachamama, fertile and receptive, Mama Qaqa is impregnable and hostile. Within the ordered Andean world, most powerful rocks (wawqi, wank'a, puruawqa, and so on) are mostly male; some are small-scale embodiments of the masculine mountain apu themselves (see chapter 1). In the higher zones outside domesticated space, however, powerful individual rocks were (and are) apparently sometimes female—Mama Qaqa or Mama Huaca. In stories told at the northern extent of the Andean area, in the western highlands of Ecuador today, *urquyaya* (hill father) seduces women, while *urqumama* (hill mother) beguiles and tempts men; both prove to be dangerous partners for human beings in contrast to Pachamama (Earth-Mother), who, as described in the story related earlier, was the Inka's mate and mother of his children.[30] Mountains, as undomesticable places high above human society and out of the reach of human order, frequently figure in Andean stories as refuges for those who do not fit in society or conform to social norms.[31]

Like the higher lands of the Andes just described, the selva too features aberrant gendering with men said to dress and act like women.[32] Procreative couples are, like agriculture and architecture, features of ordered places. As dissimilar as these two places were, both the selva and the

higher lands—places of irrational gender and cannibalistic appetites—
functioned as disorderly opposites from an Inka perspective.[33] From this
brief discussion of Inka beliefs about these dual zones of irremediable dis-
order, we can see the order of the Inka state more clearly. In areas where
they established control, a built environment was a sign of Inka order
imposed. It established not only Inka presence but also civilization that
they believed to result in the procreativity of crops, animals, and human
beings. Architecture, and its critical presence or absence, visually defined
the Inka's ordered places from the disordered spaces on their periphery.
We can best understand elements of the Inka built environment by re-
membering that it was produced in tension with these unordered geogra-
phies.

Terracing and Taming

Renowned Inka terraces—many still visible and some still functional—
are perhaps the most obvious remaining visual link between the two
ordering activities of agriculture and architecture, broadly conceived.[34]
Architectural terracing, as at Pilko Kayma (Isla del Sol) or Tarawasi, rep-
resents a particularly pointed conjunction of agricultural and built envi-
ronments. While the Inka did not "invent" terracing, they developed and
perfected it. O. F. Cook rightly observes that "notwithstanding the enor-
mous labor expended upon the building of ordinary terraces, such work
was carried far beyond the practical necessities and brought to a stage of
perfection that compels us to wonder as well as to admire." [35] Terraced
hillsides testify both to the presence of Inka agricultural genius and to
the relationship the Inka established with Pachamama (plates 10 and 12).
Rock retaining walls trace the contours of slopes, harnessing and sculpt-
ing natural topography. They stabilize and secure scree-strewn slopes
and create bounded, level plains out of precarious hillsides, allowing
for agriculture and habitation. Together with irrigation networks, ter-
racing transformed entire ecosystems.[36] Many of the finest, most care-
fully crafted Inka terraces are found on royal estates, lands belonging to
particular rulers and their descent groups (*panaqa*). Jean-Pierre Protzen,
one of the first to comment on the symbolic significance of such terraces,
calls the terracing at Ollantaytambo, said to have been the royal estate of
the ruler Pachakuti, "an expression of power, the power of the Inca, son
of the Sun, to impose his rule and to command respect." [37] This is so be-

cause terracing represents not just the ability to command large numbers of workers or to ensure increased crop output but also the power to order nature itself. The exquisite terracing exhibited on royal estates defined each individual ruler as a bringer of order and therefore as a procreator par excellence.

Yet our modern story characterizes the ordering of the environment not so much as a forced taming of resistant nature as a gentle persuasion, a wooing.[38] Terraces that follow the curves of the earth (as many do), accommodate its idiosyncrasies, respond to its slope and composition, and acknowledge its irregularities reflect what the story portrays as a romance between the Inka and the earth. Thus whatever the engineering accomplishment and the resulting increase in agricultural production, which was often considerable, on a purely visual level we must acknowledge terraces as an elegant and integral element in the ongoing dialogue between Inka inhabitant and the inhabited earth. The finest terraces feature cut and fitted, mortarless masonry of polygonal stone blocks that simultaneously recall the arbitrary shapes of natural rock while featuring the obvious labor of a well-dressed stone (figure 19).[39] The stone from which the wall is constructed is not only itself tamed but brings order to the hillside where, before construction, there was none. Terrace walls are thus a particular visible articulation of the intercourse between pre-Hispanic Inka and Mother Earth, evidence of the ordering of nature that rendered Pachamama fruitful and resulted in the "era of abundance" remembered in the story related at the outset.

It may be relevant that *allpa*, defined as arable soil,[40] complements *rumi* (rock). The Inka conceived of both "natural" elements, together composing the earth, in terms of the human body; flesh is akin to soil, and bones are akin to stone. After death, flesh decays into soil. The verb *allpaymanani*, in fact, means the conversion of the cadaver into earth.[41] Bones, in contrast, permanent and not subject to decay, are like stones. Thus soil, essential to successful agriculture, and stone, essential to highland Andean architecture (as expressed in the story), are metaphors for two of the basic components of the human body (namely, flesh and bone). The agricultural terrace, fertile soil retained by an orderly rock wall, brings these worlds together. It creates a complete, procreative body. The terrace was not just a utilitarian answer to farming and inhabiting rugged terrain; it was a sign of a civilizing presence.

THE WELL-DRESSED WALL: STONE DOMESTICATED

*"While the Inka built Cuzco completely of stone,
they say Lima is made of mud."*

The postconquest story that provides the scaffolding for this chapter iden-
tifies stone as the special building material of the Inka. Cuzco, the Inka
capital, we are told, was built entirely of stone. While the strict accuracy
of this account is doubtful, it is important to observe that stone is char-
acterized as an Inka substance.[42] Thus stone used in building may carry
great symbolism in and of itself. Once manipulated, stone — whether
stacked into a wall or in any other way distinguished from its unordered
surroundings — is the actuation of Inka ordering. We may observe that to
put stone into order, in other words to build with it, was in some ways to
tame it. Of course, the Inka were not the only Andean peoples to build
with and manipulate stone, but their masonry architecture was distinc-
tive.[43] In particular, the cut, dressed, well-joined, mortarless stone wall
signed the presence of the Inka state. Cut and fitted stonemasonry, typi-
cal of important, often sacred state-sponsored structures (in contrast to
common mud-brick construction or that of fieldstones set in mud mor-
tar), especially expressed the ordering of unordered nature through the
precise fitting of mostly unadorned stone. In such structures, stone has
been thoroughly altered to take its place within Inka architectural order.
Dressed and fitted stone might well be thought of as the most thoroughly
domesticated of all rock.

While to build an ordinary stone wall was *pircani*, the Inka referred to
the working of finely joined masonry as *canincakuchini*, which is derived
from the verb *kanini* (*canini*), meaning to bite or nibble.[44] The dictio-
nary of 1586 defines a stone wall constructed without mortar as "canic
pirca" (*kanij pirqa*), meaning "nibbled wall."[45] "Nibbling" vividly de-
scribes the process of, and techniques for, creating well-joined masonry
that Jean-Pierre Protzen has identified and re-created.[46] Once the block
was roughed out, hammer-stones, ever decreasing in size, were used to
refine the shape. While initial strokes took large bites from the stone,
gobbling its excesses, final work persistently nibbled away at the block
to achieve the desired result. Blocks were nibbled at the site of construc-
tion until they fit precisely on top of, and next to, their nibbled peers.
Walls where stone has apparently been removed reveal the precise bed-

ding joints achieved through the time-consuming, but not technically difficult, process of pecking, fitting, pecking, refitting, and so on (figure 20).[47] The phrase "nibbled masonry" thus preserves Inka ways of thinking about well-dressed and finely joined masonry as the result of innumerable minute bites.

Cut and fitted stonemasonry — what I am calling nibbled masonry — has been studied extensively; scholars have offered numerous ways of categorizing its types or styles.[48] Most authors, following observations John Howland Rowe makes in his "Introduction to the Archaeology of Cuzco" (1944), recognize two broad styles of well-worked stone wall construction, both of which consist of nibbled blocks joined without mortar. In one style, the face of the wall is coursed, referring to rectangular ashlars placed in relatively regular courses, or gives the appearance of coursed masonry (figure 21). In the second style, the face of the wall is uncoursed, comprising polygonal blocks of irregular, interlocking shapes (figures 19 and 22).[49] In coursed masonry we frequently see stone blocks of irregular height and shape creating wavy or discontinuous horizontal joint lines; Protzen and Nair introduced the term "quasi-coursed" to acknowledge masonry that looks coursed but is not consistently so.[50] The two styles are sometimes blended in the same wall where the uncoursed masonry of lower walls gradually assumes courses.

There is no general agreement on the development of Inka masonry types or styles.[51] What matters to this discussion is that, in all cases of well-joined block construction, whether mostly coursed or mostly not, the cut stones were pounded with hammer-stones of varying sizes, being "nibbled" to fit precisely in one and only one location within a wall.[52] Regardless of the final appearance, and however refined our categories become, each wall results from nearly identical stoneworking techniques.[53] Cobo, one of the few Spaniards to show much interest in masonry practices, notes that the working of stone blocks in the Inka manner is "very hard and tedious" (*muy pesada y prolija*) and explains that "to fit the stones together, it was necessary to put them in place and remove them many times to check them, and since the stones are very big, as we see, it is easy to understand what a lot of people and suffering were required."[54] Cobo emphasizes the time involved in producing a wall of nibbled stone. The key to an Inka perspective, then, may well be the concept of nibbling in which the *process*, the persistent working of individual blocks, not just the end product, the overall shape of the blocks, is emphasized. Because

19. Terrace wall, Chinchero.

(below left) 20. Unassembled wall showing bedding joints, Pisaq.

(below right) 21. Coursed wall, Pasaje Loreto, Cuzco.

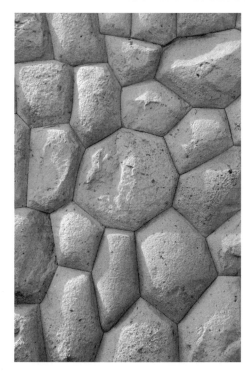

22. Uncoursed polygonal
masonry, Tarawasi.

traces of the hammer-stone on the surface of a nibbled rock constantly
recall the work of production, the performance of labor is paramount.[55]
Given the consistent linkage of architecture and food production as dual
signs of civilization in Andean stories, the notion of "nibbling" stone also
underscores the orderliness of the procedure, emphasizing the ways the
Inka "consumed" disorder, processing it, *digesting* it, to produce civiliza-
tion. We are reminded of the somewhat infamous Inka practice of turning
the skulls of vanquished enemies into cups; the ceremonial consumption
of aqha (*chicha*, or maize beer) from the head of a foe symbolized the
successful transformation from the disorder of warfare into the order of
Inka occupation.[56] In both cases, whether metaphorical nibbling or actual
quaffing, chaos was taken into the body Inka, where it put to order and
so made useful from an Inka perspective. The finer the nibbles (that is,
the smaller the hammer-stones), the more "orderly" the stone. Orderly,
nibbled walls thus metaphorically addressed the social order, where how
well one fit the Inka's established order also conveyed a sense of the dis-
tance one was removed from disorderly society. I purse the implications
of this metaphor in chapter 3.

The notion of nibbling also emphasizes the sense of taste, which contrasts with those non-Inka terms to describe the well-fitted stone wall that have relied on visual characteristics and so have been tied to the sense of sight. This could be seen as an aspect of Western ocularcentrism, the historical privileging of sight over the other senses, and the concomitant dismissal of the other senses as lesser and lower.[57] The preference for sight—and so terms referring to sight—obscured other, more Inka ways of thinking about and describing rockwork. In the previous chapter, I discussed illa—small stone figurines, as well as bezoars, associated with good fortune—and asked: under what scheme of categorization could petrous figurative likenesses be equated to the stonelike concretions found in the stomachs of ruminants? Here now we begin to glimpse a possible answer. Carefully carved stones undergo nibbling, as apparently have "stones" found in the stomachs of ruminating animals. Thus both kinds of rocks have been processed through the body (metaphorically or actually); they have been dislodged from their natural state and have been bitten and chewed and altogether changed. The alteration of form is recorded in the external shape and surface details. The nibbled stone of a well-fitted wall, like an illa (of whatever sort), bears the marks of its alteration and functions as a trace of interaction between inert stone and animate beings. It testifies to the stone's pliability, its willingness to accommodate the needs of those who shape it.

Modern scholars have struggled to describe and categorize fine Inka masonry; they are not alone. Valerie Fraser observes that the Spaniards, who were not culturally prepared to recognize value in uncanny architectonic forms, had particular problems describing—with Spanish architectural vocabulary—the uncoursed, polygonal style of Inka masonry.[58] Cobo, she notes, uses the term sillería to describe the (mostly) coursed ashlar masonry but uses mampostería for the uncoursed polygonal style. Mampostería, as Fraser points out, means fieldstone or rubble masonry and suggests little skill. As a result, Cobo is compelled to compensate for his inadequate terminology because, as he explains, Inka "mampostería" with its tight joins evinces considerable masonry expertise. Perhaps we would do well to learn from Cobo's dilemma and avoid labels that do little to reveal Inka perspectives. Instead, if we focus on process, on nibbling, we see that the dearth of adornment—so often puzzling to students of Inka masonry—makes perfect sense, for pervasive adornment of the stone's surface, whether through imagistic carving or decorative

painting, would draw attention away from the joins and pecked surfaces, from what has been so perfectly and persistently nibbled. In fact, many have noted that the lack of superficial adornment tends to create focus on the beveled, often deep-seated joins between stone blocks—precisely those areas that were tirelessly nibbled until the blocks could finally assume their proper place within Inka order.[59]

INTEGRATED OUTCROPS: WHERE BUILT AND NATURAL ENVIRONMENTS MEET

"The Inka married her [the Earth] and they
had two very handsome babies."

In our story the Inka married Pachamama, and they procreated. Later, once the Inka was gone and "unable to do anything, Jesus Christ attacked Mother Earth, cut off her head, then built churches on her." From the modern Andean perspective as expressed in the story, Christian churches are possible only when the Inka is chased away by Jesus Christ, who also kills Mother Earth. Whereas Inka interaction with the earth is characterized as procreative, Christian activity is inherently destructive.[60] It is not unreasonable to plot related notions back to pre-Hispanic times when the Inka state probably cast its building programs in opposition to groups who were the Inka's contemporaries, or those who preceded them. The Inka claimed a unique relationship with the earth they inhabited, and from their point of view, not all built environments complemented the natural environment. Certainly Inka site planning differs dramatically from that of the Wari (Huari) as manifested at the site of Pikillaqta, just south of Cuzco. Built between CE 500 and 800 (some seven hundred years before the Inka developed their distinctive style of architecture), Pikillaqta's uncompromising grid imposes itself on the land, ignoring the rolling terrain and all topographic irregularities.[61]

Whereas Wari organizational strategies are imposed on Pachamama, Inka structures seem to cooperate with her. Many Inka sites famously conform to the curving body of the earth, adopting building strategies that acknowledge topographic idiosyncrasies; with certain exceptions, they generally do not mask or ignore significant landmarks.[62] Inka sites often are, as Paternosto observed lyrically, "an efflorescence" of the land

on which they are located.[63] Even where the topography has been altered considerably, Inka settlement planners minimized the obvious appearance of their modifications. The Inka, familiar as they must have been with Pikillaqta, could not have failed to notice the different approaches relating the built environment to the natural environment. The Inka's unique approach suggests a desire to make visible a different kind of relationship with the earth. While many other Andean builders from across Andean history (e.g., Tiwanaku, Chavín, Nasca, Moche, Chimu) fabricated their own mountains, the Inka consistently emphasized and often drew attention to extant natural, rather than created, artificial forms. I discuss the Inka interest in mountains later. For now, I turn my attention to elements within the Inka built environment that speak to the special relationship between the earth and Inka that is such a prominent theme in the story that inspired this chapter.

Sites of intercourse between the Inka built environment and the natural environment are a hallmark of many Inka settlements. It was a common Inka practice to employ rock outcrops — living rock — as parts of their walls (figures 3 and 23); surely the most striking example of integration appears at Machu Picchu's so-called Tower (or Temple of the Sun and Royal Mausoleum) (figure 24). While the Inka are not alone in using outcrops in building, their use is more consistent and widespread than that of any other American peoples, with the locations of outcrops frequently affecting the form and placement of structures, as well as the overall design of settlements or parts of settlements.[64] Integrated outcrops may have been known as *tiqsirumi*, meaning foundation, first, or origin stones.[65] The Inka integration of outcrops into their built environment suggests a strategy akin to grafting, wherein Inka structures appear to grow from the earth's stony skeleton, rather than being set on it. The tiqsirumi is the root or seed from which a masonry wall springs. Bedding joints nibbled from tiqsirumi provide a nearly seamless fit for the worked blocks that surround it. Often nibbled blocks are snuggled into gaps in the tiqsirumi, purposefully confusing the juncture between outcrop and masonry (figure 25).[66] It might be more accurate to replace the word *buildings* with *graftings* when describing Inka structures that are incorporated into outcrops. In such structures, architecture very nearly becomes agriculture, as the grafted edifices grow from foundations of living rock just as plants depend on stable and well-grounded roots. Stones used in

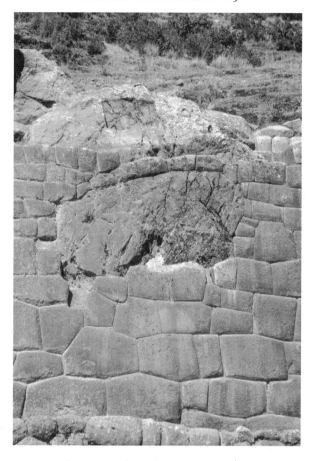

23. Integrated outcrop, Tambomachay.

the finest of these edifices — their fruits — are nibbled until they interlock with precision.

In the early twentieth century, the Swiss anthropologist and archaeologist Adolph F. Bandelier puzzled over the Inka integration of outcrops into buildings; referring to structures at Pilko Kaina (Pilco Kayma) on the Island of the Sun in what is today Bolivia, he wrote: "It is strange that people who were able to move incomparably more ponderous masses [of stone], as shown at . . . Cuzco, should have left them [large boulders] *in situ*, building over and around them."[67] Likewise, Hiram Bingham puzzled over the walls that contour boulders and outcrops at Machu Picchu; after excavating in an attempt to discover some practical pur-

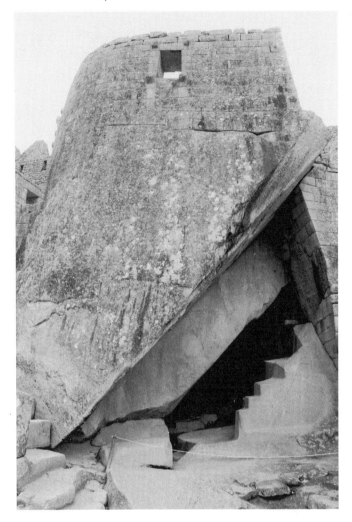

24. Tower, also known as the Temple of the Sun, Machu Picchu.

pose, he concluded that "the walls had been built chiefly to give a finished appearance to the rude bowlders."[68] More recent observers understand the Inka's incorporation of unhewn rock outcrops to have been purposeful. Certainly, grafting provided stable foundations in the Andes, an area prone to violent earthquakes, and was used wherever natural conditions allowed.[69] The integration of outcrops, however, was more than a utilitarian adaptation to sometimes unstable Andean tectonics.[70] As Edward Ranney, the gifted photographer of Inka monuments, has observed, "Archaeological documentation of Inca culture has consistently failed over

the years to convey the intimate relation between the monuments and their surroundings."[71] What Ranney describes as an "intimate relation" between built and natural environments precisely parallels the relationship between Inka and earth described in our story. The Inka use of outcrops and the strategy of grafting serve to interweave, to marry, the built environment with the natural environment, creating a stunning integration of nature and architecture that echoes still in modern storytelling.

In some structures, as noted earlier, the transition from natural to built environments is eased by the use of polygonal, irregularly shaped masonry near the base, whereas coursed, more rectilinear blocks occupy the upper levels. Walls such as this allude to the transmutability of nature under Inka order. In the ruined walls of Saqsaywaman, mostly megalithic polygonal blocks remain, but we can still see how the walls originally moved from uncoursed polygonal-faced stones to roughly coursed rectangular-faced blocks (figure 26). In grafted structures such as these, the edifice seems to grow from the ground, becoming increasingly regular, separating almost imperceptibly from its "natural" foundations to join the rectilinear world of the Inka built environment. Native, living rock is thus integrated into the human community, inextricably intertwining the work of man and the work of nature. The wall makes visible the complementary relationship between Andean natural forms (the rock) and Inka cultural norms (as expressed in architecture). As noted earlier, the Inka did not need writing to tell of their relationship with the earth. While Inka walls are not texts, they can and do contain philosophical statements about how the Inka made their way—not in or through the world, but *of* it.

The integrated outcrop is the place where Inka ordering meets the randomness of nature. The use of rock outcrops in architecture blurs the boundary between what the Inka perceived as ordered and unordered spaces. In fact, the integrated outcrop is the necessary interstitial space between Inka order and unordered nature. It is the place where complements meet. Places that represent meetings of complementary opposites have a special place in Andean thought. Quechua speakers use the word *tinku* or its cognates to identify places where, or events in which, complements merge: the confluence of rivers, ritual battles between necessary enemies, and so on.[72] The integrated outcrop, like the terrace wall, is a tinku, a coming together of natural and built environments. A related concept, *yanantin*, is used by the contemporary Macha of Bolivia

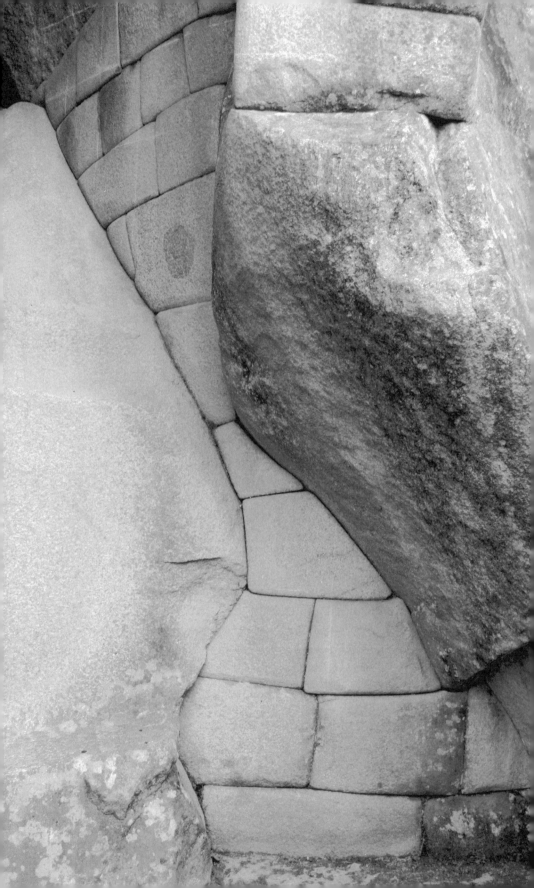

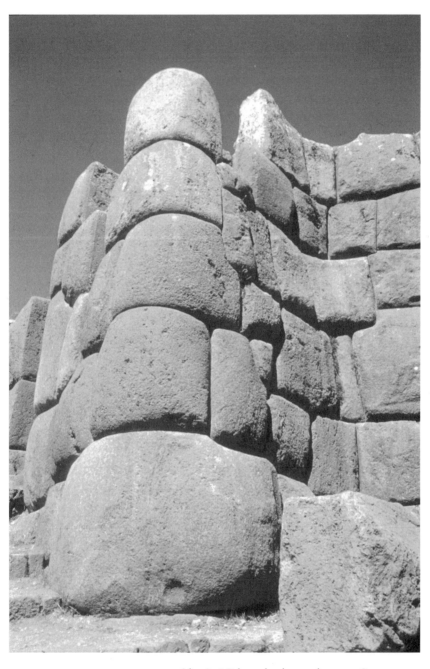

(above) 26. Polygonal and coursed masonry, Saqsaywaman.

25. Detail of outcrop integration, Tower (Temple of the Sun), Machu Picchu.

to describe a thing in which complements are united. As Tristan Platt describes, *yanantin* can be translated from the Quechua as "helper and helped united to form a unique category" but glossed simply as the word *pair*, equivalent to the more familiar Quechua phrase *qhariwarmi*, meaning "man-and-woman," as a single entity composed of complementary opposites brought together. Platt relates how the Macha instructed him that "everything is man-and-woman" (*tukuy ima qhariwarmi*), meaning that the essential structure of the universe is complementary opposition.[73] Whatever expresses the union of complements is an example of qhariwarmi.

Olivia Harris, in her studies of the Aymara-speaking Laymi of the central Bolivian highlands, identifies the married (heterosexual) couple (called *chachawarmi*) as the embodiment of society itself in contrast to unmarried people, who, she says, "in certain respects are relegated to the wild."[74] Aymara and Quechua notions of the bonded pair thus appear to be similar. In both, the couple (whether chachawarmi or qhariwarmi), and whatever exhibits the attributes of a couple, are symbols of domestication. Given how widespread this notion is in the Andes today, it is reasonable to plot back at least as far as the Inka (and probably a great deal further). Looking at what is left of Inka material culture, we can identify places and things where complements meet as places and things of great symbolic import. It is well known, for example, that pre-Hispanic Inka communities articulated their notion of necessary and vital complementarity in their division into *hanan* (upper) and *urin* (lower) components.[75] Thus a community, in its very layout, was a tinku, a place of conjoining, and an example of qhariwarmi. Garcilaso, the mestizo chronicler and childhood resident of Cuzco, seems to have understood this when he identified Hanan Cuzco as having been settled by Manco Capac (Manku Qhapaq), the male founder of the Inka state, and Urin Cuzco as having been settled by Mama Ocllo (Mama Uqllu), Manco's sister and mate.[76] His version of Inka history posits that the initial legendary, and literal, Inka qhariwarmi is manifested visually in the organization of the city the first Inka couple established.

The integrated outcrop, the tiqsirumi, also expresses qhariwarmi. In particular, it articulates the coming together of built and natural environments, or tamed and untamed nature. Bonded to the unordered earth and bonded to the ordered wall, the outcrop is a tinku. As the site of conjoining, the integrated outcrop, at once a part of architecture and a part

of nature, expresses an Inka understanding of a proper relationship with Pachamama. It is the sort of relationship alluded to earlier in the story: a romantic relationship, characterized by reciprocal giving and leading to marriage and procreation. Inka structures that incorporate living rock, the nexus of natural and built environments, are the relationship made visible; the integrated outcrop is the site of joining, the site of marriage, if you will. Structures that grow from the outcrop are, in the words of our story, the "very handsome sons" of the union. While the integrated outcrop is the visual evidence of intercourse between cultural activity and the natural environment, and while we might be tempted to say that these are places where "culture" meets "nature," it better reflects Inka (and more generally Andean) thinking to say that these are locations where ordered nature meets unordered nature, for Andeans tend not to recognize a dichotomy between human society and the world human beings inhabit. Further, we ought to avoid the gendered notions commonly associated in the West with a feminized nature and a masculinized culture. I take up the notion of variable gendering in the Andean worldview later in the chapter.

The integrated outcrop lends Inka presence on (in) the land legitimacy, as Mother Earth herself appears to have consented to, if not joined in, Inka building activity. Today in the Andes the making of dwellings, beginning with the laying of the first foundational stone, is accompanied by offerings of small amounts of alcohol on the ground.[77] In some places this offering is called *tinka*, a cognate of *tinku*, and is a reference to the conjoining of edifice to earth, something that is done successfully only with the permission of the earth as well as other nature spirits. Allen reports that today in the Quechua community of Sonqo (Department of Cuzco), the community establishes a "relationship with a place by building houses out of its soil, by living there, and by giving it offerings of coca and alcohol"; she adds that "the relationship is reciprocal, for the Runakuna's [people's] indications of care and respect are returned by the place's guardianship."[78] While no pre-Hispanic Inka exist to show us all the ways they established relationships with the lands they inhabited, we have their descendants. We also have Inka architecture grafted onto bedrock. Might we not read these as articulations of the ayni that existed between earth and Inka? Emerging from the earth as did the progenitor ancestors, the integrated outcrop remains a denizen of the ancestral innerworld as well as the world of the living; its dual citizenship makes

it ideally suited to symbolize the Inka's ability to establish relationships across realms.

Outcrop integration is a feature of many Inka sites and is present in the humblest, most functional areas, as well as in sacred sectors. Niles notes, however, that the incorporation of natural outcrops into structures is found less frequently in buildings within the city of Cuzco than it is in buildings outside the capital.[79] At this point it seems relevant to recall that the Inka ruler followed the practice of marrying the daughters of provincial leaders (or marrying them to members of the royal household). In some ways, the integration of outcrops is the architectural equivalent; through the outcrop, foreign Inka architecture married local topography. The outcrop integrated into Inka architecture relates to free-standing outcrops carved with architectonic forms.[80] In both—the integrated outcrop and the architectonically carved free-standing outcrop—built and natural environments are intertwined. Both may well be examples of qhariwarmi and, as such, are signs of the relationship the Inka claimed with Pachamama. Using fixed features of the landscape lent legitimacy to the Inka presence. I discuss this idea and the political implications of the Inka's stoneworking practices in chapter 3.

CONDUITS OF COMMUNICATION: PASSAGES, PILGRIMAGES, PORTALS, AND APACHITA

"The Inka constructed a tunnel by means of which he used to visit Mother Earth."

Passages

In the story, tunnels were constructed to facilitate communication between earth and Inka. Tales of tunnels linking Inka sites are common in Cuzco today. As noted in the previous chapter, passageways into or through rock outcrops, often called *chinkana* (labyrinths), were often specially marked by the Inka. On some, carved steps symbolized passage between realms; on others, the Inka carved animals associated with places and times of transition. Whether carved or not, rock chinkana were special places where this world met the ancestral innerworld (plate 11). Chinkana enabled communication with Mother Earth and ancestral

spirits. The Inka and other Andeans likened the bodies of ancestors to seeds (and even called them *mallki*, meaning seedlings). Corpses were planted in the earth by being placed in caves and underground spaces. Earlier, the connection between the bodies of the deceased and the fertile soil of a beneficent Pachamama was made through the verb *allpayma-nani*, meaning the conversion of the cadaver into arable land. Offerings left in chinkana or in caves were destined for both Pachamama and the ancestral realm. Underground passageways, chinkana, were thus locations of meeting, communion, and exchange between worlds.

Pilgrimages

"Mother Earth" is not the only aspect of nature with which the Inka interacted. While the story that frames this chapter focuses on the relationship with Pachamama, here I consider briefly a different and perhaps more precarious relationship: that between the Inka and sacred mountains. The Inka (like most other Andean people) identified high, especially glaciated mountains as sacred apu (lords), also addressing them as *tayta* (father) and identifying them as places of spirits called *wamani* or *auki*.[81] While the earth—Pachamama—was most commonly feminine, apu were masculine. Throughout the Andes, the fertilizing, foamy waters flowing rapidly from snowcapped mountains to irrigate lower-lying fields are equated with semen.[82] The identification of mountain peaks with males, and specifically male genitalia, has a lengthy history in the Andes, and today many indigenous Andeans consider mountains to be the spouse of the cultivated earth.[83] Mountains are places where rain is made and whence water comes; mountain deities control rain, which is both beneficent and malevolent depending on its amount, timing, and force. Mountain apu also own everything within their ranges of "vision" or within their watersheds. Thus human beings living in the shadow of one or more of these were always cognizant of the ever-watchful eye and always mindful of the need to keep open the lines of communication with these powerful entities.

The Inka drew the frequently forbidding, always ambivalent apu into social relationships, establishing reciprocity with them just as they did with Pachamama. Some were familial, like the sacred Wanakawri, a hill outside Cuzco that was identified with one of the brothers of the first Inka ruler. Most, however, seem to have been necessary, but dangerous, part-

ners. Continuous dialogue and negotiation were carried out to ensure a mostly beneficial, if often precarious, relationship between the two. We can learn from contemporary Quechua about some of the ways these relationships are conducted today and why they are so important. The most celebrated apu in the Cuzco region is mighty Ausangate (Ausan-kati, Ausanqati, Asangate, Asungate), a glaciated peak rising well over twenty thousand feet above sea level. Indigenous campesinos say that he has a frozen heart and bestows life through his gift of rain.[84] While those who live under his purview are always mindful of him, Ausangate is now specially celebrated annually in the composite Catholic and indigenous Andean festival known as Quyllur Rit'i (Qoylloriti) occurring in the days before the Catholic feast of Corpus Christi (May–June). Quyllur Rit'i is a culturally and religiously hybrid event in which more than ten thousand Peruvian campesinos from regional communities gather at around six-teen thousand feet above sea level to celebrate at a boulder (surely a pre-Hispanic waka) on which an image of the Christ child is said to have ap-peared in 1785. In the course of events, the celebrants give gifts, including miniature representations of houses, corrals, and livestock, to the dual apu (the mountain and Christ) and request gifts from the mountain/Christ.[85]

In many of its aspects, Quyllur Rit'i is the festive complement to Cor-pus Christi about which others have written extensively.[86] Honoring male mountain deities complements Corpus Christi's focus on harvest in pro-ductive, feminized lower lands. Because the streams issuing from moun-tains are analogous to semen, the ice gathered from Ausangate's glaciers by certain celebrants at the end of Quyllur Rit'i may be seen as crystal-lized semen; the collected ice is called by some *hampi*, meaning medi-cine, and is believed to have healing power.[87] The ice gatherers dress as *ukuku*, Andean spectacled bears (*Tremarctos ornatus*), animals that in-habit the forested *ceja de selva* (fringe of the forest) and, to highlanders, symbolize the selva's lack of domestication; they are creatures that span the border between human and animal realms.[88] In Quyllur Rit'i the two zones of disordered nature—warm forested lowland and icy glaciated mountain—meet. The ukuku carry Ausangate's ice to villages as well as to the steps of the cathedral in Cuzco, where they distribute it. Thus the final act of the mountain festival of Quyllur Rit'i is the fertilization of the valleys. Although Christianized, the festival is an opportunity, on a grand scale, to give to and receive from one of the most powerful and re-spected apu in the Andes. The gift of mountain ice ensures agricultural

success in the valleys. Although such direct encounters between mountain lords and human beings can be dangerous (pilgrims who spend the night on the apu's glaciers not infreqently die of exposure), ceremonies such as the Quyllur Rit'i are a sure means of securing and reaffirming an ayni between the two. Pilgrimages in the past such as *qhapaq ucha* (which I will discuss later), like those of the present, were an important means of communicating with the sacred Andean landscape.

Portals and Platforms

While pilgrimages open a spectacular conduit of communication with the mountain apu, from an Andean perspective, the village and its human inhabitants are in constant dialogue with these great watchers. Most visitors who spend any time in indigenous communities are introduced to the local apu. Although the Inka inhabitants of what are now ruins are no longer present to point to mountains on the horizon and provide proper introductions to guests, Inka architecture still performs this service. At Machu Picchu, for example, portals and windows frame distant mountain peaks, setting them off from the other elements of the horizon and directing the viewer's gaze and attention to them (figure 27). Windows and portals, viewing platforms, the angles of walls and the corners of buildings, passageways that close off views and then open on to vast vistas, all influence the ways visitors, past and present, see the site and its magnificent natural setting. Architectural elements frame space, separating out the important peaks from the rest of the horizon, distinguishing the special from the ordinary. They also organize the horizon into its important segments, ordering unordered nature. The Inka built environment thus influences the ways all future visitors see not just the edifices but their natural settings as well; long-dead Inka architects and masons, by means of the structures they built, still introduce visitors to the mountainous overseers of any particular community.

Machu Picchu, although not unique, provides the richest examples of the ways Inka architects constructed particular views and directed the gaze because windows and doorways remain largely unaltered from pre-Hispanic times. The best-known view of Machu Picchu—the standard postcard photograph that provides a view of the city stretching along a ridge in front of the peak called Wayna Picchu (Huayna Picchu) (figure 28)—is not the result of happenstance. There is a guard station at this

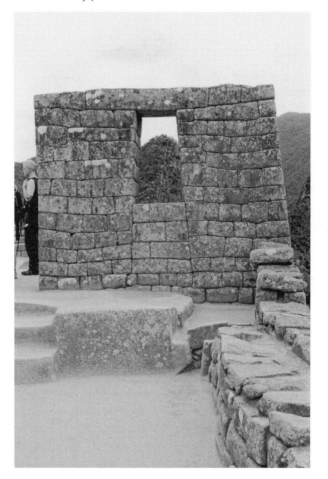

27. Mountain-framing window (once a doorway), Machu Picchu.

point, and it once served as the formal entrance to the city. Here deliberate attention is called to the placement of the site at the feet of Wayna Picchu, and so the visitor greets the mountain whether consciously or not. Because architecture structures the view, it initiates a dialogue, opens a conduit, between built and natural environments. Visitors find their attention constantly drawn outward to the natural environment by deliberate aspects of the built environment. Atop Wayna Picchu, climbers are rewarded with a view, weather permitting, of Salcantay, one of the most revered mountain peaks in the Andes (and the brother of Ausangate, discussed earlier). In many places where spectacular views are possible, the Inka leveled off outcrops to create viewing platforms.

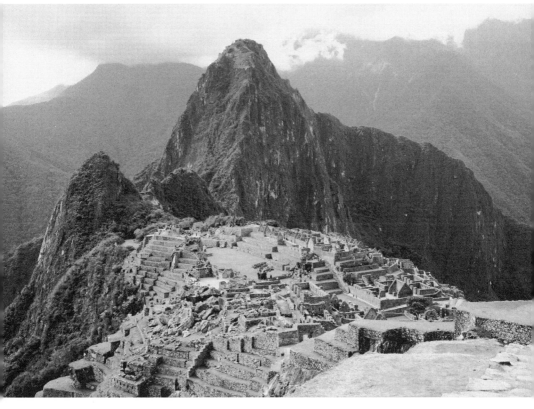

28. Machu Picchu.

In the early seventeenth century, the indigenous Andean chronicler Santa Cruz Pachacuti drew and described the Inka caves of origin as *ventanas* (windows), as noted in the previous chapter (figure 6).[89] Significantly, in Andean thought, windows and caves are metaphoric equivalents; the frame of the window or door, *t'uqu* in Quechua, is like the portal to a cave. This suggests that the interiors of buildings are, in some ways, like caves. Caves, as places of origin, of birth, are feminine places. In viewing a male apu through a t'uqu, the spectator necessarily occupies situationally feminized terrain. The frame is the permeable space where complements conjoin. The portal, then, like the integrated outcrop, is a coming together of settled and unsettled, ordered and unordered spaces. The t'uqu is a qhariwarmi, a tinku, a place where complements meet. In this particular complementary pairing, it might be observed that "unordered nature" (the mountain) is masculinized, while "ordered nature"

(the structure's interior) is feminized. Thus we see that Andean gendering
is relative and shifts, constantly seeking to identify complementary pairs.

Because Andean situational gendering runs contrary to the fixed Carte-
sian dualism that has long dominated Western thought, some brief dis-
cussion of the nature-culture debate and its intersections with Andean
thinking may be helpful to our discussion.[90] Sherry Ortner, in her in-
fluential essay "Is Female to Male as Nature Is to Culture?," argues that
in societies that employ a binary system of classification, domination
and value are usually semanticized in gendered terms and are associated
with masculinity. In familiar binary pairs, such as culture-nature, mind-
body, head-heart, reason-emotion, good-evil, purity-contamination,
objectivity-subjectivity, public-private, victor-vanquished, conscious-
unconscious, and so on, the culturally valued, dominant element is
gendered male, and the dominated element is gendered female. Many
scholars have responded to Ortner's essay, some offering supporting
documentation, others giving case studies that contradict her claims.[91]
What matters here is that Andean notions of complementarity involve
pairs that are flexible and relative rather than fixed and permanent. Also
involved is the essential conjoining so that a pair of complements always
implicates a critical third place or thing, the place of coming together.[92]
The particular gendering of space, natural forms, and even people shifts
depending on the relationship of the complements to one another in a
particular instance. In Andean complementarity, both parts of the pair
are viewed as essential, and the third part, formed by the conjoining,
is procreative, powerful, and often sacred. It is important to note that
Andean complementarity is not equality; the system subjects the "lower"
(*urin*) complement to the "upper" (*hanan*) complement. However, while
ordered nature may occupy the hanan slot in relation to the urin of un-
ordered nature in one instance, in the next, ordered nature is urin to a
powerful unordered natural hanan. Positionality is thus never fixed, and
any attempt to establish an inflexible hierarchy will ultimately prove un-
satisfactory.

Apachita

Regardless of how ordered and unordered nature, or built environment
and natural environment, were gendered, they were recognized as com-
plements whose relationship—whether hostile or cooperative—was

essentially interdependent. Such variable and varying complements required constant conversation and interaction. One site of communication between the complementary pairing of mountain apu and human beings was (and is) apachita, miniature mountains of stone (introduced in chapter 1). As explored in the previous chapter, while they are commonly thought of as piles of stone accumulated over time by travelers making small offerings of pebbles, apachita may have included a whole range of "miniature mountains," including dressed-stone structures used in state-level rites. Regardless of their particular appearance, apachita and other lithic embodiments of mountains were the locus of offerings; as miniature replicas of the mountain lords they embodied, they received gifts for the distant apu. As sites where communication between complements happened, they occupied a critical role in the Inka landscape.

Although the apachita is often thought of as occupying deserted locations — mountain passes, crossroads, isolated flatlands — through which travelers must pass and whose safe passage can be guaranteed by the apu who see all, miniature mountains were also found within the built environment of Inka settlements. As discussed in the previous chapter, mountain apu were actually present in the pre-Hispanic built environment through unworked or roughly worked rocks that embodied distant, sacred mountains. We have also noted that in many Inka sites, boulders or outcrops are left apart from structures, isolated or surrounded by masonry frames; sometimes they are shaped like miniature mountain apu echoing the hilly forms on the distant horizon (plate 4 and figure 29). These small-scale embodiments of mountain apu shared the built environment with the site's human denizens. Flesh and blood shared residence with rock. That rocks embodied mountains, becoming miniature versions of mighty apu, is consistent with the well known Inka practice of using miniatures as a way of possessing and regulating things otherwise outside their control. Offerings made to the miniature vicariously fed the real but remote mountain.

In the Andes there is a strong tradition of making miniatures for use in propitiating numina. Today miniatures are employed in sacrifices associated with the annual Quyllur Rit'i pilgrimage discussed earlier in the chapter. Both Allen and Michael J. Sallnow have discussed the contemporary practice of making miniatures in which pilgrims to Quyllur Rit'i search for stones shaped like livestock (alpacas, llamas, sheep, cows) that they place in miniature corrals.[93] Allen concludes that "these miniatures

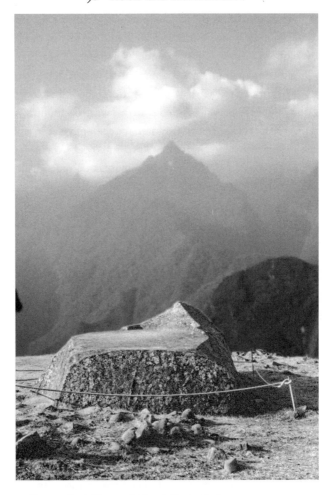

29. Funerary Rock (Ceremonial Rock), Machu Picchu.

are viewed as tiny storehouses of prosperity and well-being. They are carefully tended — 'fed' and even on occasion clothed — and ritually manipulated to bring their keepers the well-being they represent."[94] Similarly, people throughout the southern Andes keep small statues of renowned Catholic images that are referred to as *taytacha* (little fathers) and *mamacha* (little mothers); they are held to be miniature manifestations of their prototypes and are often taken on pilgrimages to "meet" the originals. In these instances, contact with the prototype enhances the preexisting visual resemblance with the powerful connection resulting from a direct encounter.

As noted in chapter 1, Murúa, the Mercedarian friar among whose native informants was Guaman Poma, described a variety of offerings intended for mountain apu.[95] These included small stones, feathers, shells, chewed coca and maize, sandals worn from traveling, fine cloth, camelids, and even children. One of the illustrations accompanying his discussion shows a native priest (labeled *echicero*, wizard) about to sacrifice a child to the apachita (figure 17). Children may not have been a common sacrifice, but they were regularly offered to important waka, including mountain apu, on special occasions. The remains of child sacrifices have been excavated at the bases of outcrops, and several bodies of sacrificed children have been found on the slopes of sacred mountains. The significance of—and even inherent logic in—child sacrifice can be understood within the Andean framework of reciprocal giving in miniature.

THE CHILD SACRIFICE: RECIPROCAL GIVING

"He [the Inka] brought her [the earth] presents,
and asked her for favors for us."

Just as sacred mountains inhabited human communities by means of their embodiment in miniatures, so the Inka sent miniature adults to reside with sacred rocks. They were left permanently on the high, icy peaks of mountain apu, where they became the petrified complements of the lithic residents of Inka communities far below. While miniature petrous embodiments, such as echo stones, symbolize the untamed apu within the Inka's orderly settlement, the Inka sent children to be the miniature representatives of their perfect order on the unordered slopes of high mountain peaks. These children, usually between five and twelve years of age, were specially selected by the Inka state; they were unblemished, pure, and perfect children, both male and female, who were therefore the best of the human community. The ritual that transformed physically flawless children into perfect adults in miniature was called *qhapaq ucha* (*qapaq ucha, capac hucha, capacocha*).[96] The ceremony, held at times of crisis and transformation such as the death of a ruler or during a drought (i.e., times of disorder within Inka society), can be reconstructed on the basis of fragmentary accounts of colonial-period chroniclers.[97] Prepubescent children, selected because of their beauty and purity, were collected as

a form of tribute and taken to the imperial capital of Cuzco, where they were paired off in a "marriage" ceremony. Having thereby been converted into symbolic—albeit miniature—adults, they were sent back to their home provinces. On the pilgrimage home, all whom they passed averted their eyes. Contact with human society was to be avoided, for these flawless miniature adults were not ever to be part of a human community. As perfect exemplars of well-regulated Inka society, they were destined for places beyond order. Whereas their trip to Cuzco was by means of the well-developed (and orderly) Inka road system, their return journey, it is said, maintained a straight line regardless of the rugged terrain. In the words of Cobo, the priests with the child sacrifices for provincial shrines "went straight toward the place where they were going without turning anywhere, going over hills and through ravines until each one reached his land."[98] Thus, before the rite of qhapaq ucha, they followed the Inka order that had been established by means of roads. After the rite, they pursued nature's course, readily encountering—rather than avoiding—topographic disorder.

Once in their homelands, the miniature adults were taken as offerings to important local shrines (waka), where they were dispatched by a variety of means, including strangulation, burial alive, and blows to the head.[99] Accompanying the children-qua-adults were finely crafted objects that the children had been given in Cuzco. These included "gold and silver service, such as plates, bowls, pitchers, jars, and drinking tumblers, along with all the utensils that a married Indian normally has, all of gold and silver," as well as small statues fashioned of precious metals depicting camelids as well as elite men and women.[100] The statues were dressed in fancy miniature textiles with elaborate ornamentation. Colin McEwan and Maarten Van de Guchte conclude that the offerings, as an assemblage, compose a complete—and perfect—human world in miniature. They compare them to the exquisite miniature garden, filled with finely crafted corncobs of gold and silver, created by the Inka in their primary temple (the Qurikancha) in Cuzco, and suggest that both sets of miniatures were means by which the Inka asserted control over the wild unpredictability of nature. The statuary offerings—standardized in form, static and bilaterally symmetrical—"embodied man's attempts to achieve a balance between the volatile forces of nature . . . and the more ordered, codified forms of the cultural world."[101] Just as the children symbolized the ideal adult in miniature, so too did the offerings represent the ideal Andean cul-

tural universe. In effect, the perfect, precise, static offerings represented the ordered Inka realm in distinct contrast to their destination—the wild, disordered mountain peaks outside of human control. The sacrificed children and companion offerings were thus miniature material metonyms of Andean society. In some of the most remarkable of recent discoveries, qhapaq ucha offerings have been found on the icy, lightning-struck peaks of mountain apu in Argentina, Chile, and Peru—places where uncontrolled and uncontrollable nature is demonstrably manifest.[102]

According to McEwan and Van de Guchte, the qhapaq ucha pilgrimage and sacrifice served numerous important imperial functions, including marking the boundaries of Inka territory, strengthening ties between the physical and conceptual center of the empire (that is, Cuzco and the ruler) and its periphery, linking human affairs (especially the activities of rulers) to a sacred and animate topography, and binding local villages into the Inka's network of waka.[103] Qhapaq ucha also identified and re-sanctified powerful nodes in imperial territory and bound them to the settled and ordered human world so proudly constructed as part of the Inka's imperial project. Additionally, I would add, the qhapaq ucha sacrifices engaged apu—sources of water and other important resources—in necessary, reciprocal relationships, in ayni, with the Inka (just as Quyllur Rit'i with its miniature offerings does today). As in the story related at the outset, the Inka initiated reciprocity by giving gifts in return for which they expected gifts. Through the rite of qhapaq ucha, the Inka gave human-made gifts to mountains: food and clothing and ultimately children. In return mountains gave natural gifts of rain and water from glacial runoff. Although the state-level rite of qhapaq ucha is no longer practiced, indigenes throughout the Andes today make what is called "the payment" (el pago) consisting of small gifts (despachos) to propitiate sacred mountains for their help and guardianship and to ensure the mountains are not angered.[104]

CONCLUDING OBSERVATIONS

"The Inka . . . ran far, far away."

Today in parts of the Andes, special individuals, called *qhaqha*, who have survived lightning strikes are thought to have the ability to communicate with sacred waka.[105] Lightning, deified by the Inka, who called it Illapa,

is the powerful touch of nature indicating selection. The individual who survives the selection process is recognized as having the potential to become a ritual specialist (*paqo*). The qhaqha, part of the human community, but also part of nature (having been touched by lightning), is himself the site of conjoining. Whether coincidence or not, the term *qhaqha* is a near homonym of *qaqa*, the name for special or unusual rocks that are themselves often perceived to be both numinous and normal (as discussed in chapter 1). One animate, one inert (at least temporarily), both are conduits of communication. Whereas in the present day it takes a ritual specialist to talk to qaqa, many indigenous Andeans today believe that in the pre-Hispanic past the Inka more generally had this ability. While the Inka are no longer speaking—having run "far, far away" (*karu karuta*), as the story tells it—the sites at which communication happened are still available for examination.

In this chapter, I have used a contemporary Quechua story to gain insights into aspects of pre-Hispanic Inka visuality—in particular, Inka ways of looking at and interacting with the earth. If we accept for the moment the basic tenets set forth in the story—that the earth and all its parts and aspects are animate and must be negotiated with if proper relations are to be established—we can perhaps see the Inka's treatment of the earth, particularly their use of rock, with new eyes. We can see that the Inka built environment—in its conception and in its ruins—harbors traces of negotiations with nature. I have highlighted some of the ways the Inka related to an animate earth and how their beliefs left visible markers on the land they inhabited. Terrace walls, "nibbled" masonry, integrated outcrops, passages through rock, mountain-framing windows and portals, viewing platforms, and apachita and other lithic embodiments of mountain apu may all be visible remnants of the pre-Hispanic dialogue between Inka and earth. Although the pre-Hispanic Inka are absent, the colloquy they once had with the earth has not been forgotten, for it echoes both in modern Quechua stories told by the living descendants of the Inka and in the petrous monuments the Inka themselves left behind.

To organize a space is to repeat the paradigmatic work of the gods.

—MIRCEA ELIADE, *The Sacred and the Profane*

·(⇄)·

CHAPTER 3

Rock and Rule

The previous chapter explored some of the ways the Inka articulated a re-
ciprocal relationship with the earth. This relationship not only concerned
the Inka but mattered to all Andeans who encountered the Inka, for Inka
state ideology—including the relationship they built with the earth and
its stony extrusions—was expansionist. It supported, justified, and en-
couraged the extension of their empire, which, by the early sixteenth
century, had grown to be the largest in the history of the pre-Hispanic
Americas. Indeed, the Inka's culture of stone was fully mobilized in sup-
port of the agenda of the aggressively expanding state. In forging an em-
pire, the Inka imposed their idea of order on the Andes and on other
Andeans. In this chapter, I consider the strategic political consequences
of the Inka's proclaimed relationship with Andean topography, including
the impact of the Inka's sense of order on other Andean peoples, many of
whom, although not considering themselves "out of order," were made
orderly from an Inka perspective. I also examine some of the petrous ar-
ticulations of Inka control and look at some strategies involving the ma-
nipulation of stone by which the Inka asserted and maintained owner-
ship over their territories. Although often developed from preexisting
Andean beliefs and practices, the Inka's culture of stone was most fully
realized when marshaled in support of their imperial objectives.

The Inka empire was called Tawantinsuyu, which is often translated
"Land of Four Quarters" or "Quartered Land," but more accurately ren-
dered "Four Parts Together."[1] The Inka located Cuzco at the hub of a
potentially limitless territory composed of four sections or *suyu* (*suyo*,
suio) that were arranged in pairs.[2] Within Cuzco, two of the four suyu
were paired as "upper" Cuzco; they were complemented by the pair that
"lower" Cuzco comprised. Tawantinsuyu thus consisted of a center and
an ever-expanding periphery that fit into these bipartite and quadripartite
schemes. Inka rulers, by measuring and ordering the space of Tawantin-
suyu, put everyone in their place.[3] The ninth ruler (Pachakuti), in particu-
lar, was credited with initiating expansion, redesigning Cuzco, and erect-
ing saywa, the sacred markers of distinct territories that were described
in chapter 1. In the early seventeenth century, Guaman Poma drew the
Andes, which he labeled *Mapa mundi del reino de las Indias* (World Map
of the Kingdom of the Indies); his map shows the way Tawantinsuyu
stretched to the edges of habitable land itself (figure 30). He situates
Cuzco at the core, with the four suyu (identified as Anti Svio, Conde
Svio, Colla Svio, and Chinchai Svio) placed to the north, south, east, and
west, respectively.[4] The actual suyu to which the four major roads out of
Cuzco traveled extended more to the northeast, southwest, southeast,
and northwest. The northeast and northwest quarters were born in upper
(*hanan*) Cuzco, and the southeast and southwest quarters emerged from
lower (*urin*) Cuzco.[5]

According to oral histories, the idea of Inka ordering began with the
founder Manku Qhapaq and his sister-wife, called by most Mama Uqllu
(Ocllo), who began organizing newly acquired lands in the valley of
Cuzco by dividing territory into complementary halves, called hanan
(upper) and urin (lower). The hanan-urin spatial division of Cuzco re-
flects a moiety system that is widespread throughout the Andes, clearly
predates the Inka, and still exists today. The royal lineage was also di-
vided along hanan-urin lines with the first four or five Inka rulers asso-
ciated with lower Cuzco, and the latter ones belonging to upper Cuzco.[6]
As the Inka expanded Tawantinsuyu, they identified hanan and urin sec-
tors of communities (if they did not already exist). Each new territory
was also identified with its quarter of the empire. While there may have
been some general environmental uniformity within each suyu, chroni-
clers describe the diverse peoples and cultural practices of each quarter
as though each suyu had distinctive unifying characteristics; the quar-

ters were thus naturalized—implying that Inka order reflected the natu-
ral pattern of things.[7] Yet Tawantinsuyu is an Inka construct that, in its
very creation, involved reordering the Andes.

The notion of place is a politicized social and cultural construct; places
are created when particular spaces are endowed with value and signifi-
cance.[8] Places are made and remade through memories and acts of re-
membering, as well as through alteration, destruction, and construction.
While memory is often spoken about as a matter of time, it is also about
space and the events that make certain places and things special.[9] The
notion that memory concerns both time and space is particularly rele-
vant in the Andes, where *pacha*, the word for earth or land, is also the
word for time.[10] Tawantinsuyu as a conceptual metaplace was produced
not just through the conquest and physical control of land but through
the social processes of remembering events that had happened in particu-
lar locations. As I observed in the previous chapter, the Inka employed
various ways of working with and marking immobile rocks to visualize
their particular sense of place and cause certain locations to be remem-
bered in specific ways. The Inka state's tactic of inextricably linking its
distinct built environment with the natural environment made clear and
permanent visual statements about belonging and consequently about
the ownership of territory.[11] This chapter explores how the Inka's particu-
lar culture of stone transformed Andean land into Inka territory. Because
the Inka were empire builders, the claims to place made through their
rockwork often disputed the rival claims of other Andeans.

First I consider visual practices associated with place making, that is,
the means through which land, whether unclaimed or belonging to rival
groups, was converted into Inka territory. The distinctive style of Inka
architecture, for example, can be seen as an articulation of their civi-
lizing presence in newly inhabited lands, as can the indices of labor in
stone. Protuberances and divots left on building blocks, as well as peck
marks that trace the method of facture, testify to the Inka's abilities to
organize and command large labor forces made up of subjected popu-
lations. The Inka also exercised ownership by taking possession of the
land's sacred parts, the petrous waka of subject populations. While those
subaltern waka that could be moved were often taken to Cuzco, those
that were immobile were possessed through reverential practices and
"guardianship," as well as what I am calling Inka marking. Marking refers
to the application of one or more of the indicia—framing, distancing,

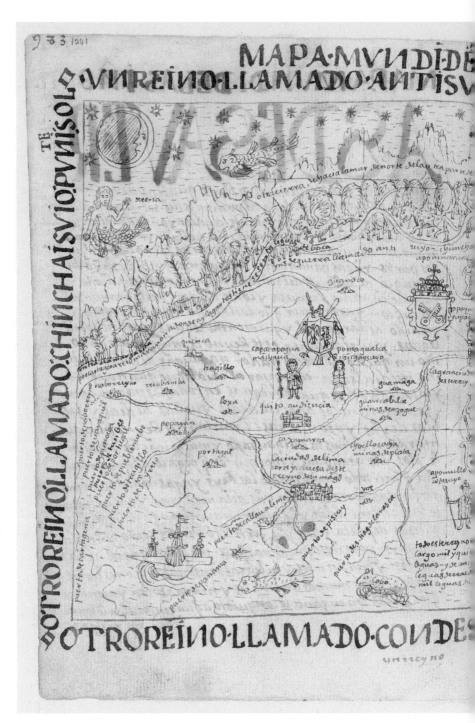

30. *Mapa mundi del reino de las Indias* (World Map of the Kingdom of the Indies).
Felipe Guaman Poma de Ayala, *El Primer Nueva Corónica*, fol. 983–84 [1001–2], ca. 1615.
Photograph provided by the Royal Library, Copenhagen, Denmark.

REINO DELAS INS
O HACIA EL DERECHO DELAR DE NORTE
MAR

OTRO REINO LLAMADO COLLASVIO SALES

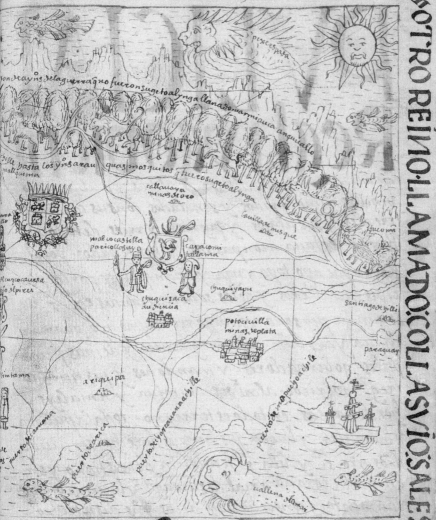

pixcespexa

con oray no delaguerra no fueron sugeto alynga llana domar y puca anguiallo

bile hasta los ynsarau quas mosquitos fueron sugeto alynga

calluaya minas de oro

canillere mesque

jucoma

mal io castilla pariollosuy

carapatomi pitalama

chuquiyapu

Marcacanesa fospiles

chuquisaca audiencia

potociuilla minas deplata

santiago de pitli

paraguay

a riquipa

puerto x y pucaumaachile

puertos mapuchoa chile

uallena llama

VIO HACIA LA MAR DE SVR LLAU oci

contouring, and carving—discussed in chapter 1 as a means of designating special rocks. Such marking practices inscribed sacred stones, integrating them into a specifically Inka landscape. Fresh memories were created so that these already remembered rocks would be thought of—and therefore re-remembered—in new, Inka ways.

After examining these place-making and place-taking practices, I consider what might best be called "place-holding practices," a phrase that refers to Inka efforts to sustain and bolster their claims to particular territories. As noted earlier, oral histories about certain rocks caused these rocks to be (re)remembered in ways that drew attention to the ordering power of Tawantinsuyu. I consider some particular stories that underscored what we might term the Inkanicity of certain places. The Inka also affirmed control of acquired territory through specific sighting practices, one of which involved the use of elevated petrous seats. By sitting on stone and exercising oversight, rulers and other authorities were characterized as wank'a, the owners of the viewed territories.

MAKING PLACES

In the previous chapter I argued that for the pre-Hispanic Inka, permanent architecture defined civilization itself. Not just edifices but the architectonic forms—steps, niches, and planar surfaces—carved into outcrops conveyed the ordered and ordering presence of the Inka. The conversion of a natural environment to a visually distinct built environment was a visible sign of the organizing presence of the Inka state. The last of the pre-Hispanic Inka rulers, Wayna Qhapaq, in particular, re-ordered the natural environment as a way of signaling his possession of and control over it.[12] In the Urubamba (or Vilcanota) Valley, he established his estate of Quispiwanka (Quispeguanca) on unclaimed and uncultivated land. Nature at Quispiwanka was made orderly, as Niles has so clearly demonstrated in her book *The Shape of Inca History*.[13] It was brought under control by the creation of an artificial yet seemingly "natural" landscape with planted trees and managed waterways. At its heart was a white boulder, probably the eponymic *quispiwank'a*, *wank'a* referring to the petrified original owner of the land, and *quispi* referring to precious stone.[14] Like a chakrayuq (the lithified "owner" of a field discussed in chapter 1), the quispiwank'a stood as the symbol of the natu-

ral environment still present, a petrified palimpsest, in the middle of the estate.

The Inka did not construct most of their empire out of unclaimed and uninhabited land, however. Marking rock outcrops enabled the Inka to claim already possessed land by visually inscribing its new identity. Large rock outcrops, marked in the Inka manner, can be found in the borderlands where Inka order abutted disorderly lands and people who resisted integration into Tawantinsuyu.[15] Examples of borderland outcrops include Samaipata in Bolivia's Piray Valley (Santa Cruz province), which looks toward the disordered selva and its Anti/Chunchu inhabitants, and Coyuctor, strategically located among rebellious groups in Ecuador. They are also found at sites venerated by pre-Inka populations where the carved rocks claimed sacred locales for the Inka. The set of carved outcrops at Intinkala in Copacabana near the Island of the Sun, a pre-Inka pilgrimage destination, distinctly marks Inka presence in the area (figure 31). Along with marked outcrops, the Inka's characteristic architectural style also stood in contradistinction to the already built environments of people whom the Inka compelled to their order.[16] Graziano Gasparini and Luise Margolies coined the phrase "architecture of power" to describe the way the visually unique and uniform style of quadrilateral structures (rectangular wherever possible) with pitched roofs, wall batter, and trapezoidal windows, doorways, and niches (figure 32) declared Inka presence wherever buildings in this style stood.[17] While these aspects of Inka architecture surely responded to the frequency of earthquakes in the Andean area, they also conveyed a sense of the Inka's solidity, their permanent, unyielding presence in the lands they occupied. Whatever the function of a specific building, whether administrative, military, or religious, they featured the same look, a repetition of form and arrangement modeled, at least symbolically, after the built environment of Cuzco.[18]

Rosaleen Howard-Malverde, based on linguistic understandings of the past in Quechua, concludes that buildings, as well as topographic features, are frequently used as mnemonic devices for remembering the past and are understood to validate certain histories.[19] They could certainly have functioned similarly in Inka times. Site planning was remembered as an admired attribute of several rulers. The ruler Pachakuti Inka Yupanki, Pachakuti for short, undertook the renovation of Cuzco after his triumph over the invading Chanka (Chanca), the event that, according to stories, made him the ninth Inka emperor.[20] He also founded estates

(above) 31. Outcrop carved with flat places or seats, Intinkala (Copacabana, Bolivia).

32. Trapezoidal niche, Ollantaytambo.

at Pisaq, Ollantaytambo, and Machu Picchu, each time following a suc-
cessful military campaign.²¹ Thupa Inka Yupanki, the tenth ruler accord-
ing to traditional lists, initiated the construction of Tomebamba in Ecua-
dor at the northern reaches of Inka territory after successfully invading
the area.²² Wayna Qhapaq, the eleventh ruler, continued the building at
Tomebamba in the name of his mother and father.²³ There, edifices in dis-
tinctive Inka style reminded the newly and unhappily subjected Cañari
(Kañari) of the Inka presence in and control over their homelands. Inka
construction thus stood as a permanent trace of the Inka and as a re-
minder of their ownership of acquired territories. Moreover, since it is
possible that particular styles of Inka building were associated with indi-
vidual rulers, architecture not only indexed the Inka generally but per-
haps recalled the specific ruler under whose authority the Inka entered
into and claimed particular territories.²⁴ Royal estates, in particular, may
have borne the stamp of a particular ruler (and his descendants). Niles
demonstrates that the rulers' estates, built by conscripted labor, were par-
ticular emblems of the conquests conducted under their command.²⁵

 The integration or incorporation of outcrops—tiqsirumi—into Inka
walls was described in chapter 2 as a symbol of reciprocity, even mar-
riage, between Inka culture and Mother Earth. They are particularly fea-
tured in buildings outside the capital city of Cuzco.²⁶ One function of
integration was surely to naturalize Inka architecture, to make it an in-
extricable part of acquired territories. That Inka architecture is natural-
ized through its integration with local topography serves to naturalize
the Inka presence in specific locations. However, because Inka architec-
ture is so readily recognizably Inka, the integrated outcrop is itself de-
localized even as Inka presence in (once) non-Inka lands is naturalized. In
other words, Inka structures, given their relatively uniform style, when
intertwined with necessarily localized outcrops by means of integration,
served to delocalize conquered territories, making them akin to other re-
gions of Tawantinsuyu. Thus the integration of outcrops, which refash-
ioned "place," claimed territory by denying local, contrary claims. The
integration of native rock into an Inka settlement can be understood in
part as politicized statements about belonging, and consequently owner-
ship.

 Niles, who has authored several indispensable studies of Inka archi-
tecture, specifically associates the integration of outcrops with the ninth
ruler, Pachakuti.²⁷ While the historicity of Pachakuti's reign and the ve-

racity of accounts that attribute nearly all major Inka accomplishments to him are doubtful, we can surmise that those sites credited to him are, at the least, relatively early in the history of imperial expansion. Niles points out that Machu Picchu, Pisaq, Tambomachay, and other locations associated with Pachakuti feature more integration of outcrops than do structures associated with later rulers.[28] She particularly contrasts Pachakuti's architecture with that of Wayna Qhapaq, the eleventh ruler, who died just before the Spaniards entered Tawantinsuyu. As an example, Niles describes Wayna Qhapaq's estate in the Urubamba Valley that, as noted earlier, created its own "natural" topography to a considerable degree. Be that as it may, several sites just finished or still under construction at the time of the Spanish arrival in the Andes, such as Saqsaywaman (just outside Cuzco), and Ingapirca and Tomebamba (both in Ecuador), also feature integration prominently.[29] How might we account for these circumstances?

As I have argued elsewhere, if the integrated outcrop is indeed the symbol of conjuncture between Inka order and disorder (whether of nature or subjected peoples), then nowhere is it so important as in places where the Inka desired to make powerful statements about belonging and staying put. In the early decades of Inka expansion (the era associated with the ruler Pachakuti), the integration of outcrops would have been important as statements of ownership of any newly incorporated lands. Later, visible statements about the naturalized relationship between earth and Inka would still have been important in areas, such as the northern reaches of the empire, where Inka presence was still relatively new and so somewhat precarious. The same reasoning might well apply to Saqsaywaman, a complex of structures that particularly spoke to the strength of the Inka military.[30] Similar statements about belonging to a particular place would not have been so critical on Wayna Qhapaq's estate, located as it was on undesirable swampland in an area unlikely at that time to be challenged.

PLACE MAKING THROUGH PROCESS

In the previous chapter, I introduced the phrase "nibbled masonry" as a way of acknowledging Inka thinking about dressed-stone masonry (the Quechua verb *kaninqakuchini*, meaning to construct a fine wall, is de-

rived from the verb *kanini*, meaning to nibble). Nibbling refers to the
persistent pecking away at stone blocks with hammer-stones to achieve
the much-admired tight joins featured in dressed-stone Inka walls. Inka
structures were about more than the final product—the strong and stable
structures, secured by outcrop foundations, interwoven with the land,
and resistant to any onslaught—they also, in their often unadorned sur-
faces, testified to the process of construction, a process that involved
the highest levels of Inka administrative acumen. Part of the symbol-
ism of dressed-stone masonry, of what I identified in the previous chap-
ter as a nibbled wall, was the evidence of the labor required to work the
stones and erect structures. With regard to Andean textiles and metal-
work, Heather Lechtman emphasizes the importance of the production
history as recorded in the details of an object's structure; she avers that
meaning inhered in process, as well as product.[31] The same emphasis on
process is true for Inka nibbled masonry.[32] Each finishing stroke of the
hammer-stone in the shaping of the block leaves telltale bite marks that
give the wall texture no matter how finely worked.[33] Even the very few
examples of bas-relief decoration, such as the serpents and pumas that are
occasionally found on isolated ashlars, do little to distract from the finely
nibbled stones that make up the wall (figure 33). By indexing facture, the
Inka underscored the means by which places were ordered and converted
successfully into Inka places.[34]

The Inka identified masons in general as *pircacamayoc* (*pirqakamayuq*),
"wall makers." [35] Given the varying qualities of Inka masonry, these wall
makers must have differed in rank and status. Cobo indicates that stone-
masons, surely those who made nibbled walls, were one of only three or
four types of craft specialists who worked exclusively for the Inka state.[36]
Walls of nibbled stone thus signaled the presence of the state. Moreover,
finely fitted stone articulated the privileged position of the Inka with re-
gard to their sacred and animate landscape—after all, not all peoples
could manipulate rock (or have it manipulated) as did the Inka. The
method of pecking away at a stone block with a stone hammer to form
the tightly fitting blocks of mortarless Inka state construction speaks to
persistence, another aspect of the state's personality expressed in stone.[37]
Inka masons frequently drew attention to the fine seams by pillowing the
surface of the blocks and countersinking the joins. The pillowing effect
comes from the technique used to draft edges; pounding also produces
rounded edges and corners.[38] Thus the precision of the joint was often

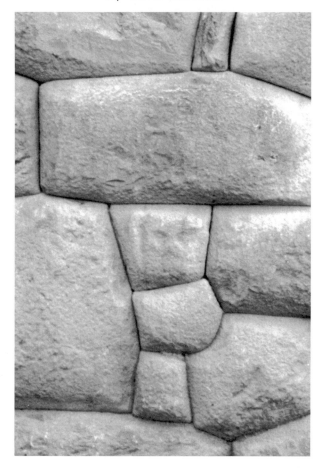

33. Carved zoomorph, Vilcashuaman.

the primary articulation of the surfaces of their walls.[39] It should be noted
that in nibbled masonry, each block of stone is worked to fit precisely in
one space within the larger pattern of the wall. While the mostly regu-
lar parallelepiped ashlars sometimes appear to be sized and shaped alike,
each is, in fact, distinct and worked to fit precisely where it is set. Al-
though such ashlars may have required somewhat less nibbling on-site
compared to polygonal blocks, all types of fine masonry required pre-
cise fitting. To the Inka, then, finely worked stone (whatever its shape)
seems to have been thought of as nibbled stone; the difference between
straight courses and polygonal patterning may not have been so acute as

it strikes us today. Niles distinguishes three basic styles of Inka masonry based on the quality of fit.[40] The finest she calls high-prestige masonry, while fieldstone masonry describes unworked or barely worked stacked stone; in between is intermediate masonry. The notion of nibbling draws attention to the fine joins that are features of high-prestige masonry. It also emphasizes the process of fitting stones rather than the differences that are emphasized when we focus on categories and types visually apparent in the final product.[41] The traces of labor visible on the surfaces of a finely nibbled, high-prestige wall thus constitute its meaning and convey its value within the Inka system (figure 34). The smaller the bite of the hammer-stone, the more time was spent refining the surface of the block. "Bites" thus memorialize the labor and testify to time invested in the block. While all nibbled stone walls were prestigious, there is, in fact, distinct variation among them, from roughly nibbled to nearly smooth.

Rowe observes that whether the faces of stone blocks were rectangular or polygonal, both referred back to the humble built environment of Andean peasantry.[42] Rectangular-faced blocks are akin to square-cut blocks of sod, while polygonal masonry is a refinement of rustic fieldstone construction. Thus fine state masonry gained meaning through comparison to architectural techniques used by Andean commoners. The labor of nibbling would have been visibly apparent to all who saw it, regardless of its coursing or not. Here it is important to note that some finely nibbled, high-prestige masonry was apparently covered over with paint or plaster.[43] In some cases the layer of paint may not have been thick enough to mask the peck marks, yet even in cases where the labor process was not visible, it was certainly "remembered," and therefore its visibility may not have necessarily been paramount.[44]

In the previous chapter, I suggested that the nibbled wall might be seen as a metaphor for the Inka social order, in which each individual fit, but not all fits were equal. If natural stone was an element of unordered nature, an unworked stone in a wall of stacked fieldstones (called *pirqa* masonry) suggests minimal ordering. A well-nibbled stone, with its miniscule peck marks embedded in a tightly fitted wall, represents a stone that has been brought into order through a time-consuming process. A stone in a nibbled wall is hyper-orderly; its fit is unique, and it is inimitable. It was also clearly prized — and remembered — for these qualities. I could draw many parallels between the nibbled walls and the Inka's social

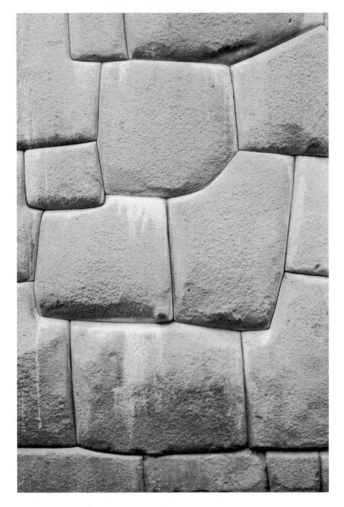

34. Pecked wall of nibbled stone, Compound of Inka Roqa
(Archbishop's Palace), Cuzco.

order. Suffice it to say that the finest integration and fit were represented
by the Inka and the Inka by privilege (those few groups whom the Inka
recognized as sharing their sense of order). Other groups who worked
to better their fit saw their value to the state increase and their prestige
rise accordingly. The message of a wall of well-nibbled stones was that
ordering processes leave traces that are visible on the individual parts as
well as in the whole. Within the Inka's scopic regime, a shaped stone was
a sign of the state's civilizing presence.[45] Individuals were, in some sense,

like ashlars, some more thoroughly nibbled then others, but each bearing some trace of the fitting process.

Protuberances or bosses, and sometimes divots, found on the lower edges of the out-facing surfaces of some stone blocks, are an intriguing aspect of some Inka stonework that emphasizes process (plate 13). Often in pairs and on larger stones, or even smaller stones placed high on a wall, protuberances are thought to be vestiges of the construction process, supports for levers, or shelves to lift and hold rocks as they were being worked for placement.[46] They are not found on quarried blocks or on blocks still in the process of transport. Because they appear on blocks at construction sites, we can conclude that they were probably used to handle blocks as they were worked on-site for placement and good fit.[47] Beyond practical functions, bosses have been interpreted in various ways. Gasparini and Margolies assume that they must have served some aesthetic function, as it would have been easy to remove the distinctive nodules if the Inka had so desired, and, indeed, some have been removed, although when they were removed and by whom is difficult to determine.[48] Paternosto also prefers an aesthetic interpretation, insisting that it "would have been unacceptable for the soiled traces of labor to be left on those constructions."[49] However, given Inka thinking about the symbolism of stone, and the ways they prioritized process over end product, it seems quite likely that protuberances were left precisely because they were the visual vestiges of the labor that went into the final shaping and placement of stones in walls. The state's ability to manipulate stone blocks was significant, especially given the potential animacy of rock. What better reminder of what had transpired, of the arduous process of building the wall, than the necessary nodules? Rather than being "soiled traces of labor," they were the very celebration of it. They are not only the evidence of stone that has been nibbled away and a nod to the original girth of the stone; they are witnesses to the making of the wall.

Protuberances are an index of the labor process, of the effort invested in construction and of the absent laborers themselves.[50] Yet protuberances are not featured on every nibbled stone wall. They are particularly prominent in Cuzco and its environs, but not seen extensively at more far-flung sites, such as Huanuco Pampa, Vilcashuaman, or Ingapirca.[51] Cuzco, like other Inka settlements, was built by laborers subject to the Inka's labor tribute system, known as *mit'a*. Skilled Lupaqa stoneworkers from Qollasuyu, for example, were likely mit'a laborers in Cuzco.[52] Pro-

tuberances may well testify to the presence of tributary labor, recalling
that Cuzco was the center to which all came. Indices of labor, and the im-
plicit power required to mobilize it, would also have resonated on royal
estates, the personal property of Inka rulers and, as noted earlier, remind-
ers of their conquests. In contrast to sites near Cuzco, the administrative
settlements, *tampu*, which were located throughout Tawantinsuyu, often
did not have large permanent populations.[53] The Inka state may well have
felt little need to highlight the presence of mit'a labor for the mostly tran-
sient populations of tampu. At Ingapirca and other far-flung outposts,
protuberances — visible reminders of the efforts of the local labor force
to move and hoist blocks into place — would also have been counterpro-
ductive to the state's message.

A well-nibbled wall is unique both in its parts and in its whole (e.g.,
compare figures 19, 21, 22, 34, 35, and plate 13). Despite its obvious mer-
its, however, many observers have found Inka masonry "uniform" and,
as a consequence, somehow lacking or even slightly disturbing. Gaspa-
rini and Margolies, for example, find nibbled Inka walls "fanatically per-
fect," which is at best a backhanded compliment.[54] The archaeologist
Donald E. Thompson concludes that Inka architecture "tends to be stark,
unadorned, repetitious and hence somewhat boring after long exposure
to it."[55] The lack of decoration or adornment similarly seems to bother
many modern viewers. That a people so skilled in stonemasonry did not
use their talents to produce a well-decorated wall runs counter to West-
ern notions that decoration for aesthetic purposes is a mark of art in the
West.[56] We look for some aspect that goes beyond function and, to our
disappointment, find that the Inka wall *appears* mostly utilitarian with
little superfluity. Gasparini and Margolies observe that the Inka "wasted"
no time on moldings, cornices, pilasters, or ornamentation of any kind
(with a few exceptions), but the authors offer no particular rationale other
than to observe that "practical solutions probably received more atten-
tion than formal problems."[57] Yet in the walls of Saqsaywaman we find
two large parallelepipeds carved with lines simulating smaller ashlars.
The carving maintains the illusion of diminishing size, a sense of tran-
sition from the large blocks near the base to the smaller ones higher on
the wall (figure 36).[58] Inka masons clearly thought about the aesthetics
of this "unadorned" wall. While these large stones may have been prac-
tical and even time-saving, aesthetics here dictated that they be carved
to resemble the smaller blocks that were more appropriate to the course

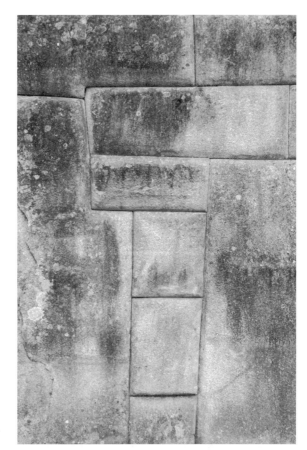

35. Masonry at Machu Picchu.

36. Incised ashlar, Saqsaywaman.

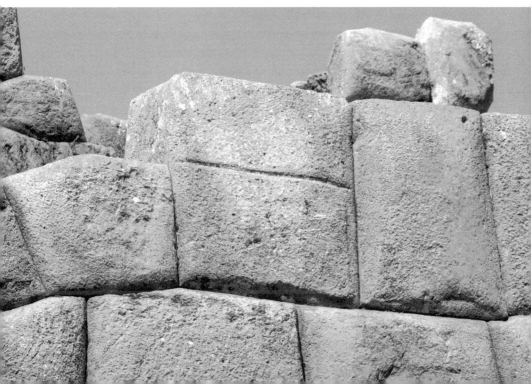

where they were placed. Perhaps the problem is not that the Inka lacked aesthetic concerns but that those concerns differed from those of modern viewers.

Often the Inka are described as a "practical people," great administrators and engineers. Recently, Juan Carlos Machicado Figueroa, an author and tour guide, observed that "scholars feel obsessed by the idea of resolving the question of how the Inkas managed to construct their buildings, and have forgotten to understand why, and what thinking was behind these constructions."[59] Indeed, Inka stonework has historically been praised for the quality of craftsmanship, rather than the ideas it might represent. Paternosto even suggests that the Inka used megaliths because "construction with large blocks offered the most efficient solution to the presumed urgency of completing the buildings."[60] He thus reasons that megaliths provided a practical solution to hurried Inka builders. From the arrival of the Spaniards to the present, admiration for Inka masonry derives from engineering feats of moving and constructing. The persistent focus on feats of transportation and manufacture has often distracted from any understanding of the symbolic impact of the nibbled wall.[61] Here I want to emphasize that labor processes appear to have been precisely the point. If we keep in mind that process in Inka culture was valued more than end product, then we see how both protuberances and peck marks render the facturing process visible and present on the surface of the stone. Rather than being unadorned and plain, nibbled stones are marked with symbolically significant strokes of hammer-stones. Both the evidence of nibbling (peck marks) and the evidence of placement (protuberances) are signs of the process of building a well-dressed, high-prestige stone wall. Both kinds of marks are evidential, bearing witness to the working of the stone. They cause the labor to be remembered and record the experience of the stone as it was transformed from the randomness of nature to the order of Inka civilization. Thus a well-worked and well-placed rock is necessarily, to some extent, a remembered rock. Its pecked and divoted or noduled surfaces bear witness to the actions taken to tame it. They are the traces of toil, of the laborious processes through which a potentially animate substance was not just turned toward Inka purposes but fully integrated into Inka order.

Since stone was a potentially numinous material, the very working of it was significant. And since the working of stone was significant, the signs of labor were significant. Hemming and Ranney, who observe that

"Inca masonry sometimes seems to adopt the most complex solutions and difficult methods," suggest that working a stone "could well have been a product of patriotic or pious devotion, a desire to build in the finest conceivable techniques for the most holy purposes."[62] The marks of facture are not byproducts of the process. Rather, they purposefully draw attention to the systematic series of actions that constitute the evidentiary value of the nibbled wall. Nibbled masonry was clearly admired by the peoples dominated by the Inka, and this seems to have been one of Inka rockwork's primary purposes.[63] Cieza, an observant Spanish soldier who traveled extensively in the former Tawantinsuyu, for example, tells us about a group of Inka buildings known as Las Piedras (The Rocks) located in Palta territory south of Tomebamba, Ecuador; he writes that the site was composed of "many and fine-quality stones" (*muchas y muy primas* [*piedras*]) and that those structures were there because "the Lord-Incas in the days of their rule had sent [the dressed stones] to their stewards or representatives, for as this province of the Paltas was considered important, these lodgings were built fine and spacious, and the stone of which they were built was very skillfully cut and joined."[64] Because the Palta region was important to the Inka, it was important to impress the people there. And one of the things that impressed them was the quality of stonework, work that emphasized the arduous and careful process of construction.

PLACE-TAKING PRACTICES

The Inka were not the only group in the Andes to build relationships with sacred rocks. The practice of venerating certain rocks predates the Inka by millennia and spans the entire area incorporated into Tawantinsuyu. In general, the Inka respected the rocks held holy by groups they subjected. After conquering an area, the Inka inquired about local waka; they not only insisted that indigenous waka would continue to be honored but often themselves offered gold and silver figurines as well as sumptuous textiles to the newly encountered numina.[65] Such seizure of sacred places — place taking — was an important aspect of Inka place making. The Quechua-language Huarochirí manuscript (ca. 1608) tells how an Inka ruler commanded thirty people from two local communities in central Peru to serve the sacred, snowcapped Paria Caca.[66] This

was, of course, something the locals had been doing anyway, since Paria Caca was the most powerful waka in the region. Perhaps the Inka regularized or increased the service to the mountain apu, but essentially, by taking over the system of worship, they took possession of the waka. Johan Reinhard, who has investigated numerous Inka sites on the high slopes of sacred mountains, concludes that the Inka, by locating ritual sites on the summits of high mountains that were only worshiped from afar by local communities, gained greater political and religious control over the people and the land they conquered.[67]

The Huarochirí account relates how the Inka took a child of Paria Caca, a waka called Maca Uisa, with them to help them in warfare.[68] Likely Maca Uisa was a boulder—considered to be both the son of, and synecdoche for, the mighty apu—that was at least small enough to be portable. This action is consistent with the Inka's practice of seizing the waka of conquered populations.[69] Polo tells us that the ruler Pachakuti was said to have kept with him, even in death, the "principal idol of the province of Andahuaylas, because he conquered it" (*el ydolo prinçipal de la provincia de Andavaylas, porque la conquistó este*).[70] Seized waka were sometimes held in Cuzco as "honored hostages"; if a region rebelled, the Inka ordered its waka displayed in public and "whipped ignominiously every day until such province was made to serve the Incas again."[71] The ambassadorial waka was punished in lieu of those it represented.

Many provincial rock shrines, however, were immobile—being outcrops or megalithic. At such places, the Inka sent offerings of their own as well as servants to care for and maintain the newly acquired subaltern shrines. Through the rite of qhapaq ucha, discussed in the previous chapter, regional shrines of supreme importance were integrated into Tawantinsuyu's waka network. Thus, through their regard for regional waka, the Inka repeatedly centered Cuzco in an expanding landscape of sacred places. Inka propitiation, as well as the establishment of permanent caretakers (such as the *aklla*, chosen women who maintained shrines and prepared *aqha*, the fermented maize drink used in offerings), also signaled Inka guardianship, which is to say possession. For the Inka, to revere something was also to entangle it in a web of Inka practices. In fact, the Inka assigned vassals to serve some regional waka; these individuals, Albornoz tells us, were to "maintain peace in the province" (*sustentase a quietud la tal provincia*).[72] The institution of Inka guardianship, together with acts of reverence and propitiation, were all place-taking strategies

that, along with military conquest and occupation, resulted in and bolstered Inka control.

The conversion of regional petrous numina into sacred Inka rocks was often accomplished not just by establishing Inka governance and introducing Inka reverential practices but also by marking those rocks as Inka. The visual strategies identified in chapter 1 as ways of distinguishing sacred rocks — framing, distancing, contouring, and carving — were deployed to reidentify rocks and make them memorable in new ways. At Samaipata, for example, the outcrop profusely carved with signs of Inka presence (steps, niches, shelves, zigzagging channels, and even a puma) was apparently revered before the arrival of the Inka.[73] Inka carving at Samaipata specifically marked Inka possession of this outcrop. At the opposite end of Tawantinsuyu, the citadel of Ingapirca in Cañari territory (central Ecuador) integrates regional waka and claims outcrops at the site by isolating, framing, and carving. A third example can be found at Apucara, a provincial capital located in Andamarca Lucanas along the royal highway (Qhapaq ñan) connecting the highlands with the coast. Apucara features a single structure of Inka-style architecture. It is located adjacent to an unworked boulder measuring upward of sixteen feet in height. Katharina J. Schreiber concludes that the stone, called Hatun Rumi, is likely a waka and that the structure right next to it, the only Inka building at the site, is likely a shrine, a royal retreat, or the residence of an Inka official or a combination of these things.[74] Given Inka practices at Ingapirca and elsewhere, Hatun Rumi was surely once a local waka that the Inka incorporated into Tawantinsuyu, "guarded," and marked as their own.

While all waka were politically charged places, locations of particular remembrances, the Inka seem to have had a special interest in two kinds: *wank'a* and *paqarisqa* (also called *paqarina*). The rock at Apucara may well be either (or both) of these things. Wank'a were lithified owners of particular places (see chapter 1). For the Inka, taking custody of the petrous owner was the supreme symbolic act of possession. Paqarisqa were the locations of emergence from which the ancestors of the inhabitants of particular places were believed to have entered this world at the time of creation. Albornoz, a priest who worked in Cuzco in the late sixteenth century, identified paqarisqa as "the principal type of waka that those who existed before being subject to the Inka had."[75] As such, paqarisqa were important for the Inka to recognize and control. However,

they were often immobile, consisting of springs, caves, lakes, valleys, nooks in rocks, trees, and hills. They were therefore locations of contact, in spatial terms, between this world and the under- or innerworld, and locations of contact in temporal terms between those living in the present and the ancestors.[76] Albornoz tells us that the Inka remodeled or built structures near them and enriched them by donating camelids (for sacrificing) and cups of gold and silver (for offerings of aqha); they also sometimes left vassals to serve the waka.[77] Here contemporary ethnography can help us understand Inka actions with regard to the paqarisqa of other populations. Joseph W. Bastien, who works with the Qollahuaya (Kallawaya) of Bolivia, explains that "blood is not entirely the lineage, but only one link with the ancestors. Living on the land of the ancestors constitutes another tie with them, if the settlers worship them by taking care of their land as the forebears had."[78] Thus it seems likely that the Inka engaged ancestral others by attending to and controlling places of emergence throughout Tawantinsuyu. They did not have to be from a particular place to establish proper relations with it.

Indeed, expansionist ideology is woven into the story of the Inka's own origin. The Inka were said to have emerged from a cave in the highlands south of Cuzco at a place called Paqaritampu.[79] They journeyed northward, founding Cuzco after a staff they tossed sank deeply into the earth. Through this action, the opening of the earth, a new paqarisqa was created; some stories locate it at the site of the Qurikancha, the holiest of places in the sacred precinct of Cuzco. While origin stories maintain that most Andean groups stayed near their paqarisqa, the Inka, we are told, left their original paqarisqa and moved into already inhabited territory. There, by establishing a new paqarisqa, they made the land their own. Locating paqarisqa—caves, nooks in rocks, springs, and so on—throughout their realm, and then carving, building near them, or just leaving offerings, were all means of making themselves "at home." Through their interactions with paqarisqa, the Inka also refined what we might call a visible rhetoric of place, that is, a sense of place that is visually constructed (through the framing, distancing, contouring, and carving of rocks) and self-consciously adopted as part of an Inka imperialist strategy.[80] In carving into or building out of native outcrops, Inka structures emanate from the land in a way that reenacts their origin story, in which their ancestors emerged from caves to inhabit already inhabited places. The Inka's visible rhetoric of place, then, actualizes their own

emergence (or that of specific segments of Inka society) and rehearses their claims of ownership and belonging.

By identifying replicas of their own archetypal models throughout foreign territories, the Inka familiarized distant lands.[81] Aspects of foreign topography that could be equated with already familiar places made new lands known. Familiarizing the foreign also involved transforming conquered lands into Inka territory complete with familiar waka. Stones moved from Cuzco to the far reaches of the empire transformed distant locations into Cuzco. Thus not just rocks but places were transubstantial. In an early draft of his history of the Inka, the Mercedarian friar Murúa tells us of Cuzqueño stones being transported to Ecuador.[82] The stones, first made into buildings in Cuzco and then dismantled and transported northward, were designed to replicate the power of Cuzco. Dennis Ogburn suggests that the moved stones embodied the sanctity and power of Tawantinsuyu's capital.[83] Destined for imperial Tomebamba, which was at the time under construction by the ruler Wayna Qhapaq, the stones were to convert Tomebamba into another Cuzco. The transported stones were thus material metonyms; they were part of Cuzco and so able to re-create Cuzco wherever they were transported.

Similar transformations, by means of material metonymy (as discussed in chapter 1), allowed immobile waka of all sorts to be moved around Tawantinsuyu. If a valued waka was rock, an actual piece of the stone (a direct material metonym of the original waka) or a textile that had touched the original waka (and so was an indirect material metonym of the original) could be placed on a stone in some new location and thus transform the new rock into the revered waka.[84] The new waka was henceforth addressed by the original waka's name. The Inka employed this practice, carrying the valley of Cuzco with them and re creating their home at distances far from the original by means of the concept of transubstantiated essences. Albornoz tells us that in the valley of Jaquija-huana (Xaquixaguana) was a stone called Maragoaçi Guanacauri (Mara-wasi Wanakawri), which was "a rock where they made many sacrifices in reverence to the Wanakawri of Cuzco."[85] He names a number of other waka that also bear the name "Guanacauri" (i.e., Wanakawri) as part of their own names. Wanakawri, considered to be the petrified brother of Cuzco's Inka founder (see chapter 1), was thus re-created many times and as far away as Ecuador.[86] Through such strategies, the Inka not only turned space into place but converted places that belonged to other

peoples into Inka places with familiar landmarks that transformed the region into the Inka's own well-known and sacred landscape.

PLACE HOLDING THROUGH REMEMBRANCE

As noted in chapter 1, significant stones, those we call remembered rocks, had stories attached to them. Stories, as much as architectural style and technique, asserted that stones, once part of undifferentiated nature, were Inka stones and the places where they stood were Inka territory. Such stories served a propagandistic function in that the telling of them constituted important place-holding practices through which the Inka continually reasserted their presence in occupied lands.[87] Sayk'uska (tired-stone) legends, for example, discussed in chapter 1, direct attention to the immensity of the task entailed in transporting megaliths, some weighing many tons, from both local and distant quarries, especially since they could be renitent transients.[88] According to a handful of stories about weary stones recorded in the Andes between 1553 and 1653, the stone is quarried in one location but transported by Inka builders to a distant location; in the course of transport, the weary rock refuses to move any farther and cries tears of blood.[89] Murúa tells one version of the tired-stone story, a tale of a megalith that the Inka were transporting when it became tired and, crying tears of blood, refused to move. Murúa's version features Ynga Urcon (Inka Urqu), identified as the son of the ruler Viracocha. He is described as a brave and accomplished war captain who conquered considerable territory on behalf of the Inka. In fact, his name is seldom mentioned by Murúa without the preceding moniker "valorous captain."[90] His tangle with an obdurate megalith, then, is seen here as part of his military experience. We are tempted to see a causal connection between his failure to move the megalith and his subsequent death soon thereafter at the hands of the indigenes under his command. His defeat by the recalcitrant stone foreshadows his actual death by others who refused to follow his orders.

Nearly all the tired-stone stories recorded by the chroniclers (perhaps because many of them collected their stories in Cuzco) identify the stone as having been intended for the building complex overlooking Cuzco, called Saqsaywaman, whose megalithic walls still stun visitors to the site (figure 37).[91] The weary stone is described as being behind (*en el llano*

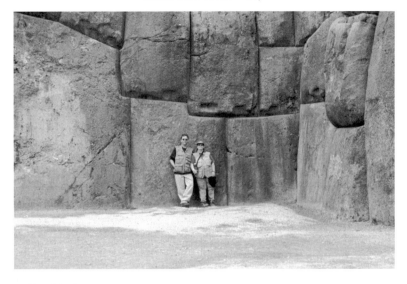

37. Megaliths, Saqsaywaman.

que está detrás de), next to (*junto a*), on the plane in front of (*en el llano antes de*), or a little distance from (*apartada un poco de*) Saqsaywaman.[92] Isolated at a small distance from Saqsaywaman, it contrasted mightily with the nibbled megaliths that make up Saqsaywaman's zigzagging walls. The complex was built by mit'a laborers from throughout the empire who worked periodically for the state as a form of tribute. Saqsaywaman manifested the extensive resources of a state that could mobilize the labor required to cut, dress, transport, and build a structure of these (apparently sometimes reluctant and always potentially animate) Herculean rocks. A moved megalith is a trace of the labor that it took to move it.[93] Stories about transporting stones, especially recalcitrant ones, induce awe and so reinforce the "wonder effect" of the structure. Not only could laborers cut, pull, shape, hoist, and ultimately fix stones into the nearly flawless walls of Inka structures, but certain individuals such as Calla Cúnchuy (Kallaq Unchuy), named by Garcilaso as one of four master masons working on the Saqsaywaman project, or Inka Urqu (Ynga Urcon, Inga Urcon), named by Guaman Poma and Murúa as a captain and the transporter of a tired stone, could and did communicate with rocks in an effort to coax resistant stones into place.[94]

Cobo also tells the story of a weary stone that resisted Inka efforts to place it in the walls of Saqsaywaman.[95] After the stone fell three times

and killed a number of workers, the Inka called on "sorcerers" who were capable of speaking to the stone. They determined that if the Inka continued their efforts to force the stone into the structure, "all would have a bad end." As they did with the tired stones who cried blood, the Inka desisted in their efforts to force the intransigent stone to do as they desired. Tales of angry killer rocks and weary stones crying blood suggest that those stones that were part of the wall were there because they wanted to be. Such stories stress the reciprocal nature of building discussed in the previous chapter. They also cause the labor of transporting *all* stones to Inka sites to be remembered. Garcilaso says that the mason Calla Cúnchuy gave his name to the weary stone, and Cobo confirms that the stone was named Collaconcho; in an illustration, Murúa identifies the stone as the weary (*saycum*) *callacuncho* (figure 15).[96] Rock and architect are identified with each other. The stone that resisted serves to underscore the master builder's accomplishment; likely it was given his name and was recognized as a waka.[97]

As in tired-stone stories, the laborious transport of stone is a feature of other stories about rock. For example, as noted earlier, the Inka were said to have moved stones for their building projects from the Cuzco area to what is today Ecuador. Cieza says that the ruler Wayna Qhapaq ordered seditious subjects to transport stones from Cuzco to Tomebamba (today's Cuenca) "to keep the people of those kingdoms well in hand" (*para tenellas* [*las jentes destos reynos*] *bien sojuzgados*).[98] Surely both the rebellious Cayambi (Cayambe, Caranqui) and the Inka (as well as populations along the traveled route) would tell stories for generations about the labor of transporting stones such incredible distances. In the telling, those rocks—those *remembered* rocks—would index their own transport and so serve to deter future rebels. People subjected to Inka control thus understood firsthand the power of the state represented by masonry structures. The transport of stone over long distances was understood as a punishment and as a declaration of state power; I discuss other implications of this practice later in the chapter.

Murúa's account of the transport of stones from Cuzco to Ecuador tells us that when the stones neared Saraguro (Ecuador), about one thousand miles from Cuzco, lightning struck and split the stone that was to serve as the lintel spanning the main door.[99] When the Inka ruler (Wayna Qhapaq) heard what had transpired, he took it as a bad omen and ordered that all the building blocks be left where they lay next to the royal road.

As in the tired-stone accounts, the Inka exercised great, but not abso-
lute, power over stones. Thus abandoned stones could testify not just
to the power of the state but to the relationship the state had with vari-
ous numina. Ogburn has verified Murúa's account, locating the storied
stones, some 450 finely nibbled andesite parallelepipeds originally from
the Rumiqolqa quarry near Cuzco, in and around the town of Paqui-
shapa in the Saraguro Basin of Ecuador.[100] He estimates that a minimum
of 4,500 people would have been needed to transport the stones, and it
would have taken them nearly one hundred days. Ogburn also notes that
the Inka were "not at all embarrassed about these actions [having a stone
they were transporting being struck by lightning and having to leave the
stones just a week or so shy of their destination], but committed them
openly and willingly"; he concludes that "the Incas were demonstrating
the depth of their regard for their gods" and that "on another level, this
was yet another avenue whereby the Inca state could emphasize the im-
mense amount of labor that they had at their command. Discarding the
stones after so great an investment was a powerful statement by the Incas
that they were not affected by such a high cost and that they had plenty
of labor to spare."[101]

Given that stones which were never even set in a wall, like the lightning-
stuck stones of Saraguro or the numerous examples of tired stones, were
potent symbols of Inka power, what kinds of messages did the completed
buildings send? Stories about such stones underscored the Inka's ability
to communicate with rock. Because the buildings are ultimately always
completed, the stories draw attention to the inevitability of Inka victory.
While the uncooperative stones of story were not persuaded to become
parts of Inka structures, many other megaliths obviously were. So what
did it mean to the Inka to quarry, cut, nibble, and fix potentially animate
and resistant rocks into the walls of their edifices? What do Inka beliefs
about the potential numinosity of stone say about the power of a state
that can marshal the resources to build such structures out of often recal-
citrant stone? The transport of stones — and stories about the difficulties
of transport — adds value above and beyond the intrinsic significance or
value of the material. Clearly, a building in Inka style was equated with
Inka order and Inka control. Is it any wonder that after the Spanish de-
feat of the Inka, peoples subject to Inka control attacked and dismantled
Inka structures? We are told, for example, that Cajamarca was destroyed
almost immediately by indigenes who detested Inka rule. The conquista-

dor Juan Ruiz de Arce, writing in 1545, reports that "because the Indians knew that we were leaving Cajamarca [on their way to Cuzco], they came and left not one stone atop another."[102]

Stories about recalcitrant stones spoke of the Inka's relationship with the numinous materials with which they built. Other stories featuring willful rocks recorded the Inka's ability to forge alliances with potent natural elements. Perhaps stories about puruawqa, introduced in chapter 1, are the best examples of this. Briefly, the puruawqa were warriors who aided the Inka when they were threatened by a powerful enemy. Once the enemy had been defeated and Cuzco was secure, the puruawqa petrified. Recognized as waka, they were located in various places in and around Cuzco; some were identified by individual names. The puruawqa promised to aid the Inka in times of war whenever they were needed, and fear of the puruawqa discouraged others from resisting the Inka. Cobo stresses that "strangers" (*forasteros*) visiting Cuzco would be shown the petrified warriors and told the story, adding "then the strangers would be persuaded to worship the stones" (*a los forasteros . . . persuadían las adorasen*).[103] Whether through persuasion or coercion, inducing visitors to Cuzco to honor puruawqa forced them to acknowledge not just the history of the Inka's military success but the promise that the earth itself would rise up in defense of the Inka.[104] We are told that the number of offerings made to the petrified warriors was great, and the puruawqa were acknowledged whenever the ruler went to or returned from war, during coronations of rulers, and at major festivals.[105] The Inka ruler and his generals surrounded themselves with these indefatigable once and future warriors. The militaristic associations of stone, as well as the numerous allegiances expressed in storied form, add a dimension of power to Inka architecture that is not readily visible but was certainly well known by those who contested Inka authority.

PLACE HOLDING THROUGH SIGHTING PRACTICES

Vantage points from which oversight was possible were clearly important to the Inka. Rowe, in his study of Cobo's list of shrines in and near Cuzco, notes that many waka were located on main roads at high points where travelers gained their first view of the capital when approaching or had a last view of the city when departing.[106] Hyslop speculates

that this practice was not limited to Cuzco and would account for the placement of some of the remains he found along the Inka roads he surveyed.[107] Although such shrines emphasize human viewers, the Inka also acknowledged "natural" overseers. Indigenous Andeans still characterize mountain apu as the owners of all within their ranges of vision. Mountain apu are called great watchers, and alpine vision relates directly to their authority; if you can see a mountain, you stand in its realm. Other far-sighted numina, including the sun and other planetary bodies, lightning, and rainbows, also oversee by virtue of their celestial positions. On a smaller scale are wank'a (petrified "owners") whose oversight was (and is) limited to smaller territories befitting their more diminutive sizes — valleys, villages, and single fields. Possession, then, is linked not just to sight but particularly to "oversight"; that is, looking at something from above and by being seen by whatever is below.[108]

Like the numinous overseers just named, Inka leaders also performed acts of possession by seeing from above and being seen from below. The best-known locations for such sighting practices in pre-Hispanic times were elevated petrous platforms situated in the plazas of settlements. At Vilcashuaman (Willka Waman) is a four- or five-level platform in the manner of a small pyramid with a single stairway; a finely carved stone dual seat remains atop the elevated base (figure 38).[109] Cieza describes the Vilcashuaman seat as the place where the Inka ruler went to pray.[110] He says it was made of a single block of stone with two seats and also reports that he was told that before the Spaniards arrived in the Andes and demanded a ransom in precious metals, it had been adorned with gold, jewels, and precious stones. In addition to being a site of prayer, the elevated stone seat also apparently played a critical part in the Inka rite of royal visitation. Guaman Poma identifies the elevated seat at Bilcas Guaman (Vilcashuaman) as a place where the Inka ruler received principal lords of his realm; he calls it an "usno" (usnu).[111] Similarly, Santa Cruz Pachacuti refers to a seat in Uillcas (i.e., Vilcashuaman) where subjects paid obeisance to the Inka ruler; he indicates that in the main plaza of Cuzco there was a seat like it, which he calls capac usno (royal usnu).[112]

Betanzos tells of a visit the eleventh ruler (Wayna Qhapaq) made to towns within twenty leagues of Cuzco: "They had in the plaza a certain seat which resembled a high platform and in the middle of the platform, a basin full of stones. On reaching the town, the Inca climbed up on the platform and sat there on his chair. From there he could see everyone in

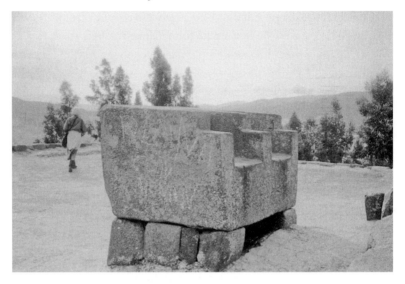

38. Double lithic seat, Vilcashuaman.

the plaza, and they could all see him."[113] Bartolomé de Segovia affirms that in each town was a plaza with an elevated rectilinear platform, accessed by a stairway, from which the Inka ruler could view and speak to the people gathered below.[114] The elevated seat atop the platform, often associated with a basin for offerings, apparently provided a place for the ruler to sit, as well as to see and be seen "praying" and making offerings to various numina.[115] Standing on a raised platform or sitting in an elevated seat necessarily made the ruler an overseer, a surveyor. Surveying, of course, relates to supervision—seeing from above as well as directing and superintending.[116] It presupposes a line of sight from the one who oversees to those who are overseen. In Inka plazas, which were basically enormous open theaters in the round where many different segments of society could gather, the raised platform provided a formal structure for seeing and being seen.[117] The importance of penetrating vision from an elevated vantage point is emphasized at the Inka's provincial center of Huanuco Pampa, where the middle of that settlement's platform is aligned so that the sightline extends through a series of four well-joined cut-stone doorways along an east–west axis.[118] What's more, Zuidema reports that modern local tradition in the area of Vilcashuaman holds that from the top of the pyramid one can see both to Cuzco and to Lima.[119]

While such supervision would literally require "super" vision, this notion underscores the act of oversight associated with the structure and its elevated seat.

That divine Inka rulers valued oversight, through which they became like the overseeing waka they themselves venerated, is suggested by the initial meeting of Spaniards and the ruler Atawalpa. Descriptions by some of the Spanish participants themselves indicate that Atawalpa kept his head down when meeting the Spaniards, something they regarded as haughty and scornful.[120] Considering that the Inka head of state was a divine ruler, the fact that he neither looked at, nor spoke directly to, the Spaniards is not surprising. However, it is also significant that, at the time of the first meeting, Atawalpa was, by all accounts, seated on a low stool (called a *tiana*).[121] Given the importance of oversight in Inka culture, it is unlikely that Atawalpa would have met the gaze of anyone looking down at him. To have done so would have been to defer implicitly to the overseer.

Occupying not just an elevated seat, but an elevated *petrous* seat, seems to have been critical to the assertion of possession. According to Sarmiento, Ayar Auca, one of the first Inka, was told by his brother Mango Cápac (Manku Qhapaq) to go to a rock marker (*mojón*) that stood where the Qurikancha would later be built; by sitting on the rock, he would take possession of the place.[122] The brother did as he was instructed and was turned to stone there; he became a wank'a, the owner of that place, and was even referred to as Cuzco's owner (*cuzco guanca*). In this story, petrifaction marks ownership, as the sitter becomes one with the stone on which he sits. Duviols relates the story of a peripatetic wank'a, the ancestral owner of several valleys on Peru's coast (see chapter 1), who used to visit the series of valleys of which his domain consisted. In each of the valleys possessed by the wank'a, he sat in a stone seat as a show of his authority.[123] The act of sitting on stone identified the sitter as a wank'a, that is, the owner of whatever was visible from the seat. The sitter, emulating Ayar Auca and the peripatetic wank'a, became a wank'a as well. The Inka, like other Andeans, believed that physical contact with something could result in a transfer of essence (kamay, as discussed in the introduction). Thus the sitter in a stone seat makes direct contact with the local topography and so becomes an "overseeing owner" somewhere on the continuum of petrous possessors, from the sacred mountains to

the chakrayuq (the petrified owners of fields); the height of, and view from, the petrous seat indicates the scope of ownership. The lithic seat is like the outcrop integrated into an Inka structure, a site where Inka order (the sitter being a metonym for the order of Inka society) meets nature (the boulder or outcrop being a metonym of the natural world). The transmutable essence of stone, which was capable of becoming human flesh, enabled human sitters to join the earth, to symbolically lithify for a period of time, and to become themselves watchers. Moreover, because the shape of the seat indexes the sitter, it acts as a trace of the watcher even in the watcher's absence.

Although some lithic seats, like that of Vilcashuaman, were squared off and apparently decorated, most extant examples of lithic seats retain the natural shape of the boulder or outcrop from which they were hewn (figure 39). With many, it seems important that the seat look natural, providing a place for the sitter to merge with the bedrock at that particular location. A decorated surface might well have impressed those who were overseen, but the decoration would have been less important than the transubstantial stoniness of the seat itself. Here it is important to note that oversight took place not just from petrous seats on platforms in the plazas of settlements (and often identified as usnu). The most prominent seat at Ollantaytambo, for example, perches on a crag facing away from the temple area (figure 39). It looks east over the settlement and the Patakancha River valley. The calcareous outcrop seat companioned by finely carved steps at Saqsaywaman, which today are called the Inka Throne, also face over Cuzco and its valley (figure 40). While in the past many observers assumed that the seat was designed to witness ceremonies on the plane in front of Saqsaywaman's great megalithic walls, some have noted that the seats do not face the open area; rather, they face the valley of Cuzco, meeting the gazes of the powerful apu Ausangate to the viewer's left and the sacred hill of Wanakawri to the right.[124] Smaller territory is claimed by the river seat in the Urubamba Valley, carved into a boulder that sits in and looks out over the flowing waters of the Urubamba River that was so important to agricultural activity in the area (figure 41).[125] Because some petrous seats are difficult if not impossible to access, we might suspect that not all seats were intended for human beings.[126] To the Inka, stone seats that could not be sat on by human beings may well have symbolized the oversight of absent, invisible, or distant numina.

Also important symbolically is the dual seating provided by many of

39. Double lithic seat, Ollantaytambo.

40. Sabacurinca, also known as the Inka Throne, Saqsaywaman.

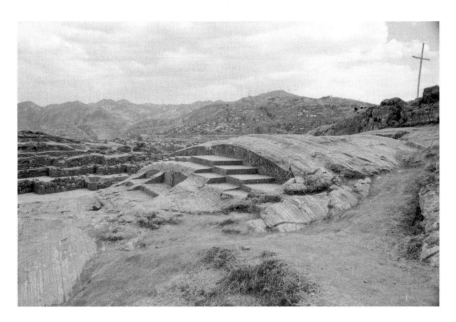

41. Double lithic seat, Urubamba River, Ollantaytambo.

the Inka's petrous perches. Dual seating reflects Andean notions of com-
plementarity that I introduced in chapter 2. In the same way that Andean
communities were commonly divided into hanan (upper) and urin (lower)
sectors, the body politic and political power was itself conceived as a con-
joining of upper and lower aspects. Hanan was the privileged position,
but because urin was necessary to define hanan, and since neither can
exist without the other, the superiority of hanan is always dependent and
relational rather than total and absolute. As Garcilaso explains:

> The distinction [between hanan and urin] did not imply that the in-
> habitants of one half should excel those of the other in privileges and
> exemptions. All were equal like brothers, the children of one father and
> one mother. . . . And he [Manku Qhapaq, the first ruler] ordered that
> there should be only one difference and acknowledgment of superiority
> among them, that those of upper Cuzco be considered and respected as
> first-born and elder brothers, and those of lower Cuzco be as younger
> children. In short they were to be as the right side and left in any ques-
> tion of precedence of place and office.[127]

Thus we may understand urin as the subordinate but necessary complement to hanan. Andean notions of properly conjoined complements are especially reflected in those dual seats that are slightly different, the seat to the right (from the perspective of those seated) often being wider, higher, or broader (or a combination of these).[128] Such differentiation corresponds to the asymmetrical relationship of hanan, identified with the right hand, to urin, identified with the left. We may imagine that, at times, the hanan leader of a particular community would have assumed the right-hand seat while to his left sat the leader of urin society. Another possible pairing might have been the leader on the right and his primary wife on the left.[129] We might also imagine that the Inka ruler (or other human dignitary) could have been paired with the wank'a of a particular territory, his wawqi (lithic brother), or the mummy of one of his predecessors. Regardless of who (or what) sat, dual seating indexes a paramount couple, a qhariwarmi (see chapter 2), whether they are representatives of hanan and urin, male and female, or other complementary pairings.

Some dual seats may have been part of what the Inka called an *usnu* (*ushnu, usñu, uẓno, osno,* and *oẓno*), a concept much discussed but still poorly understood. Guaman Poma calls the usnu the Inka ruler's throne (*trono*) and indicates that it was a site of sacrifice.[130] Santa Cruz Pachacuti defines *usnu* as "stones positioned like a dais" (*piedras puestas como estrado*).[131] The elevated platform at the Inka provincial administrative center of Huanuco Pampa, a place for the exercise of oversight, was also identified as a place where justice was done.[132] It may be significant, then, that González Holguín defines *usnu* as a rock outcrop or large stone firmly set in the earth that was used as a place of judgment or as a marker; likewise, the verb *usnuni* means to hold a tribunal or to put a stone marker in place.[133] Given González Holguín's definitions identifying the usnu as, at least sometimes, a place of justice, it is interesting to note that the Spaniards erected their gallows over the site of the usnu in Cuzco's main plaza.[134] It would not be inconsistent with Spanish practices for the conquistadors to have replaced the Inka's symbol of justice with one of their own.

From these descriptions and definitions, it is possible to identify some lithic seats as important components of usnu, locations erected in part for oversight and the administration of justice. Other early colonial-period authors, however, identify usnu as altars for worship and as sites of pro-

pitiation.[135] Santo Tomás defines *oȝño* or *osño* as an altar or "altar slab for sacrifice" (*ara para sacrificar*).[136] Albornoz ties several of these functions together, indicating that usnu were places for making offerings and seats for lords to sit on; he identifies them as waka found on royal roads and in the plazas of settlements.[137] In his memoirs, Pedro Pizarro recalls the use of what must have been the usnu located in Cuzco's main plaza; he describes at length a ceremony involving the mummies of deceased rulers who were fed in the plaza of Cuzco. While the mummies' food was burned, the aqha (*chicha*) they were given was poured on a round stone (*piedra rredondoa*) with a basin that drained into the earth. The round stone was covered with gold. Also associated with the round stone and basin was a seat, adorned with colorful feathers, where a statue (*bulto*) of the sun was placed.[138] Pizarro's description matches elements needed to fulfill the various functions associated with the usnu: the stone with a basin for burned and liquid offerings and a seat for a dignitary, which, in this case, was a rock that embodied the sun.[139]

While Pedro Pizarro may have been the first to describe the usnu in use, all those in the first company of Spaniards, while awaiting their initial audience with the Inka ruler Atawalpa in Cajamarca in the central Andean highlands, apparently saw an usnu there. None of them had the slightest idea what they were looking at, however. Estete, authoring an account of his experiences in 1535, guessed that the elevated platform at Cajamarca served some religious function, and so identified it as a stone mosque (*una meȝquita de piedra*).[140] Mena, writing in 1534, refers to it as a fortress (*fortaleȝa*); Jerez, also in 1534, describes it as a stone fortress with a masonry stairway (*fortaleȝa de piedra con una escalera de cantería*); and Hernando Pizarro, in a letter of 1533, identifies it as a small fortress (*fortalecilla*).[141] Jerez relates how a messenger from Atawalpa told Francisco Pizarro that the Spaniards could camp where they liked as long as they did not climb the "fortress" in the plaza of Cajamarca.[142] If that fortress was indeed an usnu—a sacred, elevated altar and seat for oversight ceremonies and offerings—we can readily understand this particular edict. Later, when explaining the events of Cajamarca that resulted in Atawalpa's capture on November 16, 1532, Titu Cusi Yupanqui, a nephew of Atawalpa who was not present but no doubt heard a full account from his relatives, says that the usnu was "a seat belonging to the Inka ruler that was elevated in the manner of a fortress" (*un asiento del ynga en alto, a manera de ffortaleȝa*).[143] He confirms that it was in the plaza of Cajamarca

and claims that the Spaniards would not let Atawalpa ascend when he arrived to meet Francisco Pizarro, the Spanish leader. This is not surprising, since we know from Spanish recollections of that day that Pizarro had posted several soldiers atop the usnu; when it came time to attack, Pizarro signaled them so that they would fire their guns into the crowd of Inka below and blow trumpets to cause panic and confusion.[144] That is precisely what happened.

After reviewing the disparate characterizations of usnu offered by various chroniclers, Gasparini and Margolies define it loosely as something that "may be a stepped structure, a platform, base of a throne, place intended for high ranking personages"; they say that it may also be an altar, which is generally conceived of as an elevated place for reverence and for offering sacrifices.[145] From many of the same early descriptions, as well as later studies and extant examples, Hyslop concludes that an usnu was a stone seat or reviewing stand that was located in plazas and that sometimes incorporated "the concept of a basin" with some sort of drainage system; the usnu was also a reference point for astronomical observations.[146] Other scholars have focused on the usnu's use in site planning, understanding it to be the central element of some Inka sites, the hub of the settlement's radial organization, and the point around which sites were laid out.[147] While the so-called Intiwatana at Machu Picchu, a carved outcrop that many have identified as an usnu, is not located at what we might identify as the physical center of the site, it centers Machu Picchu with regard to the world directions; from the Intiwatana at Machu Picchu, the sacred mountains align with the cardinal directions (Wakay Willka, or Mount Verónica, to the east; Wayna Picchu to the north; the Pumasillo range to the west; and, although not visible from the Intiwatana, Salcantay to the south) (figure 42).[148] Thus usnu were centralized whether in terms of the physical layout of some settlements or in terms of cosmic organization. Given that liquid offerings drained into the underworld and the smoke of burned offering wafted into the upperworld, the usnu marked the center in six directions (north, south, east, west, up, and down). F. M. Meddens, in his article "Function and Meaning of the Usnu in Late Horizon Peru" (1997), unites many of these functions by concluding that the elevated platform, or truncated pyramid, of the usnu provided a metaphorical mountain that, when occupied, whether by the ruler or by a deity, allowed the occupant to maintain the balance between this world, the world below, and the world above. The Inka made offer-

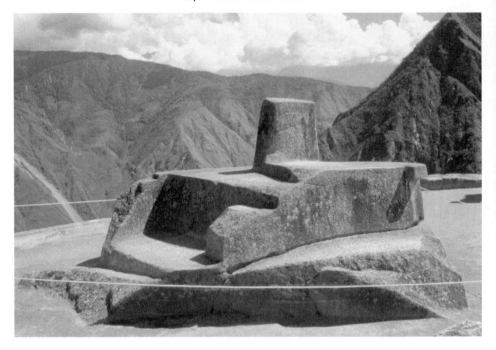

42. Intiwatana, Machu Picchu.

ings and solar sightings from these sites of power and otherworldly ac-
cess, thereby accounting for the basins, drains, and gnomons that were
features of some usnu. While the truncated pyramid or elevated platform
may have provided a visual allusion to a mountain, the stone of the meta-
phorical mountain, and particularly the seat that provided a place for the
actual conjoining with the conceptual mountain, embodied a mountain
itself. When surmounted, whatever or whoever exercised oversight from
that position assumed power similar to that of the great overseers of the
Andean pantheon.

Given that atop some petrous perches sat the numinous, from divine
rulers to wank'a to the Inti Wawqi (the lithic embodiment of the sun), it
is not surprising that the seats themselves were considered to be waka.[149]
The set of carved seats and steps on the *suchuna* outcrop at Saqsaywaman,
generally known today as the Inka Throne (discussed earlier in the chap-
ter), was clearly an important waka (figure 40). Cobo identifies it by the
name Sabacurinca and describes it as a "well-carved seat where the Incas
sat" (*un asiento bien labrado, donde se sentaban los Incas*).[150] The Inka ven-

erated the seat itself and made sacrifices to it. Cobo goes so far as to say that it was "on account of this seat the whole fortress [of Saqsaywaman] was worshipped" (*por respecto deste asiento se adoraba toda la fortaleza*).¹⁵¹ Likewise, several of the seats named as waka in and around Cuzco are said to be places where an Inka ruler rested; at least one was where a ruler sat to plan a successful military campaign.¹⁵² Thus lithic seats also linked the sitters to important events that took place in or near them. Like other remembered rocks, lithic seats bring to mind historic events and people. The seat was identified with the sitter, whom in some sense it came to embody, and remained as a permanent marker or trace of the sitter in the landscape. Because the sitter was also a watcher, his possession of what was overseen is also commemorated by the lithic seat. Petrous perches, then, are reminders of oversight and important "place holders," commemorating acts of possession as well as tracing the bodily contours of the overseer.

CONCLUDING REMARKS

Today warrior stones are brought to life in the province of Paruro, where dancers called Yayanqaqa (Father-rock), Mamanqaqa (Mother-rock), and Uñanqaqa (Baby-rock) wear costumes of natural materials (animal skins, moss, cactus) paired with stag masks.¹⁵³ They symbolize untamed nature, savage and primitive, reminders of the forces with which the Inka reckoned in their efforts to bring their sense of order to the Andes. Whereas indigenous Andeans today have "lost" the ability to command such untamed rocks, they still credit the pre-Hispanic Inka with this power. Contemporary Quechua stories about the Inka from the Cuzco region stress that, merely by speaking, the Inka could induce boulders to become parts of walls.¹⁵⁴ Likewise, modern Andean stories tell of In-karrí (Inka Rey, the "Inka king"), who transformed the world by ordering stones: "They say that the Inkarrí, when he wanted to, only pulled the stones with a whip and then they made themselves into buildings."¹⁵⁵ The Aymara residents of Qaqachaka in Bolivia say that the ancient Inka could move stones merely by waving a staff.¹⁵⁶ Such stories suggest that present-day Andeans still regard stonework in the Andes as a special sign of the Inka. These many modern accounts in which the Inka moved rocks through limited coercion and little direct interaction with the stones

themselves contrast starkly with many of the stories we have from pre-Hispanic times, which emphasized the labor of working, moving, and fitting stone alongside the Inka's ability to communicate directly with rock. Over time, Inka labor has been minimized or forgotten, though those efforts are recorded in the nibbled and noduled rocks themselves. In the next chapter, I look at the long period from the first Spanish encounter until today, during which Inka efforts to both make and hold places were gradually reconstrued, and the arduous labor through which the Inka turned space into place was reinterpreted as effortless magic.

Allegories are, in the realm of thoughts,

what ruins are in the realm of things.

—WALTER BENJAMIN,

The Origin of German Tragic Drama

·(⬌)·

CHAPTER 4

Rock in Ruins

After the Spanish invasion of the Andes, many chroniclers attempted to convey something of the quality of the Inka's finely nibbled, mortarless masonry by exclaiming that even the point of a knife blade could not fit between the well-worked joins.[1] Modern travel books inform tourists that they will not be able to fit credit cards into those same joins. From colonial times to the present, it seems that strangers to the Andes rarely resist the temptation to try to separate what the Inka joined together so perfectly. Whereas conquistadors wielded steel knives, weapons that lent the Spaniards technological superiority over the Inka, modern tourists, encouraged by guidebooks and guides alike, poke at Inka walls with their credit cards (in ways not unlike those with which they approach an ATM), tools that give them power and a certain sense of superiority over the descendants of the Inka. So in this chapter I juxtapose the colonial moment and the present, tracing some of the discourses, perceptions, and practices that still color the ways visitors to the Andes interpret Inka rocks.

My particular attention is on the rocks of Cuzco and its environs. My discussion of colonial encounters focuses on the Inka's temple, warehouse, and stronghold of Saqsaywaman, which was transformed into a ruin in the decades after Spaniards occupied Cuzco.[2] The ruination of Saqsaywaman became a trope for the conquest of Peru. Today Saqsay-

waman (which English-speaking tourists are encouraged to pronounce "sexy woman") figures in the imaginations of tourists in various ways.[3] The city of Cuzco, like Saqsaywaman, was altered dramatically in colonial times. Recently, however, the city has been reconceptualized to make its pre-Hispanic Inka past more visible. I consider how many extant rocks that were significant to the Inka—what I termed "remembered rocks" in chapter 1—are now forgotten, overlooked, or reconstrued in this reconceptualized Cuzco, and how visitors persist in creating an idea of the ancient Inka that satisfies their expectations. Because most people value common rock very little, especially rock that is used in a seemingly utilitarian way, visitors to Cuzco today generally apprehend only a fraction of what the Inka created with and through stone. Moreover, viewers of Inka rockwork today perceive the significance of stone in ways the Inka never imagined. This perceptual gap reveals much about the ongoing creation of Inka history.

RUINING SAQSAYWAMAN

The Spaniards, under the leadership of Francisco Pizarro, first encountered the divine leader of the Inka state in 1532 in Cajamarca, Peru.[4] There they captured the ruler (Atawalpa) and held him for ransom before executing him. The wealth in gold and silver objects delivered to them by the Inka astonished the Spaniards; though they recognized the items as treasures (*tesoros*), they melted most of them down (or had expert indigenous metalworkers do the smelting). As Pizarro and his men traveled across Tawantinsuyu, the Inka's realm, they marveled at many aspects of Inka visual culture, yet they and the colonizers who followed destroyed much of it as well. One Inka monument universally heralded by Spaniards was the building complex of Saqsaywaman, which sits atop a promontory overlooking Cuzco, the Inka's capital. In 1534, Sancho de La Hoz, the first to record his impressions of the site, praised the megalithic walls of Saqsaywaman, saying, "Neither the bridge of Segovia nor any of the buildings that Hercules or the Romans built are so worthy of being seen as this."[5] Sancho's hyperbole reverberated in the later writings of dozens of Spaniards. Yet despite their clear admiration of Saqsaywaman, the Spaniards dismantled most of the structure in the sixteenth and seventeenth centuries. They turned Saqsaywaman into a quarry for

already worked stones with which they constructed buildings for their own use, and thereby created a ruin of the Inka structure.

Pre-Hispanic Saqsaywaman, bounded by a precipitous incline on one side and a flat plain on the other, consisted of three terraces that restricted access to the upper levels (plate 14). The zigzagging terrace walls are characterized by polygonal masonry featuring dressed megaliths of irregular shape, each of which has been worked to fit precisely in its place. While many of these megalithic walls can still be seen, only the foundations of the rest of the complex, which comprised numerous rooms and three towers in the elevated central portion, remain.[6] Spaniards underscored the use of Saqsaywaman as an Inka stronghold by consistently referring to it as "the fortress" (*la fortaleza*), which is what many of them believed it to have been. Many chroniclers maintained, however, that Saqsaywaman was a temple of the Inka patron deity, the sun.[7] Cieza, one of the earliest chroniclers of Peru and one of the most reliable, calls Saqsaywaman a royal house of the sun (Casa real del Sol) and says it was conceived as a

> house of the sun which should surpass everything done until then, and that it should house everything imaginable, such as gold and silver, precious stones, fine garments, arms of all the types they used, materials of war, sandals, shields, feathers, skins of animals and birds, coca, bags of wool, a thousand kinds of jewels; in a word, everything anyone had ever heard of was in it.[8]

Cieza thus suggests that it was both a temple and a storage facility or treasury. Both Sancho and Pedro Pizarro describe Saqsaywaman as a depository.[9] All three functions—temple, depository, and stronghold—were likely combined. In fact, Garcilaso explains that Saqsaywaman "was considered a house of the Sun for arms and warfare" (*era casa del Sol de armas y guerra*) and that in it clothing and footwear were stored for the Inka military.[10] From these accounts, we can conclude that Saqsaywaman was a military complex dedicated to the imperial solar cult and the concomitant agenda of an aggressively expanding state.

Nearly all ethnohistorical accounts written in the sixteenth and seventeenth centuries report that the construction of Saqsaywaman began during the reign of the Inka's ninth ruler (Pachakuti) or his son, the tenth ruler (Thupa Inka Yupanki).[11] Many report that the work was continued by succeeding rulers, being finished, or nearing completion, at the time

Francisco Pizarro and his company arrived in the Andean area. Most agree that Saqsaywaman had been in construction for over fifty years.[12] While the period of construction was lengthy and may have continued until the time of the conquest, the destruction of Saqsaywaman began soon after the Spaniards settled in the area. Officially founding their city of Cuzco in March 1534 on top of Inka Cuzco, the Spaniards followed well-known precedents, including, of course, the founding of Mexico City on the ruins of the Mexica (or Aztec) capital, Tenochtitlan.[13] Such Spanish municipalities exploited the native labor and materials close at hand. In the case of Cuzco, the Spaniards used the Inka's large central plaza (the Awkaypata) as their own *plaza mayor*; they positioned their cathedral on this square, which they proceeded to reduce to a size more consistent with their notions of proper plazas.[14] All around the central precinct, Spanish edifices were erected on the foundations of Inka structures. While Spanish settlers had no firm plans for the site of Saqsaywaman, they used its masonry in building Spanish Cuzco. Apparently rumors of hidden treasure buried in Saqsaywaman also encouraged destructive excavations.[15] In Garcilaso's words:

> The Spaniards . . . demolished [Saqsaywaman] to build private houses in Cuzco. And to save themselves the expense, effort and delay with which the Indians worked the stone, they pulled down all the smooth masonry in the walls. There is indeed not a house in the city that has not been made of this stone, or at least the houses built by the Spaniards.[16]

Thus, as the fine Spanish-style houses of Cuzco were erected, Saqsaywaman was reduced to ruins.

In 1571 the city's *corregidor* (Spanish magistrate) commented that Saqsaywaman could supply enough dressed stones to build four churches like those of Seville.[17] Other officials and chroniclers affirm extensive use of stones from Saqsaywaman in the building of Cuzco.[18] Like Garcilaso, the friar Murúa claimed that all Spanish structures built in Cuzco featured stone from Saqsaywaman. He also explained that the only reason any stones were left standing at the site was that the megaliths would have been too expensive to move and would have required the labor of too many natives.[19] Contracts from the sixteenth and seventeenth centuries refer to the use of stones from Saqsaywaman in building Spanish Cuzco's symbolic center; documents dated October 6, 1559, and February 19, 1646, indicate that Saqsaywaman was the source of stone used in

building the city's cathedral.[20] An eyewitness account of the construction of that cathedral details the Inka method of lithic construction employed by native laborers—the natives this chronicler watched were undoubtedly using some of the same stones that their ancestors had used to build Saqsaywaman.[21]

While much of Saqsaywaman was dismantled, the most striking and impressive part of the complex remained—its polygonal megalithic walls featuring stones measuring over fifteen feet in height and weighing over two hundred tons (figure 37). There is no doubt that the Spaniards were truly impressed by the megalithic masonry of Saqsaywaman. One after another, their descriptions echo the words of Sancho, who wrote: "The most beautiful thing that can be seen in the edifices of this land are these walls because they are of rocks so large that no one who sees them can say how they were placed here by human hands."[22] Later writers consistently comment on the enormous size of the stones, the amount of labor required, and the quality of joins that required no mortar. While Garcilaso called Saqsaywaman an "inadequately portrayed and insufficiently praised fortress" (*no bien encarecida y mal dibujada*), it consistently generated Spanish awe.[23] Commentary repeatedly hints at European technological superiority, however, as the authors wonder at what the Inka achieved *despite* their lack of (iron) tools. Cobo, for example, estimates that when Saqsaywaman was under construction there were normally no fewer than thirty thousand laborers working on it; he goes on to say that such a high number of workers is "not surprising since the lack of implements, apparatus, and ingenuity necessarily increased the amount of work" (*no es de maravillar, porque la falta de instrumentos, ingenios y maña forzosamento había acrecentar el trabajo*).[24] Also frequently noted was the absence of arches and the lack of tile roofs.[25] Thus any words of praise are implicitly mitigated by Inka "shortcomings," and it should be noted that few Spaniards made any serious attempts at documenting Inka architectural methods or priorities (why they built the structure in the way, shape, and locations they did).[26] Clearly, most were content to marvel at the Andean "mystery" and leave the Inka's achievement virtually uninvestigated.

In the Spanish commentary on Saqsaywaman, mystery displaces local knowledge, which went unrecorded; the romance of the "inexplicable" structure necessarily sustained a fundamental belief in the inferiority of the colonized. Yet the ruins of Saqsaywaman rested uneasily as a baffling

relic of a bygone era, perhaps because so many had witnessed the process of ruination. Some Spaniards expressed distress, or at least ambivalence, at the destruction of the site. Cieza, for example, argued that Saqsaywaman ought to be preserved "in memory of the greatness of this land" (*para memoria de la grandeẓa desta tierra*).[27] Likewise, Betanzos wrote, "This was such a magnificent construction that it could be considered one of the marvels of the world. Today most of it has been knocked down to the ground, which is a shame to see," and Sarmiento said the remains of Saqsaywaman "caused great pity in those that now see its ruins" (*Hace gran lástima a los que agora ven las ruinas della*).[28] In the late eighteenth century, it was noted that the wondrous ruins would be more famous if "ambition" (*ambición*) had not led to the extraction of so many stones for use in Spanish edifices.[29] While Spanish "ambition" is an ambiguous term, Garcilaso is more straightforward when he writes that "the Spaniards . . . were as if envious of the remarkable achievements of the Incas, and not only failed to preserve the fortress, but even demolished it." [30] Thus Garcilaso suggests that while the stones of Saqsaywaman were certainly convenient for the Spaniards of colonial Cuzco, the majestic complex was more than a local source of cut stone — it was the target of envy.

SAQSAYWAMAN AS A RUIN

Adding some support to Garcilaso's allegation that the Spaniards destroyed Saqsaywaman out of envy is the fact that the colonizers did more than partially dismantle what they called "the fortress"; they adopted Saqsaywaman as their symbol of the conquest of Cuzco and of the Inka. In 1540, King Charles V awarded the city a blazon featuring a castle of gold on a red background surrounded by eight condors (figure 43).[31] In Spanish heraldry, the castle not only represented the kingdom of Castile but was a generic reference to a fortified city and was therefore a symbol of warfare. The wording of the grant itself, however, indicates that the castle on Cuzco's coat of arms referred specifically to the Inka architectural complex of Saqsaywaman and to a specific moment in the history of the conquest.

In Madrid on July 19, 1540, a grant of arms is awarded to the city of Cuzco in which the arms that are given consist of a shield inside of

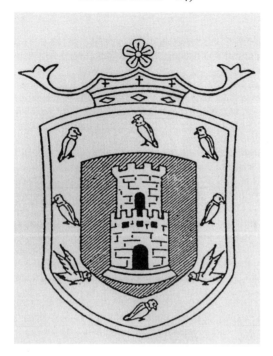

43. Coat of arms of Cuzco.

which is a golden castle on a field of red in memory that this city and its castle were conquered by the might of arms in our service. It shall have a border of eight condors that are great birds, resembling vultures, that they have in the province of Peru, in memory that at the time this city was won, these birds gathered to eat the dead that died there.[32]

The grant clearly refers to the battle for Saqsaywaman fought in 1536 between Spaniards and rebellious Inka under the command of Manku Inka (Manco Inca, sometimes called Manco II), the son of a pre-Hispanic Inka ruler and heir to his position of leadership.[33] By placing "the fortress" on the city's blazon, civil authorities ensured that Saqsaywaman became what we might call the "signature ruins" of Inka Peru, the ruins that represented the conquest of the Inka state from Ecuador to Chile.[34]

The retaking of Saqsaywaman by the Spaniards and their Andean allies was a crucial success during the Inka rebellion in which much of the city was destroyed.[35] Antonio de Herrera, who used the writings of Pedro Pizarro and other eyewitnesses to the events described, says that the rebel

indigenes were determined to burn the building that Spaniards were using as a church "because they believed that if they burned it down, it was certain that all the Castilians would die."[36] The rebels shot flaming arrows and flung hot stones onto the church's straw roof. Herrera relates how "this fire — and they all saw it — put itself out, a thing that the Castilians and the Indians took for a miracle. And from then on their [the rebels'] spirit was broken so that they never again showed courage or the accustomed fierceness against Cuzco."[37] As discussed in the previous chapter, the Inka customarily captured the principal waka of their enemies and punished the sacred items publicly as a means of disciplining those who opposed them. In these instances, the ambassadorial waka embodied the people who held it sacred, and it suffered vicariously for those who revered it. If Herrera's account (likely based on that of Cieza) is true, the rebel Inka apparently identified the sacred edifice — the church — where the Spanish occupants of Cuzco worshiped as the waka whose destruction would, in turn, ensure the annihilation of the Spaniards.

Because the Spaniards, for their part, recognized Saqsaywaman as a strategic vantage point, they exerted considerable effort recapturing it. In the process, the Spaniards, together with their native allies, suffered great losses, including that of Juan Pizarro (the brother of Francisco, who was in Lima at the time). Although the siege of Cuzco continued for many months, the "reconquest" of Saqsaywaman was the turning of the tide. Possession of Saqsaywaman thus became a metaphor for the possession of Cuzco, if not all the future viceroyalty of Peru. While Saqsaywaman was taken apart during the sixteenth century and beyond, with its stones used to build other structures, figuratively it faced reconstruction. Cuzco's new Spanish coat of arms Europeanized the Inka's "fortress" of Saqsaywaman. The emblazoned Saqsaywaman is a typical medieval European fortress similar to the castle representing Castile on the royal Spanish blazon and those on hundreds of other European coats of arms. Thus Cuzco is visually characterized as just another fortified city in the expanding Spanish landscape. But Cuzco was not a medieval European town, and its fortress was not constructed by Europeans. The blazon's fictive castle, which denies the distinctiveness of Inka architecture, figuratively converts the city from Inka to Spanish and so participates in ongoing hispanicizing efforts. The tower on Cuzco's coat of arms articulates the Spanish desire to remake Cuzco into a Spanish city. The juxtaposition of the empirical reality of Saqsaywaman (an Inka structure in the first

phases of ruination) and the imagery on the coat of arms (a whole and perfect Europeanized tower) advanced the colonizer's cultural agenda.

To the Spaniards, Saqsaywaman represented more than just military conquest and control, however, for the so-called fortress itself was more than just an Inka stronghold. Considering its associations with both the Inka's military might and their solar cult, Saqsaywaman symbolized, as no other structure in Cuzco could, both military and religious triumph. Not long after the battle of 1536 was won, the legend spread that Santiago (Saint James the Greater), the patron saint of Spain, had ridden to the aid of the Christians astride his great white charger. The Virgin Mary was also said to have rushed to the aid of the besieged Spaniards by flinging sand into the eyes of the rebel Andeans. The stories are particularly confused about the location and date of Mary's miraculous appearance.[38] It was generally believed that while Santiago appeared at Saqsaywaman, Mary descended at the *suntur wasi*, a circular tower that was a focus of Inka ritual, where the Spaniards had taken refuge. According to legend, the Spaniards decided to build Cuzco's cathedral on this site in memory of Mary's descent, and she was elected as its patron. When a new and larger cathedral was built alongside the original (finished in the seventeenth century), the earlier edifice was converted into a chapel. This chapel was called El Triunfo (the Triumph) in memory of the victory won with Mary's aid.[39] The cathedral and Saqsaywaman thus generate a dialogue between the Spanish and Christian center and the Andean and non-Christian periphery. As the cathedral was erected, Saqsaywaman was dismantled; stones from Saqsaywaman were used to edify the cathedral. The conversion of stones from their original use in Inka walls to their new appearance in European architecture not only paralleled the religious conversion effort but seemed to illustrate and actuate it.

As part of a ruin, then, the rocks of Saqsaywaman were inscribed with memories of a victorious battle against paganism. Indeed, many Spaniards described Saqsaywaman as the product of satanic handicraft. Viceroy Francisco de Toledo, for example, writing to the king from Cuzco on March 25, 1571, describes Saqsaywaman as "a thing in which the power of the devil and his subjects is well demonstrated."[40] In the mid-seventeenth century, the Franciscan Diego de Córdoba y Salinas similarly suggests that Saqsaywaman represents devil's work: "It makes one imagine that the devil helped in [building] that edifice."[41] Such characterizations not only denied ingenious Andean engineering and skilled masonry but posi-

tioned the very structure itself as an enemy. An official on Cuzco's ecclesiastical council summed up the view of the ruins as a monument to the destroyed pagan past: "[The fortress] was once dedicated as a house of the sun and in this time [1650] only serves as a witness of its ruin."[42] As Saqsaywaman was a product of devilish powers, so the reasoning goes, its ruins were a testament to the Christian god's ultimate triumph. Analogously, the creation of this particular ruin was God's work.

Indigenous residents of Cuzco not only witnessed Saqsaywaman being reduced to ruin to raise the Christian church but also performed the labor, under Spanish supervision, to dislodge the stones of Saqsaywaman and erect the cathedral. As I have argued more thoroughly elsewhere, they did not necessarily understand the ruins as evidence of conquest and capitulation, however.[43] Those who had allied with the Spaniards saw Saqsaywaman as a symbol of their victory as well, but also as a symbol of an appropriate and timely conversion to Christianity, which was something they had chosen rather than something they were compelled to do. Later indigenous versions of the siege of Saqsaywaman emphasize that the rebels had fought the supernatural—and therefore insuperable—powers of Santiago and Mary; Spanish forces play a minimal role in the events. Native Andean accounts of the famous seige characterized the battle as a lopsided conflict between formerly misguided Inka and overwhelming supramundane forces. Saqsaywaman was perceived as a site of an encounter with the sacred, rather than an ignominious military defeat. Significantly, Saqsaywaman continued to be kratophanic for Andean indigenes; its rocks were the site of numinous presence where encounters between this world and the powerful forces of other worlds occurred. Thus what was repressed in the early colonial years eventually reemerged in new stories of saintly apparitions.

EVERYTHING OLD IS NEW AGAIN

I have focused here on Saqsaywaman because it was featured in hispanicizing discourses regarding Inka ruination and Spanish triumph. Let us keep in mind, however, that Cuzco's other pre-Hispanic structures were "ruined" during the colonial-period re-creation of the city as well. For example, the Qurikancha (Coricancha), the temple of the Sun and the center of Inka religious devotion, provided the foundation for the

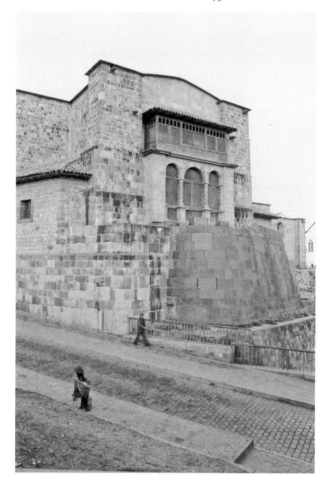

44. Qurikancha–Santo Domingo exterior, Cuzco.

church and cloister of the Dominican order. In reworking the sacred *kan-cha* (enclosure), many Inka walls of worked stone were covered over and built on (figure 44).[44] Pre-Hispanic walls of finely joined masonry were integrated into many Spanish structures bordering on or located near the central plaza. New buildings in the Spanish style, and the new purposes to which Inka buildings were put, recontextualized Inka masonry, making Cuzco a very new old city. And structures were not the only things rebuilt. The Inka's double plaza was diminished in size, and the river that ran through it was eventually covered over. Once Spaniards understood the sacred character of the sand that the Inka had imported

from the Pacific coast and covered the Inka plaza, it was removed and used in further Spanish building.[45]

While those aspects of Cuzco's built environment—its structures and plazas—that were, in some sense, comparable to elements of the standard European built environment were revised in accordance with the preferences of the colonizers, the fate of only a small percentage of the petrous waka that peppered the Inka's city is known. The wawqi, the lithic brothers of Inka rulers (see chapter 1), were seized by Spaniards who were looking for the mummified corpses of the rulers and any gold and silver objects kept with them. Gonzalo Pizarro, for example, searched diligently for the body of the Inka ruler Viracocha (Wiraqucha), believing that there was a great treasure in precious metals to be had. Cobo tells us that Gonzalo "burned some Indians, men and women" (*quemó algunos indios, hombres y mujeres*) in an effort to learn of its location, and goes on to say that after the body was found,

> Pizarro had the body [of the Inka ruler] burned, but the Indians of the Inca's *ayllo* [kin-group] collected the ashes, and, with a certain concoction, they put them in a very small earthenware jar along with the idol [i.e., the wawqi], which, since it was a stone, was left by Gonzalo Pizarro's men, who paid no attention to it. Later, at the time when Licentiate Polo was in the process of discovering the bodies and idols of the Incas, he got word of the ashes and idol of Viracocha; so the Indians moved it from where it was before, hiding it in many places because, after Gonzalo Pizarro burned it, they held it in higher esteem than before. Finally, so much care was taken in searching that it was found and taken from the possession of the Inca's descendants.[46]

As Cobo notes, the city's corregidor, Juan Polo de Ondegardo, eventually rounded up many of the royal wawqi during his efforts to seize and destroy the preserved mummies of deceased rulers. One of these wawqi, and one of the most revered of all Inka objects, was Wanakawri, the petrified brother of the first Inka ruler (see chapter 1). Cobo describes it as being "of moderate size, without representational shape, and somewhat tapering" (*era mediana, sin figura y algo ahusada*); he indicates that the Spaniards removed "a great quantity of the gold and silver from this shrine but paid no attention to the idol, because it was . . . a rough stone" (*mucha suma de oro y plata, no repararon en el ídolo, por ser . . . una piedra*

tosca).[47] Pawllu Inka (Paullu Inca), a descendant of the ruler Wayna Qha-
paq, took possession of it and housed it near his own dwelling in Cuzco,
where it continued to be celebrated until finally the Spaniards recognized
its sacred character and removed it.[48] Because most wawqi were neither
of precious materials nor finely crafted (see chapter 1), the two things
to which Spaniards given their cultural precepts responded, they were
deemed unimportant and so not preserved.

While we might presume that, like the Wanakawri wawqi, many of the
Inka's free-standing sacred rocks were eventually gathered up and done
away with, large boulders and outcrops were not so readily dispatched.[49]
Not surprisingly, then, the conversion of the Inka's sacred topography
companioned the conversion of indigenous people. Located to the east
of the city center is an outcrop known today as El Señor de Tetecaca (Our
Lord of Tetecaca). It is an outcrop sculpted with niches, platforms, steps,
and a miniature terraced landscape.[50] In the colonial period, it was trans-
formed into a sacred Christian site by the addition of a cross, and rever-
ence continues there today (figure 45). The cross concentrates reveren-
tial focus on one area of the outcrop, thereby refocusing devotion from
the rock to the cross. Indeed, the rest of the erstwhile waka has today
become a place for dumping trash. Likely, this would have been con-
sidered a relatively successful example of refocused reverential behav-
ior, something that was standard operating procedure for extirpators and
others interested in combating Andean "idolatry" and instituting Roman
Catholicism.

There are many examples of similar substitutions. Suffice it to mention
the following: in Cuzco, the parish church of Santa Ana was located on
the site of a rock waka (specifically, Marcatampu, the third waka on the
seventh siq'i of Chinchaysuyu); in Yucay, on the estate of Wayna Qha-
paq in the Urubamba Valley, is a Catholic shrine that was built near the
white boulder located in the center of Quispiwanka's main plaza; in the
village of Huanca (i.e., Wank'a) is the Wank'aq Rumi, a solitary rock
considered to be the petrified founder of the village that was Catholi-
cized through the apparition and miraculous deeds of Christ and is now
celebrated on September 14 (the Exaltation of the Cross) as El Señor de
Huanca; southeast of Chinchero, in a plaza known as Huancapata (Wan-
k'apata, or "Wank'a terrace") is a colonial church designed to redirect
reverence from the large rock outcrop wank'a (the lithified founder or

45. Señor de Tetecaca, Cuzco.

owner of territory), near which it sits; and at Copacabana a sacred rock was supplanted by the Virgin Mary, who took on many of its associations.[51]

Although we have many examples of "converted" lithic waka and although signs of Catholicism are readily visible throughout the Andes today, evidence suggests that some of these conversions were less than thorough, especially those at a distance from the watchful eyes of evangelical clergy. In addition to active resistance (as in the Taki Onkoy movement) and clandestine perseverance on the part of indigenous believers, many private or local practices, including offerings given to

guardian stones in fields (called chakrayuq; see chapter 1), were over-looked by colonial-period extirpators and continue even today.[52] Because the Andean approach to religion is inclusive rather than exclusive, mean-ing that adopting new beliefs does not require that old beliefs be aban-doned, both beliefs and practices can be added without necessarily jetti-soning what was already there. The composite results can readily be seen on spectacular occasions like Quyllur Rit'i (see chapter 2), when acts of devotion occur both at the Catholic chapel and at the nearby rock waka where the Christ child was said to have appeared in 1785. The partici-pants, in word and action, honor the regional mountain apu as well as Christ.

EVERYTHING NEW IS OLD AGAIN

Throughout the colonial period, Inka edifices, shrines, and burials were systematically looted and stripped of valuables. The fate of Saqsaywaman is best known, but contracts in Cuzco's Regional Archives tell of the dis-covery and excavation of many minor waka, most of them tombs.[53] Today campesinos still commonly suggest that a golden corncob or other pre-cious object might be found while poking around in the countryside. As I have discussed elsewhere, their urban compatriots have found more sub-stantial gold in the Inka past, although it is the wealth not of objects but of imaginations, for tourists flock to Cuzco to experience an imagined Inka past. In these imaginings, the ruins of Saqsaywaman continue to represent the city's Inka heritage. Its megalithic walls provide a powerful backdrop to the final rites of the modern sun festival, called Inti Raymi, which was introduced as a tourist event in 1944.[54] Today's Inti Raymi, it should be noted, appeals primarily to Peruvians, especially tourists from Lima and Arequipa. European and North American tourists may attend the events, but they tend to scoff at the perceived inauthenticity of the show. Indeed, one early visitor, a scholar of colonial Latin America, dis-missed the modern Inti Raymi as a "parody" and "costume party for tourists."[55] Any re-creation of the past for touristic consumption requires a measure of "popular fantasy," and Inti Raymi is no exception.[56]

North Americans seeking "authentic" experiences today seem to pre-fer New Age presentations of the Inka past.[57] Perhaps because these tour-ists are willing to pay well for their expectations to be fulfilled, newly

realized shamans can often be found near Salunpunku (often called Lajo, Laco, or Laqo, as well as the Temple of the Moon) or other Inka sites outside Cuzco. These individuals contrast with traditional Andean healers, called *paqo*, who work at the behest of locals and usually shy away from tourists, often conducting their rites at night when tourists are absent. Self-identified shamans, however, those we might think of as "tourist shamans," perform newly devised ancient Inka rituals that combine traditional Andean practices with the buffet of beliefs and practices associated with shamanism worldwide; they execute what Dean MacCannell might describe as "staged authenticity." [58] New Age tourists can also witness prearranged "mystical" rites at the sites of Kenko, Tambomachay, Lanlakuyuq, Kuslluchayoq, Ollantaytambo, and Machu Picchu. [59] Here we should note that although shamanism is often described as the most ancient of religions, it is not, unlike other religions, a codified (or even coherent) set of practices or beliefs. Rather, shamanism, as known today, is an invention of eighteenth-century (colonizing) Europeans who segregated out what they thought of as primitive practices from the recognized religions of civilized or semicivilized (usually literate) peoples and so created an illusory connection between diverse autochthonous religious complexes. [60] The practices of the new Peruvian tourist shamans often include meditation, chanting or humming, the burning of incense, the waving of condor feathers, the lighting of candles, and the making of an offering, usually of coca leaves and an alcoholic beverage. Participants are blessed by being touched with the offering before it is burned, or by being sprayed with perfumed water from the shaman's mouth. The shamans earn money through tips and by selling items used in their ceremonies. Setting these practices within the space of ruins lends an air of ancient authenticity to the rites. They also assert a certain continuity with the past, suturing themselves to the pre-Hispanic era, as though Inka religious beliefs had not been much affected by Catholic conversion efforts.

Because the ruins visited by tourists are parts of once larger structures, they are necessarily metonymic; they always implicate some missing whole of which they were once part. They are reminders of holes or gaps in history, and of incomplete knowledge. While Spaniards spanned the gaps in their knowledge of Saqsaywaman with stories of satanic handiwork that served to characterize Spaniards as agents of God, today tourists plug the holes according to their own (equally self-serving?) preconceptions. In the early 1990s, when television's *X-Files* was popular

worldwide, some tour guides identified evidence of UFO visitation in the pre-Hispanic Andes by pointing to almost any circular ruin, such as that of the Muyuqmarka tower at Saqsaywaman, as a landing pad for alien spacecraft (figure 46).[61] Alfonsina Barrionuevo aptly observes that the assertion that aliens in UFOs built spectacular pre-Hispanic structures is not that different from Spanish allegations that the same structures were built with the aid of the devil.[62] Still do we find, from colonial days to the present, that the language of "mystery" (how could it have been done?) allows for the elision of Inka engineering, craftsmanship, and creativity. The reasoning seems to work as follows: because the Inka, having only stone tools and lacking draft animals and the wheel, could never have built all that survives from the height of their empire, aliens from outer space must have. It should be noted that despite their wide variety, modern interpretations, like those of Spanish colonizers before them, largely deny Inka agency—rocks are formed not by persistent pecking (nibbling), but by stone-softening acids developed from local herbs, or lasers generated from parabolic mirrors, or alien technology.[63] The separation of the Inka from the products of their labor has been one of the most pernicious effects of the Spanish invasion. Even some Quechua speakers today maintain that the Inka were able to make the stones move only with the force of their thought. The skill and effort required to manipulate stone, aspects of stonework that were stressed by the Inka, have dissolved into magic.

Cynics will recognize that modern day tourist-shamans comply with what tourists today believe about "primitive" peoples and their religions. The anthropologist Jorge A. Flores Ochoa charts the history and rise of such "mystical tourism" to the Andes over the last twenty-five years and the concomitant commercialization of Andean religious beliefs and practices.[64] Apparently, as early as the 1940s, Cuzco was identified as being near a "telluric center" of the planet Earth, with some believers understanding that the earth's "magnetic center" had relocated itself from Katmandu in the Himalayas to the Andes near Cuzco. Tourists today are more often than not encouraged to position themselves at the center of circular ruins and, rather than look to the heavens for alien spacecraft, focus on the earth so as to absorb telluric energies. They can also be found laying hands on stones to achieve the same end (figure 47). New Agers, often known in the Andes as *esotéricos*, are, owing to their belief in the power of crystals, more inclined to recognize the numinous qualities of

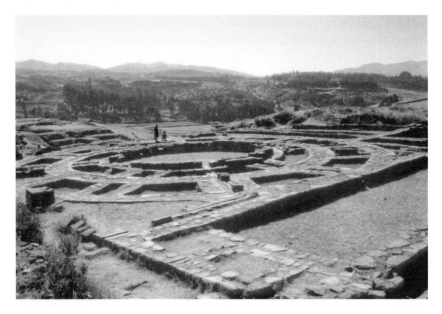

46. Foundations of Muyuqmarka, Saqsaywaman.

47. Tourists touching Intiwatana, Machu Picchu.

Inka rocks than are other visitors to Inka ruins. Unfortunately this has not led to greater respect for what is left of the Inka built environment. New Agers, desiring the healing power of Inka rock, have been blamed for chipping away at the gnomons on Pisaq's sacred outcrops until they have virtually disappeared.

The anthropologist Quetzil E. Castañeda, in his study of the Maya site of Chichén Itzá, opined that the interpretation of ruins is an act of ventriloquism, an act, we might observe, made especially obvious in sound and light shows, but one that occurs every time mute ruins are spoken for.[65] Because the believability of the ventriloquy correlates only in part with how well the voice and what it says correspond to what is actually seen, what the ventriloquizing voice pronounces reveals much about the ventriloquist and his needs and desires. At the outset of this chapter, we saw how in Spanish commentary on Saqsaywaman, the discourse of mystery displaced local knowledge and so reinforced Spanish beliefs about non-Christian people and their dealings with the devil. It is now clear that colonizing Spaniards were merely the first to mystify indigenous Andean achievements. I turn now to further contemplate some contemporary mystifications.

CREATING Q'OSQ'O

Many individuals, starting with Peru's most famous chronicler, the mestizo known as Garcilaso de la Vega, translate *cuzco* as "the navel of the world" (*ombligo de la tierra*), although there is no evidence to support this rendering; others suggest it means "landmark," "dried-up lake bed," "pile of stones," or "rock."[66] Mayor Daniel Estrada Pérez, who went on to be elected to national office in 1995, accorded official status to Q'osq'o, the so-called Quechua spelling of Cuzco.[67] Under Estrada, the city underwent a face-lift with the addition of dozens of fountains and, in particular, two grand statues of the pre-Hispanic ruler Pachakuti Inka Yupanki, who is known as the empire builder and the designer of ancient Cuzco, as well as for many other great deeds and accomplishments.[68] Pachakuti has become the human face of the Inka past in present-day Cuzco, and his name has recently been adopted as a title of authority by contemporary Peruvian leaders on ceremonial occasions.[69] Because it is the city's ancient history that lures tourists, Cuzco's pre-Hispanic Inka iden-

tity is brought to the fore and made visible; it has become a "presented past."[70] Names that were endowed during the colonial period and helped efface the Inka city are themselves being erased: the former Calle Loreto, named after an advocation of the Virgin Mary, is now labeled Intik'ijllu; and Avenida Triunfo, named after the miraculous appearance of the Virgin Mary during an Inka rebellion in the sixteenth century, is now marked Sunturwasi after an Inka structure that is believed to have once occupied the site.[71] It is interesting to note that only tourists and newcomers to the city actually use the new names. In fact, one shop owner on the plaza told me that the new street signs were not actually meant to designate new names but to serve as reminders of the Inkaic origins of the city. Needless to say, as I have noted elsewhere, the new signs are not helpful to tourists who are directed to a shop on Pasaje Arequipa when its only label is now "Q'aphchik'ijllu."[72]

In the new-old city, finely joined, mortarless Inka masonry is the primary vestige of the pre-Hispanic past. Edifices constructed in the early twentieth century imitate Inka masonry and provide a bridge from present to past.[73] The Inka's distinctive polygonal masonry can be found on food labels and shop signs. Polygonal stonework has been abstracted for part of a train logo that tourists by the thousands see as they travel from Cuzco to Machu Picchu.[74] It also provides the inspiration for contemporary jewelry by the talented Carlos Chaquiras, who makes brooches and pendants in silver and gold for the tourist market in Cuzco. While polygonal masonry is itself readily recognizable as Inka, the Stone of Twelve Angles, also called the Twelve-Angled Stone or the Twelve-Cornered Stone, is the single most recognizable block of polygonal stonework (figure 48). While other Inka polygonal blocks have even more angles, none is so readily accessible.[75] The Twelve-Angled Stone is located on Hatunrumiyoq, a walkway between the main plaza and the parish of San Blas, where many artisan shops are located. It is part of a retaining wall of finely worked polygonal, uncoursed stones that once provided the foundation for a ruler's compound. It later became the archbishop's palace and now serves as the Museo de Arte Religioso. Tours of the city stop at the stone to draw attention to the quality of the Inka masonry. Because of touristic interest, there is always considerable activity around the stone—street musicians, local children with postcards, women and children in native dress with llamas available for photographs, and so on.

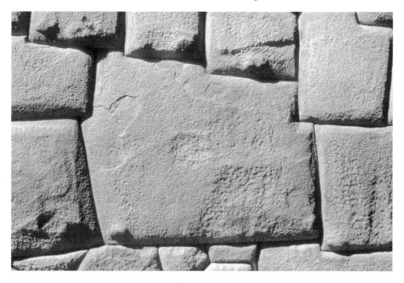

48. Twelve-Angled Stone, Cuzco.

The Twelve-Angled Stone now surely qualifies as what Alfred Gell dubbed an iconic anicon. Gell noted that something might be described as iconic if it represents something beyond itself regardless of whether it is resemblant. Thus, he argues, even anicons (nonresemblant things) can be functionally iconic.[76] The Twelve-Angled Stone represents more than just the finest Inka masonry. It signs the Inka's many accomplishments and, more generally, the glorious Inka past. It is featured on Cusqueña beer bottle labels and appears in advertisements for goods and services of all kinds, from CDs of Andean music to signs for parking garages. A smaller-scale version of the Twelve-Angled Stone was worked into the façade of the Palacio de la Municipalidad, built in 1934. A larger-scale version appears on Sol Naciente brand *pasta pura de cacao*, where it has been enlarged relative to its companion stones and placed in the corner of the uppermost row of stones in a megalithic structure (figure 49). An Inka ruler stands on it, saluting the sun, while kneeling women raise their arms in praise behind him.[77] With the popular culture of modern Cuzco saturated by images of the Twelve-Angled Stone, visitors to the city recognize its value as something apart from the wall in which it is fixed. In many representations, in fact, it is extracted from its place in the wall and exists independently, though it is the quality of precise integration that caused it to be noticed in the first place.

49. Sol Naciente brand chocolate.

Once orphaned—that is, conceptually removed from the wall—the Twelve-Angled Stone becomes part of tourist culture, expressing the interests and preconceptions of this new group of viewers.[78] From the archbishop's archives, located in the former archbishop's palace, where a window overlooks Hatunrumiyoq just above the location of the Twelve-Angled Stone, one can overhear tour guides as they stop with their groups of tourists to draw attention to this "icon" of Inka masonry. Many tourists ask why the stone has twelve angles—was twelve a significant (even magic) number to the Inka? Some guides suggest that the twelve angles correspond to the twelve months of the year, and thus that the Twelve-Angled Stone is a calendar. Before devoting time to the discussion of pre-Hispanic calendars and the seemingly overwhelming popular interest in them, I need to note that many other tour guides patiently respond to such queries by saying that twelve was the number of angles needed to fit that particular space in the wall and that the number of angles was not as important as the extraordinary craftsmanship required to fit it so precisely in place (which is what would have made it a "remembered rock," as described in chapter 3). Still, with so many images of the stone extracted from its masonry context, one can readily understand why visitors to the stone see it not as part of the wall but as an independent entity with "star power" all its own.

Now to calendars: How many times have tourists in the Andes been told that a pre-Hispanic monument is a calendar? Where does this abid-

50. Inka calendar. T-shirt based on drawings of the months by Felipe
Guaman Poma de Ayala, *El Primer Nueva Corónica*, ca. 1615.

ing interest in calendars come from? Some degree of the widespread fas-
cination with pre-Hispanic timekeeping surely comes from the celebrity
of other pre-Columbian calendars, especially those of the Maya and the
Mexica (Aztec) in Mesoamerica. Indeed, the so-called Aztec Calendar
Stone is surely the single most celebrated pre-Columbian artifact. As
such, it exerts tremendous influence, a consequence of which is the ex-
pectation that other pre-Hispanic cultures produced comparable visible
calendars. Places where pre-Hispanic cultures lack calendar stones ap-
parently feel the absence intensely. Peruvian T-shirt makers, for example,
have created a "Calendario Inka" — round, with arrowlike rays of the sun,
similar to the Aztec one — by borrowing the images of monthly festivals
from the colonial-period chronicle by the indigenous Andean author and
artist Felipe Guaman Poma de Ayala, converting them from rectangular
to wedge shaped, and arranging them in a circle around a solar visage
(figure 50).

 In lieu of an Inka version of the Aztec Calendar Stone, which is often
called the Sun Stone and is thought by many to feature the face of the

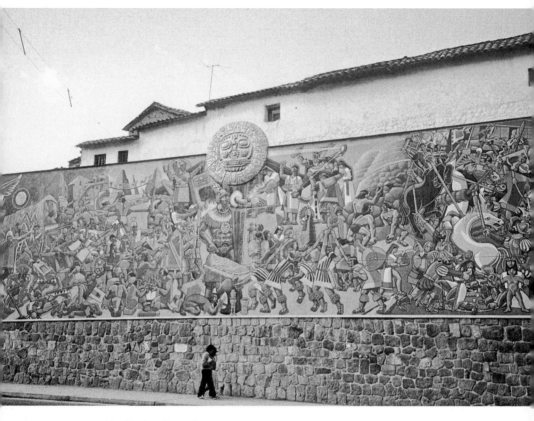

51. Mural by Juan Bravo, Cuzco.

sun, a pre-Hispanic countenance has emerged to represent the Inka sun, called Inti by the Inka.[79] It is featured in a mural on Cuzco's Avenida El Sol, painted by the artist Juan Bravo in 1992 (figure 51). This same "sun," a visage with lateral appendages, can now be found on Cuzco street signs, calendars, T-shirts, and other tourist-oriented material. Its golden face has become the official Inka sun disk, the face of Inti, the patron deity of Inka royalty. The image, however, is actually derived from a pre-Inka *repoussé* gold plaque, 13.5 centimeters in diameter, known as the Echenique Plaque, after the Peruvian president who owned it. It was published in the mid-nineteenth century when its "rayed" visage was identified as the face of the sun and as an "Inca Zodiac" or calendar in the manner of the Aztec Calendar Stone.[80] Subsequently, it was featured in numerous publications on Andean art and was even depicted on Peruvian postage stamps.

That it was eventually acquired by George G. Heye and then passed, as part of the Heye Foundation, to the Museum of the American Indian also helped sustain its popularity. Rowe has demonstrated convincingly that the plaque can be attributed to a culture that existed centuries before the Inka, and that the Inka never adopted this as the image of their solar deity.[81] Further, there is no reason to think that the plaque ever functioned as a calendar.

ICONICITY VERSUS "INKANICITY"

The opening chapter of Genesis features the well-known verses "So God created man in his own image, in the image of God created he him; male and female created he them" (Genesis 1:26–27). This passage contains several fundamental precepts of Western thought: that because human beings are mimetic reflections of their supernatural creator, God has a human form, and consequently he can be represented as human. Contrariwise, at least some Inka deities lacked "knowable" faces. Surely part of the appeal of the Echenique Plaque is that when you look at it, it appears to look back through its two golden eyes. The lack of notable Inka imagery has contributed to the notion, as observed in the last chapter, that the Inka were a practical folk concerned with feats of engineering rather than creating great works of art. It is not that the Inka did not create images, however, for the Inka produced many figurative votive statues as well as representations of several deities, among them the creator deity Wiraqucha, a war god, divine rulers, and the sun. By the time Spaniards first entered Cuzco, the Inka had already removed the "idol" representing the sun.[82] We are told that Manku Inka took it to Vilcabamba after his unsuccessful rebellion against the Spaniards, and it was later captured by the Spaniards when they took Thupa Amaru (Topa Amaro, Tupaq Amaru), the last leader of the independent Inka, prisoner in 1572. Viceroy Toledo indicated that he would send the "idol" to the Spanish king Felipe II; later he suggested that the king might offer it to the pope. Nobody knows what actually happened to the "idol," however, much less what it looked like. Some chroniclers report that it was a gold disk; others describe it as a statue. The chronicles variously use the words *imágen* (image), *bulto* (anthropomorphic statue requiring dress), *estatua* (statue

not requiring dress), *plancha* (plate or sheet), and *disco* (disk) to describe it. After considering the various sources and the likelihood of who might actually have seen it, Duviols concludes that the image of the sun called Punchao by the Inka was an anthropomorphic statue of gold.[83]

While the golden Punchao, whatever it may have looked like, resided in the temple of the sun, the Inka also had a stone that embodied the sun. As noted in chapter 1, chroniclers described it as loaf shaped with a belt of gold and say that it was frequently placed in the main plaza of Cuzco, where it could be venerated by larger numbers than were ever permitted inside the sacred enclosure of the Qurikancha. In chapter 1, I suggested that the Inka may have considered the loaf-shaped stone to be the lithic wawqi (brother) of the figurative gold statue. Just as the human Inka ruler had a stone brother that was not anthropomorphic, so too did the apparently anthropomorphic Punchao have a nonanthropomorphic stone brother. While gold and silver images were quickly spirited away and melted down by the Spaniards, the nonresemblant stones were not recognized as significant and so were frequently abandoned and lost.[84] Had this aniconic embodiment of a deity been preserved, what would be our response to it today? Based on the reception of other nonresemblant rocks, evidence indicates that recognition of its value would be hampered by a pervasive preference for imagism, a preference that might be termed iconocentricity. Shelly Errington has argued that "the naturalistic prejudice—the idea that art (whether flat or in the round) is made meaningful by resembling something in the world and that it strives to do so in a way as optically realistic as possible, even if it does not always achieve it—is very deep [in the West]." While Western aesthetics have, over the centuries, tended toward pluralism, so that today, for example, neorealists can paint alongside abstract expressionists, the mimetic mode of representation clearly dominates, especially in our evaluation of the visual cultures of those outside the West. Errington, in fact, suggests that "iconicity remains an unstated and even repressed criterion for the identification of what counts as art."[85] By iconicity she means optical naturalism, the ability of observers to find resemblance to something recognizable—most notably a person or an animal. The idea that the best art imitates nature the best has been characterized as the Daedalic ontology of art. According to Greek legend, Daedalus was the first to make statues so lifelike that they appeared to move or even were capable of movement. Thus

his art was so close to nature as to act naturally. For the Inka, of course, certain rocks could move or speak not because of their appearance but because of their essence. Owing to the West's preference for optical naturalism, the recognition of important non-Western anicons has a troubled history. Yet scholars and the public alike have often ventured into the world evaluating unfamiliar material culture and identifying art according to Western expectations.[86]

The preference for resemblant artifacts surely explains, at least in part, the anachronistic pre-Inka image (the Echenique Plaque) used today in Cuzco and identified as the Inka's sun. It may also explain the use of imagery from other pre-Hispanic periods and geographic locations by Cuzqueño institutions, a practice that Helaine Silverman describes as a "wanton" conflation of time, place, and culture.[87] One of the most frequently evoked images is the golden mask and *tumi* figures derived from the Chimu and Sicán (or Lambayeque Chimu), related cultures from Peru's north coast. Replicas of Chimu faces are sold in touristed areas of Cuzco, where they are often identified as Inka deities or divine rulers. The adventure movie *Max Is Missing* (1995), filmed in Machu Picchu, Ollantaytambo, and Cuzco, features a young American (Estadounidense) tourist who is given an "Inka treasure" by a dying grave robber. The film's great treasure, identified as the statue of the ninth ruler, Pachakuti, is in fact a slightly revised replica of a golden Chimu figurine inlaid with turquoise. The grave robber tells our young hero to go to "sexy woman" when the moon is full. While running from more grave robbers and keeping his eyes peeled for a pulchritudinous female, the protagonist has a vision of the ruler Pachakuti emerging from the rocks as an animated lithic warrior. The final showdown—at the ruins of Saqsaywaman under a full moon—features local natives in "Inka" dress skirmishing with the grave robbers, saving the young tourist and his family and retrieving Pachakuti's treasure, which will be placed in a local museum instead of being sold to a foreign buyer as the thieves had planned. While the movie takes advantage of the pre-Hispanic story of rocks coming to life to aid Pachakuti in one critical battle (see chapter 1), it simultaneously eschews Inka-looking treasures, preferring the imagistic golden Chimu statue of a male figure in fancy headdress and elaborate regalia. Inka rocks provide the background and are the setting for the action sequences that revolve around golden images and the pursuit of them. To fulfill audience expec-

tations about what a pre-Hispanic representation of Pachakuti ought to look like, the film turns to the golden iconicity of another Andean culture, the Chimu.

The Western preference for images may also explain the focus in scholarship on the relatively few examples of resemblant Inka rock carving. It may explain the recent "discovery" of images in the Inka's built environment as well. The upper portion of the so-called Tower outcrop (the Temple of the Sun) at Machu Picchu has been likened to a puma, and its curved wall has been said to mimic the circular shape of the sun as well as a rainbow (plate 5).[88] Also at Machu Picchu, the so-called (and clearly misnamed) Prison Group is now known as the Temple of the Condor; the two projections of living rock are identified as the bird's wings extending from a stone carved to portray the condor's head (plate 15). In Cuzco, recent books aimed at tourist audiences encourage the identification of zoomorphs in free-standing rocks as well as in the walls of worked Inka masonry. In the zigzagging walls of Saqsaywaman, for example, Fernando and Edgar Elorrieta Salazar find a serpent, a bird, and a fish.[89] Kenneth R. Wright and Alfredo Valencia Zegarra find a hummingbird with eggs and a baby in the megalithic wall south of the Granite Spires at Machu Picchu.[90] Juan Carlos Machicado Figueroa, an author and tour guide, has found a puma in the exterior wall of the Temple of Three Windows at Machu Picchu; a *qoa chinchay*, a mythical creature with feline head and front legs attached to a serpent's body, at Ollantaytambo; and llamas and alpacas at Saqsaywaman (figure 52).[91] Another guide (and former university professor), Darwin Camacho Paredes, reports that people have identified the Sacred Rock at Machu Picchu as a guinea pig or a fish (plate 4).[92] While Camacho refutes such notions, many other guides have embraced these identifications, likely because tourists respond positively to the supposed discovery of images in Inka masonry. In fact, it is not uncommon these days to find tourists participating in the search for surreptitious imagery in the ruins of the Inka built environment. This is the "tourist gaze" at its most extreme, for it expresses a desire not just to see the sights but to create new ones within the confines of established sites.[93] So many viewers see a puma in the framed vertical rock at Kenko Grande that it is now often referred to as the Puma Rock; Pasztory, however, identifies it as a jaguar, while Elorrieta and Elorrieta call it a toad (figure 10).[94] Because there is no evidence that the Inka valued the outcrop at Kenko for its putative likeness to a puma (or

52. Llama shape discerned in polygonal masonry (digitally enhanced), Saqsaywaman.

jaguar or toad), we must wonder whether our own iconocentricity has led us to many of these interpretations. Do we find a crouching puma in the natural rock at Kenko to meet our needs and expectations for "art"? Have we performed a modern act of lithomorphy by transforming this presentational rock into an imagistic statue?

The famed art historian E. H. Gombrich notes that humans have a universal tendency to discern secondary images in the shapes of geological formations, clouds, and other natural phenomena.[95] As discussed in chapter 1, the Inka themselves occasionally recognized the presence of sacred mountains in "echo stones," rocks that look like the mountains they embody. The Inka also identified rocks naturally and serendipitously shaped like other animate beings (animals and people) as waka. They may even occasionally have recognized the coincidental likeness of animals in their polygonal masonry. The Temple of the Condor at Machu Picchu, for example, seems a likely spot for the recognition of serendipitous likeness. Where the body of the condor would be is a passage through the outcrop. This space occupies a liminal zone between upper and under worlds, and mummies may have been kept there in Inka times. Contemporary indigenous Andeans identify the condor as a messenger able to travel among the layers of the world.[96] The Inka themselves worked the rock in front of the crevice to resemble a condor's head and enhance the resemblance (plate

15 and figure 53). Thus we have some reason to see this particular image in this one set of rocks. Yet it is clear that the Inka did not require most of their sacred rocks to be resemblant.

Like the word *waka*, *willka* (*huillca*) was translated as "idol" (*ídolo*) early in the colonial period, implying that it refers to an imagistic object. However, it also meant everything sacred (*todo lo sagrado*) regardless of appearance.[97] The Inka preference for substantial connections rather than superficial comparisons, for essence rather than appearance, means that many embodiments of the sacred will not be resemblant. To look for resemblance, then, is to see things that the Inka did not look for themselves. It is to impose the cultural order of the West on the Andes and thereby eclipse the Inka's cultural order.[98] The search for imagery in walls of finely worked dry masonry clearly responds to Western cultural precepts that are at odds with those of the Inka, who valued dressed stone for its ability both to index the facturing process and to embody absent, invisible, or distant numina. The search for zoomorphic forms in Inka polygonal masonry serves to transform the Inka's walls of purposefully aniconic stone into plein-air galleries of pictures, and its sacred topography into a sculpture garden.

That complete images are now found in the stony remains of Inka ruins also suggests that the process of ruination mattered very little in the end. Thus what is seen *in* Inka ruins mitigates the very nature of them *as* ruins; it also assuages the uncomfortable implications of ruins, that something, in this case Inka state culture, has been largely destroyed, is in large part unrecoverable, and that the erasure was often purposeful. It should also be noted that, in the process of interpreting ruins, the remains are naturalized as though ruination simply happened after the collapse of the Inka state. While today's tourists delight in finding the shapes of llamas and pumas, they also note that they are not very good representations; the approximation is rough and requires work to perceive. Ironically, then, familiarity both denies alterity and simultaneously reinforces Western superiority. What both conquistador and tourist have in common is the will, or perhaps the need, to re-create the ancient Inka in the image of, but inferior to, themselves. That this scenario recalls the Genesis account of God's creation of man as his lesser likeness should not be lost on us. The ongoing story of the rocks in Inka ruins, then, is the story of multiple conversions, if not creations, all of which render the ruins a comfortable, already known, and affirming space for visitors.

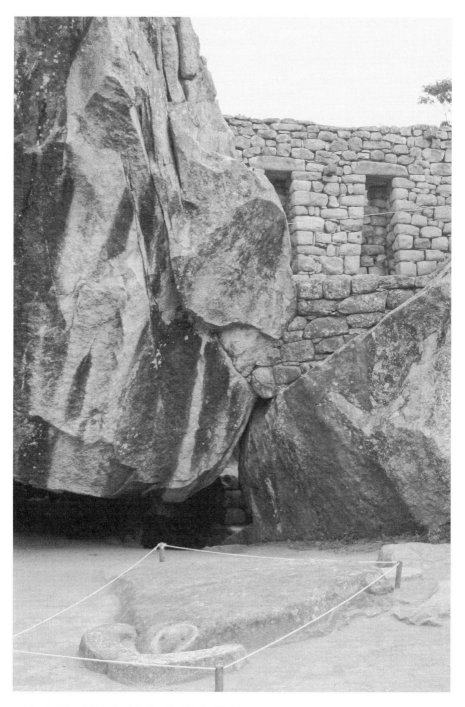

53. Condor's head, Temple of the Condor, Machu Picchu.

We might even wonder whether the appeal of the proposal that the Inka's capital of Cuzco was built in the shape of a puma owes to our desire for iconicity rather than any congruence with Inka practices. Published in 1967, Rowe's article "What Kind of a Settlement Was Inca Cuzco?" states that Cuzco was redesigned in the shape of a puma by the ninth Inka ruler, Pachakuti.[99] The evidence, laid out in footnotes, comes from two chroniclers, Betanzos (1551) and Sarmiento (1572), both of whom compared the Inka's capital to the body of a mountain lion and noted that the confluence of the Watanay (Huatanay, also known as Saphi) and the Tullumayu rivers was called Pumap Chupan, meaning "puma's tail." While Betanzos indicates that the ruler was the puma's head, Sarmiento identifies the head as Saqsaywaman. Rowe believed that the hypothetical feline shape was limited to the most sacred section of Cuzco, the part between the Tullumayu and Watanay rivers. Gasparini and Margolies, however, offer variations on the puma theme, suggesting that a crouching or reclining feline would have incorporated more of the area that pre-Hispanic Cuzco actually encompassed. Although noting that no other settlement replicated the puma shape of Cuzco, though Cuzco was the acknowledged model for other Inka settlements, Gasparini and Margolies still affirm the "puma hypothesis."[100] Zuidema, however, in his article "The Lion in the City," offers serious reservations regarding this hypothesis. He concludes that Betanzos was evoking a metaphor (that is, Cuzco was the Puma City similar to the way that New York is the Big Apple) and that Sarmiento, writing twenty years later and using Betanzos as a source, misunderstood his use of metaphor.[101] In support of Zuidema, Barnes and Slive, in their article "El Puma de Cuzco," show that the European chroniclers may have been influenced by popular (and imaginary) European drawings of cities in animal shapes. It should be noted that no other chronicler compared the city's shape to a puma. Despite these reservations, the notion that Inka Cuzco was shaped as a puma is accepted by many scholars and remains popular.

Perhaps inspired by Cuzco's purported puma shape, and prompted by recent books by Elorrieta and Elorrieta and Machicado Figueroa, tour guides at Inka sites today point out the "flying condor" at Pisaq, the "cosmic bird" of Machu Picchu, the llama of Ollantaytambo, and a variety of other supposed images found in the structures and environs of Inka settlements.[102] While English-speaking tourists often chuckle at their

guide's verbal conversion of Saqsaywaman into "sexy woman," few rec-
ognize how other acts of conversion are performed at all Inka sites, espe-
cially those in which images are identified. As pointed out earlier, how-
ever, tourists are not alone in their will to see imagery. Scholars, too, have
privileged imagism. We still often engage in processes similar to those by
which colonizing Spaniards collected and discarded certain objects. We
must wonder whether, by privileging the imagistic, by separating out
some certain artifacts as more worthy of study than others, Inka visual
culture has been stripped of its Inkanicity. Iconocentric looking seems to
have transformed Inka culture into something the West already knows
how to value.

CONCLUDING NOTE

In 1944, Luis Nieto wrote "Canto al Cuzco y a sus Piedras Sagradas"
(Song to Cuzco and to its Sacred Stones) in which he describes the Inka
stonework of Cuzco as having been asleep and dreaming for the cen-
turies since the Spanish invasion.[103] Nieto is, of course, not the first to
identify muteness as an attribute of stone. Other authors have gone fur-
ther. Alberto Flores Galindo notes that the identification of the Indian
with silent rock is a frequent and ambivalent metaphor in Peruvian lit-
erature.[104] At first blush, this seems consistent with some indigenous cre-
ation stories in which humans were first formed from stone. While the
analogy characterizes indigenes as persistent, tenacious, and enduring,
they are also silent and passive — being acted on, but never acting. Al-
though the analogy of stone and indigene is also found in Andean folk
stories of lithomorphy, most "literary" stones never come to life, never
act and respond, as they do in indigenous stories.

 Characterized as silent witnesses to bygone eras and past deeds, the
rocks of ruins frequently become inscribed with the imaginings of subse-
quent visitors — scholars, local residents, tourists and their guides. They
are the skeletons on which newly imagined stories are fleshed out. Thus
have Inka rocks been made to mouth many stories. Visitors ventriloquize,
speaking for the rocks with which the Inka once claimed to have actually
conversed. It is not coincidental that many modern Quechua speakers
observe that they no longer have the ability to speak with rocks.[105] Since

Spanish colonization, the rocks have had others speaking for them and about them. Because the Inka cannot speak, the stones cannot speak. I am reminded of Gayatri Spivak's assertion that the subaltern cannot ever speak, that to speak is to have power of self-definition, self-representation, and self-determination. Yet the Inka, like other Andeans, believed that rocks bear witness to history and are the proof of events long past. Thus, so long as those rocks stand, past events will never be forgotten entirely.

While my primary focus in this book has been on what can be discerned of Inka visuality, that is, specifically indigenous ways of seeing, I have also been mindful, especially in the introduction and here in the final chapter, of the aspects of non-Andean visualities that have circulated around Inka rockwork since Spanish colonization. Such a critical, reflexive approach underscores just how vexed cross-cultural and transhistorical understanding can be. I have argued that by taking our cues from pre-Hispanic Andeans themselves—from their words as well as their practices—we can attempt to understand rocks other than in Western ways. Moreover, we can approximate ancient Andean perspectives. The notion of remembered rocks, for example, makes clear the connection between the significance of a particular stone and oral culture in which a rock was important because it was featured in a story that conveyed something of indigenous culture or history. What is consistently emphasized in Andean oral culture, past and present, is the transubstantial nature of rock. Its implicit animacy lends a layer of significance not necessarily and not frequently expressed through a stone's superficial form or appearance. Although we can categorize the various common ways of treating uncommon, often numinous, rocks—framing, distancing, contouring, and carving—we apprehend that the form of the rock does little to communicate its precise meaning or function. We can also understand the fundamental importance of the concept of embodiment, which is quite different from the more familiar notion of representation. Understanding stone within Inka cultural matrices has allowed me to offer some new understandings, which are possibly quite old understandings in that they are consistent with Inka ways of interpreting rockwork. For example, terrace walls and finely worked stonemasonry can be understood as petrous expressions of Inka order signifying the will to organize the chaos of nature; crags in the built environment—a re-

nowned aspect of Inka site planning—embody the powerful forces of untamed nature and are significant precisely because they stand at the juncture of natural and built environments. Many of the ways the Inka worked stone expressed their colloquy with nature, the reciprocal give and take of partners in creation. The Inka relationship with nature as expressed in stone was perhaps most powerful when used strategically to reinforce Inka imperial aims. The working of stone and the indexing of facture—so apparent in mortarless masonry and megalithic construction—required petrous cooperation and so communicated the power of Inka builders. Petrous seats defined those who occupied stony perches emerging from and connected to specific territories as wank'a, powerful, numinous, and naturally ordained overseers. In the end, the Inka were like rocks—strong, resilient, unyielding—or is it that rocks were like the Inka?

In this book, I have purposefully focused on aniconic elements of the Inka's culture of stone, considering ways mostly nonresemblant petrous forms are endowed with meaning. This study might best be termed a first step in Andean aniconology. For the Inka, anicons seem to have functioned particularly as embodiments of entities, actions, and ideas. Whether nibbled blocks in a wall, integrated outcrops, lithic seats, or a dozen other petrous forms considered here, they served to memorialize and bear witness to past people, events, and deeds. By now it should be clear that I did not tell the whole story of rocks in the Inka world, nor can I be sure to have gotten all the details right. Certainly this study makes no attempt to excavate some essentialized, authentic Inka point of view. It is my hope, however, that by relying heavily on indigenous terms, concepts, and practices, we can begin to see the rocks remaining in the Andean landscape more as the Inka might have seen them and less as viewers from other cultural traditions might desire them to be, for while all interpretations may be valid, not all are consistent with Inka systems of signification. Accepting the premise that looking is not an objective exercise, I have turned to the judicious use of colonial-period accounts as well as modern Andean stories, hoping to approximate some indigenous ways of seeing and interpreting rocks the Inka once considered worth remembering. Moreover, rocks still present in the Andean landscape were once believed to bear witness to Inka acts of remembrance. Thus, while they might be in ruins and might not speak clearly to us, we might re-

member that once they did speak and that they might yet speak again. We might see them as rocks yet to be remembered, as silence yet to be broken, and as action yet to be taken. So long as we understand the rocks of Inka ruins to be like the rocks of familiar metaphor — stone cold, stone deaf, stone silent, and stone dead — we deny Inka visuality and its interpretive possibilities.

·(⇌)·

Notes

1. I use the relatively neutral term *story*, which may be either fiction or non-fiction or some combination of the two, to avoid the unfortunate implications of terms such as *myth*, *tale*, *legend*, *fable*, and *history*. For a useful discussion of various terms used to describe Quechua stories, see Allen, "Time, Place and Narrative"; and Howard-Malverde, *The Speaking of History*, 44–45. Also, I use the words *rock* and *stone* interchangeably, though the word *rock* in English sometimes retains a connotation of naturalness in comparison with *stone*.

2. Summers wisely observes that "one of the deepest and simplest projections into unfamiliar art we can make is the assumption that we understand its purpose, and as a matter of basic historical procedure, it should be assumed that *we do not immediately understand purpose*" (*Real Spaces*, 63). Whether or not the rocks considered here can be accurately termed art, as will be discussed further, I apply his point to unfamiliar material culture more generally.

3. For an insightful discussion of contemporary Andean knowledge of the land and its features based on her ethnographic work in the Quechua community of Sonqo, located north and east of Cuzco, see Allen, *The Hold Life Has*, 41.

4. There is some disagreement about whether Andeans recognize that living spirits reside in inert natural objects, or that those objects are themselves alive. For a discussion of Andean religious beliefs and some of the various characterizations — animistic, pantheistic, telluric, and so on — that have been used to describe them, see Kuznar, "Introduction to Andean Religious Ethnoarchaeology," 41–42.

5. Harrison, *Signs, Songs, and Memory*, 32–54; see also the concise discussion in Salomon, "Introductory Essay," 16–19. While *waka* and *huaca* are the two most popular spellings today, the word was often spelled *guaca* in colonial-period writing and today can also be spelled *waqa* or *wak'a*. Other indigenous Andean terms for geographically located spirits include *tira, apu, awki, achachila, mallku,* and *wamani*; see Kuznar, "Introduction to Andean Religious Ethnoarchaeology," 45.

6. Polo de Ondegardo, "Relación de los fundamentos," 189. Polo's list reads as follows: "ídolos, quebradas, peñas or piedras grandes, cerros, cumbres de montes, manantiales, fuentes y finalmente qualquier cosas de naturaleza que parezca notable y diferenciada de las demás." Juan Polo de Ondegardo, a jurist, arrived in Peru in the mid-sixteenth century and resided there for more than thirty years. He served as Cuzco's *corregidor* from 1558 to 1560 and again from 1571 to 1572. He is best known for his efforts in 1559 to track down and seize the sacred mummies of deceased Inka rulers and their wives. He studied Inka religious beliefs and customs, taking steps to discourage non-Christian practices, and wrote a number of reports concerning the religious beliefs and practices of Andeans in and around Cuzco based on interviews with Inka elders. For more on Polo's writings, see González Pujana, *Polo de Ondegardo.*

7. The Dominican friar and linguist Domingo de Santo Tomás, author of the earliest Quechua dictionary, published in 1560, defines *guaca* (*waka*) as *ydolo* (*ídolo*); see Santo Tomás, *Lexicon*, 68. The anonymous author of a dictionary first published in 1586 translates *ydolo* as both *huaca* and *villca*; see *Vocabulario y Phrasis*, 194. An anonymous Jesuit author, however, writing in the late sixteenth century, claims that "idols were called *villcas* and not *huacas*" (*Los ídolos fueron llamados Villcas y no Huacas*); see "Relación de las Costumbres Antiguas," 351. Indeed, *villca* or *willka* (*huillca*) was often understood to be the equivalent of idol (*ídolo*) and is sometimes still translated that way. Diego de González Holguín, the author of an early-seventeenth-century Spanish-Quechua dictionary, tells us that it also means "everything sacred" (*todo lo sagrado*) and so, like *waka*, ought not be narrowly defined as "idol"; see González Holguín, *Arte y Diccionario*, 146.

8. The biblical prohibition against worshiping graven images (Exodus 20:4–6) has been widely debated by Christian theologians over the centuries. In the eighth century, iconoclasts maintained that the only true image of Christ was found in the Eucharistic gifts, and that all other representation was idolatry. Defenders of icons argued that the essence of an image differed from its prototype and therefore that what was venerated was the prototype and not the image itself. The identification of Inka religion as focused on idols—a term derived from the Greek word for image or form and com-

NOTES TO INTRODUCTION 181

monly defined as a mere image without essence or substance — is particularly inapt because the Inka venerated sacred essence, which was often hosted by nonfigural forms. The Inka often held that essence could be variously circumscribed, and so found the appearance or form of the venerated host to be often irrelevant. For more on the iconoclastic debates of the early Christian church, see Pelikan, *The Christian Tradition*, vol. 2, 91–145.

9. Cobo, *Inca Religion and Customs*, 74. The Spanish reads, "[Los españoles] no repararon en el ídolo, por ser, como he dicho, una piedra tosca" (Cobo, *Obras*, vol. 2, 181). In the quoted passage, Cobo refers to Wanakawri (Huanacauri), a preeminent waka. He indicates that the Spaniards overlooked other stone "idols" as well; see Cobo, *History of the Inca Empire*, 132. Cobo, author of *Historia del Nuevo Mundo* (written before 1653), lived in Cuzco in the early seventeenth century. He learned Quechua and was an acquaintance of Alonso Topa Atau, a descendant of the pre-Hispanic Inka ruler Wayna Qhapaq, who served as one of the Jesuit's informants; Cobo also used the writings of the Cuzco parish priest Cristóbal de Molina, as well as now lost writings of Cuzco's magistrate Polo de Ondegardo.

10. Cieza de León, born a merchant's son in Spain circa 1520, left for Peru in 1535 after having glimpsed the riches brought back to Spain from the Andes by Hernando Pizarro in 1534. Cieza is considered to be one of the most reliable of Peruvian chroniclers owing to his keen eye and sensitive reportage. His lengthy, four-part history of the conquest of Peru is titled *Crónica General del Perú*; only a part of it was published before his death in 1554.

11. An anonymous Jesuit, writing in 1594, describes two kinds of Inka "temples": natural (*naturales*) and artificial or constructed (*artificiales*). See "Relación de las Costumbres," 354–55. The author of this account has been identified as Blas Valera and also as Luis López; see Gasparini and Margolies, *Inca Architecture*, 338.

12. Many scholars have considered Spanish encounters with Andean religions, including the following: Duviols, *La Destrucción de las Religiones Andinas*; MacCormack, *Religion in the Andes*; Mills, *Idolatry and Its Enemies*; Mills, "Seeing God in Mid-Colonial Peru"; and Silverblatt, *Moon, Sun, and Witches*.

13. Polo de Ondegardo, "Instrucción contra las Ceremonias," chap. 1, 189–90.

14. Santo Tomás, *Lexicon*, 131, 188, 357; González Holguín, *Arte y Diccionario*, 294. The spelling of *qillqa* varies widely, including the following: *quilca, quillca, quellca, quellka, qelqa, qhelq'a*. Definitions used here were taken from two early colonial-period Spanish-Quechua dictionaries, those of Santo Tomás (1560) and González Holguín (1608).

15. González Holguín also defines *quellka* as *carta, escritura, labor, matiʒ, adorno*; a *quellkaricuc* is *el que sabe escribir*, and a *quellkac* is *el que escribe, el escribiente, amanuense*; see González Holguín, *Arte y Diccionario*, 293. The anonymous dictionary of 1586 translates *quellca* as *papel, o carta*, and *quellcac* as *el que eschiue*; see *Vocabulario y Phrasis*, 74. The indigenous chronicler Titu Cusi Yupanqui, a descendant of Inka rulers who authored a memoir in 1570, describes the breviary, shown to the ruler Atawalpa by the Spaniards just before they took Atawalpa prisoner, as the "quillca de Dios y del rrey" (*Relación de la Conquista del Perú*, 16). For a discussion of indigenous responses to alphabetic script, see Rappaport and Cummins, "Between Images and Writing," and Quispe-Agnoli, "Cuando Occidente y los Andes se Encuentran."

16. In distinguishing between the essence of a thing and its appearance, the Inka might well have sympathized with Saint Theodore the Studite, 759–826 CE, a monk in Constantinople who wrote in defense of the veneration of icons. Theodore, although favoring the reverence of icons, carefully distinguished between the essence of forms and their external appearance; see Theodore the Studite, *On the Holy Icons*.

17. Cummins, "A Tale of Two Cities," 161. In his essay Cummins seems to follow Taylor, "Camay, Camac, et Camasca," and Salomon, "Introductory Essay," 16, both of whom discuss the meaning of *camay* in the early-seventeenth-century Quechua Huarochirí manuscript; see also Anonymous, *Vocabulario y Phrasis*, 20–21; González Holguín, *Arte y Diccionario*, 49; and Santo Tomás, *Lexicon*, 246. For more on the Quechua root *cama-*, see Taylor, "Introducción," 24–25; and Ziólkowski, *La Guerra de los Wawqi*, 27–29. A second distinct concept is that of *samay*, or "animating breath." The anonymous dictionary of 1586 translates *ʒamay* as "breath or spirit" (*aliento*) and the verb *ʒamaycuni* as "to imbue the spirit" (*infundir el alma*); see Anonymous, *Vocabulario y Phrasis*, 29. Santo Tomás and González Holguín provide similar definitions for çamay and *samay*; see Santo Tomás, *Lexicon* (246), and González Holguín, *Arte y Diccionario* (323–24). *Samay*, when possessed by normally inanimate things, implies an invisible animating essence or breath that may be, but is certainly not necessarily, reflected in form or shape. Interestingly, Santo Tomás translates soul (*alma*) as both *camaquenc* (hard *c*) and çamaynin (soft *c*) (*Lexicon*, 35). Allen, in *The Hold Life Has* (49–50), reports that residents of Sonqo (Department of Cusco) define *sami*, a word commonly translated as "good fortune," as "animating essence." Likely the meanings of the related words *samay* and *sami* have become blurred over the years.

18. Freedberg finds evidence of reverence for sacred rocks not just in ancient Greece but throughout the Middle East. For example, the black stone kept in the Kaaba in Mecca, the primary Muslim shrine, is an aniconic sacred

stone; see Freedberg, *The Power of Images*, 68. Summers notes that "the Greek term for an aniconic stone, *baetyl*, has been traced to the Hebrew *beth-el*, house of god, the term used by Jacob for the stone erected to mark the place of his dream of a ladder reaching up to heaven" (*Real Spaces*, 268). For Summers's discussion of aniconic stones in ancient Aegean cultures, see 268–69.

19. Freedberg, *The Power of Images*, 83.

20. Hallowell "Ojibwa Metaphysics," 65.

21. For a discussion of social landscapes in Papua New Guinea in which stones are linked to the activities of culture heroes and ancestors, see Kahn, "Stone-Faced Ancestors."

22. Today large boulders known as "grandfather rocks" are located in the landscaping around the National Museum of the American Indian in Washington, where they represent the ancestors who first inhabited the Americas.

23. Since at least the Qing dynasty, rocks were valued for their *shou* (leanness), *zhou* (surface texture), and *tou* (foraminate structure). This means that a rock should have no excrescences ("fat") that would obscure its internal structure; the surface should reflect the forces that formed the rock; and its foraminate structure, its many holes and openings, should express the transformations that comprise the world as a whole. Parkes, "Role of Rock," 91–98.

24. Berthier, *Reading Zen*, 42; Hay, *Kernels of Energy*, 17–18.

25. Parkes, "Role of Rock," 105.

26. Berthier, *Reading Zen*, 19.

27. Garden builders in the Zen tradition in Japan were encouraged to be responsive to the *ishigokoro* (soul, heart, or mind) of the rock, looking to it for guidance about where it was to be placed. Berthier, *Reading Zen*, 109.

28. Parkes, "Role of Rock," 119.

29. Felieu in Kagan, *Urban Images*, 11.

30. Schama, *Landscape and Memory*, 399. In his consideration of debates surrounding the carving of Mount Rushmore, Schama explores the contrast between Euro-American and Lakota ways of seeing, understanding, and valuing mountains (385–99).

31. The song "Mayqinllaraq Inginiru" (Which of the Engineers) puts words of regret in the mouths of the engineers who construct the highway. One verse reads: "Imay sunqu pobre rumi / imatam wakta ñutusqayki / Imay sunqu pobre qaqa / imatam wakta chaqusqayki." Rodrigo, Luis, and Edwin Montoya Rojas have translated these words into Spanish as follows: "¿Con qué corazón?, pobre piedra / ¿Con qué valor, podré pulverizarte? / ¿Con qué corazón podré dividirlas y esparcirlas?, pobres rocas"; see R. Montoya Rojas et al., *Urqukunapa Yawarnin*, vol. 4, 70–71.

32. Goodman, *Ways of Worldmaking*, 57–70. He rightly observes that a thing may function as a work of art in some contexts, but not in others.

33. Mason, *Ancient Civilizations of Peru*, 231; Kubler, *Art and Architecture of Ancient America*, 320.

34. Bushnell represents a distinct exception in that he concluded that no large-scale Inka sculpture survived the conquest, if it had ever existed in the first place. Evidently he did not consider carved Inka boulders and outcrops worth noting. See Bushnell, *Ancient Art of the Americas*, 127.

35. Errington also takes up this question in her book *The Death of Authentic Primitive Art and Other Tales of Progress* (1998).

36. Pasztory, "Andean Aesthetics," 60–69.

37. Schapiro, "Style," 147.

38. Paternosto argues that "internal symmetries of tectonic procedural principles" exist between works produced as part of the Constructivist movement of the early years of the Russian revolution and ancient Andean carved rocks (*Stone and the Thread*, 199–220).

39. Conquistadors and Spanish chroniclers report life-size statues of men, women, and animals made of gold along with anthropomorphic images of deities. See, for example, "Relación Francesa"; Jérez, "Verdadera Relación," 260; and Sancho de La Hoz, "Relación," chaps. 1 and 14, pp. 277–78, 320. These three authors, all writing in 1534, were eyewitnesses to the collection of the treasure paid by the Inka to the Spaniards who were holding their ruler for ransom. See the account written in 1557 by Betanzos, a Spanish soldier who arrived in Peru in 1539, resided in Cuzco, married the Inka princess who had been Francisco Pizarro's mistress, and was fluent in Quechua (*Suma y Narración*, pt. 1, chaps. 11, 18, 32, 36, and 39; *Narrative*, 47, 83, 139, 153, 161–62). Also see the memoir of Francisco's cousin Pedro Pizarro, who in 1571 wrote his recollections of the conquest of the Inka at the request of Viceroy Toledo (*Relación del Descubrimiento*, chap. 15, 89–107). At least some of the figural statues they describe were likely votive offerings rather than representations of deities.

40. Klein, "Objects Are Nice," 402. For a discussion of similar issues, see Armstrong, *Powers of Presence*; and Gell, *Art and Agency*. While Armstrong focuses on objects of African origin, Gell emphasizes the material and visual culture of the Pacific.

41. Both Paul Oskar Kristeller and Larry Shiner date modern notions of art to the eighteenth century; see Kristeller, *Renaissance Thought and the Arts*, 163, and Shiner, *Invention of Art*. For further discussion see Dean, "Trouble with (the Term) Art."

42. *Historia Natural y Moral*, bk. 5, chap. 9 (*Natural and Moral History*,

270). The Spanish reads, "Llamábanlas en el Pirú, guacas, y ordinariamente eran de gestos feos y disformes; a lo menos las que yo he visto todas eran así. Creo sin duda que el demonio en cuya veneración las hacían, gustaba de hacerse adorar en figuras mal agestadas" (*Historia Natural*, 230–31). Acosta (1540–1600) was a Jesuit priest and historian who journeyed to Peru in 1570 as one of the founders of the Jesuit mission there. Using the writings of Polo de Ondegardo as one of his sources, Acosta authored two major works: *De Promulgatione Evangelii apud Barbaros seu de Procuranda Indorum Salute* (published in 1588) and *Historia Natural y Moral de las Indias* (published in 1590). Acosta is considered to have been moderately pro-indigene; in *Historia Natural y Moral*, for example, he argues that idolatrous imagery was the result of Satan's trickery rather than indigenous duplicity. For a close examination of Acosta's work, see Del Pino Díaz, "La *Historia Moral y Natural de las Indias* como Género"; and Leuridan Huys, *José de Acosta*.

43. This does not mean that the Inka did not make resemblant images. As noted earlier, statues of precious metals, both large and small, were frequently resemblant, as were small sculptures of stone and shell. There was a specialized vocabulary to refer to them. They were known as *riqcha* (*riccha*), a term that Santo Tomás defines as color, figure, or face (*cara ó rostro*); he translates the verb *ricchani* as "to resemble" (*semejar ó paracer a otro*) (*Lexicon*, 347). According to González Holguín, *ricchhay* can be translated as color (*color*), face or visage (*faz de cualquier cosa; rostro*), image (*imágen*), or figure (*figura*) (*Arte y Diccionario*, 314). Because *color* is one of the definitions of *riccha*, it is tempting to conclude that the term refers to superficial resemblance whether through coloration or a combination of coloration and form. Çayñata (*zayñata*) can mean a dressed statue (*ymagin de bulto*) as well as a face mask (*máscara* or *carátula*) (Santa Tomás, *Lexicon*, 244). None of these terms can be translated properly as *idol*, however, as resemblance was clearly not linked to reverence.

44. Barrionuevo, for example, describing Machu Picchu's Intiwatana, a sacred stone, states: "En un espacio abierto, se encuentra el templo principal, magnífico aún en la desnudez de la piedra que otrora debió estar revestida de metales preciosos" (*Los Extraterrestres*, 168). As I've argued elsewhere, colonial-period reports of Inka objects in precious metals were likely exaggerated; see Dean, "Metonymy in Inca Art," 109.

45. Klein, "Objects Are Nice."

46. Dean, "The Trouble with (the Term) Art."

47. See, for example, Dorie Reents-Budet, who, in her catalogue of Maya ceramics, recognizes that the objects in her exhibition, being vessels and plates, are devalued owing to their perceived utility; her "goal," as she states

it, "is to help create a new category that will admit Classic Maya pictorial pottery into the aesthetic arena as one of the world's great painting traditions" (*Painting the Maya Universe*, 31).

48. Paternosto, *Stone and the Thread*, 5, 8. For an enlightening discussion of the ways the lexicon of Western art and Western patterns of thought have been (mis)applied to the visual culture of Ming China, see Clunas, *Pictures and Visuality*, 102–33.

49. Pasztory, *Thinking with Things*, 10.

50. Errington, *Death of Authentic Primitive Art*, 103. See also Preziosi, who writes about the "disciplinary machinery" of art history and its need to expand, to extend its "disciplinary horizons to all places and times" as if to prove its universal applicability (*Rethinking Art History*, 33).

51. For discussion of the necessary ambivalence in colonial mimicry, see Bhabha, "Of Mimicry and Man."

52. Consider, for example, the perspective of J. A. Mason: "It was as a craftsman — or craftswoman — rather than as an artist, that the Peruvian was pre-eminent" (*Ancient Civilizations of Peru*, 235).

53. For a discussion of Western dichotomous thinking in which culture (including so-called fine art) is set against nature, with particular focus on Western philosophy since the late eighteenth century, see Errington, *Death*, 27–33. For a consideration of the meanings of nature in Western thought, see Tuan, *Man and Nature*, 3–4.

54. Montaigne, *Selected Essays*, 77–78.

55. In *Landscape and Memory*, Schama, following Thoreau and other like-minded thinkers, reminds us that "nature" cannot exist outside cultural interpretations of it, and hence the nature-culture dichotomy that is so pronounced in Western thought is illusory. For more on the nature-culture debate as it relates to our understanding of Andean visual culture, see chapter 2.

56. Paternosto's book was revised and published in English in 1996 as *The Stone and the Thread*.

57. While Paternosto argues that carving at Kenko (Qenqo), a rock outcropping just outside Cuzco covering an area of more than eleven thousand square feet and consisting of both Kenko Grande and the lesser-known Kenko Chico, began early in Inka history (contemporaneous with his dating of Saywite), he also suggests that it may have functioned throughout the entire period of the Inka imperium as a technical school for training rock carvers (*Stone and the Thread*, 74, 77). In contrast to Paternosto, Van de Guchte dates the Saywite monolith to the early sixteenth century on the basis of the style of the sculptural forms ("Carving the World," 223). An early-sixteenth-century date would make it relatively late in the Inka sequence.

58. See Bauer's "Ritual Pathways of the Inca," as well as his *Sacred Landscape of the Inca*.

59. Gasparini and Margolies, *Inca Architecture*, 267.

60. Ibid., 325.

61. Upton, "Architectural History or Landscape History?" 198.

62. Hyslop, *Inca Settlement Planning*, 102.

63. MacLean, "Sacred Land, Sacred Water"; Nair, "Of Remembrance and Forgetting," 64–75; Niles, *Callachaca* and *The Shape of Inca History*.

64. Visuality has been a standard concept in art historical writing since Bryson's *Vision and Painting* in 1983. For essays dealing with visuality as a socially and historically conditioned operation, see Foster, *Vision and Visuality*.

65. Betanzos tells us that "the [Inka's main] temple was worshiped and held in great reverence, not just the statue [of the sun that was housed inside] but also the temple stones" (*Suma y Narración*, pt. 1, chap. 11; *Narrative*, 48). The Spanish reads, "La cual casa [del sol] era reverenciada y tenida en gran reverencia no solamente el bulto más las piedras della" (*Suma y Narración*, 52).

66. It is wise to keep Hayden White's caution in mind, to not attempt to "put oneself in the place of past agents, seeing things from their point of view" ("Politics of Historical Interpretation," 129).

67. Because the colonial-period accounts used here are of such importance, I will provide where appropriate a brief note identifying the author and the circumstances under which he recorded his information. For an analysis of many of the colonial sources on Inka history, see Pease, *Las Crónicas y los Andes*; Julien, *Reading Inca History*; and Porras Barrenechea, *Los Cronistas del Perú*.

68. Santo Tomás was a Dominican friar and linguist who published *Lexicon ó Vocabulario de la Lengua General del Perú*, the earliest Quechua dictionary, in 1560. The *Vocabulario y Phrasis en la Lengua General de los Indios del Perú Llamada Quichua y en la Lengua Española* was first published by Antonio Ricardo in Lima in 1586; its author is unidentified. The Jesuit González Holguín, who published his Quechua-Spanish dictionary in 1608, has been called the "best colonial grammarian of Quechua" (Mannheim, *Language of the Inka*, 144).

69. Starn, "Missing the Revolution." For a discussion of these issues, see Isbell and Silverman, "Writing the Andes"; and Weismantel, "Maize Beer and Andean Social Transformations," 861.

70. For a study of enduring ancestor worship in the Andes, see Doyle, "Ancestor Cult and Burial Ritual."

71. Kuznar, "Introduction"; Weismantel, "Maize Beer."

72. Foreign symbolic languages and forms introduced to the Andes can and

have been used to express Andean worldviews. The appearance of Catholic saints on or near Andean waka is one example. Catholic Mass as a dinner with the honored dead is another; see Weismantel, "Maize Beer," 867–76.

73. Elkins, "Review of *Real Spaces*," 377–78. Elkins's "On David Summers's Real Spaces" is a reprint of his earlier book review.

74. Dean, "The Inka Married the Earth."

75. It has been alleged that Guaman Poma was neither the author nor the illustrator of the *Nueva Corónica*. For a discussion of pertinent issues, see Adorno, "A Witness unto Itself"; Barnes, "Review"; Domenici and Domenici, "Talking Knots"; Estenssoro Fuchs, "Historia"; Guibovich Pérez, "Review"; Holland, "El Dibujante"; Holland, "Drawings"; Hyland, *The Jesuit*, 195–235; Mumford, "Clara Miccinelli's Cabinet"; Ossio, "Nota"; and Ossio, "Introducción," 2004: 29–50. See also various essays in Cantù, *Guaman Poma*. Clearly the argument will not soon be settled. However, given the self-referential nature of the *Nueva Corónica*, both its text and images, I will continue to credit Guaman Poma as both author and artist of that prodigious work.

76. Many scholars have addressed indigenous Andean aspects of Guaman Poma's illustrations in the *Nueva Corónica*. See, for example, Adorno, "The Rhetoric of Resistance"; López Baralt, "From Looking to Seeing" and "La Persistancia de las Estructuras Simbólicas Andinas en los Dibujos de Guaman Poma de Ayala"; and Ossio, "Guamán Poma: *Nueva Corónica*."

77. *Nueva Corónica*, fol. 79, 62.

78. Cobo describes the Wanakawri waka, saying, "era mediana, sin figura y algo ahusada" (*Obras*, vol. 2, 181; *Inca Religion*, 74).

79. For a consideration of the problems posed by translation, see various essays in *Tradition — Translation — Treason*, volume 32 of *Res*, edited by Pellizzi, as well as those in *The Translation Studies Reader*, edited by Venuti.

NOTES TO CHAPTER ONE

1. According to Santo Tomás, *caca* might refer to a large, free-standing rock (*roca, gran piedra*), as well as to a boulder in the sea (*peña en la mar*) and to a craggy rock (*peña enrriscada*) (*Lexicon*, 186, 203). He defines *ccaca* as a "rock, large rock, boulder, or crag" (*peña, gran piedra, peña o risco*) (240). The dictionary of 1586 defines it as living rock (*peña viva*) (*Vocabulario y Phrasis*, 19). Garcilaso, in his volume published in 1609, says *caca* means hill or mountain (*sierra*), but warns that both syllables must be "pronounced at the back of the throat, for if they are said as the letters sound in Spanish the word means 'an uncle, one's mother's brother'" (hanse de pronunciar ambas sílabas caca en

lo interior de la garganta, porque pronunciada como suenan las letras espa-
ñoles quiere decir tío, hermano de madre); see Garcilaso, *Comentarios Reales*,
pt. 1, bk. 3, chap. 25, 136 (*Royal Commentaries*, vol. 1, 189). Garcilaso, born in
Cuzco in 1539 with the name Gómez Suárez de Figeroa, was the illegitimate
son of the Spanish conquistador Captain Sebastián de La Vega Vargas (who
had arrived in Peru in 1534) and the Inka ñusta Chimpu (Isabel) Ocllo, a sec-
ond cousin to the rulers Waskar and Atawalpa. He wrote his *Royal Commen-
taries* after emigrating to Spain; the first part was published in 1609, and the
second was published posthumously in 1616–17.

2. Both the author of the 1586 dictionary (*Vocabulario y Phrasis*, 172) and
Santo Tomás (*Lexicon*, 187) define *piedra preciosa* as *quespi* (*quispe*). Santo
Tomás also identifies a ruby as *rumi quispi* and defines *sacana* as *piedra o cah-
lar* (*Lexicon*, 204, 349). According to González Holguín, *cachca rumi* means
piedra pomes (*pómez*) (*Arte y Diccionario*, 45). Murúa defines *corpa* as *piedras
de metales* (*Códice Murúa*, bk. 3, chap. 49, fol. 101r). For a listing of many dif-
ferent kinds of specialized stones, see *Vocabulario y Phrasis*, 172.

3. *Extirpación de la Idolatría en el Pirú*, chap. 2, 28. Arriaga writes of the
venerated rocks: "les llaman con nombres particulares." Arriaga, a Jesuit, re-
corded his findings in the early seventeenth century after decades of extirpa-
tory activity and several anti-idolatry campaigns in the Andes. For a lengthy
analysis of his work and its historical context, see Urbano's "Estudio prelimi-
nar" in Arriaga, *Extirpación de la Idolatría en el Pirú*, xi–cxxx.

4. "Relación sobre la Idolatría," 380. After ordination, Avendaño, a Limeño
native, served as a *cura* in several indigenous pueblos where he rooted out
idolatrous practices. He held offices in the cathedral in Lima and became
bishop of Santiago de Chile.

5. Dean, "Metonymy in Inca Art." Freedberg's *The Power of Images* remains
the preeminent study of presence in inanimate objects. While Freedberg fo-
cuses primarily on presence in resemblant imagery, others have a broader
scope; see Armstrong, *Powers of Presence*; Dean, "Metonymy"; and Gell, *Art
and Agency*.

6. Albornoz, "Instrucción para Descubrir," 179. Albornoz, a parish priest
in Cuzco in the late sixteenth century, spent considerable time documenting
indigenous "idolatry." His findings are included in his report "La Instrucción
para Descubrir Todas las Guacas del Pirú y sus Camayos y Haziendas" of
1584.

7. *Inca Religion*, 51–84; *Obras*, vol. 2, 169–86. The 328 waka were organized
along hypothetical lines called *siq'i* (*ceque, ceq'e, zeq'e*, or *zeque*). Many schol-
ars have studied the siq'i system of lines that radiated from the Inka's main
temple (the Qurikancha) and the waka on them that were maintained and
cared for by specific kinship groups. See the following: Agurto Calvo, *Cusco*;

Agurto Calvo, *Estudios acerca de la Construcción*; Bauer, "Ritual Pathways of the Inca"; Bauer, *Sacred Landscape of the Inca*; Bauer and Dearborn, *Astronomy and Empire*; Chávez Ballón, "Ciudades Incas"; Hyslop, *Inca Settlement Planning*; Rowe, "Shrines of Ancient Cuzco"; Sherbondy, "Los Ceques"; Wachtel, "Estructuralismo e Historia"; Zuidema, *Ceque System of Cuzco*; Zuidema, "Hierarchy and Space"; and Zuidema, "Inka Dynasty and Irrigation." The Cuzco Ceque System Research Project identified waka, or the sites of now absent waka, in the Cuzco area today (Bauer, "Ritual Pathways" and *Sacred Landscape*). Cobo indicates that not all waka were part of the siq'i system and estimates that there was a minimum of 350 Inka shrines in the Cuzco area (*Inca Religion*, 83). Murúa approximates the number of waka in Cuzco at 340, saying, "Los guacas y adoratorios de esta ciudad [de Cuzco] y algunas leguas alrededor de ella son 340 de diversos nombres y debía de haber otras más de todo lo cual mucha parte se ha olvidado" (*Códice Murúa*, bk. 1, chap. 7, fol. 14r).

8. Bauer, noting that "both historical sources and archaeological remains suggest that Inca shrines could take the form of either natural or carved stones," cautions against focusing on carving as the single indicium of stone waka ("Pacariqtambo and the Mythical Origins of the Inca," 16).

9. "Es imposible tirarles esta superstrición [*sic*] porque para tirar dichas guacas es necesario mucha fuerza de gente que toda la del Pirú no es parte [para] mudar estas piedras ni cerros" ("Instrucción para Descubrir," 169).

10. Hyslop identifies carving, enclosing within walls, prominent display on terraces, and setting on platforms as the distinguishing features of important stones (*Inca Settlement Planning*, 113–14). While MacLean is correct to maintain that "there is no way to identify sacred places securely purely on a formal basis" ("Sacred Land," 116), visual cues such as those noted by Hyslop and those discussed here can help us spot petrous waka.

11. Niles, *Callachaca*, 18–19.

12. Dransart defines the *kancha* (corral) today as a site or space where humans and animals produce words, noises, gestures, and actions ("Cultural Transpositions," 85). As such, the kancha is a place of specialized living distinct from the non-kancha space of human and animal occupation. For a thorough discussion of kancha form and function in the Inka built environment, see Gasparini and Margolies, *Inca Architecture*, 181–91.

13. *Relación de Antigüedades*, fol. 8v, 198. As a devout Catholic of noble Inka ancestry, Santa Cruz Pachacuti authored the Spanish and Quechua *Relación de Antigüedades deste Reyno del Pirú* around 1613. His account of pre-Hispanic history argues that indigenous Andeans were traditionally monotheistic. The three openings or "windows" that he pictures in his account

are named Tampottoco, Marasttoco, and Sutittoco. According to Santa Cruz Pachacuti, they correlate to the uncles, maternal grandparents, and paternal grandparents of the first Inka. The underworld is often referred to as *ukhupa-cha*, a term that was commonly translated into Spanish as *infierno* (hell) in the colonial period (*Vocabulario y Phrasis*, 153). Barnes, in her essay "Catechisms and Confessionarios" (78–79), hypothesizes that Spanish evangelizers in the Andes introduced the tripartite notion of the universe, consisting of ukhupa-cha, *kaypacha* (this world), and also *hananpacha* (the upperworld or heaven); she cautions us to be wary of assuming that these terms reflect pre-Hispanic Andean perspectives. Pease (*Los Últimos Incas del Cuzco*, 87), on the other hand, finds the proposed tripartite Andean cosmos to be substantiated by chronicles, dictionaries, and other colonial-period sources.

14. In historical sources *t'uqu* is also spelled *toco*, *tocco*, and *ttoco*.

15. MacLean, "Sacred Land," 93–96.

16. Nair, "Remembrance and Forgetting," 71–72. There are also several locations in which outcroppings of rock appear to have once been contoured, but from which the worked masonry ashlars have been removed since Inka times. All that remains are the horizontal bedding cuts carved into the rocks' surfaces. Ollantaytambo's Inkamisana sector is one of these places, as are portions of Inquilltambo, Salunpunku, and Pisaq; see Van de Guchte, "Carving the World," 167, 184, 197.

17. The curved wall of the Qurikancha (Golden Enclosure), also known as the Temple of the Sun, is sometimes called the Solar Drum. Curved walls of fine masonry at other sites have been identified as belonging to Sun temples based on this feature, which they share with the Qurikancha of Cuzco. Bingham, for example, identified the Torreón at Machu Picchu as a possible Temple of the Sun based on its curved wall (*Machu Picchu*, 174). The curved wall of the upper structure at Wiñay Wayna has also led to the identification of that structure as a Temple of the Sun.

18. *Inca Architecture*, 233. For a study of the Qurikancha's layout, see Rowe, "Introduction to the Archaeology of Cuzco."

19. Cobo relates that one of the original four Inka brothers came ahead of the rest to Cuzco, where he sat down and was converted to stone; this later became the Qurikancha (*History*, 104). Sarmiento de Gamboa reports that Ayar Auca was petrified at the place that became the Qurikancha (*Historia de los Incas*, chap. 13, 57). Sarmiento, an adventurer, captain, and navigator, wrote his *Historia de los Incas*, which was the second part of his larger work *Índica*, at the behest of Viceroy Toledo in 1571–72, but it was not published until later. Using Betanzos as well as Polo as his sources, Sarmiento argued that the Inka had not been the legitimate rulers of the Andes, and thus the

Spanish invasion was justified. Despite his bias, his chronicle "contains some of the finest recorded descriptions of Inca mythology" (Bauer and Dearborn, *Astronomy and Empire*, 36).

20. Betanzos, *Suma y Narración*, pt. 1, chap. 4 (*Narrative*, 16).

21. MacLean points out that curved walls are found at all the sites within the so-called Machu Picchu sanctuary ("Sacred Land"). While some of these were waka, the curving shape cannot be said to be diagnostic. I am distinguishing here between free-standing curvilinear walls (often marking funerary and storage structures, as well as towers such as Muyuqmarka at Saqsaywaman) and curvilinear contouring walls that draw attention to the curved topography of a particular locale.

22. Paternosto, *Piedra Abstracta*; Paternosto, *Stone and the Thread*; Van de Guchte, "Carving the World"; Bauer, *Sacred Landscape*; Hyslop, *Inca Settlement Planning*. Van de Guchte maintains that not all carved rocks were waka, but does not provide any discussion ("Carving the World," 346).

23. Paternosto, *Stone and the Thread*, 62.

24. Uhle first observed that what often look like seats carved into large stones probably functioned as altars; see "Datos para la Explicación de los Intihuatanas." Regarding carved channels, González Holguín defines *qquencu qquencu* as *cosas de muchas vueltas, muy retuertas, de muchas revueltas y escondrijos* and *ppaccha* as *fuente, chorro de agua, canal, caño, cascada* (*Arte y Diccionario*, 283, 303). Santo Tomás defines *paccha* as *pila de agua* (*Lexicon*, 188). Cups and undulating channels carved into rock may be large versions of *paqcha* cups, which were usually carved wooden basins or cups with an extension into which an undulating canal was carved and along which liquid offerings flowed; see Paternosto, *Stone and the Thread*, 66. For a discussion and analysis of paqcha, see Carrión Cachot, who believes paqcha to be phallic and composed of two parts: the round basin or cup and the undulating canal along which liquid runs and pours out (*Culto al Agua*, 43); see also Larrea, *Corona Incaica*, 231–36. Paternosto suggests that carvings in the shape of a cup with a channel, sometimes called a paqcha (as at Kenko Grande and Kenko Chico), represent the earliest phases of Inka rock carving (*Stone and the Thread*, 74).

25. Rowe, "Inca Culture at the Time of the Spanish Conquest," 297. Flores Ochoa, in *Pastoralists of the Andes* (85), describes illa used in modern Paratía, Department of Puno, as "shapes representing animals, made of white stone or metal, or [they] can even be a simple rock of a whimsical shape found in the countryside." For more on contemporary illa, see Allen, *The Hold Life Has*, 59–60, Flores Ochoa, "Enqa, Enqaychu, Illa, y Khuya Rumi," and Salomon, "Andean Opulence."

26. Today some scholars use the word *qonopa* (*conopa*) to refer to a small sculpture with a depression in it and reserve the term *illa* for reference to small sculptures with no depression; see, for example, Burger and Salazar, "Catalogue," 170–73.

27. For a detailed description and analysis of carvings on the Saywite monolith, see Paternosto, *Stone and the Thread*, 123–35; and Van de Guchte, "Carving the World," 220–26. For a drawing of its top and sides, see Angrand, *Imagen del Perú*, 268.

28. Paternosto characterizes the Saywite monolith as a giant paqcha (*Stone and the Thread*, 127).

29. The Saywite monolith and other nearby carved stones, for example, are located in a zone of springs. See Sherbondy, "Canal Systems" and "Los Ceques," as well as Van de Guchte, "Carving the World," for stones that mark water courses in the Cuzco area. Van de Guchte concludes that "almost all carved rocks are related to or associated with bodies of water" (38).

30. Bingham, *Machu Picchu*, 46.

31. Krickeberg suggests that stepped curves (as at Quillarumi) were symbols of the sky (*Felsplastik und Felsbilder*, 8). Van de Guchte identifies the step-fret design as symbolic of mountains ("Carving the World," 194). Paternosto believes that the many nonfunctional step cuts made in outcrops are "the obsessive metaphoric representation of a communication . . . between the world of the here and now, the Kay Pacha, and . . . Hanan Pacha" (*Stone and the Thread*, 71). Setting aside his regrettable use of "obsessive," I agree that carving near caves and crevices emphasizes Inka relations with the under- or innerworld. Paternosto also maintains that, in occupying mountain crests, as at Machu Picchu, the Inka were attempting to enter *hananpacha*, the "above" world, which was accessed via sacred mountains (105). I explore the Inka colloquy with sacred mountains in chapter 2. As noted earlier, Barnes in "Catechisms and Confessionarios" (78–79), hypothesizes that Spanish evangelizers in the Andes introduced the tripartite notion of the universe, consisting of ukhupacha, *kaypacha* (this world), and also *hananpacha* (the upperworld or heaven); she cautions us to be wary of assuming that these terms reflect pre-Hispanic Andean perspectives. Pease (*Los Últimos Incas del Cuzco*, 87), on the other hand, finds the proposed tripartite Andean cosmos to be substantiated by chronicles, dictionaries, and other colonial-period sources.

32. Valcárcel writes that Kenko "has been known from the time of the conquest as an empty violated tomb which probably held the remains of the Inca Emperor Pachacuti" ("Cuzco Archeology," 180). Niles speculates that the worked chinkana at the Rumi Wasi area of Callachaca might once have served as a tomb (*Callachaca*, 83). At Machu Picchu, burial sites were ex-

cavated in crevices beneath or adjacent to large boulders (Salazar, "Machu Picchu," 43).

33. In addition to the places named in the text, lakes and trees, with parts extending into this world as well as the under- or innerworld, are also named as paqarisqa. Hollows (*juturi*) in the landscape are implicated in the emergence of herded animals from the underworld; see Dransart, "Cultural Transpositions," 87.

34. The cave of origin for the people of Goalla, for example, was a waka called Autviturco; Cobo tells us that it was the fourth waka on the first siq'i of Antisuyu near Cuzco (*Inca Religion*, 63). For a discussion of modern interaction with origin places, see Flores Ochoa, *Pastoralists of the Andes*, 84. For a discussion of the relationship between the living and the dead in the Andes, see Salomon, "The Beautiful Grandparents."

35. Preziosi characterizes such modes of reckoning with the visual environment as anaphoric (*Rethinking Art History*, 169). An anaphora is a linguistic device of syntactical cross-referencing. The Inka monuments discussed here signify through both references to, and contrasts with, other familiar built forms.

36. Gell, *Art and Agency*, 123.

37. *Extirpación de la Idolatría en el Pirú*, chap. 2, 28. He writes: "A cerros altos y montes y algunas piedras muy grandes también adoran y mochan, y les llaman con nombres particulares y tienen sobre ellos mil fábulas de conversiones y metamórfosis que fueron antes hombres, que se convirtieron en aquellas piedras."

38. Betanzos, for example, indicates that the creator (Contiti Viracocha) turned the first human beings into stone for having offended him (*Suma y Narración*, pt. 1, chap. 1; *Narrative*, 7). Based on stories of this sort, Paternosto understands petrifaction as an eternity of punishment (*Stone and the Thread*, 184). Duviols, however, interprets petrifaction as perennation and sanctification ("Symbolisme de l'Occupation"). Clearly the meaning of the lithomorph varies according to circumstances.

39. According to Cieza, Ayar Cache was turned to stone and was known as Guanacauri (Wanakawri) (*Crónica del Perú*, pt. 2, chap. 7, 16). Cristóbal de Molina, a parish priest in Cuzco and a knowledgeable source on Inka religious practices who recorded some of his information around 1574, concurs with Cieza ("Relación de las Fábulas," 75). Betanzos tells us that Ayar Oche turned to stone on the hill of Wanakawri to become an "idol" (*ídolo*) for his siblings (*Suma y Narración*, pt. 1, chap. 4, 19; *Narrative*, 15–16). According to Sarmiento, one brother (Capac-toco) turned to stone at the point of departure, the second brother (Ayar Ucho) was petrified at Guainacauri (Wana-

kawri), and the third (Ayar Auca) and fourth (Manco Capac) were petri-
fied at or near the place that became the Qurikancha (*Historia*, chap. 11–14,
49–62). According to Murúa, a servant of one of the first four Inka brothers
(Ayarauca) was converted into stone after an act of betrayal; another of the
brothers (Ayarcache) sat on a waka, was turned to stone, and was called Gua-
nacauri (*Historia General*, bk. 1, chap. 2, 49–51). Cobo relates several versions
of the Inka's origins; in one, two of the brothers turned themselves into stone,
while in another, one brother turned to stone (*History*, 103–7). For a thorough
discussion of the various accounts of Inka origin, see Julien, *Reading Inca
History*, 269–92.

40. Dean, "Andean Androgyny," 168–70. Andean perspectives contrast
with Freud's well-known equation of petrifaction with castration; see Sarup,
Introductory Guide to Post-Structuralism, 120.

41. For the story of Cuni Raya and Caui Llaca, see Salomon and Urioste,
Huarochirí Manuscript, 46–48; for other examples of lithomorphy, see 59, 63,
134.

42. Núñez del Prado B., "Supernatural World of the Quechua," 243, 246.
Also see Barrionuevo, *Extraterrestres*, 112; Decoster, "Cultural Production
of Collective Identity," 62–63; and Granadino, *Cuentos de Nuestros Abuelos
Quechuas*. Decoster discusses ñusta outcrops in twentieth-century Accha
(in Paruro province south of Cuzco) and offers other pertinent observa-
tions about the gendering of landscape features. For further discussion of
toponyms and the gendered landscape, see Molinié, "The Spell of Yucay,"
210–18.

43. *Inca Religion*, 61; *Obras*, vol. 2, 174.·

44. Murúa, *Historia General*, chaps. 91–92, 329–37. Murúa, or Morúa, au-
thored two histories of the Inka. The first was finished in the late sixteenth
century (1590); the second, completed around 1613, represents a significant
revision of the first. A Mercedarian, Murúa was in Cuzco around 1590 and
served in several posts during his time in Peru. The indigenous author and
artist Felipe Guaman Poma de Ayala likely contributed to Murúa's work as an
illustrator, copyist, and informant. Murúa also relied on reports composed by
Polo de Ondegardo. For observations on Murúa's two manuscripts, see Men-
dizábal, "Dos Versiones de Murúa." For more on the relationship between
Murúa and Guaman Poma, see Ballesteros, "Relación entre Fray Martín de
Murúa y Felipe Huamán Poma de Ayala"; Ossio, "Guaman Poma y Murúa";
Ossio, "Introducción" (1985); Ossio, "Introducción" (2004), 50–55; Ossio,
"Paralelismos"; and Ossio, "Research Note." For an analysis of the Chuqui-
llanto/Acoitapia stories, see Millones, Galdo, and Dussault, "Reflexiones en
Torno al Romance en la Sociedad Indígena."

45. Although he does not relate this story, Albornoz, in his list of sacred geography, names Sausiray as a sacred mountain near Calca ("Instrucción para Descubrir," 180).

46. Murúa, *Códice Murúa*, bk. 4, chap. s/n, fol. 144r–47v. The Galvin manuscript also contains a drawing, illustrating a chapter on *akllawasi*, that depicts a mountain labeled "Sauaçiray" and the twin peaks of Pituçiray and Urcosiray. A group of buildings, labeled "acllauasi" and "casa de recojidas," is featured. Outside its walls we see a *pastor* (herdsman) with his llama herds, just like the fabled Acuytapra. There is also a slumbering porter failing to prevent illicit access to the akllawasi; see Murúa, *Códice Murúa*, bk. 3, chap. 43, fol. 94v. Many of the watercolor illustrations in Murúa's Galvin manuscript appear to be by the hand of Guaman Poma. For an examination of the relationship between Guaman Poma's *Nueva Corónica* and Murúa's Galvin and Wellington manuscripts, see Ossio, "Introducción" (2004), 29–50; and "Research Note."

47. Many scholars have extensively studied the interrelated concepts of time and space in the Andes. See, among others, Allen, "Patterned Time"; Allen, "Time, Place, and Narrative"; Bengtsson, "Concept of Time/Space in Quechua"; Bouysse-Cassagne and Harris, "Pacha"; Fioravanti-Molinié, "Tiempo del Espacio"; and Salomon, "Introductory Essay," 14–16.

48. Howard-Malverde, "Introduction," 15.

49. Harvey, "Peruvian Independence Day," 23. Harvey states: "It is now generally acknowledged that both history and memory are social constructions whose difference lies in their conditions of production and reproduction rather than in their truth value."

50. For a study of postal letters among nonliterates in Matapuquio, Peru, see Lund, "On the Margin." She writes: "It seems paradoxical that, within written tradition, the letter is a literary genre/type which strives for the oral tone. . . . From the standpoint of a non-literate tradition such as that of Matapuquio, letter-writing has nothing to do with conversation. Rather, it is characterized by formulaic ingredients: an elaborate focus is placed on devices of authentication such as the signature, seal, dates and place, and identified witnesses. The physical document is scrutinized, while the written contents are given little or no critical examination" (194–95). Letters for Matapuqenian readers serve as important signs of recognition, legitimizing the accompanying oral message. We might surmise that in Inka times, remembered rocks served similar functions.

51. Abercrombie, *Pathways of Memory and Power*, 113–14, 317. Abercrombie studies Andean ways of knowing history among the Aymara-speaking K'ulta of the Bolivia highlands.

52. Tuan, a geographer who investigates cross-cultural notions of place, helps us understand why rocks may have been used in this way. In his book *Space and Place*, he suggests that "places are defined by whatever stable object catches our attention" (161). In the Andean landscape, prominent rocks were logical landmarks to invest with historical significance. For a discussion of the relationship between contemporary Andean storytellers and their local landscape, see Allen, "Time, Place and Narrative."

53. In his article "How the *Huacas* Were," Salomon, based on his study of the transubstantial waka described in the Quechua Huarochirí manuscript (ca. 1608), concludes that lithification was commonly the "final" stage of an Andean numen's metamorphosis. The powerful and constantly changing Cuni Raya Vira Cocha represents a distinct exception to this norm (as Salomon notes), however, and so opens the possibility that petrification, while a natural state for many waka, was not necessarily permanent.

54. MacCormack, *Religion in the Andes*, 408–9.

55. Efforts to use only human labor to move Inka megaliths weighing many tons from a quarry, down a steep slope, across a river, and over the cobblestone plaza in Ollantaytambo were documented in "Secrets of Lost Empires," an episode of *Nova* (1997).

56. For beliefs about communication with rocks in the Quechua community of Sonqo in the Department of Cuzco, see Allen, *The Hold Life Has*. Because the residents of Sonqo have lost the ability to speak directly to stones, they must receive these communications indirectly through signs: configurations of coca leaves, dreams, unusual events, and the state of one's luck and health. Elsewhere in the Andes, the lyrics to Quechua songs suggest that stones do still sometimes speak. According to a *waynu* (*huayno*) sung in the Cuzco region, a shepherd searching for a lost cow is told by boulders to look among the rocks: "Q'aqapi, q'aqapi, q'aqapas niwashian" (Among the boulders, among the boulders, the boulders are telling me) (Montoya Rojas et al., *Urqukunapa Yawarnin*, vol. 4, 30–31).

57. According to the semiotician Peirce, writing in the late nineteenth century, there are three primary types of sign, the smallest unit of meaning: (1) tokens or symbols, which acquire meaning through shared cultural convention; (2) indices, which have some existential or natural connection with what they represent; and (3) icons, which resemble what they represent (*Collected Papers*, vol. 3, 210–11).

58. Gombrich, *Meditations on a Hobby Horse*, 1–11.

59. The Inka and other Andeans apparently had a much easier time with the notion of transubstantiation than did Europeans. Consider, for example, the long, slow, and controversial history of the belief in transubstantiation

in the Roman Catholic Church, where the doctrine of the Real Presence was not formally defined by the Vatican until 1215. The feast of Corpus Christi, which celebrates the transubstantiated body of Christ in the consecrated Eucharistic host, was introduced first in 1264 and then again in 1317.

60. Betanzos, *Suma y Narración*, pt. 2, chap. 6 (*Narrative*, 205). The Spanish reads: "Eran servidos y acatados estos bultos de los naturales de las provincias y pueblos por do [donde] este bulto llevaban como si fuera la persona del mesmo Ynga" (Betanzos, *Suma y Narración*, 221). In this passage, Betanzos refers specifically to the wawqi of the ruler Atahualpa (Atawalpa, Ataw Wallpa). Although perceived to be the ruler they embodied, wawqi were apparently named individually. According to Cobo, the wawqi of the eighth through eleventh rulers (whom he identifies as Viracocha, Pachacutic, Tupa Inca Yupanqui, and Guayna Capac) were named (again using his spelling) Inca Amaro, Inti Illapa, Cuxichuri, and Guaráquinga, respectively (*History*, 132, 141, 151, 162).

61. According to Cobo, it was the seventh waka on the sixth siq'i of Collasuyu (*Inca Religion*, 74). For discussion of the many colonial-period accounts of Wanakawri, see Julien, *Reading Inca History*, 276–85. Another stone brother of Manku Qhapaq was called Michosamaro; according to Cobo, it was the first waka on the first siq'i of Chinchaysuyu (*Inca Religion*, 51).

62. Betanzos, for example, reports that Atahualpa (Atawalpa) had two statues made using his father's sheddings; both of these could have been considered the wawqi of Huayna Capac (Wayna Qhapaq) (*Suma y Narración*, pt. 2, chap. 2; *Narrative*, 192).

63. Cobo reports that the second waka on the first siq'i of Antisuyu was Turuca, the "guauque" of Ticci Viracocha (*Inca Religion*, 63). Betanzos describes a sugarloaf-shaped stone ("una piedra de la hechura de un pan de azucar") that embodied Inti, the sun (*Suma y Narración*, pt. 1, chap. 11, 52; *Narrative*, 48). Although Hyslop argues that the sugarloaf-shaped stone served as an *usnu* (*ushnu*), an elevated lithic bench or platform with a basin for offerings, I believe that the sugarloaf-shaped stone was Inti's wawqi and was placed on the usnu platform for display purposes (*Inca Settlement Planning*, 71–72). Pedro Pizarro, in fact, describes how a stone that embodied the sun (i.e., Inti's wawqi) was placed on a lithic bench (i.e., the usnu) in the middle of Cuzco's plaza (*Relación del Descubrimiento*, 90–91). I consider the uses and symbolism of usnu in chapter 3.

64. Betanzos, *Suma y Narración*, pt. 1, chaps. 11–12 (*Narrative*, 48, 52–53).

65. Both Ballesteros, in Murúa, *Historia General* (414–15n567), and Van de Guchte, "Sculpture and the Concept of the Double" (261), identify a sculpted human head in the collection of the Museo de América (Madrid) as part of a

wawqi. Ballesteros concedes that there is no proof of this, and Van de Guchte acknowledges that aspects of the image were clearly sculpted in colonial times. Kubler writes: "In 1930 a large stone head which has been thought to represent the Inca Viracocha was excavated at a depth of 8 m. (25 feet) below the pavement of the Jesuit church in Cuzco. This fragment is unique, and it may have been re-cut in the colonial period, with a timid effort to represent the features of a middle-aged man by incisions representing wrinkles" (*Art and Architecture*, 321). For a discussion of how the head was discovered, as well as some preliminary analysis of it, see Larrea, *Corona Incaica*, 153–209.

66. Cobo, *History*, 112; *Obras*, vol. 2, 67. The mestizo author Garcilaso de la Vega visited Polo in 1560, just before leaving Cuzco for Spain, and saw five royal mummies that Polo had seized, three males and two females; he reports that Acosta also saw at least one of the mummies while they were in Polo's possession (*Comentarios Reales*, pt. 1, bk. 5, chap. 29; *Royal Commentaries*, vol. 1, 306–7). Rowe surmises that a lost report by Polo on his activities and finds was likely the source of information on both mummies and wawqi that would later be reported by Sarmiento and Cobo ("What Kind of a Settlement Was Inca Cuzco?" 69n24).

67. Dean, "Andean Androgyny," 168–70. Both Polo and Acosta, who probably used Polo as a source, assert that the wawqi of rulers were taken to war as well as carried in processions to ensure adequate rainfall and good harvests. See Polo, "De los Errores y Supersticiones," chap. 3, 10–11; Acosta, *Historia Natural y Moral*, bk. 5, chap. 6 (*Natural and Moral History*, 265–66).

68. "Vsaron los Indios nombrar ciertas estatuas, o piedras en su nombre, para que en vida y en muerte se les hiziesse la misma veneración que á ellos. Y cada ayllo, ó linage tenía sus Idolos, ó estatuas, de sus Yngas, las quales lleuauan á la guerra y sacauan en processión para alcanzar agua y buenos temporales y les hazían diuersas fiestas y sacrificios. Destos Idolos vuo gran summa en el Cuzco, y en su comarca; entiéndese que á cessado del todo, ó en gran parte la superstición de adorar estas piedras después que se descubrieron" (Polo, "De los Errores," chap. 3, 10). For a discussion of Polo's activities and discoveries, see Bauer, *Ancient Cuzco*, 159–84.

69. Cobo, *History*, 112–51; *Inca Religion*, 37.

70. For reports of golden wawqi, see Sarmiento, *Historia*, chaps. 47 and 62, pp. 127, 151. Acosta, however, indicates that all wawqi were made of stone ("cada rey en vida hacía un ídolo o estatua suya, de piedra, la cual llamaba guaoiqui, qu quiere decir hermano") (*Historia Natural y Moral*, bk. 5, chap. 6, 227). Of those who report that rulers had statues of precious metals, the most reliable is Betanzos. He says that both a "golden image" (*un bulto de oro hecho a su semejança*) and another made of bodily sheddings were taken by Manco

(Manku) when he rebelled against the Spaniards and fled Cuzco (Betanzos, *Suma y Narración*, pt. 1, chap. 32, 149–50; *Narrative*, 138–39). He says that both objects came into the possession of Francisco Pizarro by way of the Inka noblewoman Angelina Cuxirimay Ocllo, the woman who had been wife to Atawalpa, became Pizarro's Inka mistress, and eventually married Betanzos. Since this happened before Doña Angelina married Betanzos, Betanzos likely didn't see either object. Nevertheless, his source for this information was undoubtedly Doña Angelina, someone who would have to be considered extremely knowledgeable. It is significant that Betanzos doesn't use the term *wawqi* with regard to the golden statue, however, and it may not have been considered one. For further discussion, see Dean, "Metonymy in Inca Art."

71. Acosta, *Historia Natural y Moral*, bk. 5, chaps. 6 and 10, pp. 226, 234. While Acosta viewed several of the royal mummies while they were in Polo's possession, there is no evidence that he saw any wawqi. He did, however, author a theory about the foundations of idolatry worldwide based on the practice of portraiture, which he posited as a universal mode of image making often leading to a mistaken equation of the picture with the person depicted; see Acosta, *Historia Natural y Moral*, bk. 5, chap. 6 (*Natural and Moral History*, 265). Clearly clouded by European image-making practices as well as debates within the Catholic Church, he appears to have forced Inka visual culture into a preconceived mold.

72. Sarmiento, *Historia*, chaps. 14–15, pp. 61, 63.

73. See *History*, 114; *Inca Religion*, 37, 74; and *Obras*, vol. 2, 161, 181. Unlike Cobo, Molina describes "Huanacauri" as a large boulder (*peña grande*) in the shape of a man (*figura de hombre*) ("Relación de las Fábulas," 34). Although Molina was a resident of Cuzco, there is no particular reason to think he actually saw the Wanakawri waka that had been taken from the hill of that name by indigenes shortly after the Spanish occupied the city; see Cobo, *Inca Religion*, 74.

74. Polo writes, "Y de los Yngas cada uno en vida hazía una estatua suya que llamaua, Huauqui" ("De los Errores," chap. 2, 8).

75. Since wawqi were not portraits of rulers, the anonymous Jesuit suggests that they represented symbolically familial or even national deities; he writes that "no eran las estátuas suyas de su nombre y representantes de su persona, sino del dios que tenía particular la familia, o nación, o casa de donde procedía" ("Relación de las Costumbres," 361).

76. Dean, "Metonymy in Inca Art."

77. "Mandó luego hacer un bulto de sus mismas uñas y cabellos el cual imitaba a su persona y mandó que se llamase este bulto Ynga Guauquin que dice el hermano del Ynga" (*Suma y Narración*, pt. 2, chap. 6, 220; *Narra-*

tive, 205). Betanzos also tells us that the same thing was done for the ruler Pachacuti (Pachakuti), for Yamque Yupanque (Yamqi Yupanki), who was the elder brother of the ruler Topa Inca Yupanque (Thupa Inka Yupanki), and for Manco Inca (Manku Inka), the postconquest leader of the Inka who led an unsuccessful rebellion against the Spaniards and then founded a neo-Inka state beyond Spanish territory; see *Suma y Narración*, pt. 1, chaps. 32 and 36, and pt. 2, chap. 33 (*Narrative*, 138, 153, 298). For additional references to the Inka's use of sheddings, see Betanzos, *Suma y Narración*, pt. 1, chap. 32, and pt. 2, chap. 2 (6, 33) (*Narrative*, 138, 192, 204, 298); as well as Cobo, *History*, 177. Although Sancho de la Hoz, Francisco Pizarro's secretary who wrote the first description of Cuzco in 1534, did not identify wawqi by name, he did observe "otras imágenes hechas de yeso o de barro las que solamente tienen los cabellos y uñas que se cortaba y los vestidos que se ponía en vida, y son tan veneradas entre aquellas gentes como si fueran sus dioses" ("Relación," 334). While he believed these venerated objects to have been of plaster or clay, media used for sculptures in Europe, he likely did not analyze them too carefully.

78. Cobo indicates that all things pertaining to the ruler were perceived to have metonymic properties when he writes, "All leftovers from the meal and whatever the Inca [ruler] touched with his hands were kept by the Indians in *petacas* [chests]; thus, in one chest they kept the little rushes that they placed before him when he ate; in another, the bones of the poultry and meat left over from his meals; in another the clothes that he discarded. Finally, everything that the Inca [ruler] had touched was kept in a *buhio* [hut] that an important Indian had charge of, and on a certain day each year it was all burned" (*Todo lo que se levantaba de la mesa y cuantas cosas el Inca tocaba con sus manos, lo guardaban los indios en petacas; de manera que en una tenían recogidos los junquillos que le echaban delante cuando comía; en otra, los huesos de las aves y carne que alzaban de la mesa; en otra, los vestidos que desechaba; finalmente, todo cuanto el Inca había tocado, se guardaba en un buhio que tenía a su cargo un indio principal, y en cierto día del año lo quemaban todo*) (*History*, 247; *Obras*, vol. 2, 139–40). Not burning hair cuttings and fingernails so that they might be included in inert wawqi was an extraordinary exception to normal practices.

79. The site of Caral on Peru's central coast, the oldest city in the Americas with pyramidal structures dating to the fifth millennium BCE, features an unhewn elongated monolith centered in the main plaza; today the monolith is referred to as a wank'a, and it may well have functioned as one. For more on the site of Caral, see Shady, *Caral, la Ciudad del Fuego Sagrado*; and Shady, *Caral Supe*.

80. Duviols, "Symbolisme de l'Occupation," 7, 9.

81. Referring to chakrayuq, Polo reports that the Inka used to put "en medio de las Chacras vna piedra luenga para desde allí inuocar la virtud de la tierra y que para que le guarde la Chacra" ("Relación de los Fundamentos," 191). Murúa, borrowing from Polo, writes that the Inka "ponían en medio de las chácaras una piedra grande, para en ella invocar a la Tierra, y le pedían les guardase las chácaras" (*Historia General*, bk. 2, chap. 28, 423).

82. "Le huanca était donc l'image tangible et permanente du héros colonisateur" ("Symbolisme Andin du Double," 359).

83. Rostworowski, *Historia del Tahuantinsuyu*, 33.

84. *Extirpación de la Idolatría en el Pirú*, chap. 2, 37. See also Duviols, "Symbolisme Andin du Double," 359. Doyle discusses the possibility that some wank'a were carved imagistically, but the evidence is not particularly convincing, as it comes from extirpation campaigns conducted by individuals who were looking for "idols" ("Ancestor Cult and Burial Ritual," 64–65).

85. "Relación sobre la Idolatría," 380.

86. Duviols reports a legend in which two brothers transform into wank'a while their sister becomes a *puquio* (a spring or fountain) ("Symbolisme de l'Occupation," 21). This suggests that springs, commonly gendered female, were complements to masculinized stone wank'a. Furthering the identification of wank'a with males, "Wank'a" (or its cognates Huanca or Guanca) was used as a name for males among the Inka. See, for example, Betanzos, *Suma y Narración*, pt. 2, chap. 7 (*Narrative*, 207); Cieza, *Discovery and Conquest of Peru*, pt. 3, chap. 39, 185; or Cobo, *History*, 167.

87. Duviols, "Symbolisme Andin du Double," 362–63; "Symbolisme de l'Occupation," 21–23.

88. Duviols, "Symbolisme Andin du Double," 360; "Symbolisme de l'Occupation," 8.

89. Classen, *Inca Cosmology*, 91.

90. Duviols, "Symbolisme de l'Occupation," 11–12. See also "Symbolisme Andin du Double," 360.

91. "[Cada provinicia tuvo un adoratorio] que fué el lugar donde entendían haberse salvado aquellos que tenían por principio y cepa de cada nación; y eran estos lugares en cada provincia muy conocidos y venerados con toda suerte de sacrificios" (*Inca Religion*, 17; *Obras*, vol. 2, 153). Contrary to Duviols's assumption that every ancestral stone corresponded to an ancestral mummy, Cobo says that "nowhere did the Indians have the bodies of these ancestors because the whole thing was imaginary. . . . He [the devil] made them think that at the end of their [the originators'] lives, which they say were very long, their ancestors were changed into stones, and they worshiped these stones and offered sacrifices to them instead of worshiping their an-

cestor's bodies" (*en ninguna parte tuvieron los cuerpos dellos, mas como fueron imaginaciones, halló también el demonio camino para hacerles entender que, cumplido el tiempo de su vida, que dicen haber sido muy larga, se habían convertido en piedras, y a éstas en lugar de sus cuerpos tenían en veneración y les ofrecían sacrificios*) (*Inca Religion*, 17; *Obras*, vol. 2, 153). One such ancestral stone was located just outside Cuzco; it was a sacred rock called Senqa (Cinca) that was the origin stone of the Ayarmaca kinship group. Cobo identifies it as the ninth waka on the fifteenth siq'i of Chinchaysuyu (*Inca Religion*, 58). Zuidema clarifies that the origin stone was located on the mountain called Senqa, which is on the road to Yucay ("Inka Dynasty," 193). Still today in the Andean highlands, some large stones are held to be the residences of ancestors; see Gow and Condori, *Kay Pacha*, 61.

92. Rostworowski, *Historia del Tahuantinsuyu*, 33.

93. Duviols, "Symbolisme de l'Occupation," 21.

94. Murúa suggests that there was indeed a wank'a for the Cuzco valley; known as Cuzco Huanca (i.e., Cuzco Wank'a), it was said to be the petrified remains of the individual who founded Cuzco (*Historia General*, bk. 3, chap. 10, 499).

95. *Arte y Diccionario*, 330. González Holguín indicates that a Sayacsayac Rumi was a post or column (328). Santo Tomás defines *sayua* as a boundary marker (*mojón o lindero de heredad*) and defines both çaytorumi and *sayuarumi* as columns of rock (*columna de piedra*) (*Lexicon*, 244, 350). Today in some parts of the Andes, *saywa* refers to roadside piles of rocks made as offerings to mountain spirits in thanks for safe passage and for good fortune on the remainder of the journey; rock piles with this same function are elsewhere identified as *apachita*, which was the term commonly used in colonial-period records.

96. Granadino, *Cuentos de Nuestros Abuelos*, 142–55, 207.

97. Polo, "Relación de los Fundamentos," 92. Polo may have confused saywa with sukanka, as he identifies them as markers used to track the passage of time; see the discussion of sukanka hereafter.

98. Guaman Poma, *Primer Nueva Corónica*, fol. 352 [354], 324; Murúa, *Códice Murúa*, bk. 3, chap. 28, fol. 79v.

99. *Historia General*, bk. 2, chap. 10, 370; *Códice Murúa*, bk. 3, chap. 29, fol. 81r. Guaman Poma identifies those who actually constructed saywa as *sayua checta suyoyoc*; see *Primer Nueva Corónica*, fol. 353 [355], 325. Van de Guchte concludes that saywa makers came from specific kinship groups, specifically the Conaraqui and Unacaucho *ayllu*, who were what was known as Inka-by-privilege ("Carving the World," 323).

100. See, for example, Betanzos, *Suma y Narración*, pt. 1, chap. 12 (*Narrative*, 51).

101. Collanasayba was the thirteenth and last waka on the eighth siq'i of Chinchaysuyu; it marked the end of the siq'i and the beginning of Siclla-bamba (Cobo, *Inca Religion*, 61). Cascasayba was the ninth of ten waka on the second siq'i of Antisuyu, Illansayba was the sixth of seven waka on the fourth siq'i of Antisuyu, and Aquarsayba was the seventh of ten waka on the fifth siq'i of Antisuyu (64, 66, 67).

102. Cobo, *Inca Religion*, 66. The Spanish reads: "Unas piedras a que sacri-ficaban por la salud de los que entraban en la provincia de los Andes" (*Obras*, vol. 2, 177).

103. Cobo, *Inca Religion*, 73; Cobo, *Obras*, vol. 2, 180; Bauer, "Ritual Path-ways," 193.

104. For example, Cobo tells us that the eleventh waka on the first siq'i of Antisuyu was Quiscourco: "It was a round stone, not very big, which served as the limit and marker of these guacas" (*era una piedra redonda no muy grande, que servía de término y mojón destas guacas*) (*Inca Religion*, 64; *Obras*, vol. 2, 175).

105. Van de Guchte, "Carving the World," 212. Zuidema suggests that the Saywite monolith was a wank'a, the owner of the valley where it sits ("Lion in the City," 226). Although evidence is better for its having functioned as a saywa, the two functions are not mutually exclusive, and a single stone may well have served in multiple capacities.

106. According to González Holguín, *ppuruauka* also refers to a stone used in a slingshot weapon ("bola de piedra para defender las fortalezas, soltándola sobre el enemigo") (*Arte y Diccionario*, 291). A puruawqa, regardless of size or shape, is thus a stone that is dangerous and can seriously harm enemies.

107. MacCormack provides a lengthy discussion of the various accounts of the puruawqa (*Religion in the Andes*, 286–301). For colonial-period ac-counts, see Acosta, *Historia Natural y Moral*, bk. 6, chap. 21 (*Natural and Moral History*, 364); Cobo, *History*, 128–29; Cobo, *Inca Religion*, 35–36; Gar-cilaso, *Comentarios Reales*, pt. 1, bk. 5, chap. 18 (*Royal Commentaries*, vol. 1, 279–82); and Santa Cruz Pachacuti, *Relación de Antigüedades*, fol. 19r, 219.

108. *Relación de Antigüedades*, fol. 19r, 219.

109. Cobo, *Inca Religion*, 51–84.

110. Cobo, *History*, 128–29; Cobo, *Inca Religion*, 35–36.

111. Niles, *Shape of Inca History*, 58–61.

112. According to Cobo, the third waka on the fifth siq'i of Chinchaysuyu was called Cuzcocalla; it comprised "a fair quantity of stones which they said were all puruauca" (*buena cantidad de piedras, que todas decían ser de los Pu-ruráucas*) (*Inca Religion*, 57; *Obras*, vol. 2, 172). He names the first waka on the sixth siq'i of Chinchaysuyu as a puruawqa called Catonge (*Inca Religion*,

58). Albornoz identifies "Catungui" as a "squadron of warrior-like rocks" (*un escuadrón de piedras como gentes de guerra*), by which he means a group of puruawqa ("Instrucción para Descubrir," 179). The first waka on the first siq'i of Cuntisuyu was an officer of the puruawqa called Sabaraura; the second waka on that same siq'i was another puruawqa named Quingil (Cobo, *Inca Religion*, 78). Tuicalla was the name of a group of ten puruawqa named by Cobo as the second waka on the fifth siq'i of Cuntisuyu (80). Both Duviols and Zuidema conclude that the Inka epic about their conflict with the Chanka is a myth and that the chroniclers confused the mythical Chanka with the historical ones from present-day Andahuaylas. Zuidema concludes that the puruawqa "symbolically and spatially represented social units, subject to the Inca king and belonging to Cuzco as a city" ("Lion in the City," 212). For a complete discussion, see Duviols, "Guerra entre el Cuzco y los Chancha"; Zuidema, "Bureaucracy and Systematic Knowledge"; Zuidema, "Inka Dynasty," 199–200; Zuidema, "Lion in the City," 201–12; and Zuidema, "Myth and History."

113. Cobo, *History*, 162; *Obras*, vol. 2, 94.

114. *Primer Nueva Corónica*, fol. 159 [161], 138. Guaman Poma's drawing of the sayk'uska corresponds to Inka methods for transporting sizable stones. Cieza, for example, says that six thousand workers hauled stones to the site of Saqsaywaman using "great cables of leather and hemp" (*grandes maromas de cuero y de cabuya*) (*Crónica del Perú*, pt. 2, ch. 51; *The Incas*, 154; *Crónica*, 148). For more on Inka methods of transporting stones, see Protzen, *Inca Architecture and Construction*, 175–83.

115. Murúa, *Códice Murúa*, bk. 2, chap. 3, fol. 37v–38r. According to Guaman Poma, Ynga Urcon was the son of the tenth ruler Topa Ynga Yupanqui (Thupa Inka Yupanki) (*Primer Nueva Corónica*, fol. 160 [162], 139). Murúa, however, identifies him ("Ynga Urcum") as the son of the eighth ruler (*Historia General*, bk. 1, chap. 87, 314). Other chroniclers agree with Murúa; see Cieza, *Crónica del Perú*, pt. 2, chaps. 43–46; Betanzos, *Suma y Narración*, pt. 1, chap. 8 (*Narrative*, 27); and Sarmiento, *Historia*, chaps. 24–25, pp. 80–82. Although Murúa describes "Ynga Urcum" in glowing terms, both Cieza and Betanzos identify him as a coward who, along with his father, abandoned Cuzco to the invading Chanka armies.

116. *Inca Religion*, 56–57; *Obras*, vol. 2, 171. Cobo names Collaconcho as the sixth waka on the fourth siq'i of Chinchaysuyu.

117. Garcilaso, *Comentarios Reales*, pt. 1, bk. 7, chaps. 27 and 29 (*Royal Commentaries*, vol. 1, 464, 470–72).

118. *Inca Religion*, 51–84. According to Cobo, the quarry Guayrangallay was the seventh waka on the second siq'i of Chinchaysuyu, and the fourth

waka on the fourth siq'i of Antisuyu was the quarry named Viracocha (*Inca Religion*, 55, 66). He indicates that the fourth waka on the second siq'i of Antisuyu was the quarry called Curovilca, and says that "they sacrificed to it so that it might not give out, and so that the buildings built of stone from it might not fall" (*Sacrificábanle por que no se acabase ni se cayesen los edificios que dellas se hacían*) (Cobo, *Inca Religion*, 64; *Obras*, vol. 2, 176).

119. Reinhard, "Sacred Peaks of the Andes," 95.

120. *Suma y Narración*, pt. 1, chap. 37 (*Narrative*, 157). The Spanish reads: "En el llano que está detrás desta fortaleza que está una piedra muy grande la cual piedra trujeron como las demás de las canteras y por ser que aquesta piedra fuese traída se trujo de más de legua y media de allí y trayéndola pusiéronla un tiro de piedra de la fortaleza en el llano ya dicho y allí fueron y nunca más la pudieron menear de allí . . . y viendo esto el Ynga dijo que sin duda se había cansado aquella piedra y que se llamase la piedra cansada y ansi la llaman hoy día" (Betanzos, *Suma y Narración*, 170). Also referring to a sayk'uska located close to Saqsaywaman are Cieza, *Crónica del Perú*, pt. 2, chap. 51; Garcilaso, *Comentarios Reales*, pt. 1, chap. 37 (*Royal Commentaries*, vol. 1, 464, 470–72); and Ocaña, *A Través de la América del Sur*, chap. 34, 225. Diego de Ocaña, a Jeronimite, journeyed to the Americas to promote the cult of Our Lady of Guadalupe, the statue of which was (and is) located in Extremadura. The memoirs of his travels date from 1580, when he left the monastery in Guadalupe, to 1605, when he departed from Peru bound for New Spain. He was an avid observer but, in this case, likely just reported what he was told about Saqsaywaman.

121. Van de Guchte, "El Ciclo Mítico de la Piedra Cansada," 548. There is considerable disagreement with this identification, however. Both Angles Vargas and Paternosto argue that the Chinkana Grande has been erroneously associated with Garcilaso's "tired stone," since it is an outcrop and could never have been moved; see Angles Vargas, *Sacsayhuamán*, 100–103, 179; and Paternosto, *Stone and the Thread*, 83. However, considering the implied animacy of presentational stones, that it appears today (or even appeared in Inka times) as an outcrop probably mattered not at all to the Inka. Barrionuevo offers other objections, saying that the sayk'uska of Saqsaywaman was destroyed, reduced to a handful of dust, in 1733 (*Extraterrestres*, 61).

122. Van de Guchte, "Ciclo Mítico."

123. The word *sukanka* is not defined in early Quechua dictionaries; it may be related to the verb *sucani*, meaning "hacer camellones" (to make ridges), and thus might refer to any constructed prominence (González Holguín, *Arte y Diccionario*, 344).

124. See Bauer, *Sacred Landscape*; and Bauer and Dearborn, *Astronomy and*

Empire, 25–53. There were also two sukanka on the Island of the Sun; see Bauer and Stanish, *Ritual and Pilgrimage*, 208–12.

125. Polo, "De los Errores," chap. 7, 16. He writes: "Y á cada luna, ó mes tenían puesto su mojón ó pilar al derredor de Cuzco donde llegaua el Sol aquel mes. Y estos pilares eran adoratorios principales, á los quales ofrecían diuersos sacrificios y todo lo que sobraua de los sacrificios de las Huacas, se lleuaua á estos lugares que se llamauan Sucanca, y el que es principio de Inverno, Puncuy sucanca, y el principio de verano, Chirao sucanca." Cobo identifies "sucanca" as the seventh waka on the eighth siq'i of Chinchaysuyu (*Inca Religion*, 60).

126. According to Cobo, the third waka on the thirteenth siq'i of Cuntisuyu was called Chinchincalla; it is described as "a large hill where there were two markers; when the sun reached them, it was time to plant" (un cerro grande donde estaban dos mojones, a los cuales, cuando llegaba el sol, era tiempo de sembrar) (*Inca Religion*, 83; *Obras*, vol. 2, 185). The ninth waka on the sixth siq'i of Chinchaysuyu was a hill named Quiangalla; on the hill were two "markers or pillars" (*dos mojones o pilares*) that denoted the beginning of summer (Cobo, *Inca Religion*, 59; *Obras*, vol. 2, 172). See Zuidema, "Pillars of Cusco," for a study of Cuzco sukanka.

127. Cobo, *Inca Religion*, 51–84; Murúa, *Códice Murúa*, bk. 3, chap. 70, fol. 122r; and Murúa, *Historia General*, bk. 2, chap. 38, 449.

128. As with so many of the Inka's accomplishments and practices, the ruler Inca Yupanqui (Pachakuti) is credited with creating a twelve-month calendar and establishing the times of festivals; see Betanzos, *Suma y Narración*, pt. 1, chap. 15 (*Narrative*, 65).

129. *Intiwatana* refers to carved stones, usually with gnomons, that were used to track solar progress through the calendar year. Rowe, however, has observed that the word *intiwatana* is not mentioned by Spanish chroniclers, nor does it appear in the earliest Quechua dictionaries; he argues that the name postdates the Inka and cannot be taken as evidence of the function of particular monuments ("Inca Culture," 328). Rowe suggests these stones may have symbolized the place spirit of the hills on which they stand (328). Those who have suggested various astronomical alignments disagree; see, for example, Valcárcel, *Machu Picchu*, 94; and Paternosto, *Stone and the Thread*, 107.

130. Valencia and Gibaja identify the Intiwatana at Machu Picchu as an usnu (*Machu Picchu*, 89). Machicado Figueroa agrees, pointing out how closely it resembles altarlike objects pictured by Guaman Poma in his drawings of rituals of February and March (*When the Stones Speak*, 63–64). See Guaman Poma, *Primer Nueva Corónica*, fols. 238 [240] and 240 [242], pp. 212 and 214.

131. Dearborn and White propose that the outcrop contoured by the Tower at Machu Picchu served as an astronomical marker ("Archaeoastronomy at Machu Picchu"; "'Torreón' of Machu Picchu"). One of its windows is aligned toward the northeast, framing the rising winter solstice sun in June and lighting a carved area on the outcrop. One of the contoured rocks in the Intiwatana sector of Pisaq has a cut edge similar to that on the tower's outcrop, but the extant wall gives no indication whether or not a window might have been similarly positioned so as to identify the day of June solstice. Paternosto has identified the so-called Third Stone at Saywite as an instrument for watching the movement of the sun between the solstices (*Stone and the Thread*, 135). For more on Inka astronomical observation, see Bauer and Dearborn, *Astronomy and Empire*; Dearborn and Schreiber, "Here Comes the Sun"; Dearborn, Schreiber, and White, "Intimachay"; Dearborn and White, "Archaeoastronomy"; Dearborn and White, "'Torreón' of Machu Picchu"; Rivera Sundt, "Horca del Inka"; Trimborn, *Archäologische Studien*; and Zuidema, "The Pillars of Cusco."

132. On the primacy of sight in enactments of history in contemporary Colombia, see Rappaport, "Art of Ethnic Militancy," 59–62. On contemporary Quechua songs in which divine knowledge is acquired by seeing, see Harrison, *Signs, Songs, and Memory*.

133. Others have reached similar conclusions with regard to Inka stone waka; see, for example, Duviols, "Symbolisme de l'Occupation," 7; Paternosto, *Stone and the Thread*, 178; and Rostworowski, *Estructuras Andinas del Poder*, 62.

134. This may explain why Polo identifies sukanka as saywa, saying that "saybas" are "pilares o topos . . . que están en torno de la Ciudad de Cuzco" that were used to mark the passage of time ("Relación de los Fundamentos," 92).

135. Rostworowski, *Historia del Tahuantinsuyu*, 33.

136. Núñez del Prado, "Supernatural World," 244. Andeans refer to mountain deities by a variety of names, including *achacila, apusuyu, aposento, awki, awkillo, jurq'u, mamani, urqutaytacha, urqu yaya*, and *wamani*; see Earls and Silverblatt, "Realidad Física y Social," 310; Gutiérrez Estévez, "Sobre el Origen"; and Urton, "Animal Metaphors," 258. Núñez del Prado, based on research among Quechua speakers of Qotobamba and Q'ero in the southern Andean highlands in the department of Cuzco, argues that although indigenous Andeans are often said to venerate mountains and earth, "worship is directed to the spirits that inhabit the mountains and the earth whose existence is independent of their material habitats" ("Supernatural World," 243). He notes that *urqo* refers to the mountain, while *apu* refers to the spirit of the

mountain. Others, however, who work in Quechua communities stress that indigenous Andeans do not distinguish between the spirit of a place and that place itself. Neither the variance in terminology across the Andean region nor the question of whether it is the mountain itself or mountain spirits that affect human affairs is of significant consequence to the present discussion.

137. Frost, *Exploring Cusco*, 198–99.

138. *Inca Religion*, 66; *Obras*, vol. 2, 177. Maychaguanacauri was the seventh waka on the fourth siq'i of Antisuyu. In her essay "Imágenes en un Paisaje Sagrado," Brittenham discusses the waka in and around Cuzco, concluding that Maychaguanacauri was a waka precisely because it was mimetic; its visual similitude made it stand out from all other rocks.

139. The Inka were not the first in the Andes to embody mountains in miniature. The Moche, at Huaca de la Luna, for example, enveloped a small portion of Cerro Blanco, the granite hill abutting the structure, by incorporating a rock outcrop into one of their plazas (Plaza 3a). The adobe walls of the upper courtyard embrace the outcrop much as the later Inka would incorporate outcrops into their structures. The Moche sacrificed numerous individuals in the courtyard at the base of the outcrop. Morris and von Hagen conclude that the sacrificial victims were pushed from the outcrop after death (*Cities of the Ancient Andes*, 93). Given the many depictions of mountains in sacrifical scenes on Moche ceramics, it is tempting to suggest that the Huaca de la Luna outcrop was the miniature embodiment of a sacred mountain and so was an ambassadorial recipient of the most important sort of sacrifices.

140. For discussions of miniatures produced and used throughout the Andean region today in various contexts, see Allen, "When Pebbles Move Mountains"; Aranguren Paz, "Las Creencias y Ritos"; Fauvet-Berthelot and Lavallée, *Ancien Pérou*, figs. 296, 365; Flores Ochoa, "Enqa, Enqaychu"; Flores Ochoa, *Llamichos y Paqocheros*; Lapidus de Sager, "Significado de Algunos Ideogramas"; Meddens, "Mountains, Miniatures, Ancestors, and Fertility," 139–41; and Santillana, "Andenes, Canales y Paisaje," 69. For colonial-period commentary on the Inka's use of miniatures, see Albornoz, "Instrucción para Descubrir," 165. For a discussion of the universal notion that miniatures make the things they represent (or, I would argue, embody) possessable and manipulable, see Summers, *Real Spaces*, 319.

141. González Holguín defines *apachitas* as "montones de piedras, adoratorios de caminantes: vana observancia idolátrica" (*Arte y Diccionario*, 27). *Apachita* is derived from the Quechua verbs *apachiy* (*encargar*) or *apachikuy* (*encomendar*). This section summarizes an argument I have made more fully elsewhere; see Dean, "Rethinking *Apacheta*."

142. Albornoz, "Instrucción para Descubrir," 168. He also says that another

word for *apachita* is *camachico*, and indicates that they could be found on roads throughout Peru.

143. *Extirpación de la Idolatría en el Pirú*, chap. 6, 69.

144. "Relación," 354; Polo, "Relación de los Fundamentos," 57; and Acosta, *Historia Natural y Moral*, bk. 5, chap. 5, 224.

145. *Inca Religion*, 45; *Obras*, vol. 2, 166. Arriaga makes this claim as well in *Extirpación de la Idolatría en el Pirú*, chap. 6, 69.

146. Santo Tomás defines *puytoc* as *bóueda* (vault) (*Lexicon*, 342). *Uasi* (*huasi* or *wasi*) means "house."

147. "Carving the World," 144. Van de Guchte estimates the height of the original wall framing the upright stone as two meters.

148. *Extirpación de la Idolatría en el Pirú*, chap. 6, 69.

149. Murúa, *Códice Murúa*, bk. 3, chaps. 50–54, fols. 102r–106r.

150. Albornoz confirms that apachita were offered a great variety of things, although his list, which includes flowers, feathers, and branches, as well as chewed coca and maize, consists of fairly common items. He also describes how straw found near the apachita would be knotted, saying, "Otros hazen nudos a las pajas questán cerca [las apachitas]" ("Instrucción para Descubrir," 168). The knotted straw may be explained by the fact that those who made offerings at apachita confided in the mountain-shaped waka, telling it of either their travails or good fortune (*sus travajos o prosperidades*) (168). Like a poorman's *khipu* (the knotted cords used by Inka administrators), the knotted straw may have recorded mnemonically the traveler's tales of good or ill tidings.

151. Kuznar, "Introduction," 50–52.

152. La Barre, *Aymara Indians*, 166; Kuznar, "Introduction," 51.

153. Hyslop, *Inka Road System*, 23.

154. Albornoz, "Instrucción para Descubrir," 180–88.

155. Gow and Condori, *Kay Pacha*, 13.

156. Zuidema, "Inka Dynasty," 184–85.

157. *Suma y Narración*, pt. 1, chap. 32 (*Narrative*, 138–39). The Spanish reads: "Encima de su sepulcro mandó Ynga Yupangue que fuese puesto un bulto de oro hecho a su semejanza . . . y de las uñas y cabellos que en su vida se cortaba mandó que fuese hecho un bulto" (Betanzos, *Suma y Narración*, 149). Pachakuti's son and successor also had two "statues" made, one of gold and the other of sheddings (*Suma y Narración*, pt. 1, chap. 36; *Narrative*, 153).

158. Betanzos, *Suma y Narración*, pt. 1, chap. 32, 150 (*Narrative*, 139). The Spanish reads: "Cuando ansi le sacasen le sacasen cantando las cosas que él hizo en su vida ansi en las guerras como en su ciudad."

159. Albornoz, "Instrucción para Descubrir," 171. In his instructions for

destroying waka, Albornoz advises would-be extirpators to seize first and then burn all precious textiles (*bestidos de cumbe*), for if any of the textiles touched the waka (things he terms relics), devotees could recreate the waka elsewhere (196). There is some ethnographic evidence to suggest that people who come into contact with powerful waka could thereby (and not necessarily intentionally) become its host; for anecdotal evidence relating to sacred mountains, see Reinhard, who by climbing powerful apu has on more than one occasion been identified with the sacred power of particular mountains ("Sacred Peaks of the Andes").

160. Cummins observes that "the act of cutting the stone alters its natural state, but it never loses the material appearance as stone" (*Toasts with the Inca*, 27).

161. Cobo records an instance of accidental imagism in the discovery of a stone that resembled a person: "They say that when they were cutting stone from there [a quarry] for a house of the Inca, it came out so, and the Inca ordered that it should be a guaca" (*en [una cantera] había una piedra que parecía persona, la cual refieren que, cortando de allí piedra para una casa del Ina, salió así y mandó el Inca que fuese guaca*) (*Inca Religion*, 66; *Obras*, vol. 2, 177). Another stone shaped like a human figure was found; the Inka named it Unugualpa and "worshiped it as a remarkable thing" (*por cosa notable la adoraron*) (Cobo, *Inca Religion*, 68; *Obras*, vol. 2, 178). The ninth waka on the third siq'i of Chinchaysuyu, called Cugiguaman, was a stone shaped like a falcon (Cobo, *Inca Religion*, 56); this may also have been an example of serendipitous mimeticism. In these cases, the unlikely event of imagism in unhewn rock was a sign of the sacred. For a more detailed discussion, see Brittenham, "Imágenes."

162. *Arte y Diccionario*, 154.

163. Lira, cited in Niles, *The Shape of Inca History*, 205.

164. According to Salomon, illa are sacred objects containing "the fecundating essence of the good they represent" (Salomon and Urioste, *The Huarochirí Manuscript*, 74n257). While today illa usually refers to a petrous object, it can also describe magical persons such as twins (255). Salomon also notes that the word *illa* refers not just to objects, but to the precious essence of objects called illa as well; see Salomon, "Andean Opulence." Kuznar defines illa in use today as "special stone carvings that . . . represent both the telluric character of Andean religions, and their focus on fertility" ("Introduction," 55).

165. Lamadrid, *Treasures of the Mama Huaca*, 12.

166. Muñoz-Bernand, "Autoctonía y Descendencia"; Muñoz-Bernand, *Enfermedad, Daño, e Ideología*; and Alvarez Pazos, "Corpus Christi en Socarte," 52. Alvarez Pazos writes: "Si el cerro es pequeño, la gente que nace y vive

a sus alrededores también 'sale' de tamaño pequeño. . . . Y lo contrario si el cerro es alto. Si el cerro es 'bravo,' los hombres son impulsivos, irascibles; si el cerro es tranquilo sus moradores serán de genio apacible" (52). For a consideration of the ways the Kallawaya (Callahuaya, Qollahuaya) of Bolivia understand their own bodies in terms of the mountain on which they live, see Bastien, *Qollahuaya Rituals* and *Mountain of the Condor*.

NOTES TO CHAPTER TWO

1. This chapter and the next significantly amplify my article "The Inka Married the Earth."
2. Ortiz, "Mito de la Escuela," 238–42. The original Quechua reads:

Dius munaysapa, Taytanchik, ñaupaq purirqa mundu intirupi. Karuskas iskay churin: Inkapi, Jesuspi. Inka nin: "Rimaychik hamkuna" llapanchik yachasunchik, kunanpunchaumanta yachanchisun llapallan churichikta, wawanchikta. Inka Mama Pachata nin: "Mikuyta huy" chaymi allpata hallayhunku ruayta tarpunampaq. Chaysi llamapis, vacapis kasurun. Chay ñaupa timpuqa imapis maqtasuskasa. . . . Inka ruarun Cuscu llaqtata, llapachampis rumillas. Limaqa mitus ninsi. . . . Chaymantas uchkuta ruarun Cuscupi. Chay uchkutas rirqa Pacha Mamaman regalukunata aparikuspa, chaypis rimanku chaymantas ñoqaykupaqpis mañan imapis munasanta. Inka casadarukusa Mama Pachawan. Chaymanta iskay wawan karun. Sumaq sumaqsi wawachakuna. . . . Iskay wawakunas nacieramuspa chay Santu Jesusta rabiachisqa, llakichisqa Sucristus wiñaruspansi kallpa sapa maqta kasa, hinaspansi chay mayur wawquinta vinciruyta munasqa ¿"Imaynaraq vinciruyma"? nisqa. Killapis rikurusqa Jesusta llakirukun, "Noqa yanapasayki" chay killamantas kachaykamun huk papil qelqasata. Sucristus nin: "Kaywanqa ñam mancharikunqaña Inka." Tutayaq pampapis rikuykachin papilta. Inka mancharikun mana kelqasata mana yachaspa. ¿"Ima ninanchiki wak dibojo"? Pasarun karu karuta. . . . Inka mannas imaruaytapis atis sañachu Sucristus magarun Allpa Mama Pachata, kunkanta kuchurun. Inglisiatas ruarachin.

Ortiz translates the story to Spanish as follows:

Dios poderoso, Nuestro Padre, recorría el mundo. Tuvo dos hijos: Inka y Sucristus (Jesucristo o Jesús). Inka nos dijo "Hablen" y aprendimos a hablar. Desde entonces enseñamos a nuestros hijos a hablar. Inka pidió a Mama Pacha que nos diese de comer, y aprendimos a cultivar. Las llamas y vacas nos obedecieron. Esa fue una época de abundancia. . . . Inka con-

struyó el Cuzco, todo de piedra dicen que es. Lima de barro, dicen que es. . . . Después construyó en túnel (uchku) que está en el Cuzco. Por este túnel el Inka visitaba a Nuestra Madre Tierra. Le conversaba, le llevaba regalos, le pedía favores para nosotros. El Inka se casó con Mama Pacha. Tuvo dos hijos. Lindas criaturas son. . . . Cuando nacieron mucha cólera y pena le dio a Jesús Santo. Como ya había crecido Jesucristo y era joven y fuerte, quiso ganar a su hermano mayor Inka. "¿Cómo le ganaré?" decía. A la luna le dio pena. "Yo puedo ayudarte" le dijo, y le hizo caer una hoja con escrituras. Jesús pensó: "Seguro, con esto se va a asustar Inka." En una pampa oscura le enseñó el papel. El Inka se asustó de no entender las escrituras. "¿Qué cosa serán esos dibujos? ¿Qué quiere mi hermanito?" Se corrió, se fue lejos. . . . Cuando el Inka ya no podía hacer nada, Jesucristo le pegó a la Madre Tierra, le cortó el cuello. Luego se hizo construir Iglesias. (239–43)

Classen's English translation of Ortiz's Quechua transcription can be found in her article "Literacy as Anticulture," 418.

3. Classen reads this story as a critique of literacy and literate cultures ("Literacy as Anticulture").

4. For a consideration of the Andean regard for mountains, both ancient and modern, see Reinhard's "Sacred Mountains," as well as his "Sacred Peaks of the Andes."

5. For a discussion of the term *ayni* and its implications, see Mannheim, *Language of the Inka*, 89–93; and Ziólkowski, *Guerra de los Wawqi*, 29–30. For a discussion of ayni as practiced in Quechua communities today, see Allen, *The Hold Life Has*; Allen, "When Pebbles Move Mountains"; and Urton, *At the Crossroads*.

6. For a discussion of the Andean female earth-related spirit or deity, commonly called Pachamama, see Kuznar, "Introduction," 46. For a discussion of Aymara and Quechua beliefs that high, rocky, prominent landforms are male, see Bastien, *Mountain of the Condor*, 89; Harris, "Complementarity and Conflict," 24; and Isbell, *To Defend Ourselves*, 59. *Urqu*, the Quechua word for mountain or hill, also means male or masculine (usually with reference to animals).

7. Classen, *Inca Cosmology*, 56–57.

8. Guaman Poma, *Primer Nueva Corónica*, fol. 250 [252], 224.

9. *Historia General*, bk. 2, chap. 28, 423.

10. Bierhorst, *Black Rainbow*, 20.

11. Garcilaso, *Comentarios Reales*, pt. 1, bk. 1, chap. 15 (*Royal Commentaries*, vol. 1, 42–45). The same viewpoint can be found in the writings of other chroniclers; see, for example, Sarmiento, *Historia*, chap. 8, 43.

12. Gordillo, in his study of the Argentinean Chaco, concludes that "local knowledge is permanently informed by the experience of *not* knowing other geographies" (*Landscapes of Devils*, 184). He stresses that places are most often defined not in absolute terms but through contrasts with other places.

13. Cieza, in the second part of his lengthy *Chronicle of Peru*, identifies the Inka as the great civilizers of the Andes. No doubt he acquired this perspective from the testimony of the *khipukamayuq* (indigenous historians who kept records by means of colored, knotted cords) whom he had interviewed in Cuzco in the mid-sixteenth century. Garcilaso de la Vega, whose work also maintains an Inka perspective, not only relied on what his Inka relatives had told him as a boy, but also read the first part of Cieza's work, which had been published in Europe in 1553.

14. In the Peruvian Andes, the word *montaña* as used in the colonial period and today refers to the Amazonian piedmont of the eastern Andean cordillera, especially the thickly forested areas between five hundred and three thousand meters in altitude; this zone is referred to as the *yungas* in Bolivia. This area, as well as the Amazonian lowlands beyond, can be glossed as the selva. The boundary between the highlands, or sierra, and the montaña and selva is marked by the *ceja de selva* (fringe of the forest). The ceja is an area of dense clouds and heavy rainfall. The air warms in this and lower zones, and the vegetation grows thick; thus the selva and its ceja are differentiated from the dry, cold sierra not only by altitude but by distinctive types of flora and fauna.

15. Many chroniclers use the terms *Anti* and *Chunchu* interchangeably. The Quechua term *anti* was often written *andes* by Hispanic authors; it originally designated only the montaña northeast of Cuzco. In the colonial period, Spaniards applied the term to the Amazonian piedmont of the eastern cordillera and its inhabitants more generally. *Anti* tended to be used by people in the Cuzco region, while further south the term *Chunchu* or *Chuncho* enjoyed greater popularity.

16. Inka expansion into this zone was probably prompted by the desire to acquire lands for raising both coca and tobacco. Other valued products included *chunta* (*Bactris setosa ciliaba*, a dark-colored hardwood palm), cinnamon, gold, salt, peppers, animal pelts, medicinal herbs and insects, and the brightly colored feathers of tropical birds. Battles between Inka and Anti/Chunchu persisted in imagery well into the colonial period. Depictions of battles between the two groups can be found on all manner of colonial-period wares, especially wooden drinking cups called *qiru* (*qero*, *kero*) and textiles. Montaña warriors in colonial-period works are readily identifiable by facial paint, jaguar skin tunics, and feather headdresses. Also, they use bows and

arrows, which are the traditional weapons of montaña inhabitants. In such scenes the montaña warriors are signifiers of chaos, the agents of disorder who are properly defeated by the Inka so as to establish order; see Flores Ochoa, Kuon Arce, and Samanez Argumedo, *Qeros*; and Cummins, *Toasts with the Inca*, 250–61.

17. Renard Casevitz, Saignes, and Taylor, *Al Este de los Andes*, 43.

18. Cieza, *Crónica del Perú*, pt. 2, chap. 22, 65; Betanzos, *Suma y Narración*, pt. 1, chap. 28 (*Narrative*, 125).

19. Guaman Poma, *Primer Nueva Corónica*, fols. 77–78, 339 [341] (1988: 60–61, 312). Antisuyu was also filled with dangerous fauna. Guaman Poma, for example, in his map of the Andean area emphasizes the fabulous yet fearsome aspect of Antisuyu by depicting fantastical animals such as unicorns and serpents with wings (*ibid.*, fols. 983–84 [1001–1002]; 1988: 914–15).

20. Dean, "Andean Androgyny," and "Renewal of Old World Images." In Inka rhetoric concerning the selva, recorded during the colonial period, an extensive set of complementary pairings emerges. While the highlands were understood as inside, male, high, light, dry, open, clothed, and civilized, the selva was outside, female, low, dark, wet, closed, naked, and barbarous. Although the Inka clearly perceived themselves to be superior to montaña peoples, they found that they could not dominate them. They ascribed magical powers to the forest that they could not control. In some respects, the Inka viewpoint persists to the present day. The selva resonates as a place beyond government control. In what may well be an ironic twist of historical consciousness, many highland Andeans identify the selva as the home of their ancestors and the refuge of true—that is, un-Westernized—Indians. Selva magic promises to heal highland illnesses; in fact, as Bandelier tells us, the Collahuaya (Qullawaya) medicine men of the Lake Titicaca region who acquire both knowledge of healing and some of their medicinal plants in the ceja and beyond are sometimes called Chuncho (*Islands of Titicaca*, 104). Forest magic also promises to liberate highlanders from poverty and cultural domination; see Taussig, *Shamanism, Colonialism, and the Wild Man*, 222–36.

21. Guaman Poma, *Primer Nueva Corónica*, fol. 168 [170], 147.

22. The savagery of the Anti/Chuncho is defined by their difference and, most particularly, by what they lacked (clothes, manners, architecture, agriculture, and so on). As Peter Mason notes, "The exotic is always empty, it is characterised by lack, and this incompleteness calls forth and justifies attempts to fill in this gap in iconographical, textual, sexual and military terms" (*Deconstructing America*, 110).

23. The high-altitude plain above 3,800 meters found between the major

mountain ranges of the Andes is generally called puna or altiplano. See Du-viols, "Huari y Llacuaz"; Fioravanti-Molinié, "Contribution a l'Étude des Sociétés Étagées"; Flannery, Marcus, and Reynolds, *Flocks of the Wamani*; Isbell, *To Defend Ourselves*; Harris, "Power of Signs"; and Platt, "Mirrors and Maize."

24. The mountains are said to own both wild and domesticated plants and animals, all things that depend on the weather to live. Because runoff from the snowpack feeds the rivers of the selva, mountains are considered to be the owners of tropical forest resources as well.

25. Muñoz-Bernand, *Enfermedad, Daño e Ideología*, 152; Lamadrid, *Treasures of the Mama Huaca*, 29.

26. Mama Huaca is also known as Urcu Mama, Achikee, and Chificha; see Gutiérrez Estévez, "Hipótesis y Comentarios." Other studies of Mama Huaca include Lamadrid, *Treasures of the Mama Huaca*; and Muñoz-Bernand, "Seducción o Castigo."

27. In some parts of the Andes, the cannibalistic souls of the damned are said to wander glaciated mountain tops. See Allen, "Time, Place, and Narrative," 92.

28. Lamadrid, *Treasures of the Mama Huaca*, 2–3.

29. Barrionuevo, *Extraterrestres*, 103. It should not be understood, however, that "wild" nature is female in contrast to "civilized" male culture. Harris, based on her work among the Aymara-speaking Laymi of Bolivia, explains that the contrast between wild and tamed is not one of gender; rather, it is between married and unmarried couples ("The Power of Signs," 84–85).

30. Alvarez Pazos, "Corpus Christi en Socarte," 52.

31. One of many examples is the legend of Utqha Paucar, a man who falls in love with a woman (Ima Sumaj) who is also loved by his brother (Utqha Maita). While Utqha Paucar was a warrior and thus a source of potential disorder, his brother practiced agriculture, an orderly and ordering pursuit. The brothers entered into a competition with the one who was first to build an aqueduct to win the hand of Ima Sumaj. Utqha Maita won (because, as a farmer, he had experience building canals), but Utqha Paucar refused to accept defeat and challenged Utqha Maita to a battle. Before the martial contest could begin, however, Utqha Paucar realized that he was wrong and defaulted. Because he still loved his brother's betrothed, he withdrew to a distant mountain and lived out his miserable life there; see Lara, *Leyendas Quechuas*, 47–50. It is significant that in this story construction (the building of canals) together with agriculture defines civilization, while warfare is linked to the natural environment of the untamed mountains. The story of Chuquillanto, related in chapter 1, also posits the mountains as appropriate

places for those who violate the norms of social interaction. In fact, according to the story, both Chuquillanto and her illicit lover do not just flee to the mountains but transform bodily into mountains.

32. Guaman Poma, in *Primer Nueva Corónica* (fol. 323 [325], 298), for example, avers that Anti/Chunchu men dress *like* women ("todos los hombres bestidos como muger"), and argues that Anti/Chunchu males *look* like females, while females of the selva, who are often described as warriors, *behave* like males; see Dean, "Andean Androgyny."

33. Both Anti/Chunchu and Qulla are featured in colonial-period qiru imagery, where they serve as the foils to Inka ordering activity; see Cummins, *Toasts with the Inca*, 235–41, 250–61.

34. While Sarmiento identifies the native name for terrace as "sucre," most early sources give the name *pata*, a term that refers to a stepped landscape consisting of both a riser, or vertical element, and a runner, or horizontal element (*Historia de los Incas*, 93); see Nair, "Of Remembrance and Forgetting," 58–59n104.

35. Cook, "Staircase Farms," 494. Cook, although incorrectly crediting the most stunning of Inka terraces to some unknown pre-Inka culture, provides useful information about the structure and soil composition of Andean terraces.

36. Protzen observes that the Inka's investment of labor and resources into agricultural works "exceeds, or at least equals, that of the famous road network" (*Inca Architecture and Construction*, 11).

37. Ibid., 30. For a discussion of some of the symbolic dimensions of Inka terracing, see Farrington, "Mummy, Estate, and Palace," 57.

38. Garcilaso describes how certain Inka songs, called *hailli* (*haylli*, meaning "triumph") were sung at the time of ploughing; the men who ploughed were likened to both "noble lovers" (*enamorados discretos*) and "brave soldiers" (*soldados valientes*) (*Comentarios Reales*, pt. 1, bk. 5, chap. 2, 171; *Royal Commentaries*, vol. 1, 244). Hence agricultural work was analogized as both romantic seduction and warfare. The relationship between human beings and Pachamama could be difficult, calling for force rather than persuasion; for a discussion of how twentieth-century political sentiments have helped romanticize native relationships with Pachamama, see Molinié, "Resurrection of the Inca," 239.

39. Paternosto maintains that polygonal masonry had the structural function of retention (as in terraces and retaining walls), while coursed masonry was free-standing (*Stone and the Thread*, 35). This is not always the case, however. Coursed masonry at the Qurikancha and at Ingapirca "retains," while free-standing walls of polygonal masonry also exist.

40. According to González Holguin, *allpa* means "la tierra de labrar y el suelo" (*Arte y Diccionario*, 17).

41. Ibid.

42. Although the stone of Cuzco is contrasted in the story with the mud of Lima, the Spanish capital, the Inka were not strangers to mud-brick construction, and they used it extensively. Sancho de La Hoz, secretary to Francisco Pizarro and someone who saw the city as it was in Inka times, writes: "La mayor parte de estas casas [de Cuzco] son de piedra y las otras tienen la mitad de la fachada de piedra; hay muchas casas de adobe, y están hechas con muy buen orden" ("Relación," chap. 17, 328).

43. Although Cieza (*Crónica del Perú*, pt. 1, chap. 105, 235; *The Incas*, 284) and later Cobo (*History*, 141) report that Inka architecture was based on Tiwanaku models, Protzen and Nair have shown that in form, style, and construction techniques, buildings at Tiwanaku are significantly different from those of the Inka ("Who Taught the Inca Stonemasons"). Thus, while possibly inspired by masonry at Tiwanaku, the Inka did not copy it in any direct or obvious way (other than featuring stone).

44. Santo Tomás, *Lexicon*, 116; González Holguín, *Arte y Diccionario*, 271. González Holguín defines *canincakuchini* as "trabar bien la pared" and *canini* as "morder" (51).

45. *Vocabulario y Phrasis*, 21.

46. See Protzen, "Inca Quarrying and Stonecutting," and "Inca Stonemasonry." For a study of tools used by the Inka, see Gordon, "Laboratory Evidence."

47. While the load-bearing, horizontal joins of nibbled masonry usually fit perfectly throughout, vertical seams sometimes fit closely only to the depth of a few centimeters, with mud or gravel used to fill the internal gaps that are not visible from the exterior of the wall.

48. See, for example, Agurto Calvo, *Estudios*; Fraser, *Architecture of Conquest*; Gasparini and Margolies, *Inca Architecture*; Hyslop, *Inca Settlement Planning*; Kendall, *Aspects of Inca Architecture*; Kendall, "Descripción e Inventario"; Lee, "Design by Numbers"; Menotti, *The Inkas*; Morris and von Hagen, *Cities of the Ancient Andes*; Protzen, "Inca Stonemasonry"; Protzen and Nair, "Who Taught the Inca Stonemasons"; and Rowe, "Introduction to the Archaeology of Cuzco."

49. Paternosto prefers the terms "rectangular" and "polygonal" to describe the two styles (*Stone and the Thread*, 35). Rowe not only identifies the two basic categories, coursed and polygonal uncoursed, but traces their ancestry to common mud-brick construction and unworked fieldstone construction, respectively. Agurto Calvo, in *Estudios acerca de la Construcción*, has rendered

perhaps the most detailed study of types of Inka masonry to date; he identifies four types of fitted-stone (nibbled) masonry as follows: cellular, for uncoursed masonry in which polygonal stones have rectilinear sides; fitted, for uncoursed masonry in which polygonal stones have curved edges; cyclopean, for uncoursed masonry employing megaliths; and sedimentary, for masonry of rectangular ashlars arranged in relatively straight courses. He also discusses other aspects of Inka masonry, including typical stone block shapes, differing types of joints, and diverse cross sections, profiles, and surface textures. In most cases, these aspects can be combined in various ways even within a single wall.

50. Protzen and Nair, "Who Taught the Inca Stonemasons," 148–50.

51. Most scholars agree, however, that architectural styles do vary over time. I take up this issue in the next chapter.

52. For a description of the Inka's one-on-one fitting and laying technique, see Protzen's "Inca Quarrying and Stonecutting," 191–95; see also Protzen, *Inca Architecture and Construction*, 259.

53. Protzen, "Inca Quarrying and Stonecutting."

54. Cobo, *Inca Religion*, 228. The Spanish reads: "Para encajar unas piedras en otras, era necesario quitallas y ponellas muchas veces para proballas, y siendo tan grandes como vemos, bien se echa de ver la mucha gente y sufrimiento que sería menester" (*Obras*, vol. 2, 261).

55. Bryson uses the term "deictic," which he borrows from linguistics, to describe visual works that call attention to the means and manner of their own creation. He maintains that Chinese painting, which emphasizes the visibility of the constitutive strokes of the brush, is deictic, whereas Western painting is "predicated on the disavowal of deictic reference" (*Vision and Painting*, 89). Following Bryson's thinking, the Inka's nibbled rocks could certainly be termed deictic.

56. For more on the Inka's association of ritual drinking with specialized vessels and order, see Cummins, *Toasts with the Inca*, 80–98.

57. Classen has studied this topic extensively. See her following works: *Worlds of Sense*; "Foundations for an Anthropology of the Senses"; "The Social History of the Senses"; and "The Museum as Sensescape" (coauthored with David Howes).

58. Fraser, *Architecture of Conquest*, 32. See Cobo, *Obras*, vol. 2, 260–62.

59. See, for example, Fraser, *Architecture of Conquest*, 117; as well as Protzen and Nair, "Who Taught the Inca Stonemasons," 147.

60. Scully once observed that the Greek temple stands in "geometric contrast to the shapes of the earth"; he also commented that the Temple of Hera at Paestum "weighs heavily on the land" (*The Earth, the Temple, and the*

Gods, i). Western religious architecture, with a few exceptions, has a long history of dominating local topography.

61. Stone-Miller and McEwan, "The Representation of the Wari State," 57.

62. MacLean, "Sacred Land," 89. Niles concludes that architecture that imitates natural forms and frames mountains is more typical of early Inka architecture than later buildings that use more straight lines and right angles (*Shape of Inca History*, 290–92).

63. *Stone and the Thread*, 60. Paternosto speaks in this passage specifically of the site of Machu Picchu, but his observation can be applied more generally.

64. Hyslop, *Inca Settlement Planning*, 102; MacLean, "Sacred Land," 72, 93–98. Many years before the Inka, the Chachapoya used the integration of outcrops. At Vira Vira, for example, they built circular structures into crags at the upper, elite end of the site; see Muscutt, Lee, and Sharon, *Vira Vira*.

65. "Ticcirumi" is translated as *piedra fundamental* in one early dictionary (*Vocabulario y Phrasis*, 172).

66. Protzen, in *Inca Architecture and Construction* (figs. 1.15 and 1.16), provides an excellent example of an integrated outcrop at the site of Ollantaytambo.

67. Bandelier, *Islands*, 195.

68. Bingham, *Machu Picchu*, 56.

69. MacLean, "Sacred Land," 45, 93; Protzen and Nair, "Who Taught the Inca Stonemasons," 160.

70. Hyslop, *Inca Settlement Planning*, 102–28. MacLean observes that building on bedrock "preserves every available centimeter of useful land for horticulture" ("Sacred Land," 95). She also notes, however, that other concerns, such as viewpoints, helped determine the locations of structures.

71. See Hemming and Ranney, *Monuments of the Incas*, 9.

72. For a discussion of the ritual battle called tinku among the Macha of Bolivia, see Platt, "Mirrors and Maize."

73. Ibid., 241–45. See also Gutmann, who translates *yanantin* as "un compañero con el otro" ("Visión Andina del Mundo," 253). Allen tells us that residents of Sonqo (Department of Cuzco) use the phrase *warmi-qhari* to refer to the heterosexual couple (*The Hold Life Has*, 72–85).

74. Harris, "Power of Signs," 90.

75. Likewise, Aymara communities are divided into upper and lower moieties called *alasaa* and *masaa*, respectively.

76. Garcilaso, *Comentarios Reales*, pt. 1, bk. 1, chap. 16 (*Royal Commentaries*, vol. 1, 44).

77. See, for example, Flores Ochoa's *Pastoralists of the Andes*, 50.

78. Allen, *The Hold Life Has*, 106. In Sonqo, houses today are usually made of adobe rather than stone. According to Allen, "Each house lives because she is formed out of the living Earth" and "Nothing takes place in or around the house that she [the earth] does not see" (44).

79. Niles, "Provinces in the Heartland," 157.

80. Paternosto observes that "the distinction between 'sculpture' and 'architecture' seems to evaporate" and calls the carved outcrops "sculptarchitecture" (*Stone and the Thread*, 48, 61).

81. Andeans refer to mountain deities by a variety of names, including *achacila, apusuyu, aposento, awki, awkillo, jurq'u, mamani, urqutaytacha,* and *urqu yaya*; see Earls and Silverblatt, "Realidad Física y Social," 310; Gutiérrez Estévez, "Sobre el Origen"; and Urton, "Animal Metaphors," 258. Neither the variance in terminology across the Andean region nor the question of whether it is the mountain itself or mountain spirits that affect human affairs is of significant consequence to the present discussion.

82. Isbell, *To Defend Ourselves*, 124, 143, 163; Ossio, "Simbolismo del Agua," 379–81; Urton, *Crossroads*, 202–4.

83. Bergh, "Death and Renewal."

84. Barrionuevo, *Extraterrestres*, 79.

85. Quyllur Rit'i has been described and analyzed by many scholars, including Allen, *The Hold Life Has*, 200–205; Allen, "When Pebbles Move Mountains"; Flores Lizana, *El Taytacha Qoyllur Rit'i*; D. Gow, "Taytacha Qoyllur Rit'i"; D. Gow, "Roles of Christ and Inkarrí"; R. Gow and Condori, *Kay Pacha*; Morote Best, "El Oso Raptor," 159–60; Poole, "Accommodation and Resistance"; Ramírez, "La Novena al Señor de Qoyllur Rit'i"; Randall, "Qoyllur Rit'i"; Randall, "Peru's Pilgrimage to the Sky"; Randall, "Return of the Pleiades"; and Sallnow, *Pilgrims of the Andes*, 207–42.

86. Dean, *Inka Bodies*; Flores Ochoa, *El Cuzco*; Huayhuaca Villasante, *Festividad del Corpus Christi*; Molinié, *Celebrando el Cuerpo de Dios*.

87. Allen, *The Hold Life Has*, 197; Randall, "Peru's Pilgrimage," 67.

88. In stories documented by Morote Best, in his "El Oso Raptor," the ukuku dancer (that is, a man dressed in ukuku costume) is conceived of as the product of intercourse between a human female and a male bear. For more on ukuku, see Allen, "Of Bear-Men and He-Men"; Isbell, "The Metaphoric Process," 306; and Urton, "Animal Metaphors," 272. For modern ukuku stories from the Cuzco area, see Payne, *Cuentos Cusqueños*, 51–60.

89. *Relación de Antigüedades*, fol. 8v, 198.

90. For more on Cartesian dualism, see Cantrell, "Analogy as Destiny," 218. Binary thinking runs deep in the West and in Christianity. In his *City of God*,

Saint Augustine (CE 354–430) outlined his vision of a binary world engaged in the battle between the forces of good (*Civitas Dei*) and those of evil (*Civitas diaboli*).

91. The Andeanist Olivia Harris shows that "Ortner's thesis is clearly not supported by the Laymi case," wherein the opposition unmarried-married is more significant than female-male in analogies to the nature-culture binary ("The Power of Signs," 90).

92. For a discussion of the concept of the between space, *chawpi* in Quechua and *taypi* in Aymara, see Bouysse-Cassagne and Harris, "Pacha."

93. Today writing, to some extent, has replaced the making of miniatures in that literate pilgrims write their desires on slips of paper. See Allen, "When Pebbles Move Mountains"; and Sallnow, *Pilgrims of the Andes*, 201–2.

94. Allen, "When Pebbles Move Mountains," 75.

95. *Códice Murúa*, bk. 3, chaps. 50–54, fols. 102r–106r.

96. McEwan and Van de Guchte, "Ancestral Time and Sacred Space," 359. McEwan and Van de Guchte translate "capac hucha" as "royal obligation" (ibid.). Betanzos calls the rite "capa cocha" and translates it as "solemn sacrifice" (*sacrificio solemne*) (*Suma y Narración*, pt. 1, chap. 30, 142; *Narrative*, 132). Salomon suggests it be rendered "opulent prestation" ("Introductory Essay," 112n557).

97. See Betanzos, *Suma y Narración*, pt. 1, chaps. 11 and 30 (*Narrative*, 46, 132); Cieza, *Crónica del Perú*, pt. 2, chap. 29, 87–89; Cobo, *History*, 235–36; Cobo, *Inca Religion*, 151–53; Guaman Poma, *Primer Nueva Corónica*, fols. 228 [230], 247 [249], 262 [264] and 265 [267], pp. 203, 221, 234 and 239; Molina, "Relación de las Fábulas," 69–77; and Sarmiento, *Historia*, chaps. 13 and 31, pp. 57–58, 95. Hernández Príncipe, an extirpator of idolatries in the archdiocese of Lima who recorded his findings around 1622, also provides information about "capacocha" as it was remembered by native informants on the central coast in the early seventeenth century ("Mitología Andina"). To date, McEwan and Van de Guchte, in their "Ancestral Time and Sacred Space," offer the most comprehensive study of qhapaq ucha. See also Duviols's study "La Capa Cocha" and Zuidema's "Shaft-Tombs and the Inca Empire."

98. Cobo, *Inca Religion*, 156. The Spanish reads: "Iban derechos hacia el lugar que caminaban sin torcer a ninguna parte, atravesando montes y quebradas, hasta llegar cada uno a su tierra" (*Obras*, vol. 2, 223).

99. Sarmiento reports that the sacrifice was by burial alive (*Historia*, chap. 31, 95). Cobo indicates that the children were strangled or killed by a blow with a club (*History*, 235–36). The sacrifices could also be thrown into the sea if the ceremony ended there (Betanzos, *Suma y Narración*, pt. 1, chap. 30; *Narrative*, 132).

100. Betanzos, *Suma y Narración*, pt. 1, chap. 17 (*Narrative*, 77).

101. McEwan and Van de Guchte, "Ancestral Time and Sacred Space," 364–66.

102. For reports on the finding of qhapaq ucha sacrifices and their archaeo-logical contexts, see Besom, "Another Mummy"; Reinhard, "High Altitude Archaeological Survey"; Reinhard, "Frozen in Time"; Reinhard, "Llullai-llaco"; Reinhard, "Sacred Peaks of the Andes"; Reinhard and Ceruti, "Sacred Mountains"; and Schobinger, "Sacrifices of the High Andes."

103. McEwan and Van de Guchte, "Ancestral Time and Sacred Space."

104. Reinhard reports that sacrifices of human blood are still occasionally offered in the Andes ("Sacred Peaks of the Andes," 95). In particular, blood that is shed today in the context of ritual battles is considered to be an offer-ing to both Pachamama and the mountain fathers. For a study of the Andean despacho, see Ackerman, "The Despacho," and Dalle, "El Despacho."

105. Allen, "When Pebbles Move Mountains," 78.

NOTES TO CHAPTER THREE

1. The Inka were not alone in characterizing their realm as consisting of four parts. Naram Sin, the Mesopotamian king of the third millennium BCE, took the title "Lord of the Four Quarters," proclaiming himself to be the cen-ter where north, south, east, and west meet, and from which the world could be measured infinitely in all directions; likewise, Cyrus of Persia, in the first millennium BCE, dubbed himself "Lord of the Four Quarters." See Summers, *Real Spaces*, 221–24.

2. It should be noted that Cuzco was not just a community of people or a collection of buildings but a sacred space. In stories, as well as performance, the sacred city was centered in the space of the burgeoning empire. As Tuan observes, "Myths and legends are created to give credence to the idea that a place—otherwise unremarkable—is the center of the world" (*Man and Na-ture*, 18). Garcilaso, in fact, translates "Cuzco" as "the navel of the world" (*ombligo de la tierra*) (*Comentarios Reales*, pt. 1, bk. 2, chap. 11, 66; *Royal Com-mentaries*, vol. 1, 93). While his translation is likely not accurate, it is clear that the Inka ordered their empire to make Cuzco the political and religious heart of the Andes. I discuss the meaning of *cuzco* (or *q'osq'o*) in chapter 4.

3. Summers observes that "the making of places always entails the shaping of social relations. Place is the conditional basis for all the culturally specific situations in which groups and individuals 'know their places' within a social order, most usually a stratified order in which some individuals, groups and

activities are regarded as higher than others" (*Real Spaces*, 123). Although Lefebvre, in *The Production of Space*, was primarily concerned with the relationship between conceptions of space and the constitution of modernity in the West, his observation that space is always socially and culturally constructed is a critical one.

4. Guaman Poma, *Primer Nueva Corónica*, fols. 983–84[1001–1002], 914–15. For a discussion of Guaman Poma's *Mapamundi*, see Ossio, "Guamán Poma: *Nueva Corónica* o Carta al Rey"; and Wachtel, *Sociedad e Ideología*, 77.

5. Although some have concluded that the Watanay (Saphi) River divided the hanan from the urin sector of Cuzco, Gasparini and Margolies and others locate the division slicing through the city on a northwest-southeast axis, running along the southeast edge of the double plaza (*Inca Architecture*, 58). While the city of Cuzco was the conceptual center, Tawantinsuyu also featured a center that was mobile and never fixed in place. Houston and Cummins, in "Body, Presence, and Space," 374–77, and Ramírez, in *To Feed and Be Fed*, 13–56, observe that the Inka ruler was himself both the ideological and physical center of Tawantinsuyu. In fact, early Spanish chroniclers referred to him by the title "El Cuzco." The Inka saw no need to reconcile the two Cuzcos, for the ruler carried with him the embodied (transubstantiated) essence of Cuzco, thus maintaining his centrality, while Cuzco, the city, housed the essence of all of its rulers.

6. While it is commonly thought that the first five rulers belonged to urin Cuzco, Cobo tells us that the founder (Manco Capac/Manku Qhapaq) was both urin and hanan (*History*, 123). According to Betanzos, it was the ruler Pachakuti who ordered the royal families to settle in the appropriate parts of the city; that is, those belonging to urin would inhabit lower Cuzco, and those belonging to hanan would live in upper Cuzco (*Suma y Narración*, pt. 1, chap. 16; *Narrative*, 71). Some scholars have proposed alternative actualizations of the upper and lower houses of Inka royalty; specifically, they argue that hanan and urin rulers formed a diarchy and were contemporaneous rather than successive. See Duviols, "Algunas Reflexiones"; Duviols, "Dinastía de los Incas," 77; Rostworowski, *Estructuras Andinas del Poder*, 130–79; Rostworowski, *History of the Inca Realm*, 177–81; Zuidema, *Ceque System*, 137–38, 145–46; Zuidema, "Inka Dynasty and Irrigation," 177–78; and Zuidema, "Moieties of Cuzco."

7. The descriptions of Andean people by Guaman Poma particularly reflect a sort of pan-suyu identity. Royal estates, because they were the personal property of the ruler, were apparently exempt from suyu affiliation. For an excellent summary of Inka militarism and provincial administration, see D'Altroy, *The Incas*, 205–62.

8. Rodman, "Empowering Place"; Tuan, *Space and Place*.

9. Gordillo, *Landscapes of Devils*, 4.

10. As noted earlier, many scholars have extensively studied the inter-related concepts of time and space in the Andes. See, among others, Allen, "Patterned Time"; Allen, "Time, Place, and Narrative"; Bengtsson, "Concept of Time/Space in Quechua"; Bouysse-Cassagne and Harris, "Pacha"; Fioravanti-Molinié, "Tiempo del Espacio"; and Salomon, "Introductory Essay," 14–16.

11. Like more conventional "rock art"—painting on rock and petroglyphs—Inka rockwork was intimately connected to, and so made claims on, particular places.

12. Niles, *Shape of Inca History*; see also Niles, "The Nature of Inca Royal Estates," 64–67.

13. See also Farrington, "Mummy, Estate, and Palace."

14. Today white stones, or *yuraqrumi*, are commonly associated with fertility; see Gow and Gow, "La Alpaca en el Mito y el Ritual," 153.

15. McEwan and Van de Guchte, "Ancestral Time," 368; Van de Guchte, "Carving the World," 334.

16. The Inka did not treat all frontier areas in identical ways, of course, but appear to have adapted to local circumstances. For analyses of Inka actions and interactions along diverse frontiers, see Alconini, "Prehistoric Inka Frontier"; Alconini, "Southeastern Inka Frontier"; Bray, "Effects of Inca Imperialism"; D'Altroy, *Provincial Power*; D'Altroy et al., "Inka Rule"; Dillehay, "Tawantinsuyu"; Earle et al., *Archaeological Field Research*; Gyarmati and Varga, *The Chacaras of War*; Heffernan, *Limatambo*; Hyslop, *Inca Settlement Planning*; Julien, "Oroncota entre Dos Mundos"; Meyers, *Incas en el Ecuador*; Schjellerup, *Incas and Spaniards*; see also various essays in Dillehay and Netherly, *Frontera del Estado Inca*; and Malpass, *Provincial Inca*.

17. Gasparini and Margolies, *Inca Architecture*, 195–303. MacLean points out that Inka doors and windows are technically not trapezoidal, as they are usually not composed of straight lines ("Sacred Land," 60). Nevertheless I will use the term *trapezoid*, as do most who discuss Inka architectural forms. Gasparini and Margolies credit the ruler Pachakuti with developing the characteristic and repetitive style of Inka architecture known as the "Cuzco style" (*Inca Architecture*, 5). They maintain that Pachakuti's successors, Thupa Inka Yupanki and Wayna Qhapaq, relied on Pachakuti's standardized model over the remaining eighty years of Inka dominance in the Andes (ibid.). Kendall, however, has found considerable variability in Inka architectural style over time ("Descripción e Inventario"). See also Kendall, *Aspects of Inca Architecture*; Kendall, Early, and Sillar, "Arquitectura Inca Temprana"; Niles, *Shape*

of Inka History; and Protzen, "Inca Architecture" and *Inca Architecture and Construction*, 263–69.

18. Protzen, however, observes that contrary to what is conventionally thought, Inka architecture is not as uniform as portrayed: "There is, no doubt, an amazing formal unity in Inca architecture; many of its elements were indeed standardized, and proven solutions were replicated over the whole empire. But to stress standardization and repetition is to disregard the range of variations and of subtle differences that do exist from one building to the next and from one site to another, and it is to distract from discovering the richness of Inca architecture" (*Inca Architecture and Construction*, 283).

19. Howard-Malverde, *The Speaking of History*, 73–83. Howard-Malverde's study focuses on stories told in the central highlands of Peru (Department of Huánuco). Arnold, working in the modern Aymara community of Qaqachaka, Bolivia, aptly characterizes house building as an "art of memory"; see "The House of Earth-Bricks."

20. For detailed versions of the Chanka war, see Betanzos, *Suma y Narración*, pt. 1, chaps. 6–8 (*Narrative*, 19–30); Santa Cruz Pachacuti, *Relación de Antigüedades*, fols. 18r–20r, 217–22; Sarmiento, *Historia*, chaps. 26–29, pp. 83–91). Duviols ("La Guerra entre el Cuzco y los Chancha," 83), and Zuidema ("The Lion in the City"), based on the lack of archaeological evidence, have questioned the historicity of this event. For a discussion of the evidence countering the traditional notion that a battle with the Chanka marked the foundation of the Inka state, see Bauer, *Development of the Inca State*.

21. Rowe, "Machu Picchu a la Luz de Documentos." Rowe suggests that Pachakuti founded his estates to commemorate military accomplishments; Pisaq and Ollantaytambo, for example, memorialized conquests in the Urubamba Valley, and the founding of Machu Picchu was related to his campaign to conquer Vitcos (142–43). Rowe, using information provided by Cabello Valboa, set the date for Pachakuti's victory over the Chanka and his expansion of the realm to circa 1438 ("Absolute Chronology in the Andean Area"). Bauer and Covey have shown that Inka imperial expansion had begun before 1400, however; see Bauer, *Ancient Cuzco*, 71–90.

22. Thupa Inka Yupanki's estates were at Chinchero, Urcos, and Huayllabamba.

23. Urubamba and Yucay were also estates that belonged to Wayna Qhapaq and his descendants.

24. Niles, *Shape of Inca History*, 262–97. Building palaces and developing lands was important symbolically because such projects established the new ruler's legitimacy. Architectural projects identified the ruler as being like all ruler-builders before him. Niles writes that "for the Incas, architecture

was a way to give form to claims of mythical or legendary history. . . . The placement of a structure, the story told about its construction, and aspects of its design all helped to give shape not only to a building but to the history which caused it to be made" (*Shape of Inca History*, 84). Nair, in her study of Thupa Inka Yupanki's royal estate at Chinchero, concludes that construction "reflected a particular and pointed image of the patron" ("Of Remembrance and Forgetting," 21).

25. Niles, *Shape of Inca History*, 133; Niles, "Nature of Inca Royal Estates," 50.

26. Niles, "Provinces in the Heartland," 157.

27. Niles, "Nature of Inca Royal Estates," 60. Niles also notes that the integration of outcrops occurs in the Inka built environment throughout the period of the imperium.

28. Niles, "The Nature of Inca Royal Estates," 60; "Provinces in the Heartland," 157; *Shape of Inca History*, 268. Niles suggests that Pachakuti, who according to Cobo had a personal encounter with the creator deity (Pachayachachic), may consciously have emulated the Creator in his architecture by using and improving on nature: "What the deity had left unfinished, Pachacuti completed. What the deity made good, Pachacuti made better, by framing a good view and making it perfect" ("Nature of Inca Royal Estates," 62).

29. Nearly all ethnohistorical accounts written in the sixteenth and seventeenth centuries report that Saqsaywaman was begun during the reign of the Inka's ninth ruler (Pachakuti) or his son, the tenth ruler (Thupa Inka Yupanki). Many report that the work was continued by succeeding rulers, being finished, or nearing completion, at the time Francisco Pizarro and his company arrived in the Andean area in 1532.

30. Garcilaso, calling Saqsaywaman the Inka "trophy of trophies" (*trofeo de sus trofeos*), concludes that its primary purpose was to impress; in fact, he says that "it was indeed made to impress rather than for another reason" (*se hizo más para admirar que no para otro fin*) (*Comentarios Reales*, pt. 1, bk. 7, chaps. 27 and 29, pp. 325, 328; *Royal Commentaries*, vol. 1, 465, 469).

31. Lechtman, "Cloth and Metal." For the relationship of structure to meaning in Andean textile work, see also Conklin, "Structure as Meaning." For additional observations on process and product in Andean metalwork, see Lechtman, "Andean Value Systems," "Style in Technology," and "Technologies of Power."

32. Nair suggests that the process of making fine Inka masonry was "as important as the product" ("Of Remembrance and Forgetting," 285).

33. Protzen and Nair, "Who Taught the Inca Stonemasons," 156.

34. Given the Inka emphasis on the facturing process, it is particularly dis-

tressing that a variety of hypotheses—including the use of herbal juices, which softened or dissolved stone, or laser beams, which cut through stone like butter—persists. I discuss such hypotheses further in chapter 4.

35. Falcón, "Representación," 50. Francisco Falcón was a *licenciado* in the service of the provincial council in Lima; his report of 1567, written to document ongoing idolatrous behavior, identifies the titles of numerous indigenous specialists.

36. Cobo, *Inca Religion*, 240.

37. According to Garcilaso, stonemasons worked their stone with "some black pebbles called *hihuana*, with which they pounded rather than cut" (*unos guijarros negros que llamaban hihuana, con que las labran machucando más que no cortando*) (*Comentarios Reales*, pt. 1, bk. 2, chap. 28, 95; *Royal Commentaries*, vol. 1, 131). Gasparini and Margolies note that Garcilaso likely meant *hihuaya* (*Inca Architecture*, 342).

38. Protzen and Nair, "Who Taught the Inca Stonemasons," 157.

39. Fraser, *Architecture of Conquest*, 117.

40. Niles, "Niched Walls in Inca Design," 277–78.

41. Sometimes the "perfect" seam between blocks is only a few inches deep. Paternosto explains: "In the internal part of the wall, the irregularities and fissures between the ashlar blocks were filled in with mud and gravel" (*Stone and the Thread*, 42).

42. Rowe, "Introduction," 24.

43. Sancho de La Hoz, who saw Cuzco before it was burned in the Inka uprising of 1535–36, describes four Inka buildings near their central plaza as "pintadas y labradas y de piedra" ("Relación para su Majestad," chap. 17, 328).

44. Trever, "Slithering Serpents," 16; MacLean, "Sacred Land," 49. For a discussion of the Inka use of paint and plaster in architectural decoration, see Protzen, "Inca Architecture," 198–99.

45. Christian Metz introduced the term "scopic regime" to describe a hegemonic visuality; see Metz, *The Imaginary Signifier*, 61.

46. Protzen notes that the protuberances are present only on blocks at the construction site and not on stones at the quarry or abandoned in transit ("Inca Stonemasonry," 101, 105). For a detailed description of bosses at Ollantaytambo, see Protzen, *Inca Architecture and Construction*, 201. For more on the techniques of stone fitting and placement, see Protzen, "Inca Quarrying and Stonecutting," 191–93; Lee ("The Building of Sacsahuaman") has offered a less plausible hypothesis regarding a fitting technique called scribing and coping.

47. Protzen, *Inca Architecture and Construction*, 203.

48. Gasparini and Margolies, *Inca Architecture*, 325–31. Rowe, in "Inca Culture at the Time of the Spanish Conquest" (226), and Hemming and Ranney, in *Monuments of the Incas* (33), also conclude that the protuberances must have met some aesthetic criteria.

49. Paternosto, *Stone and the Thread*, 150. Paternosto concludes that the bosses were visual signs heightening the symbolic meaning of the architecture where they are found; for example, he observes that at Ollantaytambo, protuberances seem to announce proximity to the Temple of the Sun. Bosses, he avers, achieve meaning through the contrast of the protuberance, which he calls a lithic knot, to the plain surface of the stone block, just as the knot of the khipu signifies through its difference from the unknotted cord (150–55). Trever offers an interesting interpretation based on the Inka belief in the once and future animacy of rock; she suggests that the bosses may be "organic vestiges of the former, or potential, human bodies of the stones" ("Slithering Serpents," 31).

50. The Inka system of labor featured *mitmaq*, individuals who worked for the state for a limited period as a form of labor tax. For more on the mit'a labor system, see Espinoza Soriano, *Los Incas*, 360.

51. Paternosto, *Stone and the Thread*, 152.

52. Gasparini and Margolies, *Inca Architecture*, 8–11.

53. Morris, "State Settlements in Tawantinsuyu." Tampu were centers of control — economic, political, military, and religious — in subject areas. For more on the layout and function of sections of Huanuco Pampa, in particular, see Morris and Thompson, *Huanuco Pampa*.

54. Gasparini and Margolies, *Inca Architecture*, 331.

55. Thompson, "Review," 585.

56. Spaniards, following the European distinction between art and craft, admired Inka skill at masonry but did not recognize their architecture as being artful. See Fraser, "Architecture and Imperialism," 331.

57. Gasparini and Margolies, *Inca Architecture*, 320.

58. For a photograph of the second carved parallelepiped, see Gasparini and Margolies, *Inca Architecture*, 321.

59. Machicado Figueroa, *When the Stones Speak*, 21. Machicado Figueroa relies on modern Andean ritual specialists, called *paqo*, to reveal the meaning underlying some Inka stonework. I consider Machicado Figueroa's work further in chapter 4.

60. Paternosto, *Stone and the Thread*, 145.

61. Summers, with reference to the colossal Olmec heads of Mexico, makes the point that once we recognize symbolic value (whether religious, political, or some other form), "then it might be possible to understand why existing

technology was stretched far beyond its ordinary limits, or why the making of certain images or structures might even have spurred technological invention." He also observes that the value or sanctity or power of a work may consist "precisely in denying the limits of both technology and technique" (*Real Spaces*, 71).

62. Hemming and Ranney, *Monuments of the Incas*, 53.

63. Ogburn, in "Dynamic Display," examines other ways the Inka enhanced the perception of the state's control over labor; in particular, he considers the building of imperial temples and palaces, royal visits to the provinces, the maintenance of state infrastructure (roads, bridges, storehouses), the resettlement of sizable populations to far-flung parts of the empire, the transportation of luxury goods from throughout the empire to Cuzco, and the transportation of large building stones from Cuzco to various parts of Tawantinsuyu.

64. Cieza, *Crónica del Perú*, pt. 1, chap. 56 (*The Incas*, 87–88). The Spanish reads: "Los reyes incas en el tiempo de su reinado habían mandado a sus mayordomos o delegados, por tener por importante esta provincia de los Paltas, se hiciesen estos tambos, los cuales fueron grandes y galanos, y labrada política y muy primamente la cantería con que estaban hechos" (Cieza, *Crónica del Perú*, 150).

65. Albornoz writes: "Y siempre [el ynga] dio orden que las sustentasen con el orden que de antes. Y a muchas guacas de las dichas ennobleció con muchos servicios y haziendas y basos de oro y plata y ofreciendole[s] sus propias personas en figuras de oro o de plata y otras figuras de carneros y de otros animals y aves del dicho oro y plata, e ofreciendo y quemando de todos los mantenimientos que ellos usavan, y dándoles bestidos ricos que para el efeto mandavan hazer" ("Instrucción para Descubrir," 163–64).

66. Salomon and Urioste, *The Huarochirí Manuscript*, 97.

67. Reinhard, "Sacred Mountains," 314; "Llullaillaco," 48. For a report on the archaeological remains on ten Chilean summits, see Reinhard, "High Altitude Archaeological Survey."

68. Salomon and Urioste, *The Huarochirí Manuscript*, 99. As Salomon and Urioste note, Avila understood Maca Uisa to have been a golden idol (99 n. 443). Since he never saw it, we cannot take his report as fact.

69. Polo writes: "Quando el Ynga conquistaua de nueuo una Prouincia ó pueblo, lo primero que hazía era tomar la Huaca principal de tal prouincia ó pueblo y la traía al Cuzco assí por tener á aquella gente del todo sujeta, y que no se rebelasse, como porque contribuyessen cosas y personas para los sacrificios y guardas de las huacas y para otras cosas" ("De los Errores," chap. 15, 42). Morris and von Hagen, in *The Cities of the Ancient Andes* (171), suggest

that the seized waka were wank'a, the lithic bodies of founding ancestors who had turned to stone (see chapter 1).

70. Polo, "Relación de los Fundamentos," 97.

71. Cobo, *Inca Religion*, 3–4. Murúa tells us that the captured waka were placed in the Qurikancha, the center of Inka religious activities (*Códice Murúa*, bk. 3, chap. 45, fol. 97r). Betanzos, however, describes the *llaxa guaçi*, a structure that housed "the insignias and things of this sort that were brought from the war" (*las insignias e cosas desto que en la guerra traían*) (*Suma y Narración*, pt. 1, chap. 19, 96; *Narrative*, 90). The seized waka were questioned about the future and were either rewarded for accurate predictions made in the past or punished for previously inaccurate prognostications; see Mac-Cormack, *Religion in the Andes*, 103–4.

72. Albornoz, "Instrucción para Descubrir," 170–71.

73. Boero and Rivera, *El Fuerte Preincaico*; Meyers and Ulbert, "Archaeological Explorations in Eastern Bolivia," 29. For detailed description of the carved rock at Samaipata, see Trimborn, *Archäologische Studien*. See also Meyers, "Campañas Arqueológicas."

74. Schreiber, "Inca Occupation," 92–102. The Inka structure is a two-story rectangular building of fieldstone and adobe blocks.

75. "El prencipal género de guacas que antes que fuesen subjetos al ynga tenían" (Albornoz, "Instrucción para Descubrir," 169). Albornoz also tells us that no kin group (*ayllu*) was without its individual place of origin (197).

76. Anders, "Dual Organization," 786, 788–91, 911–16.

77. Albornoz, "Instrucción para Descubrir," 170–71.

78. Bastien, "Metaphorical Relations," 26.

79. Bauer argues that the Inka may have located their paqarisqa in the province of Paruro at the rock outcrop called Puma Orco ("Pacariqtambo," 24). Urton, in *The History of a Myth*, suggests that the identification of the town called Pacariqtambo as the Inka's paqarisqa was a colonial-period phenomenon, however. The Inka may have re-created dozens of places of origin throughout Tawantinsuyu by marking caves, caverns, and underground passages as sacred passageways of emergence. Different components of Inka society would have advocated different versions of the story to support their own land claims. For more on the Inka remains at Puma Orco, see Bauer, *Development of the Inca State* (109–23).

80. Parmenter, in her book on place and identity in Palestinian literature, uses the term "land rhetoric" to refer to a self-conscious construction of place; see *Giving Voice to Stones*, 84. In her consideration of how Palestinians have responded to Israel's powerful and compelling land rhetoric, I am reminded of the ways the Inka's "land rhetoric," as recorded by Spaniards (who

had a powerful land rhetoric of their own), obscured views of place held by groups incorporated into Tawantinsuyu.

81. For a discussion of related notions, see Paternosto, *Stone and the Thread*, 93.

82. *Códice Murúa*, bk. 3, chap. 14, fol. 66r. According to Murúa, it was the eleventh ruler, Guainacapac (Wayna Qhapaq), who had this done.

83. Ogburn, "Power in Stone," 123–24.

84. Albornoz, "Instrucción para Descubrir," 171.

85. "[Es] una piedra donde hazían muchos sacrificios en reverencia del Guanacauri del Cuzco" (ibid., 180).

86. Murúa, *Historia General*, bk. 1, chap. 31, 113.

87. Ogburn explores the propagandistic aspects of Inka stories (sometimes presented as ballads) about military conquests, the suppression of rebellions, and the punishment of rebels or other offenders ("Dynamic Display," 234–36). I view many of the stories about stones—whether recalcitrant or co-operative—as functioning similarly.

88. For a discussion of modes of transport, see Protzen, "Inca Stone-masonry," 102–3.

89. Van de Guchte, "El Ciclo Mítico."

90. *Códice Murúa*, bk. 2, chap. 3, fol. 38r. While Murúa praises Ynga Urcon, Cieza and Betanzos both identify him as the cowardly son of Viracocha Inca and heir to the throne who, along with his father, abandoned Cuzco to the invading Chanka; see Cieza, *Crónica del Perú*, pt. 2, chap. 44, 129; and Betanzos, *Suma y Narración*, pt. 1, chap. 8 (*Narrative*, 27). Ynga Urcon was later killed by Pachakuti Inca Yupanqui, another of Viracocha's sons, who had stayed to defend the city.

91. Betanzos, *Suma y Narración*, pt. 1, chap. 37 (*Narrative*, 157); Cieza, *Crónica del Perú*, pt. 2, chap. 51, 148–49; Garcilaso, *Comentarios Reales*, pt. 1, bk. 7, chap. 29 (*Royal Commentaries*, vol. 1, 470); Murúa, *Historia General*, bk. 1, chap. 87, 314–16; and Ocaña, *A Través de la América del Sur*, chap. 34, 225). According to Guaman Poma, the stone was quarried in Cuzco and was being taken to Guanuco; later, he reports, an attempt was made to take it to Quito in Ecuador (*Primer Nueva Corónica*, fol. 160 [162], 139).

92. Betanzos, *Suma y Narración*, pt. 1, chap. 37, 170; Cieza, *Crónica del Perú*, pt. 2, chap. 51, 148; Garcilaso, *Comentarios Reales*, pt. 1, bk. 7, chap. 29, 328 (*Royal Commentaries*, vol. 1, 470). As mentioned in chapter 1, the tired stone has been identified as what is now referred to as la Chinkana Grande, a rock outcrop located north and east of Saqsaywaman; see Van de Guchte, "El Ciclo Mítico," 548.

93. Summers introduces the notion of the trace, which, like the semiotic

index, is contiguous with its cause but, unlike the index, does not have to resemble its cause (*Real Spaces*, 255).

94. Garcilaso, *Comentarios Reales*, pt. 1, bk. 7, chap. 29 (*Royal Commentaries*, vol. 1, 470); Guaman Poma, *Primer Nueva Corónica*, fol. 160 [162], 139; Murúa, *Códice Murúa*, bk. 2, chap. 3, fol. 37v.

95. Cobo, *Inca Religion*, 56–57.

96. Garcilaso, *Comentarios Reales*, pt. 1, bk. 7, chap. 29 (*Royal Commentaries*, vol. 1, 470); Cobo, *Inca Religion*, 56–57; Murúa, *Códice Murúa*, bk. 2, chap. 3, fol. 37v. Beyersdorff suggests that "Collaconcho" can be translated "Large Cut-Stone Work" ("Suggested Glosses," 183).

97. Cobo names the stone as being the sixth waka on the fourth siq'i of Chinchaysuyu.

98. Cieza, *Crónica del Perú*, pt. 2, chap. 65, 190; *The Incas*, 77. Ogburn, in his study of stories of stones moved from Cuzco to Ecuador, explains that the term *Quito* was often used by Spaniards to refer to a broad geographic region that included Tomebamba, the site of Wayna Qhapaq's most prized building project ("Power in Stone," 108).

99. *Códice Murúa*, bk. 3, chap. 14, fol. 66r.

100. Ogburn, "Evidence for Long-Distance Transportation" and "Power in Stone."

101. Ogburn, "Power in Stone," 126–30.

102. "Como los indios supieron que éramos partido de Caxamarca, vienen sobre ella y no dejan piedra sobre piedra" (Ruiz de Arce, "Advertencias," 425–26).

103. Cobo, *Inca Religion*, 36 (*Obras*, vol. 2, 162). Cobo states: "Even though they [the puruawqa] had turned into stones after the Battle of the Chancas was over, they emerged from there to help the Inca's people when it was necessary" (*si bien acabada la batalla de los Chancas se habían vuelto piedras, de allí salían a ayudarles cuando era necesario*) (*Inca Religion*, 36; *Obras*, vol. 2, 162). He also writes: "The fear inspired by the pururaucas was more effective than the fighting of the Inca's troops in all of their successful encounters because often the enemy would flee almost without putting up a fight" (*y así acaeció después en todos sus buenos sucesos, que hacía más operación el miedo que tenían destos pururáucas, que lo que peleaban los escuadrones del Inca, porque muchas veces huían casi sin llegar a las manos*) (*Inca Religion*, 35; *Obras*, vol. 2, 162).

104. Stories of stones animating in support of heroic or honored individuals are a familiar theme in world folklore. While the potential animacy of stone is central to Andean beliefs, many cultures appreciate the potent notion of stones, normally silent and still, coming to life.

105. Cobo, *Inca Religion*, 36. Cieza refers to a "stone of war" (*la piedra de*

la guerra) that the Inka called on for help when they faced battle; he says that "captains and leaders" (*capitanes y mandones*) were appointed beside the stone of war that was placed in the square of Cuzco (*Crónica del Perú*, pt. 2, chap. 63, 182). This stone may have been one of the puruawqa. He describes it as being "large and set with gold and precious stones" (*grande y bien engastonada en oro y piedras*) (pt. 2, chap. 36, 109). Hyslop thinks Cieza's "war stone" may have been the usnu, a special stone that I discuss later in the chapter (*Inca Settlement Planning*, 71–72). It may also have been the Inti Wawqi, a lithic embodiment of the sun that was often taken to the plaza for ceremonies; Betanzos describes this stone as having a belt of gold (see chapter 1).

106. Rowe, "Shrines of Ancient Cuzco," 62, 71.

107. Hyslop, *The Inka Road System*, 82–83. Vantage points from which first sight of a particular place is gained remain important in some parts of the Andes. Abercrombie reports that all trails leading to Santa Bárbara de Culta, in the Bolivian highlands, were marked with stone pillars at the point where walkers would first (or last) see the community (*Pathways of Memory*, 54).

108. For a consideration of the importance of lines of sight with regard to sacred Andean things, see Kuznar, "Introduction," 49–50. Elevated viewing is privileged universally; see Tuan, *Space and Place*, 37.

109. Vilcashuaman was a major Inka center to the north of the Soras and Lucanas province. It was a major settlement on an imperial road (Qhapaq ñan), a collection point for coastal tribute, and a military staging area. The area was repopulated with mitmaq, mostly from Lucanas and Aymaraes; see Julien, "Finding a Fit," 200. For a full description of the viewing platform at Vilcashuaman, see Hyslop, *Inca Settlement Planning*, 69–101.

110. Cieza, *Crónica del Perú*, pt. 1, chap. 89, 209.

111. Guaman Poma, *Primer Nueva Corónica*, fol. 445 [447], 413.

112. Santa Cruz Pachacuti, *Relación de Antigüedades*, fol. 32r, 245.

113. *Suma y Narración*, pt. 1, chap. 42 (*Narrative*, 168). The Spanish reads: "Le tenían hecho cierto asiento a manera de un castillejo alto y en do medio del castillejo una pileta llana de piedras y como llegase el Ynga al pueblo subíase en aquel castillejo y allí se sentaba en su silla y de allí veía a todos los de la plaza y ellos le veían a él" (*Suma y Narración*, 185).

114. Molina, "Destrucción del Perú," 22. Segovia writes: "En cada pueblo [había una] plaza grande real y en medio de ella un cuadro alto de terraplén, con una escalera muy alta; se subían el Inca y tres señores a hablar al pueblo y ver la gente de guerra cuando hacían sus reseñas y juntas." Segovia, So-Chantre de la Catedral de Santiago (Chile), authored his account around 1553; his work was formerly credited to Cristóbal de Molina.

115. We have no specific evidence of an elevated platform associated directly with Cuzco's usnu. Hyslop suggests that the elevated platform may have been a particular feature of usnu in conquered territories (*Inca Settlement Planning*, 70). Zuidema also stresses a close association between usnu and conquered areas, concluding that usnu symbolized the power of the Inka state in conquered communities ("Relación entre el Patrón," 48).

116. For a discussion of the notion of surveying and its implications, see Summers, *Real Spaces*, 416.

117. For an insightful comparison of Inka plazas with those of other Andean peoples, see Moore, "Archaeology of Plazas." For a study of possible usnu at the Inka tampu of Huanuco Pampa, Taparaku, Chakamarka, and Pumpu, see Pino, "El *Ushnu* Inka."

118. Photographs and site plans of Huanuco Pampa can be found in Gasparini and Margolies, *Inca Architecture*, 105–8; and Morris and Thompson, *Huanuco Pampa*. For discussion of the layout of the Inka's regional capital of El Shincal in northwestern Argentina, which focused on, and was organized around, its usnu, an elevated masonry platform, see Raffino et al., "El Ushnu de El Shincal."

119. Zuidema, "El Ushnu," 355.

120. Cristóbal de Mena ("Conquista del Perú," 142) and Hernando Pizarro ("Carta," 122), for example, both say that Atawalpa spoke to Captain Hernando de Soto with his head lowered (*la cabeça baja*). Hernando Pizarro was the brother of the leader of the Spanish band, and Mena served as captain; both wrote eyewitness accounts of the conquest, Pizarro in a letter dated 1533 and Mena in 1534. Francisco de Jérez (or Xérez), a native of Seville, served as a secretary to Francisco Pizarro and, in 1534, wrote his account of the activities he witnessed during the initial contacts between Spaniards and Inka in Peru; Jérez reports that Atawalpa appeared to Pizarro, who arrived on the scene shortly after Soto had met the Inka ruler, with "his eyes planted on the ground without raising them to look anywhere" (*los ojos puestos en tierra, sin los alçar a mirar a ninguna parte*) ("Verdadera Relación," 224). However, Miguel de Estete, one of the conquistadors who witnessed the capture of the Inka ruler Atawalpa at Cajamarca and wrote two accounts (dated 1533 and 1535) of the events in which he participated, does indicate that Atawalpa responded to Pizarro's supplications by turning his head and looking at him ("Noticia del Perú," 322).

121. Estete, for example, says that Atawalpa was seated very low to the ground (*muy baja del suelo*) ("Noticia del Perú," 321); Pedro Pizarro says that Soto found Atawalpa seated on a *duho* (low stool) surrounded by servants so that nobody could see him (*Relación del Descubrimiento*, chap. 8, 33). While I

am interested here in immobile lithic seats, the tiana, or wooden stool, was an important mobile emblem of authority; see Martínez Cereceda, *Autoridades en los Andes*, 69–79, 131–45; and Ramírez, *To Feed and Be Fed*, 161–79.

122. Sarmiento, *Historia*, chap. 13, 57.

123. Duviols, "Symbolisme de l'Occupation," 11–12.

124. One of the first to comment on the fact that the throne does not face the so-called parade ground was Ubbelohde-Doering, in *On the Royal Highway of the Inca*, 198. The dual seats face roughly east-southeast.

125. For a thorough discussion of this seat, see Van de Guchte, "Carving the World," 195–96.

126. It should also be noted that not all carved rocks that look like seats may actually have functioned as seats, even symbolically. Some seatlike niches may well have been places for setting offerings rather than sitting, a possibility suggested by Uhle ("Datos"), Bingham (*Machu Picchu*, 79), and others. Some nonfunctional seats appear to have been "elevated to uselessness," a phrase referring to the ways objects of utilitarian form often achieve special status when made of nonutilitarian materials or, like some lithic seats, positioned in nonutilitarian ways; see Rubin, *Art as Technology*, 47. A possible parallel to some Inka stone seats is the Sika Dwa Kofi (Gold Stool Born on Friday) of the Asante people of Ghana. It was said to have descended into the hands of the first Asante leader. Although that ruler may have physically possessed the stool, the seat itself belongs to the nation and, from that time until today, has never been sat on by a human being.

127. "Esta división de ciudad no fue para que los de la una mitad se aventajasen de la otra mitad en exenciones y preeminencias, sino que todos fuesen iguales como hermanos, hijos de un padre y de una madre. . . . Y mandó que entre ellos hubiese sola una diferencia y reconocimiento de superioridad: que los del Cuzco alto fuesen respetados y tenidos como primogénitos, hermanos mayores, y los del bajo fuesen con hijos segundos; en suma, fuesen como el brazo derecho y el izquierdo en cualquiera preeminencia de lugar y oficio" (*Comentarios Reales*, pt. 1, bk. 1, chap. 16; *Royal Commentaries*, vol. 1, 44–45; *Comentarios*, 31).

128. Burger and Salazar observe that with "matching" sets of Inka vessels, one is always a bit larger than the other ("Catalogue," 141).

129. Silverblatt, in *Moon, Sun, and Witches*, has suggested that while the Inka ruler had ultimate authority, power was structured so that the ruler ruled over men, while his primary wife, the *quya* (*qoya*, *coya*) was the head of all women in Tawantinsuyu.

130. Guaman Poma, *Primer Nueva Corónica*, fols. 262 [262], 265 [267], 385 [387] and 398 [400], pp. 236, 239, 357, and 370. Guaman Poma illustrates two

usnu, one at Cajamarca and one at Cuzco (fols. 384 [386] and 398 [400], pp. 356 and 370).

131. Santa Cruz Pachacuti, *Relación de Antigüedades*, fol. 9v, 200.

132. Gasparini and Margolies, *Inca Architecture*, 271.

133. González Holguín, *Arte y Diccionario*, 386. González Holguín defines *usnu* as "tribunal del juez, de una piedra incada. Mojón, cuando es de piedra grande hincada"; he defines the verb *usnuni* as "hacer los tribunals: hincar los mojones." *Ushnu* means "pantano" (swamp, marsh, lake), and the verb *ushnuni* means "empantanarse, enterrarse en pantano. Remojar en agua, humedecer metiendo en agua un cuero, un trapo" (386). The word *usnu* or its cognates are still used in the central highlands of Peru to mean a variety of things including holes, wells, subterranean places, rock walls, ruins, and places associated with the dead and with the pre-Hispanic past. *Usnu* also refers to places where water is filtered and places of gravel, or pure rock, as well as platforms on the tops of high mountains; see Pino, "El *Ushnu* Inka." Pino proposes that the concept of the usnu was originally developed in the Andes to the north and west of Cuzco (Chinchaysuyu) as a place where water runs through rocks. The Inka politicized it, retaining its function as a receptacle and drainage for liquid offerings, but adding ceremonial functions as well as astronomical observations to its uses. Under the Inka, the usnu became a sign of authority and centrality and so was used in planning important provincial settlements.

134. Betanzos identifies the Spanish gallows as having been built in the middle of Cuzco's main plaza on the site where the Inka displayed a lithic embodiment of the sun (*Suma y Narración*, pt. 1, chap. 11; *Narrative*, 47). Aveni, in "Horizon Astronomy," and Zuidema, in "Inka Observations," identify that as the location of the usnu. While some believe that the solar stone shaped like a sugar loaf, described by Betanzos, was itself the usnu, it is likely that the solar stone was placed on the seat atop the usnu where it could "oversee" the people gathered there and receive their libations.

135. Albornoz, "Instrucción para Descubrir," 176; Cabello Balboa, *Obras*, pt. 3, chap. 21, 343; Hernández Principe, "Mitología Andina," 63; and "Relación de las Costumbres," 354–55. The anonymous Jesuit author of "Relación de las Costumbres" describes two kinds of Inka "temples," natural and artificial or constructed. He says that usually nothing was built at natural temples (such as lakes, springs, mountain peaks, rushing rivers, caves, and so on); but sometimes, he writes, "hacían en los tales lugares un altar de piedra, que llamaban *osno* para sus sacrificios." Cabello Balboa refers to the usnu of Tomebamba, saying, "Edificó así mismo en la plaza cierto lugar llamado Usno (y por otro nombre Chuquipillaca) donde sacrificaban la chicha al sol, a sus

tiempos y coyunturas." Miguel Cabello Balboa (Valboa) came to the Americas as an adventurer but then joined the Franciscan order. As a missionary, he traveled widely in the Andes, from Colombia to Bolivia, completing his monumental *Miscelanea Antártica* in 1586. Much of his information about Inka customs, beliefs, and practices comes from his native sources in Quito, including relatives of the ruler Atawalpa, as well as reports composed by the knowledgeable Cuzco residents Polo de Ondegardo and Molina.

136. Santo Tomás, *Lexicon*, 332.

137. Albornoz writes: "Ay otra guaca general en los caminos reales y en las plaças de los pueblos, que llaman uznos," and says that "sentávanse los señores a bever a el sol en el dicho uzno y hazían muchos sacrificios a el sol" ("Instrucción para Descubrir," 176). He also reports, however, that usnu were shaped like skittles used in bowling games (*eran de figura de un bolo*) and were "made of different kinds of rock or of gold or silver" (*hecho de muchas diferencias de piedras o de oro y de plata*), and that all of them had buildings (*edificios*) with towers of handsome masonry (*torres de muy hermosa cantería*) (176). Elsewhere Albornoz describes the usnu of Cuzco as "a basin of gold in the plaza where they drank to the Sun" (*un pilar de oro donde bevían al Sol en la plaça*) (179).

138. P. Pizarro, *Relación del Descubrimiento*, chap. 15, 90–91). Pizarro reports: "Esta piedra [redonda] tenía una funda de oro que encaxaua en ella y la tapaua toda, y asimismo tenía hecho una manera de buhihuelo [buhío] de esteras texidas, rredondo, con que la cubrían de noche. Asimismo sacauan un bulto pequeño, tapado, que dezían que hera el sol, lleuándolo un yndio que ellos tenían como a çaçerdote. . . . Para donde asentauan este bulto que ellos dezían hera el sol, tenían puesto en la mitad de la plaça un escaño pequeño, todo guarnesçido de mantas de pluma muy pintadas, y aquí ponían este bulto. . . . Pues dauan de comer a este sol por la horden que tengo dicho la dauan a los muertos, y de beuer."

139. As noted earlier, the solar stone described by P. Pizarro is likely the same as that mentioned by Betanzos (*Suma y Narración*, pt. 1, chap. 11; *Narrative*, 48). Although some believe that the solar stone might be the usnu itself, it is more likely that the stone was the sun's lithic wawqi (brother), as described in chapter 1, and that it was sometimes brought into the plaza and placed on the usnu's seat. Pizarro also tells of a stone bench encased in gold inside the Qurikancha on which the "sun" sat when it was not in the plaza (*Relación del Descubrimiento*, chap. 15, 92).

140. Estete, "Noticia del Perú," 322. As mentioned in the introduction, it was commonplace in the early days of the conquest for the Spaniards to identify indigenous religious structures as mosques, since the non-Catholic

others with whom they were most familiar were the Muslim moors of southern Spain.

141. Mena, "La Conquista del Perú," 145; Jérez, "Verdadera Relación," 222; H. Pizarro, "Carta," 123.

142. Jérez, "Verdadera Relación," 224. Jérez writes: "Vino un indio de Atabalipa [Atawalpa] a decir al Gobernador [Francisco Pizarro] que se aposentase donde quisiese, con tanto que no se subiese en la fortaleza de la plaza."

143. Titu Cusi Yupanqui, *Relación de la Conquista del Perú*, 18. Baptized Diego de Castro, Titu Cusi Yupanqui was the grandson of the last pre-Hispanic ruler (Wayna Qhapaq) and son of Manku Inka, ruler and the leader of the Inka rebellion against the Spaniards. Yupanqui became head of the rebellious neo-Inka state when his half brother, Sairi Thupa, died after capitulating to the Spanish colonial government. Yupanqui authored his account of the conquest in 1570 with the aid of Augustinian Marcos García, who translated it into Spanish. For analysis of the work by Ralph Bauer, as well as its English translation, see Titu Cusi Yupanqui, *An Inca Account of the Conquest of Peru*.

144. Pedro Pizarro, who was not present at Cajamarca but, as page to his elder relative Francisco, was part of the original expedition to Peru, indicates in his memoirs that Francisco sent two or three foot soldiers with trumpets to climb "una fortaleçilla qu está en la plaça de Caxamarca," where they were to shoot and play the trumpet at Francisco Pizarro's signal once Atawalpa and all his forces were in the plaza (*Relación del Descubrimiento*, chap. 9, 35). The gunshots and trumpets signaled the hidden Spaniards to attack. Cieza, who was also not at Cajamarca for the capture of Atawalpa but wrote an early and fairly reliable chronicle of the events, mentions "a high place designated for watching games or making sacrifices" (*lugar alto que estava diputado para ver los juegos o haⱬer los sacrefiçios*) in the plaza of Cajamarca; he says it was the place where Pedro de Candia was positioned to discharge guns, at Pizarro's signal, at the Inka gathered in the plaza below (*Crónica del Perú*, pt. 3, chap. 45, 131; *Discovery and Conquest*, 209).

145. Gasparini and Margolies, *Inca Architecture*, 264–80, 343. The authors maintain that usnu must have varied in design and form (271, 342). This is logical given the Inka interest in essential function and purpose, rather than superficial form and appearance.

146. Hyslop, *Inca Settlement Planning*, 69–72. For a comprehensive discussion of usnu, see Zuidema, "El Ushnu." For the usnu as an astronomical observatory or marker, see Aveni, "Horizon Astronomy in Incaic Cuzco"; Bauer and Dearborn, *Astronomy and Empire*; Ziólkowski and Sadowski, *Arqueoastronomía*; and Zuidema, "Inka Observations."

147. For the usnu's use in site organization, see Matos, "El Ushnu de

Pumpu," 59; and Pino, "El *Ushnu* Inka," 306–9. Matos argues that the plaza with its usnu was probably the first architectonic element constructed at Pumpu (a tampu in Chinchaysuyu); the remainder of the site was laid out according to the placement of the usnu. Pino adds supporting data from various settlements in the provinces of Huánuco and Chinchaycocha to suggest that the usnu was the first thing located and constructed at many of the important settlements in Chinchaysuyu.

148. Reinhard, "Sacred Peaks of the Andes," 110–11. Gasparini and Margolies (*Inca Architecture*, 267) and Valencia and Gibaja (*Machu Picchu*, 89), among others, have identified the Intiwatana as an usnu.

149. Cobo says that the first waka on the fifth siq'i of Antisuyu was a stone called Usno that was in the plaza of Hurinaucaypata (*Inca Religion*, 66). Zuidema has identified this as the second of Cuzco's usnu ("El Ushnu").

150. Cobo, *Inca Religion*, 57 (*Obras*, vol. 2, 172). Specifically, Cobo names it as the sixth waka on the fifth siq'i of Chinchaysuyu. The outcrop out of which the dual seat is carved also features "slides." Owing to its polished, slippery surface, it is called *suchuna* (slippery place).

151. Ibid. As discussed in chapter 1, steps refer to passage from the inner- or underworld to this world. Paternosto, with little evidence, suggests that this carved seat prefigured the Inka usnu (*Stone and the Thread*, 79).

152. Cobo, *Inca Religion*, 51–84. Tampucancha, the first waka on the ninth siq'i of Collasuyu, is described as a seat where the ruler Mayta Capac was known to sit. "While he was sitting here he arranged to give battle to the Acabicas [Alcabiças]. Because he defeated them in the battle, they regarded the said seat as a place to be venerated" (*y que sentado aquí concertó de dar la batalla a los Acabicas [Allcahuiças]; y porque en ella los venció, tuvieron el dicho asiento por lugar de veneración*) (76; Cobo, *Obras*, vol. 2, 182).

153. Barrionuevo, *Extraterrestres*, 70n1.

154. Allen, *The Hold Life Has*, 215. Allen records stories from the Quechua community of Sonqo to the north and east of Cusco in the department of Cusco, province of Paucartambo. Some contemporary Aymara-speaking Andeans also believe stones once moved of their own volition to make construction easy; see Abercrombie, *Pathways of Memory*, 334. Classen understands such stories to affirm the creative power of speech in the Andes (*Inca Cosmology*, 36; and "Literacy as Anticulture"). Flores Ochoa, however, tells us that many Quechua speakers today believe that the Inka were able to make the stones move only with the force of their thought ("Contemporary Significance," 110).

155. Arguedas, "Puquio, una Cultura en Proceso de Cambio," 229. Briefly, the legend of Inkarrí, first formulated during the colonial period, promises

that the beheaded Inka king will be reassembled and will rise from the earth to preside over a utopian Andean future. Some today believe that the head is kept as a prisoner in the palace of the Peruvian president. Many scholars have discussed Inkarrí stories; see Arguedas, "El Mito de Inkarrí"; Burga, *Nacimiento de una Utopia*; Curatola, "Mito y Milenarismo en los Andes"; Ferrero, "Significado e Implicaciones Universales"; Flores Galindo, *Buscando un Inca*, 180; Flores Ochoa, "Inkariy y Qollariy"; Getzels, "Los Ciegos"; D. Gow, "The Roles of Christ and Inkarrí"; R. Gow, "Inkarri and Revolutionary Leadership in the Southern Andes"; López Baralt, *El Retorno del Inca Rey*; Millones, "Un Movimiento Nativista"; Núñez del Prado, "Versión del Mito de Inkarrí"; Ortiz Rescaniere, *De Adaneva a Inkarrí*; Ortiz Rescaniere, "El Mito de Inkarrí"; Ossio, "Mito de Inkarrí"; Pease, *Del Tawantinsuyo a la Historia del Perú*; Pease, "El Mito de Inkarrí"; Pease, "Una Versión Ecológica"; Urbano, "Del Sexo"; Valencia Espinoza, "Inkari Qollari Dramatizado"; Vázquez, "Reconstruction of the Myth"; Vázquez, "Las Versiones del Mito"; Vivanco, "Nueva Versión del Mito"; and Wachtel, *Vision of the Vanquished*.

156. Arnold, "The House of Earth-Bricks," 18.

NOTES TO CHAPTER FOUR

1. See, for example, Garcilaso, *Comentarios Reales*, pt. 1, bk. 7, chap. 27 (*Royal Commentaries*, vol. 1, 464). Many others claim that not even coins or the point of a pin would fit into the joins between the fitted stone blocks.

2. Some of this discussion is drawn from Dean, "Creating a Ruin."

3. Modern English-speaking tourists follow in a long line of people who have had difficulty pronouncing "Saqsaywaman"; the conquistador Ruiz de Arce, for example, called it "Calisto" ("Advertencias," 429).

4. "Spaniard" is a unifying abstraction for a heterogeneous people. In the sixteenth century, those we now call Spaniards more commonly identified themselves, as a group, as "Christians." Thus they conceived of themselves as distinct from Andeans (another unifying abstraction) and other Amerindians, all of whom they called *indios*, by virtue of different religious beliefs as well as geographic origins.

5. Sancho wrote: "Los españoles que las ven dicen que ni el puente de Segovia, ni otro de los edificios que hicieron Hércules ni los romanos, no son cosa tan digna de verse como esto. La ciudad de Tarragona tiene algunas obras en sus murallas hechas por este estilo, pero no tan fuerte ni de piedras tan grandes" ("Relación para su Majestad," chap. 17, 329).

6. Garcilaso names the three towers as Móyoc Marca, Sácllac Marca, and

Páucar Marca (*Comentarios Reales*, pt. 1, bk. 7, chap. 29; *Royal Commentaries*, vol. 1, 468–69). Both P. Pizarro (*Relación del Descubrimiento*, chap. 15, 104) and Cieza (*Crónica del Perú*, pt. 2, chap. 51, 149), report that Saqsaywaman had just two towers, however. The largest tower was circular.

7. Gasparini and Margolies suggest that the Spaniards identified Saqsaywaman as a fortress because its masonry reminded them of medieval European strongholds (*Inca Architecture*, 280–81). They conclude that many of the Inca structures called fortresses by the Spaniards were actually religious edifices designed to protect sacred spaces. For an official Spanish perspective, see Contreras, *Relación de la Ciudad del Cusco*, 4; and Herrera, *Historia General*, decade 5, bk. 3, chap. 13, 237. Vasco de Contreras y Valverde, a Cuzco native who was educated and ordained in Lima, served as *deán* of Cuzco's cathedral. He wrote his *relación*, a description of the bishopric of Cuzco, in 1650 in response to an episcopal mandate to comply with the royal order issued by King Felipe IV requiring a full description of his American domain (known as the "Relaciones Geográficas de Indias"). Antonio de Herrera y Tordesillas was Spain's official historian of the Indies; he finished his monumental history in 1615.

8. Cieza, *Crónica del Perú*, pt. 2, chap. 51 (*The Incas*, 153). The Spanish reads: "Se hiziese otra casa del Sol que sobrepujase el edefiçio a lo hecho hasta allí y que en ella se pusiesen todas las cosas que pudiesen aver, así oro como plata, piedras ricas, ropa fina, armas de todas las quellos usan, muniçión de guerra, alpargates, rodelas, plumas, cueros de animales, alas de aves, coca, sacas de lana, joyas de mil jéneros; en conclusion, avía de todo aquello de quellos podían tener notiçia" (*Crónica del Perú*, 147).

9. Sancho, "Relación para su Majestad," chap. 17, 329–30; P. Pizarro, *Relación del Descubrimiento*, chap. 15, 104.

10. Garcilaso, *Comentarios Reales*, pt. 1, bk. 7, chap. 29, 327 (*Royal Commentaries*, vol. 1, 469).

11. While most chroniclers maintain that Pachakuti was another name for Inka Yupanki, Garcilaso holds that they were distinct individuals (*Comentarios Reales*, pt. 1, bk. 7, chap. 29; *Royal Commentaries*, vol. 1, 471). He claims that the construction of Saqsaywaman began under "Inca Yupanqui," although he concedes that the former ruler may have planned the work and collected much of the stone. A number of chroniclers agree with Garcilaso that Pachakuti's successor began work on the structure; this number includes the four indigenous Andean record keepers (*quipucamayos*) who were assembled in 1542 at the request of Governor Vaca de Castro to compose a relación covering the early years of the conquest (Collapiña et al., *Relación de la Descendencia*, 40). Gasparini and Margolies date the beginning of construction to around 1440 (*Inca Architecture*, 195).

12. For varying estimates of the construction period, see Garcilaso, *Comentarios Reales*, pt. 1, bk. 7, chap. 29 (*Royal Commentaries*, vol. 1, 471–72); and Esquivel, *Noticias Cronológicas*, vol. 1, 40–43. Diego de Esquivel y Navia served as *deán* of the Cathedral of Cuzco and, in the mid-eighteenth century, wrote a detailed account of events in Cuzco from Inka times until 1740.

13. According to Sancho, Francisco Pizarro convened the majority of the Spaniards who were in Cuzco in March 1534 and "hizo una acta de fundación y formación del pueblo, diciendo que lo asentaba y fundaba en su mismo ser, y tomó posession de él en medio de la plaza, y en señal de funar y comenzar a edificar el pueblo y colonia hizo ciertas ceremonias, según se contiene an la acta que se hizo, la que yo el escribano leí en voz alta a presencia de todos; y se puso el nombere a la ciudad 'la muy noble y gran ciudad del Cuzco,' y coninuando la población, dispuso la casa para la Iglesia que había de hacerse en la dicha ciudad sus terminus, límites y jurisdicción y enseguida echo bando diciendo que podían venir a poblar aquí y serían recibidos por vecinos los que quisieran poblar, y vinieron muchos en tres años" ("Relación para su Majestad," chap. 14, 320–21). From among the assembled Spaniards Pizarro chose the most capable for public office. Pizarro then divided the natives among the *encomenderos* "para que los enseñaran y dotrinaran en las cosas de nuestra santa fe católica."

14. Cuzco's double plaza seemed excessively large to the Spaniards. The initial distribution of house lots included partitioning the plaza to reduce its vastness.

15. Cieza, *Crónica del Perú*, pt. 2, chap. 51, 149; Garcilaso, *Comentarios Reales*, pt. 1, bk. 7, chap. 29 (*Royal Commentaries*, vol. 1, 471).

16. "Los españoles . . . la derribaron para edificar las casas particulares que hoy tienen en la ciudad del Cuzco, que, por ahorrar la costa y la tardanza y pesadumbre con que los indios labraban las piedras para los edificios, derribaron todo lo que de cantería pulida estaba edificado dentro de las cercas, que hoy no hay casa en la ciudad que no haya sido labrada con aquella piedra, a lo menos las que han labrado los españoles" (Garcilaso, *Comentarios Reales*, pt. 1, bk. 7, chap. 29, 329).

17. Polo, "Relación de los Fundamentos," 107.

18. See, for example, Sarmiento, *Historia*, chap. 53, 137; and Toledo, "Carta al Rey." Francisco de Toledo served as the Spanish viceroy in Peru from 1569 to 1581. From Cuzco, he ordered the capture and execution of the last of the independent Inka rulers (Thupa Amaru) in 1572. While in the highlands, he gathered information concerning the Inka, their customs, institutions, and edifices, which he then used to write numerous edicts.

19. Murúa, *Historia General*, bk. 3, chap. 10, 500. Murúa writes: "Es de

suerte que todos los edificios modernos que después se han hecho en la ciudad por los españoles, han alido de la piedra de allí, aunque a las piedras grandes y toscas no han llegado, por no poder llevarlas a otro lugar sin costa excesiva e infinito trabajo de los indios."

20. Valcárcel, "Sajsawaman Redescubierto," 176; Cornejo, *Derroteros de Arte Cuzqueño*, 147.

21. Cobo describes the method of dragging large stones to construction sites and the use of earthen ramps to place them: "I saw this method used for the Cathedral of Cuzco which is under construction. Since the laborers who work on this job are Indians, the Spanish masons and architects let them use their own methods of doing the work, and in order to raise up the stones, they made the ramps mentioned above, piling earth next to the wall until the ramp was as high as the wall" (*la cual traza vi usar en la catedral del Cuzco que se va edificando; porque como los peones que trabajan en la obra son indios, los dejan los maestros y arquitectos españoles que se acomoden a su uso, y ellos hacen para subir la piedra los dichos terraplenos, arrimando tierra a la pared hasta emparejar con lo alto della*) (*Inca Religion*, 229–30; *Obras*, vol. 2, 262).

22. "La más linda cosa que puede verse de edificios en aquella tierra, son estas cercas, porque son de piedras tan grandes, que nadie, que las vea no dirá que hayan sido puestas allí por manos de hombres humanos" (Sancho, "Relación para su Majestad," chap. 17, 329).

23. Garcilaso, *Comentarios Reales*, pt. 1, bk. 7, chap. 29, 329 (*Royal Commentaries*, vol. 1, 471). Polo estimated that some of the larger stones would have required twenty masons an entire year to dress. He writes: "Cierto cosa maravillosa de ver en la fortaleza del Cuzco, que ay piedras tan grandes y ajuntadas, que yo e estado presente delante de canteros y se espantan como se podían suvir sin artificio, avn que el edificio no es muy alto, a labrallas e ponellas de suerte que bynyesen vien; entieéndese cierto aue ay piedras de aquellas que vna sola sería menester trauajo de veynte personas un año entero para desvastarla, y vistas las obra [*sic*] que allí ay debaxo de la tierra y encima al derredor del Cuzco" ("Relación de los Fundamentos," 106). Toledo also found it difficult to believe that Saqsaywaman was made by the "strength and industry of men" (*parece imposible haberlo hecho fuerza ni industria de hombres*) ("Carta al Rey"). P. Pizarro writes: "Auía piedras . . . tan grandes y tan gruesas, que parecía cosa ymposible habellas puesto manos" (*Relación del Descubrimiento*, chap. 15, 104). For similar views dating to the seventeenth century, see Murúa, *Historia General*, bk. 3, chap. 10, 500; and Cobo, *Inca Religion*, 229.

24. Cobo, *Inca Religion*, 229 (*Obras*, vol. 2, 262).

25. Valerie Fraser, in the *Architecture of Conquest*, has argued that in the built

environment of viceregal Peruvian cities, arches were particularly significant as they replaced and were perceived to be superior to post-and-lintel construction.

26. Typical is the mitigated exaltation of conquistador Estete, who wrote that "toda la cantería de está ciudad hace gran ventaja a la de España; aunque carecen de teja" ("Noticia del Perú," 330). Like Estete, many early Spanish commentators hover on the edge of compliments, offering words of praise only to pull back at the last moment with notes on what the Inka failed or were unable to do. Later writers continue to emphasize technologies not used by the Inka. Bingham, for example, although admiring the stonework of a wall near the Tower at Machu Picchu, also noted that "there is not a mathematically correct right angle or straight line in the entire wall, the builder having no instruments of precision" (Machu Picchu, 92).

27. Cieza, Crónica del Perú, pt. 2, chap. 51, 149 (The Incas, 155). Perhaps knowing that that was not reason enough for most of his countrymen, Cieza also took a practical tack, adding that Spaniards could use Saqsaywaman as a fort at little cost to themselves (because it was already built).

28. Betanzos, Suma y Narración, pt. 1, chap. 37 (Narrative, 157–58). The Spanish reads: "Era un edificio tan insigne y suntuoso que se podría poner por unas de las maravillas del mundo está el día de hoy toda la más della derribada y puesta por tierra que siendo una cosa tan insigne es lástima de la ver" (Suma y Narración, 170–71). Sarmiento, Historia, chap. 53, 137.

29. Castro, Relación del Cuzco, 39–40. Ignacio de Castro, rector of the Colegio Real de San Bernardo and curate of the parish of San Jerónimo, wrote his Relación del Cuzco in 1788 on the occasion of the founding of the Real Audiencia there. Part of Castro's manuscript was published in 1795 in Madrid.

30. "Los españoles como envidiosos de sus admirables victorias . . . no solamente no la sustentaron, mas ellos propios la derribaron" (Comentarios Reales, pt. 1, bk. 7, chap. 29, 329; Royal Commentaries, vol. 1, 471).

31. The city's coat of arms was finally replaced in the late twentieth century by a blazon featuring a stylized pre-Hispanic figure of a feline.

32. "En Madrid XIX dias del mes de julio de MDXL años se despacho un previllegio de armas para la ciudad del cuzco en que se le dieron por armas un escudo que dentro del esté un castillo de oro en campo colorado en memoria que la dha ciudad y el castillo della fueron conquistados por fuerza de armas en nro. servicio e por orla ocho condures que son unas aves grandes a manera de buytres que ay en la provincia del peru en memoria que al tiempo que la dha ciudad se gano abaxaron las dichas aves a comer los muertos que en ella murieron los quales esten en campo de oro" (Montoto de Sedas, Nobiliario de Reinos, 75).

33. Manku Inka was the son of the Inka ruler Wayna Qhapaq. Manku was named ruler with the blessing of the Spaniards in 1533.

34. For an introduction to the notion of "signature buildings," structures that were held to represent entire cities, see Kagan, *Urban Images*, 138. Of Cuzco, he concludes that the cathedral was the closest thing to a signature building; Saqsaywaman, which he describes as "the crumbling Inca fortress," served as a symbol of Cuzco primarily to "foreigners and outsiders" (185). I do not wholly disagree with Kagan's interpretation, but I suggest that the cathedral represented Spanish and Christian Cuzco, while what was left of Saqsaywaman represented the city's Inka past.

35. See P. Pizarro's eyewitness account of the siege of Cuzco in *Relación del Descubrimiento*, chap. 19, 127–34.

36. "Aconteció que estando los indios con gran deseo de quemar la Iglesia, porque tenían opinion que si la quemaban era cierto que habían de morir todos los castellanos" (Herrera, *Historia General*, decade 5, bk. 8, chap. 7, 224). In addition to the writings of Pizarro, Herrera used the third part of Cieza's *Crónica del Perú* in crafting this portion of his history; see Cieza, *Discovery and Conquest*, 461–62.

37. "Este fuego todos vieron que ello mismo sematō, cosa que los castellanos y los indios tuvieron por milagro, y desde entonces se les quebró el ánimo, de manera que nunca más mostraron bríos ni la acostumbrada ferocidad contra del Cuzco" (Herrera, *Historia General*, decade 5, bk. 8, chap. 7, 224; Cieza, *Discovery and Conquest*, 461–62).

38. The Mercedarian Murúa provides one version of the Santiago legend, saying: "Quiero referir lo que he oído contar a españoles e indios por cosa constante y verdadera, y es que dicen que andanzo en el mayor conflicto de la pelea apareció uno de un caballo blanco, peleando en favor de los españoles y haciendo en los indios gran matanza, y que todos huían dél. Muchos españoles tuvieron por cierto que era Mansio Sierra [Mancio Sierra de Legízamo], conquistador principal del Cuzco, y que después, averiguando el caso, hallaron que Mansio Sierra no había peleado allí sino en otra parte y no había otro que tuviese caballo blanco, sino él, y así se entiende haber sido el Apóstol Santiago, singular patrón y defensor de España el aue allí apareció, por lo cual la ciudad del Cuzco le tiene por abogado" (*Historia General*, bk. 1, chap. 66, 235). Of the apparition of Mary, Murúa writes: "También se refiere por los indios que, estando abajo peleando y teniendo apretados en gran manera a los españoles, un mujer les cegaba con puñados de arena y no podían parar delante della, sino todos le huían, la cual se presume haber sido Nuestra Señora Abogada y Madre de los pecadores, que querría en aquel trance favorecer a los españoles, y así la Santa Iglesia del Cuzco la tiene por patrona y titular

suya" (235–36). Esquivel reports that "la Reina de los Cielos" appeared at night on May 21, 1536, the seventeenth day of the eight-month siege (*Noticias Cronológicas*, vol. 1, 99). It should be noted that Pedro Pizarro, who was in Cuzco during the siege, made no mention of either apparition. Cieza, who arrived in Cuzco shortly after the siege was broken, also does not mention either Santiago or Mary.

39. It may be significant that both Mary and Santiago were said to have appeared at the sites of well-known circular Inca towers (Muyuqmarka, at Saqsaywaman, and the *suntur wasi* in the Awkaypata). The Spanish identified both towers, being tall and circular, with castle fortresses and therefore with armed resistance and military triumph. Both towers were destroyed in the decades after the broken siege and failed uprising. While both Inka "castles" were ruined, only Saqsaywaman was left to stand as a ruin.

40. "Es cosa en que se muestra bien el poderío del diablo" (Toledo, "Carta al Rey").

41. "Le hace imaginar que el demonio ayudó a aquel edificio" (Córdoba y Salinas, *Crónica Franciscana*, 45–46). Friar Córdoba chronicled the activities of the Franciscan order in Peru in 1651.

42. "Fue dedicada al principio para casa del Sol y en este tiempo, solo sirve de testigo de su ruina" (Contreras, *Relación de la Ciudad del Cusco*, 4).

43. Dean, "Creating a Ruin."

44. Earthquakes, especially the one on May 21, 1950, and excavations have uncovered the Inka foundations. A decade ago, the Qurikancha–Santo Domingo complex became the center of a debate about how Cuzco would reconcile its pre-Hispanic and colonial periods. The archaeologist Raymundo Béjar Navarro and others favored destroying the colonial edifice to thoroughly excavate the Inka temple on which (and of which) the Spanish church was built. The compromise resolution has produced controversial but stunning results, wherein the rear of Santo Domingo opens onto a sort of "ruins garden," bordering on the busy Avenida El Sol. As the walls of the colonial church of Santo Domingo blend into its Inka foundations and the worked masonry empties into a "park" comprising scattered blocks of worked stone, it is not clear to the casual observer just where Inka masonry ends and colonial masonry (prepared and placed by indigenous workers) and modern reconstruction begin. What is clear is that contemporary Cuzqueños engage the past in a constant dialogue. See Dean, *Inka Bodies*, 213–14.

45. Polo, "Relación de los Fundamentos," 109–10. The sand was used to lay the foundations of the city's cathedral, as well as four bridges across the river that ran through the center of Cuzco. As Cummins has aptly observed, although Polo trusted that the reuse of the sand in building Hispanic monu-

ments would help abolish the "great reverence" that indigenes had for the Inka's plaza, he failed to recognize that it was the essence of the sand that was sacred, not the form that the sand assumed ("Tale of Two Cities," 161).

46. "Hizo el dicho Pizarro quemar su cuerpo, mas los indios de su ayllo recogieron las cenizas, y con cierta confección las metieron en una tinajuela pequeña junto con el ídolo, que, como era de piedra, se lo dejaron los de Gonzalo Pizarro sin reparar en él. Después, al tiempo que el licenciado Polo andaba descubriendo los cuerpos e ídolos de los Incas, en teniendo noticia de las cenizas e ídolo déste, lo mudaron los indios de donde antes estaba, escondiéndolo en muchas partes; porque, después que lo quemó Gonzalo Pizarro, le tuvieron en mayor veneración que antes. Ultimamente se puso tan Buena diligencia, que fué hallado y sacado de poder de sus descendientes" (*History*, 132; *Obras*, vol. 2, 77).

47. Cobo, *Inca Religion*, 74 (*Obras*, vol. 2, 181). Wanakawri was the seventh shrine on the sixth siq'i of Quyasuyu (Collasuyu).

48. Although Andeans were aware of Spanish concerns regarding wawqi, they continued to make and revere them. Cobo tells us: "Although Paulla [*sic*] Inca [a descendant of Inka royalty and head of the Inka who remained loyal to the Spaniards after Manku's uprising] died a Christian and as such was given a church burial, nevertheless, the Indians made a small statue of him. On it they put some fingernails and hair that they had secretly taken from him. This statue was venerated by them just as much as any of the bodies of their other Inca kings" (*Aunque Paullu-Inca murió cristiano y como tal fué enterrado en la iglesia, con todo eso, los indios le hicieron una estatua pequeña y le pusieron algunas uñas y cabellos que secretamente le quitaron; la cual estatua se halló tan venerada dellos como cualquiera de los otros cuerpos de los reyes Incas)* (*History*, 177; *Obras*, vol. 2, 103).

49. Some smaller petrous objects, such as *enqaychu*, which Quechua indigenes believed to have a male inseminating function, likely survived as heirlooms.

50. It may have marked one entry of water into the valley; see Van de Guchte, "Carving the World," 88–89.

51. Cobo, *History*, 59; Bauer, *Sacred Landscape*, 66; Niles, *Shape of Inca History*, 173; Nair, "Of Remembrance and Forgetting," 189, 248–49; Gisbert, Arze, and Cajías, *Arte Textil*, 9. For more on the regional shrine at Huanca, see Barrionuevo, *Extraterrestres*, 91–97; and Sallnow, *Pilgrims of the Andes*, 243–58, 262–66. See Sallnow's *Pilgrims of the Andes* for an excellent study of regional shrines in the department of Cuzco, many of which were pre-Hispanic rock waka.

52. Kubler, "Quechua in the Colonial World," 402.

53. See, for example, the following contracts, all of which are in the Archivo Regional de Cusco: Cristóbal de Bustamante, Legajo 26, Años 1698–99, fol. 74r–v, *Fiansa de Guaca*; Gregorio Serrano Basquez, Legajo 54, Año 1707, fol. 116r–v, *Fiansa de Guaca*; and Matias Ximemez Ortega, Legajo 291, Años 1723–27, fol. 127r–v, *Compañía para Descubrir Entierros del Tiempo Antiguo*.

54. Dean, *Inka Bodies*, 203–11. For descriptions and analysis of the Inti Raymi celebration in contemporary Cuzco, see Fiedler, "Corpus Christi in Cuzco," 338–54; and Dean, *Inka Bodies*, 203–14.

55. Castedo writes: "Our first visit to Cuzco, in 1952, coincided with the beginning of a costume party for tourists, organized by the authorities and repeated far too frequently: a parody of the 'Inti-Raimi' in the ruins of Sacsahuaman. Cuzco's Plaza de Armas was aglitter with the ornaments and costumes of a crowd of Quechua Indians from the sierra and Aymaras from the Collao. We intruders dressed as North Americans and Europeans were few" (*The Cuzco Circle*, 36).

56. Graburn and Moore, "Anthropological Research on Tourism."

57. The so-called New Age was born in California in the 1970s. Groups such as Esalen blended mysticism of the Far East with aspects of Western psychology. Adherents select from a variety of practices including divination, meditation, chanting, and "ancient" esoteric practices. For the rise of New Age spiritualism and the ways it preserves—even celebrates—the traditional Western nature-culture dichotomy, see Errington, *Death of Authentic Primitive Art*, 35–37.

58. MacCannell, *The Tourist*. Fainstein and Gladstone observe that "tourism depends on exoticism to fulfill the desires of the traveler, but exoticism is almost necessarily fake" ("Evaluating Urban Tourism," 34). The relative veracity or authenticity of "tourist shamans" is not at issue here, however. Although I've distinguished between paqo, who serve the needs of contemporary indigenes, and "tourist shamans," whose services are geared toward the needs of New Age tourism, the two groups are not mutually exclusive. Indeed, a few paqo have found that being a tourist shaman today is a lucrative profession. In Cuzco today we also find what might be called "indigenista shamans," that is, self-identified shamans who consciously adopt neo-Inka religious practices, blending them with a deep interest in ethnic heritage. For a discussion of the appeal of neo-Inka shamanic practices in contemporary Peru, see Molinié, "Resurrection of the Inca." For a critique of shamanic rites (the "salad of confusion") performed for tourist audiences, see Camacho, *True of Machupicchu*.

59. Flores Ochoa, "Contemporary Significance," 110.

60. Flaherty, *Shamanism and the Eighteenth Century*, 6–7. Eliade, whose book *Shamanism* is the seminal work on that subject, thought of it as any practice featuring crossings between deathlike (or trance) states and life; thus both Western and non-Western religious practitioners could qualify as shamans. Recently some have raised doubts about the ways contemporary scholarship has evoked the notion of shamanism in the study of the pre-Hispanic past; see Klein et al., "Role of Shamanism."

61. At other times, circular objects are identified as calendars, as will be discussed later.

62. Barrionuevo, *Extraterrestres*, 12.

63. Colonel Fawcett, an early-twentieth-century explorer, reported the existence of a plant-based liquid that was used by the Inka to dissolve stone (*Exploration Fawcett*, 252). He also insisted that megalithic ruins such as Saqsaywaman and Ollantaytambo were constructed by giants before the Inka era. "Secrets of Lost Empires: Inca" (1997), an episode of *Nova*, documented an experiment by the geoscientist Ivan Watkins at Ollantaytambo to "thermally disaggregate" (i.e., cut) rocks of the sort used in Inka construction by using parabolic reflectors to concentrate solar rays; see also Watkins, "Rock Chips."

64. Flores Ochoa, "Contemporary Significance," 113–17. For an insightful study of New Age interaction with the Maya ruins of Chichén Itzá, see Castañeda, *In the Museum of Maya Culture*. Many of Castañeda's observations could be applied to Machu Picchu and other Inka ruins.

65. Castañeda, *In the Museum*, 156–62.

66. Garcilaso, *Comentarios Reales*, pt. 1, bk. 2, chap. 11, 66 (*Royal Commentaries*, vol. 1, 93). Garcilaso tells us that *cuzco* means navel in "the private language of the Incas" (*en la lengua particular de los Incas*), suggesting some other language than Quechua, which was widely spoken (ibid.). For the etymology of the word, see Itier, *Parlons Quechua*, 152. Murúa reports that *cuzco* means *cosa resplandeciente* in Quechua, though he defines *tupa* in the same way (*Historia General*, bk. 3, chap. 10, 500). For a discussion of possible meanings of *cuzco*, see Angles Vargas, *Historia del Cusco*, vol. 1, 25–27; D'Altroy, *The Incas*, 56; and Hyslop, *Inca Settlement Planning*, 30.

67. Molinié provides the wording of the municipal decree that declares that "the true name" of the city be Q'osq'o ("Resurrection of the Inca," 246). The decree was issued on June 23, 1990, on the occasion of Inti Raymi.

68. The ruler Pachakuti is credited with organizing the empire and redesigning and rebuilding Cuzco (including the Qurikancha); he is said to have established new festivals to promote the state religion, improved imperial roads, introduced sumptuary laws restricting the wearing of vicuña, and organized the siq'i system, many shrines of which record his personal accom-

plishments and history. For more on Cuzco's facelift under Estrada and its current touristic projects, see Silverman, "Touring Ancient Times."

69. Molinié reports that in the 1990s both the mayor of Cuzco and the president of Peru had themselves referred to as Pachakuti ("Resurrection of the Inca," 247).

70. Holcomb observes that "history sells" and many modern cities "hype" their heritage for tourists ("Marketing Cities for Tourism," 65). Stone and Molyneaux popularized the term "presented past" to evoke the ways history is arranged, produced, and imparted for various purposes (education, entertainment, and so on); see their book *The Presented Past*.

71. See Silverman for other ways Cuzco is reinventing itself today ("Touring Ancient Times," 884–93).

72. Dean, *Inka Bodies*, 216–17.

73. Serpents carved in the rocks of Cuzco's modern buildings, although intended to recall what was thought to be an Inka practice, actually replicate colonial-period stonework; see Trever, "Slithering Serpents," 44–67.

74. The logo consists of a quartered circle: in the upper left is a mountain; in the upper right a llama; in the lower right, stonework; and in the lower left, a textile pattern featuring a bird.

75. There is a stone with thirty-two angles in the so-called House of the Priests in Machu Picchu's Sacred Precinct, and reports of a forty-four-angled stone at Torontoy; see Frost, *Exploring Cusco*, 76.

76. Gell, *Art and Agency*, 97.

77. The bar of chocolate itself has a trapezoidal shape and is thicker toward the widest part of the trapezoid in imitation of the wall batter in Inka architecture. Gasparini and Margolies identify the trapezoid as the leitmotif of Inka architecture (*Inka Architecture*, 259).

78. I borrow the concept of orphaned objects from Clarke, who uses it to describe images from ancient Roman culture that are literally or conceptually removed (most often through photography) from their original settings. He observes that orphaned objects "are no longer part of the culture that created them; they become part of our (or the dominant) culture, expressing our desires, our pre-conceptions, and our prejudices" ("Just Like Us," 18).

79. The face in the center of the Aztec Calendar Stone is traditionally identified as Tonatiuh, the Aztec's day sun. While Klein, in "Identity of the Central Deity," argues that it was most likely the face of the Night Sun, other scholars identify the face in the center of the Calendar Stone as an Earth Deity.

80. Bollaert, "Account of a Zodiac." Recently, Machicado, in his provocative book *When the Stones Speak*, attempts to refute the notion that the Inka

worshiped the sun (94). As part of his argument, he identifies the entity on the Echenique plate as a pan-Peruvian creator deity with feline features.

81. Rowe, "El Arte Religioso."

82. According to Cabello Balboa, it was removed from the temple by an Inka general named Atoc (Atuq); see *Obras*, pt. 3, chap. 28, 396.

83. Duviols, "Punchao, Ídolo Mayor," 156–63. Duviols rejects the claim made by Garcilaso, Santa Cruz Pachacuti, and Manco Serra, as well as those who used them as sources, that Punchao was an oval plate of gold (156–71). He concludes that descriptions provided by chroniclers such as Molina and Antonio de Vega, who may actually have seen the image of Punchao in Cuzco when it was taken from Thupa Amaru, and who describe it as a gold statue of an Inka with rays coming from its head, are more accurate. For additional discussion of Inka images of the Creator, see Ziólkowski, *Guerra de los Wawqi*, 46–50. For the possible fate of the image of Punchao, see Julien, "History and Art in Translation," 75–76.

84. Because Spaniards used their own aesthetic standards to evaluate Andean artifacts, they dismissed the significance of many waka. The scribe Estete, for example, found the "idol" at Pachacamac to be "mal tallada y mal formada" ("Noticia del Perú," 327). As I noted in the introduction, Acosta found Andean "idols" to be "ugly and deformed" (*feos y disformes*) (*Natural and Moral History*, 270).

85. Errington, "What Became Authentic Primitive Art," 208–9. Errington traces what she calls the "domination of the mimetic theory of meaning" to Panofsky (1955) specifically, and the dominance of Renaissance studies within art history more generally. She summarizes Panofsky as follows: "Meaning, [Panofsky] wrote in his well-known article on the subject, can be preiconic, iconographic, and iconologic. Paintings' iconic contents, in turn, are illustrations of prior texts. And yet, if an object's meaning is signified otherwise than through the iconic function, the whole method of interpretation, taught to generations of art history students, collapses. Thus one might explain the difficulty of conventional art history as a discipline in dealing with 20th-century Western arts, pre-Renaissance arts, and non-western arts generally, all of which may have iconic content but very few of which imagine themselves to be primarily *about* mimesis" (208–9). Is it any wonder, then, that in searching for the origins of "art," scholars go back to the first *iconic* imagery (ca. 30,000 BCE)? See Preziosi, *Rethinking Art History*, 133.

86. Dean, "Trouble with (the Term) Art."

87. Silverman, "Touring Ancient Times," 887. The Libertador, one of Cuzco's leading hotels, has as its emblem the mouth mask from the Nasca culture of Peru's south coast, and the celebrated Inka Grill restaurant uses a

character from a Mixtec manuscript of southern Mexico to convey its indige-
nous character.

88. Salazar, "Machu Picchu," 36–37.

89. Elorrieta and Elorrieta, *Cusco and the Sacred Valley*, 53–54.

90. Wright and Zegarra, *Machu Picchu: A Civil Engineering Marvel*, 77. Ac-
knowledging that scholars doubt the intentionality of zoomorphic elements
in Inka masonry, the authors suggest that the hummingbird "might be the
work of renegade Inca stonemasons who strayed from the strict empire-wide
practice [of non-iconic stonemasonry]."

91. Machicado concludes that the lithic zoomorphs are "entities of power"
that, like illa (small stone effigies), were propitiated by the Inka and served
to animate the structures in which they are found (*When the Stones Speak*,
22, 44–80, 135). Although ultimately I do not concur with his conclusions,
Machicado's argument is thought provoking and ought not be dismissed
summarily.

92. Camacho Paredes, *True of Machupicchu*, 91.

93. For discussion of touristic looking and its effect on both seer and what
is seen, refer to Urry, "Sensing the City" and *The Tourist Gaze*.

94. The so-called Puma Rock is an outcrop, just under twenty feet high,
framed by masonry and facing a semicircular wall with the remains of a door-
way and nineteen niches. Angles Vargas, who believed it to be a gigantic
sculpture disfigured by Christian extirpators of idolatry, claimed it was once
covered with monkeys and frogs or toads (*Sacsayhuaman*, 107, 112). He was
also apparently the first to identify it as a puma; in this, he has been fol-
lowed by numerous others, including Hemming and Ranney (*Monuments of
the Incas*, 172–73), Paternosto (*Stone and the Thread*, 58, 66, 69), and Stone-
Miller (*Art of the Andes*, 200, fig. 158). See also Pasztory, *Pre-Columbian Art*,
163; and Elorrieta and Elorrieta, *Cusco and the Sacred Valley*, 58–59.

95. Gombrich, *Art and Illusion*, 181–83.

96. Machicado, *When the Stones Speak*, 35; Seibold, "Textiles and Cos-
mology," 170.

97. González Holguín, *Arte y Diccionario*, 146.

98. For a discussion of the imposition of cultural order on nature, see
Schama, *Landscape and Memory*, 6–7.

99. Rowe notes that the original observation about Cuzco's puma shape
came from Manuel Chávez Ballón; see Chávez Ballón, "Ciudades Incas."

100. Gasparini and Margolies, *Inca Architecture*, 48, 66.

101. It should also be noted that in his lengthy discussion of the building of
Saqsaywaman, Betanzos makes no mention that the complex was designed as
the "puma's head"; see *Suma y Narración*, pt. 1, chap. 37 (*Narrative*, 155–58).

102. Elorrieta and Elorrieta, suggesting that the Inka and even their pre-decessors, taking advantage of natural formations, enhanced the topography of some of their settlements to make them resemble stellar constellations and animals or objects of symbolic import, have found a guanaco at Tiwanaku; a condor, "the Tree of Life," two llamas, a corncob, and Wiracocha or Tunupa (a humanoid creator deity) at Ollantaytambo; a condor at Pisaq; and a lizard or *amaru*, a crouching puma, a standing puma, and a "cosmic bird" at Machu Picchu (*Cusco and the Sacred Valley*). Machicado identifies a portion of Ollan-taytambo as a llama and a section of Machu Picchu as a sitting alpaca (*When the Stones Speak*, 49, 59–64). Both, he argues, functioned as illa, containing the animating force of the sacred site.

103. Neito, "Canto al Cuzco," 446–49.

104. Flores Galindo, *Buscando un Inca*, 314.

105. We are told, however, that some Andean ritual specialists, called paqo, report that Inka stones speak to them; see Machicado, *When the Stones Speak*, 21. Machicado titled his book *When the Stones Speak* as a way of suggesting that perhaps, with the help of paqo, he is able to speak for Inka stones. In-deed, his book is a sensitive treatment of the topic of Inka stonework. Some of his arguments are unfortunately influenced by Western cultural precepts, including the book's latter section, in which the author argues that the Inka worshiped a single creator deity; his argument, in part, centers around the fact that there are no images (idols) of various Inka objects of reverence, and thus the Inka could not have been idolators (92–93).

·⟨↔⟩·

Glossary of Quechua Terms

Anti. Inhabitants of the heavily forested eastern Andean slopes and lowlands. Also called Chunchu.

apachita. Petrous roadside waka that received offerings from travelers.

apu. "Lord," often a term of address used to refer to sacred mountains.

aqha. A fermented drink made of maize, also known as chicha.

ayni. A reciprocal relationship.

camay. See *kamay*.

chakrayuq. The petrous owner of a field or terrace.

chinkana. Labyrinth.

Chunchu. Inhabitants of the heavily forested eastern Andean slopes and lowlands. Also called Anti.

hanan. Upper.

huaca. See *waka*.

illa. Small stones or stonelike substances, often figuratively shaped, held to be repositories of good fortune and prosperity.

intiwatana. "Hitching post of the sun." Carved stones used to track solar movement.

kamay. The particular essence of a thing or type of things.

mallki. Ancestral cadaver.

markayuq. The petrous owner of a village.

pacha. The earth, as well as periods of time.

Pachamama. Mother Earth.

paqarisqa. Origin places from which ancestral beings emerged to populate this world.

paqcha. Channel for carrying liquids.

puna. High plains of the Andes.

puruawqa. Petrous warriors who helped the Inka defend Cuzco against the Chanka.

qaqa. Boulder, crag, or other large, significant rock.

qhapaq ucha. An Inka rite involving child sacrifice.

qhariwarmi. "Man-and-woman," referring to a thing composed of conjoined complements.

qillqa. Superficial decoration.

Qulla. Camelid-herding inhabitants of the Andean highlands.

rumi. Rock or stone.

sayk'uska. "Tired stones," quarried rocks that were intended for building projects but were abandoned before use.

samay. Animating breath.

saywa. A petrous boundary or territorial marker.

siq'i. "Line," usually referring to the conceptual organization of waka in and around Cuzco.

sukanka. A stone pillar used to track the sun and embody a period of time.

tinku. Places where, or events in which, complements merge.

tiqsirumi. Foundation, first, or origin stone.

t'uqu. Window, or the mouth of a cave.

urin. Lower.

waka. A sacred thing, landscape feature, or shrine.

wank'a. The petrous owner of a place.

wawqi. A male's brother and also the petrous embodiment of an important male.

Bibliography

Abercrombie, Thomas A. *Pathways of Memory and Power: Ethnography and History among an Andean People*. Madison: University of Wisconsin Press, 1998.

Ackerman, Raquel. "The Despacho: Analysis of a Ritual Object." *Journal of Latin American Lore* 17, nos. 1–2 (1991): 71–102.

Acosta, Joseph (José) de. *Historia Natural y Moral de las Indias* (1590). Ed. Edmundo O'Gorman. 2nd ed. México: Fondo de Cultura Económica, 1962.

———. *Natural and Moral History of the Indies* (1590). Ed. Jane E. Mangan. Trans. Frances M. López-Morillas. Durham: Duke University Press, 2002.

Adorno, Rolena. "The Rhetoric of Resistance: The 'Talking' Book of Felipe Guaman Poma." *History of European Ideas* 6, no. 4 (1985): 447–64.

———. "A Witness unto Itself: The Integrity of the Autograph Manuscript of Felipe Guaman Poma de Ayala's *El Primer Nueva Corónica y Buen Gobierno* (1615–1616)." In *New Studies of the Autograph Manuscript of Felipe Guaman Poma de Ayala's* Nueva Corónica y Buen Gobierno, ed. Rolena Adorno and Ivan Boserup, 7–106. Copenhagen: Museum Tusculanum Press, 2003.

Agurto Calvo, Santiago. *Cusco: La Traẓa Urbana de la Ciudad Inca*. Project PER 39, UNESCO, Instituto Nacional de Cultura del Perú. Cuzco: Imprenta Offset Color S.R.L., 1980.

———. *Estudios acerca de la Construcción, Arquitectura, y Planeamiento Incas*. Lima: Cámera Peruana de la Construcción, 1987.

Albornoz, Cristóbal de. "Instrucción para Descubrir Todas las Guacas del

Pirú y sus Camayos y Haziendas" (1584). In *Fábulas y Mitos de los Incas*, ed. Henrique Urbano and Pierre Duviols, 161–98. Madrid: Historia 16, 1988.

Alconini, Sonia. "Dis-embedded Centers and Architecture of Power in the Fringes of the Inka Empire: New Perspectives on Territorial and Hegemonic Strategies of Domination." *Journal of Anthropological Archaeology* 27 (2008): 63–81.

————. "Prehistoric Inka Frontier: Structure and Dynamics in the Bolivian Chaco." Ph.D. diss., University of Pittsburgh, 2002.

————. "The Southeastern Inka Frontier against the Chiriguanos: Structure and Dynamics of the Inka Imperial Borderlands." *Latin American Antiquity* 15, no. 4 (2004): 389–419.

Allen, Catherine J. "Body and Soul in Quechua Thought." *Journal of Latin American Lore* 8, no. 2 (1982): 179–95.

————. *The Hold Life Has: Coca and Cultural Identity in an Andean Community*. Washington: Smithsonian Institution Press, 1988.

————. "Of Bear-Men and He-Men: Bear Metaphors and Male Self-Perception in a Peruvian Community." *Latin American Indian Literatures* 7, no. 1 (1983): 38–51.

————. "Patterned Time: The Mythic History of a Peruvian Community." *Journal of Latin American Lore* 10, no. 2 (1984): 151–73.

————. "Time, Place, and Narrative in an Andean Community." *Société Suisse des Américanistes Bulletin* 57–58 (1993–94): 89–95.

————. "When Pebbles Move Mountains: Iconicity and Symbolism in Quechua Ritual." In *Creating Context in Andean Cultures*, ed. Rosaleen Howard-Malverde, 73–84. New York: Oxford University Press, 1997.

Alvarez Pazos, Carlos. "Corpus Christi en Socarte: Ritualidad de Propiciación y Fertilidad del Ganado." Tesis de Maestría en Cultura y Sociedad en Los Andes, Centro de Estudios Regionales Andinos "Bartolomé de Las Casas," Escuela Andina de Postgrado, 1999.

Anders, Martha Biggar. "Dual Organization and Calendars Inferred from the Planned Site of Azangaro — Wari Administrative Strategies." Ph.D. diss., Cornell University, 1986.

Angles Vargas, Víctor. *Historia del Cusco*. 2 vols. Lima: Industrialgráfica, 1978–83.

————. *Sacsayhuaman: Portento Arquitectónico*. Lima: Industrialgráfica, 1990.

Angrand, Léonce. *Imagen del Perú en el Siglo XIX*. Lima: Editor Carlos Milla Batres, 1972.

Aranguren Paz, Angelica. "Las Creencias y Ritos Mágicos-Religiosos de los Pastores Puneños." *Allpanchis Phuturinqa* 8 (1975): 103–32.

Arguedas, José María. "El Mito de Inkarrí y las Tres Humanidades." In *Ideología Mesiánica del Mundo Andino*, ed. Juan M. Ossio A., 379–91. Lima: Ignacio Prado Pastor, 1973.

——. "Puquio, una Cultura en Proceso de Cambio." In *Estudios Sobre la Cultura Actual del Perú*, ed. José María Arguedas, 221–72. Lima: Universidad Nacional Mayor de San Marcos, 1964.

Armstrong, Robert Plant. *The Powers of Presence: Consciousness, Myth, and Affecting Presence*. Philadelphia: University of Pennsylvania Press, 1981.

Arnold, Denise. "The House of Earth-Bricks and Inka Stones: Gender, Memory, and Cosmos in Qaqachaka." *Journal of Latin American Lore* 17, nos. 1–2 (1991): 3–69.

Arriaga, Pablo Joseph de. *La Extirpación de la Idolatría en el Pirú* (1621). Ed. Henrique Urbano. Cuzco: Centro de Estudios Regionales Andinos "Bartolomé de Las Casas," 1999.

Avendaño, Fernando de. "Relación sobre la Idolatría" (1648). In *La Imprenta en Lima (1584–1824)*, 4 vols., ed. José Toribio Medina, vol. 1, 375–83. Santiago de Chile: Fondo Histórico y Bibliográfico José Toribio Medina, 1904.

Aveni, Anthony F. "Horizon Astronomy in Incaic Cuzco." In *Archaeoastronomy in the Americas*, ed. Ray A. Williamson, 305–18. Los Altos, Calif.: Ballena Press, 1981.

Ballesteros Gaibrois, Manuel. "Relación entre Fray Martín de Murúa y Felipe Huamán Poma de Ayala." In *Amerikanistische Studien / Estudios Americanistas*, 2 vols., ed. Roswith Hartmann and Udo Oberem, vol. 1, 39–47. St. Agustin: Haus Völker and Kulturen, Anthropos-Institut, 1979.

Bandelier, Adolph F. *The Islands of Titicaca and Koati*. New York: Hispanic Society of America, 1910.

Barnes, Monica. "Catechisms and Confessionarios: Distorting Mirrors of Andean Societies." In *Andean Cosmologies through Time: Persistence and Emergence*, ed. Robert V. H. Dover, Katharine E. Seibold, and John H. McDowell, 67–94. Bloomington: Indiana University Press, 1992.

——. "Review of the Conference 'Peru in Black and White and in Color: Unique Texts and Images in the Colonial Andean Manuscripts of Martín de Murúa and Guaman Poma' held at the Newberry Library, Chicago, 19–20 April 2002." *Colonial Latin American Review* 12, no. 1 (2003): 129–34.

Barnes, Monica, and Daniel J. Slive. "El Puma de Cuzco: ¿Plano de la Ciudad Ynga o Noción Europea?" *Revista Andina* 11, no. 1 (1993): 79–102.

Barrionuevo, Alfonsina. *Los Extraterrestres, ¿Construyeron Saqsaywaman?* Lima: Servicios de Artes Gráficas, 1989.

Bastien, Joseph William. "Metaphorical Relations between Sickness, Society, and Land in a Qollahuaya Ritual." In *Health in the Andes*, ed. Joseph W.

Bastien and John M. Donahue, 19–37. Special publication of the American Anthropological Association no. 12. Washington: American Anthropological Association, 1981.

————. *Mountain of the Condor: Metaphor and Ritual in an Andean Ayllu.* Prospect Heights, Ill.: Waveland Press, 1985.

————. *Qollahuaya Rituals: An Ethnographic Account of the Symbolic Relations of Man and Land in an Andean Village.* Ithaca, N.Y.: Cornell University Press, 1973.

Bauer, Brian S. *Ancient Cuzco: Heartland of the Inca.* Austin: University of Texas Press, 2004.

————. *The Development of the Inca State.* Austin: University of Texas Press, 1992.

————. "Pacariqtambo and the Mythical Origins of the Inca." *Latin American Antiquity* 2, no. 1 (1991): 7–26.

————. "Ritual Pathways of the Inca: An Analysis of the Collasuyu Ceques in Cuzco." *Latin American Antiquity* 3, no. 3 (1992): 183–205.

————. *The Sacred Landscape of the Inca: The Cusco Ceque System.* Austin: University of Texas Press, 1998.

Bauer, Brian S., and David S. P. Dearborn. *Astronomy and Empire in the Ancient Andes: The Cultural Origins of Inca Sky Watching.* Austin: University of Texas Press, 1995.

Bauer, Brian S., and Charles Stanish. *Ritual and Pilgrimage in the Ancient Andes: The Islands of the Sun and the Moon.* Austin: University of Texas Press, 2001.

Bengtsson, Lisbet. "The Concept of Time/Space in Quechua: Some Considerations." In *Past and Present in Andean Prehistory and Early History: Proceedings of a Workshop Held at the Etnografiska Museet, Göteborg, Sweden, September 16–17, 1996,* ed. Sven Ahlgren, Adriana Muñoz, Susana Sjödin, and Per Stenborg, 119–27. *Etnologiska Studier* 42. Göteborg: Etnografiska Museet, 1998.

Benjamin, Walter. *The Origin of German Tragic Drama,* trans. John Osborne. London: Verso, 1998.

Bergh, Susan E. "Death and Renewal in Moche Phallic-Spouted Vessels." *Res* 24 (1993): 78–94.

Berthier, François. *Reading Zen in the Rocks: The Japanese Dry Landscape Garden,* trans. Graham Parkes. Chicago: University of Chicago Press, 2000.

Besom, Thomas. "Another Mummy." *Natural History* 100, no. 4 (1991): 66–67.

Betanzos, Juan de. *Narrative of the Incas* (1557). Ed. and trans. Roland Hamilton and Dana Buchanan. Austin: University of Texas Press, 1996.

————. *Suma y Narración de los Incas* (1557). Ed. María del Carmen Martín Rubio. Madrid: Atlas, 1987.

Beyersdorff, Margot. "Suggested Glosses of Huaca Names." Appendix 3 in *The Sacred Landscape of the Inca: The Cusco Ceque System*, by Brian S. Bauer, 179–96. Austin: University of Texas Press, 1998.

Bhabha, Homi K. "Of Mimicry and Man: The Ambivalence of Colonial Discourse." *October* 28 (Spring 1984): 125–33.

Bierhorst, John. *Black Rainbow: Legends of the Incas and Myths of Ancient Peru*. New York: Farrar, Straus and Giroux, 1976.

Bingham, Hiram. *Machu Picchu: A Citadel of the Incas*. Report of the Explorations and Excavations made in 1911, 1912, and 1915 under the auspices of Yale University and the National Geographic Society. New York: Hacker Art Books, 1979.

Boero Rojo, Hugo, and Oswaldo Rivera Sundt. *El Fuerte Preincaico de Samaipata*. La Paz: Editorial Los Amigos del Libro, 1979.

Bollaert, William. "An Account of a Zodiac of the Incas, and Also of Some Antiquities Recently Found at Cuzco, Now in the Possession of General Echenique, Late President of Peru." *Proceedings of the Society of Antiquaries of London*, 2nd ser., 1 (1861): 78–81.

Bouysse-Cassagne, Thérèse, and Olivia Harris. "Pacha: En Torno al Pensamiento Aymara." In *Tres Reflexiones sobre el Pensamiento Andino*, 11–59. La Paz: HISBOL, 1987.

Bray, Tamara Lynn. "The Effects of Inca Imperialism on the Northern Frontier." Ph.D. diss., State University of New York, Binghamton, 1991.

Brittenham, Claudia. "Imágenes en un Paisaje Sagrado: *Huacas* de Piedra de los Incas." In *La Imagen Sagrada y Sacralizada: Memoria del XXVIII Coloquio Internacional de Historia de Arte*. México: Instituto de Investigaciones Estéticas, Universidad Nacional Autónoma, forthcoming.

Bryson, Norman. *Vision and Painting: The Logic of the Gaze*. New Haven, Conn.: University of Yale Press, 1983.

Burga, Manuel. *Nacimiento de una Utopia: Muerte y Resurrección de los Incas*. Lima: Instituto de Apoyo Agrario, 1988.

Burger, Richard L., and Lucy C. Salazar. "Catalogue." In *Machu Picchu: Unveiling the Mystery of the Incas*, ed. Richard L. Burger and Lucy C. Salazar, 125–217. New Haven, Conn.: Yale University Press, 2004.

Bushnell, Geoffrey H. S. *Ancient Art of the Americas*. New York: Praeger, 1967.

———. *Peru*. London: Thames and Hudson, 1963.

Cabello Balboa, Miguel. *Obras* (1586–1603). 2 vols. Quito: Editorial Ecuatoriana, 1945.

Camacho Paredes, Darwin. *The True of Machupicchu*. Cuzco: Indusgraf, 2001.

Cantrell, Carol H. "Analogy as Destiny: Cartesian Man and Woman Reader." In *Aesthetics in Feminist Perspective*, ed. Hilde Hein and Carolyn Korsmeyer, 218–28. Bloomington: Indiana University Press, 1993.

Cantù, Francesca, ed. *Guaman Poma y Blas Valera: Tradición Andina e Historia Colonial*. Rome: Istituto Italo-Latinoamericano, 2001.

Carrión Cachot, Rebeca. *El Culto al Agua en el Antiguo Perú: La Pacha, Elemento Cultural Pan-Andino*. 2nd ed. Lima: Instituto Nacional de Cultura, 2005.

Castañeda, Quetzil E. *In the Museum of Maya Culture: Touring Chichén Itzá*. Minneapolis: University of Minnesota Press, 1996.

Castedo, Leopoldo. *The Cuzco Circle*. New York: Center for Inter-American Relations and the American Federation of Arts, 1976.

Castro, Ignacio de. *Relación del Cuzco* (1788). Lima: Universidad Nacional Mayor de San Marcos, 1978.

Cerrón-Palomino, Rodolfo. *Quechua Sureño: Diccionario Unificado*. Lima: Biblioteca Nacional del Perú, 1994.

Chávez Ballón, M. "Ciudades Incas: Cuzco Capital del Imperio." *Wayka* 3 (1970): 1–15.

Cieza de León, Pedro de. *La Crónica del Perú (primera parte)*. Ed. Raúl Porras Barrenechea. Lima: Promoción Editorial Inca (Peisa), 1984.

———. *Crónica del Perú, segunda parte*. Ed. Francesca Cantù. Lima: Pontificia Universidad Católica del Perú, 1986.

———. *Crónica del Perú, tercera parte*. Ed. Francesca Cantù. Lima: Pontificia Universidad Católica del Perú, 1987.

———. *The Discovery and Conquest of Peru: Chronicles of the New World Encounter* (ca. 1550). Ed. and trans. Alexandra Parma Cook and Noble David Cook. Durham: Duke University Press, 1998.

———. *The Incas* (1553). Ed. Victor Wolfgang von Hagen. Trans. Harriet de Onis. Norman: University of Oklahoma Press, 1959.

Clarke, John R. "'Just Like Us': Cultural Construction of Sexuality and Race in Roman Art." In *Race-ing Art History: Critical Readings in Race and Art History*, ed. Kymberly N. Pinder, 13–20. New York: Routledge, 2002.

Classen, Constance. "Foundations for an Anthropology of the Senses." *International Social Sciences Journal* 153 (1997): 401–12.

———. *Inca Cosmology and the Human Body*. Salt Lake City: University of Utah Press, 1993.

———. "Literacy as Anticulture: The Andean Experience of the Written Word." *History of Religions* 30, no. 4 (1991): 404–21.

———. "The Social History of the Senses." In *Encyclopedia of European Social History*, ed. P. Stearns, 355–63. New York: Charles Scribner's Sons, 2001.

———. *Worlds of Sense: Exploring the Senses in History and across Cultures*. London: Routledge, 1993.

Classen, Constance, and David Howes. "The Museum as Sensescape: Western Sensibilities and Indigenous Artifacts." In *Sensible Objects: Colonialism, Museums, and Material Culture*, ed. Elizabeth Edwards, Chris Gosden, and Ruth B. Phillips, 199–222. Oxford: Berg Publishers, 2006.

Clunas, Craig. *Pictures and Visuality in Early Modern China*. London: Reaktion Books, 1997.

Cobo, Bernabé. *History of the Inca Empire: An Account of the Indians' Customs and Their Origins Together with a Treatise on Inca Legends, History, and Social Institutions* (1653). Ed. and trans. Roland Hamilton. Austin: University of Texas Press, 1979.

———. *Inca Religion and Customs* (1653). Ed. and trans. Roland Hamilton. Austin: University of Texas Press, 1990.

———. *Obras del P. Bernabé Cobo*. 2 vols. Ed. Francisco Mateos. Biblioteca de Autores Españoles, vols. 91–92. Madrid: Real Academia Española, 1956.

Collapiña, Supno, y otros Quipucamayos. *Relación de la Descendencia, Gobierno, y Conquista de los Incas* (1542–75). Ed. Juan José Vega. Lima: Editorial Jurídica, 1974.

Conklin, William J. "Structure as Meaning in Ancient Andean Textiles." In *Andean Art at Dumbarton Oaks*, ed. Elizabeth Hill Boone, vol. 2, 321–28. Washington: Dumbarton Oaks Research Library and Collection, Trustees for Harvard University, 1996.

Connerton, Paul. *How Societies Remember*. Cambridge: Cambridge University Press, 1989.

Contreras y Valverde, Vasco de. *Relación de la Ciudad del Cusco, 1649* (1650). Ed. María del Carmen Martín Rubio. Cuzco: Imprenta Amauta, 1982.

Cook, O. F. "Staircase Farms of the Ancients: Astounding Farming Skill of Ancient Peruvians, Who Were among the Most Industrious and Highly Organized People in History." *National Geographic Magazine* 29, no. 5 (1916): 474–534.

Córdoba y Salinas, Diego de. *Crónica Franciscana de las Provincias del Perú* (1651). Ed. Lino G. Canedo. Washington: Academy of American Franciscan History, 1957.

Cornejo Bouroncle, Jorge. *Derroteros de Arte Cuzqueño: Datos para una Historia del Arte en el Perú*. Cuzco: Ediciones Inca, 1960.

Cummins, Thomas B. F. "A Tale of Two Cities: Cuzco, Lima, and the Construction of Colonial Representation." In *Converging Cultures: Art and Identity in Spanish America*, ed. Diana Fane, 157–70. New York: Brooklyn Museum and Harry N. Abrams, 1996.

———. *Toasts with the Inca: Andean Abstraction and Colonial Images on Quero Vessels*. Ann Arbor: University of Michigan Press, 2002.

Curatola, Marco. "Mito y Milenarismo en los Andes: Del Taki Onqoy a In-
karrí, La Visión de un Pueblo Invicto." *Allpanchis Phuturinqa* 10 (1977):
65–92.

Dalle, Luis. "El Despacho." *Allpanchis Phuturinqa* 1 (1969): 139–54.

D'Altroy, Terence N. *The Incas*. Oxford: Blackwell, 2002.

———. *Provincial Power in the Inka Empire*. Washington: Smithsonian Insti-
tution Press, 1992.

D'Altroy, Terence, Ana Maria Lorandi, Milena Calderani, Veronica Williams,
Christine Hastorf, Elizabeth DeMarrais, and Melissa B. Hagstrum. "Inka
Rule in the Northern Calchaqui Valley, Argentina." *Journal of Field Archae-
ology* 27 (2000): 1–26.

Dean, Carolyn. "Andean Androgyny and the Making of Men." In *Gender in
Pre-Hispanic America*, ed. Cecelia F. Klein, 143–82. Washington: Dum-
barton Oaks Research Library and Collection, Trustees for Harvard Uni-
versity, 2001.

———. "Creating a Ruin in Colonial Cusco: Sacsahuamán and What Was
Made of It." *Andean Past* 5 (1998): 161–83.

———. *Inka Bodies and the Body of Christ: Corpus Christi in Colonial Cuzco,
Peru*. Durham: Duke University Press, 1999.

———. "The Inka Married the Earth: Integrated Outcrops and the Making
of Place." *Art Bulletin* 89, no. 3 (2007): 502–18.

———. "Metonymy in Inca Art." In *Presence: The Inherence of the Prototype
within Images and Other Objects*, ed. Robert Maniura and Rupert Shepherd,
105–20. Aldershot, U.K.: Ashgate, 2006.

———. "The Renewal of Old World Images and the Creation of Colonial
Peruvian Visual Culture." In *Converging Cultures: Art and Identity in Span-
ish America*, ed. Diana Fane, 171–82. New York: Brooklyn Museum and
Harry N. Abrams, 1996.

———. "Rethinking *Apacheta*." *Ñawpa Pacha* 28 (2006): 93–108.

———. "The Trouble with (the Term) Art." *Art Journal* 65, no. 2 (Summer
2006): 24–32.

Dearborn, David S. P., and Katharina Schreiber. "Here Comes the Sun: The
Cuzco-Machu Picchu Connection." *Archaeoastronomy* 9, nos. 1–4 (1986):
15–37.

Dearborn, David S. P., Katharina Schreiber, and Raymond E. White. "Inti-
machay: A December Solstice Observatory at Machu Picchu." *American
Antiquity* 52, no. 2 (1987): 346–52.

Dearborn, David S. P., and Raymond E. White. "Archaeoastronomy at
Machu Picchu." In *Ethnoastronomy and Archaeoastronomy in the American
Tropics*, ed. Anthony F. Aveni and Gary Urton, 249–59. Annals of the New

York Academy of Sciences, vol. 385. New York: New York Academy of Sciences, 1982.

―――. "The 'Torreón' of Machu Picchu as an Observatory." *Archaeoastronomy* 14, no. 5 (1983): S37–S49.

Decoster, Jean-Jacques. "Cultural Production of Collective Identity in an Andean Community." Ph.D. diss., Cornell University, 1994.

Del Pino Díaz, Fermín. "La *Historia Moral y Natural de las Indias* como Género: Orden y Genesis Literaria en Acosta." *Histórica* (Lima) 24, no. 2 (2000): 295–326.

Dillehay, Tom D. "Tawantinsuyu Integration of the Chillon Valley, Peru: A Case of Inca Geo-Political Mastery." *Journal of Field Archaeology* 4, no. 4 (1977): 397–405.

Dillehay, Tom D., and Patricia Netherly, eds. *La Frontera del Estado Inca.* Proceedings: 45th International Congress of Americanists, Bogotá, Colombia, 1985. BAR International Series 442. Oxford: British Archaeological Reports, 1988.

Domenici, Viviano, and Davide Domenici. "Talking Knots of the Inka: A Curious Manuscript May Hold the Key to Andean Writing." *Archaeology* 49, no. 6 (1996): 50–56.

Doyle, Mary Ellen. "Ancestor Cult and Burial Ritual in the Seventeenth and Eighteenth Century, Central Peru." Ph.D. diss., University of California at Los Angeles, 1988.

Dransart, Penny. "Cultural Transpositions: Writing about Rites in the Llama Corral." In *Creating Context in Andean Cultures*, ed. Rosaleen Howard-Malverde, 85–98. New York: Oxford University Press, 1997.

Duviols, Pierre. "Algunas Reflexiones Acerca de la Tesis de la Estructura Dual del Poder Incaico." *Histórica* (Lima) 4, no. 2 (1980): 183–96.

―――. "La Capa Cocha: Mecanismo y Función del Sacrificio Humano, su Proyección Geometrica, su Papel en la Política Integracionista en la Economía Redistributiva del Tawantinsuyu." *Allpanchis Phuturinqa* 9 (1976): 11–57.

―――. *La Destrucción de las Religiones Andinas (Conquista y la Colonia).* Trans. Albor Maruenda. Mexico: Universidad Nacional Autónoma de México, 1977.

―――. "La Dinastía de los Incas: Monarquía o Diarquía? Argumentos Heurísticos a Favor de un Tésis Estructuralista." *Journal de la Société des Américanistes* 66 (1979): 67–83.

―――. "La Guerra entre el Cuzco y los Chancha: ¿Historia o Mito?" In *Economía y Sociedad en los Andes y Mesoamerica*, ed. José Alcina Franch. Revista de la Universidad Complutense (Madrid) 28, no. 117 (1979): 363–71.

―――. "Huari y Llacuaz: Agricultores y Pastores: Un Dualismo Pre-hispánico de Oposición y Complementaridad." *Revista del Museo Nacional* (Lima) 39 (1973): 153–93.

―――. "Punchao, Ídolo Mayor del Coricancha: Historia y Tipología." *Antropología Andina* 1–2 (1976): 156–83.

―――. "Un Symbolisme Andin du Double: La Lithomorphose de l'Ancêtre." *Actes du XLIIe Congrès International des Américanistes: Congrès du Centenaire, Paris, 2–9 Septembre 1976*, 4 (1978): 359–64.

―――. "Un Symbolisme de l'Occupation, de l'Aménagement et de l'Exploitation de l'Espace: Le Monolithe Huanca et sa Fonction dans les Andes Préhispaniques." *L'Homme* 19, no. 2 (1979): 7–31.

Earle, Timothy K., Terence N. D'Altroy, Christine A. Hastorf, Catherine J. Scott, Cathy L. Costin, Glenn S. Russell, and Elsie Sandefur. *Archaeological Field Research in the Upper Mantaro, Peru, 1982–83: Investigations of the Inka Expansion and Exchange.* UCLA Institute of Archaeology Monograph 28. Los Angeles: Institute of Archaeology, University of California, 1987.

Earls, John, and Irene Silverblatt. "La Realidad Física y Social en la Cosmología Andina." *Actes du XLIIe Congrès International des Américanistes: Congrès du Centenaire, Paris, 2–9 Septembre 1976*, 4 (1978): 299–325.

Eliade, Mircea. *The Sacred and the Profane: The Nature of Religion.* New York: Harcourt Brace Jovanovich, 1959.

―――. *Shamanism: Archaic Techniques of Ecstasy.* Trans. Willard R. Trask. London: Routledge and Kegan Paul, 1964.

Elkins, James. "On David Summers's Real Spaces." In *Is Art History Global?* ed. James Elkins, 41–71. New York: Routledge, 2007.

―――. "Review of *Real Spaces: World Art History and the Rise of Western Modernism* by David Summers." *Art Bulletin* 86, no. 2 (2004): 373–81.

Elorrieta Salazar, Fernando E., and Edgar Elorrieta Salazar. *Cusco and the Sacred Valley of the Incas.* Trans. Beverly Nelson Elder. Cuzco: Tanpu, 2001.

Errington, Shelly. *The Death of Authentic Primitive Art and Other Tales of Progress.* Berkeley: University of California Press, 1998.

―――. "What Became Authentic Primitive Art?" *Cultural Anthropology* 9, no. 2 (1994): 201–26.

Espinoza Soriano, Waldemar. *Los Incas: Economía, Sociedad, y Estado en la Era del Tahuantinsuyo.* La Victoria: Amaru Editories, 1990.

Esquivel y Navia, Diego de. *Noticias Cronológicas de la Gran Ciudad del Cuzco* (ca. 1749). 2 vols. Ed. Félix Denegri Luna, Horacio Villanueva Urteaga, and César Gutiérrez Muñoz. Lima: Fundación Augusto N. Wiese, Banco Wiese, 1980.

Estenssoro Fuchs, Juan Carlos. "¿Historia de un Fraude o Fraude Histórico?" *Revista de Indias* 57, no. 210 (1997): 566–78.

Estete, Miguel de. "Noticia del Perú" (1535). *Boletín de la Sociedad Ecuatoriana de Estudios Históricos Americanos* (Quito) 1, no. 3 (1918): 300–50.

Fainstein, Susan S., and David Gladstone. "Evaluating Urban Tourism." In *The Tourist City*, ed. Dennis R. Judd and Susan S. Fainstein, 21–34. New Haven, Conn.: Yale University Press, 1999.

Falcón, Francisco. "Representación" (1567). In *Colección de Libros y Documentos Referentes a la Historia del Perú*, ed. Carlos A. Romero and Horacio H. Urteaga, serie 1, tomo 11, 133–76. Lima: Librería e Imprenta Gill, 1918.

Farrington, I. S. "The Mummy, Estate, and Palace of Inka Huayna Capac at Quispeguanca." *Tawantinsuyu: An International Journal of Inka Studies* 1 (1995): 55–65.

Fauvet-Berthelot, Marie-France, and Danièle Lavallée. *Ancien Pérou: Vie, Pourvenir, et Mort*. Paris: Editions Fernand Nathan, 1987.

Fawcett, Percy Harrison. *Exploration Fawcett*. Ed. Brian Fawcett. London: Hutchinson, 1953.

Ferrero, Onorio. "Significado e Implicaciones Universales de un Mito Peruano." In *Ideología Mesiánica del Mundo Andino*, ed. Juan M. Ossio A., 415–38. Lima: Ignacio Prado Pastor, 1973.

Fiedler, Carol Ann. "Corpus Christi in Cuzco: Festival and Ethnic Identity in the Peruvian Andes." Ph.D. diss., Tulane University, 1985.

Fioravanti-Molinié, Antoinette. "Contribution a l'Étude des Sociétés Étagées des Andes: La Vallée de Yucay (Pérou)." Études Rurales 57 (1975): 35–39.

———. "Tiempo del Espacio y Espacio del Tiempo." *Journal de la Société des Américanistes* 71 (1985): 97–114.

Flaherty, Gloria. *Shamanism and the Eighteenth Century*. Princeton: Princeton University Press, 1992.

Flannery, Kent V., Joyce Marcus, and Robert G. Reynolds. *The Flocks of the Wamani: A Study of Llama Herders on the Punas of Ayacucho, Peru*. San Diego: Academic Press, 1989.

Flores Galindo, Alberto. *Buscando un Inca: Identidad y Utopia en los Andes*. La Habana, Cuba: Casa de Las Américas, 1986.

Flores Lizana, Carlos. *El Taytacha Qoyllur Rit'i: Teología India Hecha por Comuneros y Mestizos Quechuas*. Sicuani, Perú: Instituto de Pastoral Andina, 1997.

Flores Ochoa, Jorge A. "Contemporary Significance of Machu Picchu." In *Machu Picchu: Unveiling the Mystery of the Incas*, ed. Richard L. Burger and Lucy C. Salazar, 109–23. New Haven, Conn.: Yale University Press, 2004.

———. *El Cuzco: Resistencia y Continuidad*. Cuzco: Centro de Estudios Andinos Cuzco, 1990.

———. "Enqa, Enqaychu, Illa, y Khuya Rumi." In *Pastores de Puna: Uywa-*

michiq Punarunakuna, ed. Jorge Flores Ochoa, 211–37. Lima: Instituto de Estudios Peruanos, 1977.

———. "Inkariy y Qollariy en una Comunidad del Altiplano." In *Ideología Mesiánica del Mundo Andino*, ed. Juan M. Ossio A., 301–36. Lima: Ignacio Prado Pastor, 1973.

———. *Llamichos y Paqocheros: Pastores de Llamas y Alpacas*. Cuzco: Centro Bartolomé de Las Casas, 1988.

———. *Pastoralists of the Andes: The Alpaca Herders of Paratía*. Trans. Ralph Bolton. Philadelphia: Institute for the Study of Human Issues, 1979.

Flores Ochoa, Jorge A., Elizabeth Kuon Arce, and Roberto Samanez Argumedo. *Qeros: Arte Inka en Vasos Ceremoniales*. Colección Arte y Tesoros del Perú. Lima: Banco de Crédito del Perú, 1998.

Foster, Hal, ed. *Vision and Visuality*. New York: New Press, 1999.

Fraser, Valerie. "Architecture and Imperialism in Sixteenth-Century Spanish America." *Art History* 9, no. 3 (1986): 325–35.

———. *The Architecture of Conquest: Building in the Viceroyalty of Peru, 1435–1635*. Cambridge: Cambridge University Press, 1990.

Freedberg, David. *The Power of Images: Studies in the History and Theory of Response*. Chicago: University of Chicago Press, 1989.

Frost, Peter. *Exploring Cusco*. 5th ed. Lima: Nuevas Imágenes, 1999.

Garcilaso de la Vega, "El Inca" [Gómez Suárez de Figueroa]. *Comentarios Reales* (Part 1, 1609). Ed. José de la Riva-Agüero. México: Editorial Porrúa, 1984.

———. *Royal Commentaries of the Incas and General History of Peru* (1609–17). 2 vols. Trans. Harold V. Livermore. Austin: University of Texas Press, 1966.

Gasparini, Graziano, and Luise Margolies. *Arquitectura Inka*. Caracas: Centro de investigaciones Históricas y Estéticas, Facultad de Arquitectura y Urbanismo, Universidad Central de Venezuela, 1977.

———. *Inca Architecture*. Trans. Patricia J. Lyon. Bloomington: Indiana University Press, 1980.

Gell, Alfred. *Art and Agency: An Anthropological Theory*. Oxford: Clarendon Press, 1998.

Getzels, Peter. "Los Ciegos: Visión de la Identidad del Runa en la Ideología de Inkarrí-Qollarí." In *Q'ero: El Último Ayllu Inka*, ed. Jorge A. Flores Ochoa and Juan V. Núñez del Prado Béjar, 170–201. Cuzco: Centro de Estudios Andinos Cuzco.

Gisbert, Teresa. *Los Ángeles de Calamarca*. La Paz: Compañía Boliviana de Seguros, 1983.

———. "The Angels." In *Gloria in Excelsis: The Virgin and Angels in Vice-*

regal Paintings of Peru and Bolivia, 58–63. New York: Center for Inter-American Relations, 1986.

Gisbert, Teresa, Silvia Arze, and Martha Cajías. *Arte Textil y Mundo Andino*. La Paz: Gisbert y Cía, 1987.

Gombrich, E. H. *Art and Illusion: A Study in the Psychology of Pictorial Representation*. 2nd ed. Bollingen series 35. New York: Bollingen Foundation, 1961.

———. *Meditations on a Hobby Horse and Other Essays on the Theory of Art*. London: Phaidon Press, 1963.

González Holguín, Diego. *Arte y Diccionario Qquechua-Español* (1608). Lima: Imprenta del Estado, 1901.

González Pujana, Laura. *Polo de Ondegardo: Un Cronista Vallisoletano en el Perú*. Valladolid: Instituto Interuniversitario de Estudios de Iberoamérica y Portugal, 2000.

Goodman, Nelson. *Ways of Worldmaking*. Indianapolis: Hackett, 1978.

Gordillo, Gastón R. *Landscapes of Devils: Tensions of Place and Memory in the Argentinean Chaco*. Durham: Duke University Press, 2004.

Gordon, Robert B. "Laboratory Evidence of the Use of Metal Tools at Machu Picchu (Peru)." *Journal of Archaeological Science* 12 (1985): 311–27.

Gow, David. "The Roles of Christ and Inkarrí in Andean Religion." *Journal of Latin American Lore* 6, no. 2 (1980): 279–96.

———. "Taytacha Qoyllur Rit'i." *Allpanchis Phuturinqa* 7 (1974): 49–100.

Gow, David, and Rosalind Gow. "La Alpaca en el Mito y el Ritual." *Allpanchis Phuturinqa* 8 (1975): 141–64.

Gow, Rosalind C. "Inkarrí and Revolutionary Leadership in the Southern Andes." *Journal of Latin American Lore* 8, no. 2 (1982): 197–223.

Gow, Rosalind, and Bernabé Condori. *Kay Pacha*. 2nd ed. Cuzco: Centro de Estudios Rurales Andinos "Bartolomé de las Casas." 1982.

Graburn, Nelson H. H., and Roland S. Moore. "Anthropological Research on Tourism." In *Travel, Tourism, and Hospitality Research: A Handbook for Managers and Researchers*, 2nd ed., ed. J. R. Brent Ritchie and Charles R. Goeldner, 223–42. New York: John Wiley and Sons, 1994.

Granadino, Cecilia. *Cuentos de Nuestros Abuelos Quechuas: Recuperando la Tradición Oral*. Lima: Centro de Difusión Cultural Wasapay, 1993.

Guaman Poma de Ayala, Felipe. *El Primer Nueva Corónica y Buen Gobierno* (ca. 1615). 2nd ed. Ed. John V. Murra and Rolena Adorno. Quechua trans. Jorge L. Urioste. México: Siglo Veintiuno, 1988.

Guibovich Pérez, Pedro. "Review Essay: Las Polémicas en Torno a Guaman Poma de Ayala. Review of *Guaman Poma y Blas Valera: Tradición Andina e Historia Colonial*, ed. Francesca Cantù (Rome: Istituto Italo-Latinoamericano, 2001)." *Colonial Latin American Review* 12, no. 1 (2003): 99–103.

Gutiérrez Estévez, Manuel. "Hipótesis y Comentarios sobre la Significación de la Mama-Huaca." In *Memorias del Primer Simposio Europeo sobre Antropología del Ecuador*, ed. Segundo E. Morales Yáñez, 335–75. Quito: Abya-Yala, 1985.

———. "Sobre el Origen de algunas Creencias Populares." *Revista del Instituto Azuayo de Folklore* (Cuenca) 6 (1979): 61–83.

Gutmann, Margit. "Visión Andina del Mundo y Conceptos Religiosos en Cuentos Orales Quechuas del Perú." In *Mito y Simbolismo en los Andes: La Figura y la Palabra*, ed. Henrique Urbano, 239–58. Cuzco: Centro de Estudios Regionales Andinos "Bartolomé de Las Casas," 1993.

Gyarmati, János, and András Varga. *The Chacaras of War: An Inka Estate in the Cochabamba Valley, Bolivia*. Budapest: Museum of Ethnography, 1999.

Hallowell, A. Irving. "Ojibwa Metaphysics of Being and the Perception of Persons." In *Person Perception and Interpersonal Behavior*, ed. Renato Taguiri and Luigi Petrullo, 6–85. Stanford: Stanford University Press, 1958.

Harris, Olivia. "Complementarity and Conflict: An Andean View of Women and Men." In *Sex and Age as Principles of Social Differentiation*, ed. J. S. La Fontaine, 21–40. Association of Social Anthropologists Monograph no. 17. New York: Academic Press, 1978.

———. "The Power of Signs: Gender, Culture, and the Wild in the Bolivian Andes." In *Nature, Culture, and Gender*, ed. Carol P. McCormack and Marilyn Strathern, 70–94. Cambridge: Cambridge University Press, 1980.

Harrison, Regina. *Signs, Songs, and Memory in the Andes: Translating Quechua Language and Culture*. Austin: University of Texas Press, 1989.

Harvey, Penelope. "Peruvian Independence Day: Ritual, Memory, and the Erasure of Narrative." In *Creating Context in Andean Cultures*, ed. Rosaleen Howard-Malverde, 21–44. New York: Oxford University Press, 1997.

Hay, John. *Kernels of Energy, Bones of Earth: The Rock in Chinese Art*. New York: China House Gallery, China Institute in America, 1985.

Heffernan, Ken. *Limatambo: Archaeology, History, and the Regional Societies of Inca Cuzco*. BAR International Series. Oxford: British Archaeological Reports, 1996.

Hemming, John, and Edward Ranney. *Monuments of the Incas*. Boston: New York Graphic Society, 1982.

Hernández Príncipe, Rodrigo. "Mitología Andina" (ca. 1622). *Inca* 1 (1923): 25–68.

Herrera y Tordesillas, Antonio de. *Historia General de los Hechos de los Castellanos en las Islas y Tierra Firme del Mar Oceano* (1601–15). Ed. Miguel Gómez del Campillo. Madrid: Real Academio de la Historia, 1934–57.

Holcomb, Briavel. "Marketing Cities for Tourism." In *The Tourist City*, ed.

Dennis R. Judd and Susan S. Fainstein, 54–70. New Haven, Conn.: Yale University Press, 1999.

Holland, Augusta E. Schröder de. "El Dibujante de la Nueva Corónica." In *Guaman Poma y Blas Valera: Tradición Andina e Historia Colonial*, ed. Francesca Cantù, 49–61. Rome: Istituto Italo-Latinoamericano, 2001.

———. "The Drawings of 'El Primer Nueva Corónica y Buen Gobierno': An Art Historical Study (Felipe Guaman Poma de Ayala)." Ph.D. diss., University of New Mexico, 2002.

Houston, Stephen D., and Tom Cummins. "Body, Presence, and Space in Andean and Mesoamerican Rulership." In *Palaces of the Ancient New World: A Symposium at Dumbarton Oaks (10th and 11th October 1998)*, ed. Susan Toby Evans and Joanne Pillsbury, 359–98. Washington: Dumbarton Oaks Research Library and Collection, Trustees for Harvard University, 2004.

Howard-Malverde, Rosaleen. "Introduction: Between Text and Context in the Evocation of Culture." In *Creating Context in Andean Cultures*, ed. Rosaleen Howard-Malverde, 3–18. New York: Oxford University Press, 1997.

———. *The Speaking of History: "Willapaakushayki" or Quechua Ways of Telling the Past*. Institute of Latin American Studies Research Papers 21. London: University of London, 1990.

Huayhuaca Villasante, Luis A. *La Festividad del Corpus Christi en el Cusco*. Cuzco: L. A., 1988.

Hyland, Sabine. *The Jesuit and the Incas: The Extraordinary Life of Padre Blas Valera, S.J.* Ann Arbor: University of Michigan Press, 2003.

Hyslop, John. *Inca Settlement Planning*. Austin: University of Texas Press, 1990.

———. *The Inka Road System*. Orlando: Academic Press, 1984.

Isbell, Billie Jean. "The Metaphoric Process: 'From Culture to Nature and Back Again.'" In *Animal Myths and Metaphors in South America*, ed. Gary Urton, 285–313. Salt Lake City: University of Utah Press, 1985.

———. *To Defend Ourselves: Ecology and Ritual in an Andean Village*. Latin American Monographs, vol. 47. Austin: Institute of Latin American Studies, University of Texas, 1978.

Isbell, William H., and Helaine Silverman. "Writing the Andes with a Capital 'A.'" In *Andean Archaeology I: Variations in Sociopolitical Organization*, ed. William H. Isbell and Helaine Silverman, 371–80. New York: Kluwer Academic, 2002.

Itier, César. *Parlons Quechua: La Langue du Cuzco*. Paris: L'Harmattan, 1997.

Jérez, Francisco de. "Verdadera Relación de la Conquista del Perú y Provincia del Cuzco, lamada la Nueva Castilla" (1534). In *Biblioteca Peruana: El*

Perú a Través de los Siglos, series 1, vol. 1, 191–273. Lima: Editores Técnicos Asociados, 1968.

Julien, Catherine J. "Finding a Fit: Archaeology and Ethnohistory." In *Provincial Inca: Archaeological and Ethnohistorical Assessment of the Impact of the Inca State*, ed. Michael A. Malpass, 178–233. Iowa City: Iowa University Press, 1993.

———. "History and Art in Translation: The Paños and Other Objects Collected by Francisco de Toledo." *Colonial Latin American Review* 8, no. 1 (1999): 61–89.

———. "Oroncota entre Dos Mundos." In *Espacio, Etnias, Frontera: Atenuaciones Políticas en el Sur del Tawantinsuyu, Siglos XV–XVII*, 97–160. Ediciones ASUR 4. Sucre: Antropologos del Surandino, Inter-American Foundation, 1995.

———. *Reading Inca History*. Iowa City: University of Iowa Press, 2000.

Kagan, Richard L. *Urban Images of the Hispanic World, 1493–1793*. New Haven, Conn.: Yale University Press, 2000.

Kahn, Miriam. "Stone-Faced Ancestors: The Spatial Anchoring of Myth in Wamira, Papua New Guinea." *Ethnology* 29 (1990): 51–66.

Kendall, Ann. *Aspects of Inca Architecture: Description, Function, and Chronology*. 2 vols. BAR International Series 242. Oxford: British Archaeological Reports, 1985.

———. "Descripción e Inventario de las Formas Arquitectónicas Inca: Patrones de Distribución e Inferencias Cronológicas." *Revista del Museo Nacional* (Lima) 42 (1976): 13–96.

———. "Inca Planning North of Cuzco between Anta and Machu Picchu and along the Urubamba Valley." In *Recent Studies in Pre-Columbian Archaeology*, ed. Nicholas J. Saunders and Olivier de Montmollin, vol. 2, 457–63. BAR International Series 421. Oxford: British Archaeological Reports, 1988.

Kendall, Ann, Rob Early, and Bill Sillar. "Arquitectura Inca Temprana en Juchuy Coscco." *Buletin de Lima* 17, no. 97 (1995): 43–68.

Klein, Cecelia F. "The Identity of the Central Deity on the Aztec Calendar Stone." *Art Bulletin* 58 (1976): 1–12.

———. "Objects Are Nice, But. . . ." *Art Bulletin* 76, no. 3 (1994): 401–4.

Klein, Cecelia F., Eulogio Guzman, Elisa C. Mandell, and Maya Stanfield-Mazzi. "The Role of Shamanism in Mesoamerican Art: A Reassessment." *Current Anthropology* 43, no. 3 (2002): 383–420.

Krickeberg, Walter. *Felsplastik und Felsbilder bei den Kulturvölkern Altamerikas mit besonderer Berücksichtigung Mexicos*. Berlin: Palmen-Verlag, 1949.

Kristeller, Paul Oskar. *Renaissance Thought and the Arts: Collected Essays* (1965). Princeton: Princeton University Press, 1980.

Kubler, George. *The Art and Architecture of Ancient America: The Mexican, Maya, and Andean Peoples*. Baltimore: Penguin Books, 1962.

—————. "The Quechua in the Colonial World." In *Handbook of South American Indians*, ed. Julian H. Steward, vol. 2, 331–410. Washington: United States Government Printing Office, 1946.

Kuznar, Lawrence A. "An Introduction to Andean Religious Ethnoarchaeology: Preliminary Results and Future Directions." In *Ethnoarchaeology of Andean South America: Contributions to Archaeological Method and Theory*, ed. Lawrence A. Kuznar, 38–66. Ann Arbor: International Monographs in Prehistory, 2001.

La Barre, Weston. *The Aymara Indians of the Lake Titicaca Plateau, Bolivia*. Washington: American Anthropological Association, 1948.

Lamadrid, Enrique R. *Treasures of the Mama Huaca: Oral Tradition and Ecological Consciousness in Chinchaysuyu*. University of New Mexico Latin American Institute Research Paper Series no. 25. Albuquerque: University of New Mexico Press, 1993.

Lapidus de Sager, Nejama. "El Significado de Algunos Ideogramas Andinos: Contribución al Estudio de la Comunicación Prehispánica." In *Idiomas, Cosmovisiones, y Cultura*, ed. Germán Fernández Guizzetti, 72–95. Rosario, Argentina: Instituto de Antropología, Universidad Nacional del Litoral, 1968.

Lara, Jesús. *Leyendas Quechuas: Antología*. La Paz: Librería-Editorial Juventad, 1980.

Larrea, Juan. *Corona Incaica*. Córdoba: Facultad de Filsofía y Humanidades, Universidad Nacional de Córdoba, 1960.

Lechtman, Heather. "Andean Value Systems and the Development of Prehistoric Metallurgy." *Technology and Culture* 25, no. 1 (1984): 1–36.

—————. "Cloth and Metal: The Culture of Technology." In *Andean Art at Dumbarton Oaks*, ed. Elizabeth Hill Boone, vol. 1, 33–43. Washington: Dumbarton Oaks Research Library and Collection, Trustees for Harvard University, 1996.

—————. "Style in Technology—Some Early Thoughts." In *Material Culture: Styles, Organization, and Dynamics of Technology*, ed. Heather Lechtman and Robert S. Merrill, 3–20. St. Paul, Minn.: West Publishing, 1977.

—————. "Technologies of Power: The Andean Case." In *Configurations of Power in Complex Society*, ed. Patricia Netherly and John Henderson, 244–80. Ithaca, N.Y.: Cornell University Press, 1993.

Lee, Vincent R. "The Building of Sacsahuaman." *Ñawpa Pacha* 24 (1986): 49–60.

—————. "Design by Numbers: Architectural Order among the Inkas." Paper

presented at the 36th Annual Meeting of the Institute of Andean Studies, Berkeley, January 1996. Wilson, Wyo.: Lee, 1996.

Lefebvre, Henri. *The Production of Space*. Trans. Donald Nicholson-Smith. Oxford: Blackwell, 1991.

Leuridan Huys, Johan. *José de Acosta y el Orígen de la Idea de Mission, Perú, Siglo XVI*. Lima: Centro de Estudios Regionales Andinos "Bartolomé de Las Casas" y Universidad de San Martín Porres, Facultad de Ciencias de la Comunicación, Turismo y de Psicología, 1997.

López-Baralt, Mercedes. "From Looking to Seeing: The Image as Text and the Author as Artist." In *Guaman Poma de Ayala: The Colonial Art of an Andean Author*, 14–31. New York: Americas Society, 1992.

———. "La Persistancia de las Estructuras Simbólicas Andinas en los Dibujos de Guaman Poma de Ayala." *Journal of Latin American Lore* 5, no. 1 (1979): 83–116.

———. *El Retorno del Inca Rey: Mito y Profecía en el Mundo Andino*. Madrid: Editorial Playor, 1987.

Lund, Sarah. "On the Margin: Letter Exchange among Andean Non-Literates." In *Creating Context in Andean Cultures*, ed. Rosaleen Howard-Malverde, 185–95. New York: Oxford University Press, 1997.

MacCannell, Dean. *The Tourist: A New Theory of the Leisure Class*. New York: Schocken, 1989.

MacCormack, Sabine. *Religion in the Andes: Vision and Imagination in Early Colonial Peru*. Princeton: Princeton University Press, 1991.

Machicado Figueroa, Juan Carlos. *When the Stones Speak: Inka Architecture and Spirituality in the Andes*. Cuzco: Inka 2000 Productions, 2002.

MacLean, Margaret Greenup. "Sacred Land, Sacred Water: Inca Landscape Planning in the Cuzco Area." Ph.D. diss., University of California, Berkeley, 1986.

Malpass, Michael A., ed. *Provincial Inca: Archaeological and Ethnohistorical Assessment of the Impact of the Inca State*. Iowa City: University of Iowa Press, 1993.

Mannheim, Bruce. *The Language of the Inka since the European Invasion*. Austin: University of Texas Press, 1991.

Martínez Cereceda, José Luis. *Autoridades en los Andes: Los Atributos del Señor*. Lima: Pontificia Universidad Católica del Perú, 1995.

Mason, J. Alden. *The Ancient Civilizations of Peru*. Baltimore: Penguin Books, 1957.

Mason, Peter. *Deconstructing America: Representations of the Other*. New York: Routledge, 1990.

Matos, Ramiro. "El Ushnu de Pumpu." *Cuicuilco* 18 (1986): 45–61.

McEwan, Colin, and Maarten Van de Guchte. "Ancestral Time and Sacred

Space in Inca State Ritual." In *The Ancient Americas: Art from Sacred Landscapes*, ed. Richard F. Townsend, 359–71. Chicago: Art Institute, 1992.

Meddens, Frank M. "Function and Meaning of the Usnu in Late Horizon Peru." *Tawantinsuyu* 3 (1997): 5–14.

———. "Mountains, Miniatures, Ancestors, and Fertility: The Meaning of a Late Horizon Offering in a Middle Horizon Structure in Peru." *Bulletin of the Institute of Archaeology* 31 (1994): 127–50.

Mena, Cristóbal de. "La Conquista del Perú, Llamada la Nueva Castilla" (1534). In *Biblioteca Peruana: El Perú a través de los Siglos*, series 1, vol. 1, 135–69. Lima: Editores Técnicos Asociados, 1968.

Mendizábal Losack, Emilio. "Las Dos Versiones de Murúa." *Revista del Museo Nacional* (Lima) 32 (1963): 153–85.

Menotti, Francesco. *The Inkas: Last Stage of Stone Masonry Development in the Andes*. Ed. Rajka Makjanic. British Archaeological Reports International Series no. 735. Oxford: Archaeopress, 1998.

Metz, Christian. *The Imaginary Signifier: Psychoanalysis and the Cinema*. Trans. Celia Britton et al. Bloomington: Indiana University Press, 1982.

Meyers, Albert. "Las Campañas Arqueológicas en Samaipata, 1994–1996." *Boletín* (Sociedad de Investigaciones del Arte Rupestre de Bolivia) 12 (1998): 59–86.

———. *Los Incas en el Ecuador: Análisis de los Restos Materiales*. 2 vols. Trans. Christina Borchart de Moreno. Quito: Ediciones del Banco Central del Ecuador and Abya-Yala, 1998.

Meyers, Albert, and Cornelius Ulbert. "Archaeological Explorations in Eastern Bolivia: The Samaipata Project." In *Past and Present in Andean Prehistory and Early History: Proceedings of a Workshop Held at the Etnografiska Museet, Göteborg, Sweden, September 16–17, 1996*, ed. Sven Ahlgren, Adriana Muñoz, Susana Sjödin, and Per Stenborg, 19–31. *Etnologiska Studier* 42. Göteborg: Etnografiska Museet, 1998.

Millones, Luis. "Un Movimiento Nativista del Siglo XVI: El Taki Onquoy." In *Ideología Mesiánica del Mundo Andino*, ed. Juan M. Ossio, 83–103. Lima: Ignacio Prado Pastor, 1973.

Millones, Luis, Virgilio Galdo G., and Anne Marie Dussault. "Reflexiones en Torno al Romance en la Sociedad Indígena: Seis Relatos de Amor." *Revista de Crítica Literaria Latinoamericana* (Lima) 7, no. 14 (1981): 7–28.

Mills, Kenneth. *Idolatry and Its Enemies: Colonial Andean Religion and Extirpation, 1640–1750*. Princeton: Princeton University Press, 1997.

———. "Seeing God in Mid-Colonial Peru." In *Andean Art: Visual Expression and Its Relation to Andean Beliefs and Values*, ed. Penny Dransart, 302–17. Aldershot: Avebury, 1995.

Molina, Cristóbal de [Bartolomé de Segovia]. "Destrucción del Perú" (1553).

In *Las Crónicas de los Molinas*, ed. Francisco A. Loayza. Lima: Domingo Miranda, 1943.

Molina, Cristóbal de. "Relación de las Fábulas y Ritos de los Incas" (1574). In *Las Crónicas de los Molinas*, ed. Francisco A. Loayza. Lima: Domingo Miranda, 1943.

Molinié, Antoinette, ed. *Celebrando el Cuerpo de Dios*. Lima: Pontificia Universidad Católica del Perú, 1999.

————. "The Resurrection of the Inca: The Role of Indian Representations in the Invention of the Peruvian Nation." *History and Anthropology* 15, no. 3 (2004): 233–50.

————. "The Spell of Yucay: A Symbolic Structure in Incaic Terraces." In *Structure, Knowledge, and Representation in the Andes: Studies Presented to Reiner Tom Zuidema on the Occasion of His 70th Birthday*, ed. Gary Urton. *Journal of the Steward Anthropological Society* 24, nos. 1–2 (1996): 203–30.

Montaigne, Michel de. *Selected Essays*. New York: Walter J. Black, 1943.

Montoto de Sedas, Santiago. *Nobiliario de Reinos, Ciudades y Villas de la América Española*. Colección de Documentos Inéditos para la Historia de Hispano-América, vol. 3. Madrid: Compañía Ibero-Americana de Publicaciones, 1928.

Montoya Rojas, Rodrigo, Luis Montoya Rojas, and Edwin Montoya Rojas. *Urqukunapa Yawarnin: La Sangre de los Cerros*. 2nd ed. 5 vols. Lima: Universidad Nacional Federico Villarreal, 1998.

Moore, Jerry D. "The Archaeology of Plazas and the Proxemics of Ritual: Three Andean Traditions." *American Anthropologist*, n.s., 98, no. 4 (1996): 789–802.

Morote Best, Efraín. "El Oso Raptor." *Archivos Venezolanos de Folklore* 5 (1957–58): 135–79.

Morris, Craig. "State Settlements in Tawantinsuyu." In *Contemporary Archaeology: A Guide to Theory and Contributions*, ed. Mark P. Leone, 393–401. Carbondale: Southern Illinois University Press, 1972.

Morris, Craig, and Adriana von Hagen. *The Cities of the Ancient Andes*. London: Thames and Hudson, 1998.

Morris, Craig, and Donald Thompson. *Huanuco Pampa: An Inca City and Its Hinterland*. New York: Thames and Hudson, 1985.

Mumford, Jeremy. "Clara Miccinelli's Cabinet of Wonders." *Linguafranca* 10, no. 1 (2000): 36–45.

Muñoz-Bernand, Carmen. "Autoctonía y Descendencia: Contribución al Estudio de las Huacas." In *Amerikanistische Studien / Estudios Americanistas*, ed. Roswith Hartman and Udo Oberem, vol. 2, 81–86. St. Augustin: Haus Völker und Kulturen, Anthropos-Institut, 1979.

————. *Enfermedad, Daño e Ideología*. Quito: Abya-Yala, 1986.

————. "Seducción o Castigo: El Poder de los Cerros en la Sierra del Ecuador." *Folklore Americano* 50 (1990): 213–28.

Murúa, Martín de. *Códice Murúa: Historia y Genealogía de Los Reyes Incas del Perú (Códice Galvin)* (1590). Ed. Juan M. Ossio. Madrid: Testimonio Compañía Editorial, 2004.

————. *Historia General del Perú* (1613). Ed. Manuel Ballesteros Gaibrois. Crónicas de América no. 35. Madrid: Historia 16, 1986.

Muscutt, Keith, Vincent R. Lee, and Douglas Sharon. *Vira Vira: A "New" Chachapoyas Site*. Wilson, Wyo.: Sixpac Manco, 1993.

Nair, Stella Elise. "Of Remembrance and Forgetting: The Architecture of Chinchero, Peru, from Thupa 'Inka to the Spanish Occupation." Ph.D. diss., University of California, Berkeley, 2003.

Nieto, Luis. "Canto al Cuzco y a sus Piedras Sagradas" (1944). In *Antología del Cuzco*, ed. Raúl Porras Barrenechea, 446–49. Lima: Librería Internacional del Perú, 1961.

Niles, Susan A. *Callachaca: Style and Status in an Inca Community*. Iowa City: University of Iowa Press, 1987.

————. "The Nature of Inca Royal Estates." In *Machu Picchu: Unveiling the Mystery of the Incas*, ed. Richard L. Burger and Lucy C. Salazar, 49–68. New Haven, Conn.: Yale University Press, 2004.

————. "Niched Walls in Inca Design." *Journal of the Society of Architectural Historians* 46, no. 3 (1987): 277–85.

————. "The Provinces in the Heartland: Stylistic Variation and Architectural Innovation near Inca Cuzco." In *Provincial Inca: Archaeological and Ethnohistorical Assessment of the Impact of the Inca State*, ed. Michael A. Malpass, 146–76. Iowa City: University of Iowa Press, 1993.

————. *The Shape of Inca History*. Iowa City: University of Iowa Press, 1999.

Núñez del Prado, Oscar. "Versión del Mito de Inkarrí en Q'eros." In *Ideología Mesiánica del Mundo Andino*, ed. Juan M. Ossio A., 275–80. Lima: Ignacio Prado Pastor, 1973.

Núñez del Prado B., Juan Víctor. "The Supernatural World of the Quechua of Southern Peru as Seen from the Community of Qotobamba." In *Native South Americans: Ethnology of the Least Known Continent*, 238–50. Boston: Little, Brown, 1974.

Ocaña, Diego de. *A Través de la América del Sur* (1580–1605). Ed. Arturo Álvarez. Crónicas de América 33. Madrid: Historia 16, 1987.

Ogburn, Dennis. "Dynamic Display, Propaganda, and the Reinforcement of Provincial Power in the Inca Empire." *Archaeological Papers of the American Anthropological Association* 14 (2005): 225–39.

————. "Evidence for Long-Distance Transportation of Building Stones in

the Inka Empire, from Cuzco, Peru, to Saraguro, Ecuador." *Latin American Antiquity* 15, no. 4 (2004): 419–40.

———. "Power in Stone: The Long-Distance Movement of Building Blocks in the Inca Empire." *Ethnohistory* 51, no. 1 (2004): 101–35.

Ortiz Rescaniere, Alejandro. *De Adaneva a Inkarrí*. Lima: Retablo de Papel, 1973.

———. "El Mito de la Escuela." In *Ideología Mesiánica del Mundo Andino*, ed. Juan M. Ossio A., 237–50. Lima: Ignacio Prado Pastor, 1973.

Ortner, Sherry B. "Is Female to Male as Nature Is to Culture?" In *Woman, Culture, and Society*, ed. Michelle Zimbalist Rosaldo and Louise Lamphere, 67–87. Stanford: Stanford University Press, 1974.

Ossio, Juan M. "Guaman Poma y Murúa ante la Tradición Oral Andina." Íconos (Quito) 4, no. 2 (2000–2001): 44–57.

———. "Introducción." In *Códice Murúa: Historia y Genealogía de Los Reyes Incas del Perú (Códice Galvin)*, by Martín de Murúa, ed. Juan M. Ossio, vol. 1, 7–72. Madrid: Testimonio Compañía Editorial, 2004.

———. "Introducción." In *Los Retratos de los Incas en la Crónica de Fray Martín de Murúa*, iii–ix. Lima: Oficina de Asuntos Culturales de la Corporación Financiera de Desarrollo, 1985.

———. "Mito de Inkarrí Narrado por Segunda Vez Diez Años Después." *Anthropológica* 2 (1984): 169–94.

———. "Nota Sobre el Coloquio Internacional 'Guaman Poma de Ayala y Blas Valera: Tradición Andina e Historia Colonial,' Istituto Italo-Latinamericano, Roma 29–30 de Setiembre de 1999." *Colonial Latin American Review* 9, no. 1 (2000): 113–16.

———. "Paralelismos entre las Cróncias de Guaman Poma y Murúa." In *Guaman Poma y Blas Valera: Tradición Andina e Historia Colonial*, ed. Francesca Cantù, 63–84. Rome: Istituto Italo-Latinoamericano, 2001.

———. "Research Note: El Original del Manuscrito Loyola de Fray Martín de Murúa." *Colonial Latin American Review* 7, no. 2 (1998): 271–78.

———. "El Simbolismo del Agua y la Representación del Tiempo y el Espacio en la Fiesta de la Acequia de la Comunidad de Andamarca." *Actes du XLII Congrès International des Américanistes* 4 (1978): 377–95.

Ossio A., Juan M. "Guamán Poma: *Nueva Corónica* o Carta al Rey; Un Intento de Aproximación a las Categorías del Pensamiento del Mundo Andino." In *Ideología Mesiánica del Mundo Andino*, ed. Juan M. Ossio A., 155–213. Lima: Ignacio Prado Pastor, 1973.

Parkes, Graham. "The Role of Rock in the Japanese Dry Landscape Garden." In *Reading Zen in the Rocks: The Japanese Dry Landscape Garden*, by François Berthier, trans. Graham Parkes, 85–146. Chicago: University of Chicago Press, 2000.

Parmenter, Barbara McKean. *Giving Voice to Stones: Place and Identity in Palestinian Literature*. Austin: University of Texas Press, 1994.

Pasztory, Esther. "Andean Aesthetics." In *The Spirit of Ancient Peru: Treasures from the Museo Arqueológico Rafael Larco Herrera*, ed. Kathleen Berrin, 60–69. New York: Thames and Hudson, 1997.

———. *Pre-Columbian Art*. Cambridge: Cambridge University Press, 1998.

———. *Thinking with Things: Toward a New Vision of Art*. Austin: University of Texas Press, 2005.

Paternosto, César. *Piedra Abstracta: La Escultura Inca, una Vision Contemporánea*. Lima: Fondo de Cultura Económica, 1989.

———. *The Stone and the Thread: Andean Roots of Abstract Art*, trans. Esther Allen. Austin: University of Texas Press, 1996.

Payne, Johnny. *Cuentos Cusqueños*. Biblioteca de la Tradición Oral Andina 5. Cuzco: Centro de Estudios Rurales Andinos "Bartolomé de Las Casas," 1984.

Pease García Yrigoyen, Franklin. *Las Crónicas y los Andes*. Lima: Pontificia Universidad Católica del Perú, Instituto Riva Agüero; Mexico City: Fondo de Cultura Económica, 1995.

———. *Del Tawantinsuyo a la Historia del Perú*. Lima: Instituto de Estudios Peruanos, 1978.

———. "El Mito de Inkarrí y la Visión de los Vencidos." In *Ideología Mesiánica del Mundo Andino*, ed. Juan M. Ossio A., 439–60. Lima: Ignacio Prado Pastor, 1973.

———. *Los Úlimos Incas del Cuzco*. 5th ed. Lima: Instituto Nacional de Cultura del Perú, 2004.

———. "Una Versión Ecológica del Mito de Inkarrí." *Collectanea Instituti Anthropos* 21 (1979): 136–39.

Peirce, Charles Sanders. *Collected Papers*. 2nd ed. 7 vols. Ed. Charles Hartshorne and Paul Weiss. Cambridge, Mass.: Belknap Press of Harvard University Press, 1960.

Pelikan, Jaroslav. *The Christian Tradition: A History of the Development of Doctrine*. 5 vols. Chicago: University of Chicago Press, 1974.

Pellizzi, Francesco, ed. *Tradition — Translation — Treason*. Res 32 (1997).

Pino Matos, José Luis. "El *Ushnu* Inka y la Organización del Espacio en los Principales *Tampus* de los *Wamani* de la Sierra Central del Chinchaysuyu." *Chungara, Revista de Antropología Chilena* 36, no. 2 (2004): 303–11.

Pizarro, Hernando. "Carta de Hernando Pizarro" (1533). In *Biblioteca Peruana: El Perú a través de los Siglos*, series 1, vol. 1, 119–30. Lima: Editores Técnicos Asociados, 1968.

Pizarro, Pedro. *Relación del Descubrimiento y Conquista de los Reinos del Perú*

(1571). 2nd ed. Ed. Guillermo Lohmann Villena. Lima: Pontificia Universidad Católica del Perú, 1986.

Platt, Tristan. "Mirrors and Maize: The Concept of *Yanantin* among the Macha of Bolivia." In *Anthropological History of Andean Polities*, ed. John V. Murra, Nathan Wachtel, and Jacques Revel, 228–59. Cambridge: Cambridge University Press, 1986.

Polo de Ondegardo, Juan. "De los Errores y Supersticiones de los Indios, Sacadas del Tratado y Averiguación que Hizo el Licenciado Polo" (1571). In *Informaciones Acerca de la Religión y Gobierno de los Incas*, ed. Horacio H. Urteaga, 3–43. Lima: Imprenta y Librería Sanmartí, 1916.

———. "Instrucción contra las Ceremonias y Ritos que Usan los Indios, Conforme al Tiempo de su Infidelidad" (1571). In *Informaciones Acerca de la Religión y Gobierno de los Incas*, ed. Horacio H. Urteaga, 189–203. Lima: Imprenta y Librería Sanmartí, 1916.

———. "Relación de los Fundamentos Acerca del Notable Daño que Resulta de no Guardar a los Indios sus Fueros" (1571). In *Informaciones Acerca de la Religión y Gobierno de los Incas*, ed. Horacio H. Urteaga, 45–188. Lima: Imprenta y Librería Sanmartí, 1916.

Poole, Deborah A. "Accommodation and Resistance in Andean Ritual Dance." *Drama Review* 34, no. 2 (1990): 98–126.

Porras Barrenechea, Raúl. *Los Cronistas del Perú*. Biblioteca Clásicos del Perú, no. 2. Lima: Banco de Crédito del Perú, 1986.

Preziosi, Donald. *Rethinking Art History: Meditations on a Coy Science*. New Haven, Conn.: Yale University Press, 1989.

Protzen, Jean-Pierre. "Inca Architecture." In *The Inca World: The Development of Pre-Columbian Peru, A.D. 1000–1534*, ed. Laura Laurencich Minelli, 193–217. Norman: University of Oklahoma Press, 1992.

———. *Inca Architecture and Construction at Ollantaytambo*. New York: Oxford University Press, 1993.

———. "Inca Quarrying and Stonecutting." *Ñawpa Pacha* 21 (1983): 183–214.

———. "Inca Stonemasonry." *Scientific American* 254, no. 2 (1986): 94–105.

Protzen, Jean-Pierre, and Stella Nair. "Who Taught the Inca Stonemasons Their Skills? A Comparison of Tiahuanaco and Inca Cut-Stone Masonry." *Journal of the Society of Architectural Historians* 56, no. 2 (1997): 146–67.

Quispe-Agnoli, Rocio. "Cuando Occidente y los Andes se Encuentran: *Qellqay*, Escritura Alfabética, y *Tokhapu* en el Siglo XVI." *Colonial Latin American Review* 14, no. 2 (2005): 263–98.

Raffino, Rodolfo, Diego Gobbo, Rolando Vázquez, Aylen Capparelli, Victoria G. Montes, Rubén Itturriza, Cecilia Deschamps, and Marcelo Mannasero. "El Ushnu de El Shincal de Quimivil." *Tawantinsuyu* 3 (1997): 22–39.

Ramírez, Andrés. "La Novena al Señor de Qoyllur Rit'i." *Allpanchis Phuturinqa* 1 (1969): 61–88.

Ramírez, Susan Elizabeth. *To Feed and Be Fed: The Cosmological Bases of Authority and Identity in the Andes*. Stanford: Stanford University Press, 2005.

Randall, Robert. "Peru's Pilgrimage to the Sky." *National Geographic* 162, no. 1 (1982): 60–69.

———. "Qoyllur Rit'i, an Inca Fiesta of the Pleiades: Reflections on Time and Space in the Andean World." *Bulletin de l'Institut Français d'Etudes Andines* (Lima) 11, nos. 1–2 (1982): 37–81.

———. "Return of the Pleiades." *Natural History* 96, no. 6 (1987): 42–53.

Rappaport, Joanne. "The Art of Ethnic Militancy: Theatre and Indigenous Consciousness in Colombia." In *Creating Context in Andean Cultures*, ed. Rosaleen Howard-Malverde, 55–69. New York: Oxford University Press, 1997.

Rappaport, Joanne, and Tom Cummins. "Between Images and Writing: The Ritual of the King's *Quillca.*" *Colonial Latin American Review* 7, no. 1 (1998): 7–32.

Reents-Budet, Dorie. *Painting the Maya Universe: Royal Ceramics of the Classic Period*. Durham: Duke University Press, 1994.

Reinhard, Johan. "Frozen in Time." *National Geographic* 196, no. 5 (1999): 36–55.

———. "A High Altitude Archaeological Survey in Northern Chile; Reconocimiento arqueológico de montañas andinas en el norte de Chile." *Chungara, Revista de Antropología Chilena* 34, no. 1 (2002): 85–99.

———. "Llullaillaco: An Investigation of the World's Highest Archaeological Site." *Latin American Indian Literatures Journal* 9, no. 1 (1993): 21–54.

———. "Sacred Mountains: An Ethno-Archaeological Study of High Andean Ruins." *Mountain Research and Development* 5, no. 4 (1985): 299–317.

———. "Sacred Peaks of the Andes." *National Geographic* 181, no. 3 (1992): 84–111.

Reinhard, Johan, and Constanza Ceruti. "Sacred Mountains, Ceremonial Sites, and Human Sacrifice among the Incas." *Archaeoastronomy* 19 (2005): 1–43.

"Relación de las Costumbres Antiguas de los Naturales del Piru" (1594). *Revista del Archivo Histórico del Cuzco* 4, no. 4 (1953): 346–415. Authorship attributed to an anonymous Jesuit, also referred to as Luis López, published as Blas Valera.

"Relación Francesa de la Conquista del Perú (Notícias Verdaderas de las

Islas del Perú)" (1534). In *Biblioteca Peruana: El Perú a Través de los Siglos*, series 1, vol. 1, 171–90. Lima: Editores Técnicoa Asociados, 1968.

Renard-Casevitz, F. M., Th. Saignes, and A. C. Taylor. *Al Este de los Andes: Relaciones entre las Sociedades Amazónicas y Andinas entre los Siglos XV y XVII.* 2 vols. Trans. Juan Carrera Colin. Quito: Ediciones Abya-Yala; Lima: Instituto Francés de Estudios Andinos, 1988.

Rivera Sundt, Oswaldo. "La Horca del Inka." *Arqueología Boliviana* 1 (1984): 91–101.

Rodman, Margaret C. "Empowering Place: Multilocality and Multivocality." *American Anthropologist*, n.s., 94, no. 3 (1992): 640–56.

Rostworowski de Diez Canseco, María. *Estructuras Andinas del Poder: Ideología Religiosa y Política.* 2nd ed. Lima: Instituto de Estudios Peruanos, 1986.

———. *Historia del Tahuantinsuyu.* Lima: Instituto de Estudios Peruanos, 1988.

———. *History of the Inca Realm.* Trans. Harry B. Iceland. Cambridge: Cambridge University Press, 1999.

Rowe, John Howland. "Absolute Chronology in the Andean Area." *American Antiquity* 10, no. 3 (1945): 265–84.

———. "An Account of the Shrines of Ancient Cuzco." *Ñawpa Pacha* 17 (1979): 2–80.

———. "El Arte Religioso del Cuzco en el Horizonte Temprano." *Ñawpa Pacha* 14 (1976): 1–30.

———. "Inca Culture at the Time of the Spanish Conquest." In *Handbook of South American Indians*, ed. Julian Haynes Steward, vol. 2, 183–330. Bureau of American Ethnology Bulletin 143. Washington: United States Government Printing Office, 1946.

———. "An Introduction to the Archaeology of Cuzco." *Papers of the Peabody Museum of American Archaeology and Ethnology* 27, no. 2 (1944): 3–59.

———. "Machu Picchu a la Luz de Documentos de Siglo XVI." *Historica* (Lima) 14, no. 1 (1990): 139–54.

———. "What Kind of a Settlement Was Inca Cuzco?" *Ñawpa Pacha* 5 (1967): 59–77.

Rubin, Arnold. *Art as Technology: The Arts of Africa, Oceania, Native America, Southern California.* Ed. Zena Pearlstone. Beverly Hills: Hillcrest Press, 1989.

Ruiz de Arce (o Albuquerque), Juan. "Advertencias" (1545). In *Biblioteca Peruana: El Perú a Través de los Siglos*, series 1, vol. 1, 405–37. Lima: Editores Técnicas Asociados, 1968.

Salazar, Lucy C. "Machu Picchu: Mysterious Royal Estate in the Cloud Forest." In *Machu Picchu: Unveiling the Mystery of the Incas*, ed. Richard L.

Burger and Lucy C. Salazar, 21–47. New Haven, Conn.: Yale University Press, 2004.

Sallnow, Michael J. *Pilgrims of the Andes: Regional Cults in Cusco*. Smithsonian Series in Ethnographic Inquiry, ed. Ivan Karp and William L. Merrill. Washington: Smithsonian Institution Press, 1987.

Salomon, Frank. "Andean Opulence: Indigenous Ideas about Wealth in Colonial Peru." In *The Colonial Andes: Tapestry and Silverwork, 1530–1830*, ed. Elena Phipps, Johanna Hecht, and Cristina Esteras Martín, 114–124. New York: The Metropolitan Museum of Art, 2004.

———. " 'The Beautiful Grandparents': Andean Ancestor Shrines and Mortuary Ritual as Seen through Colonial Records." In *Tombs for the Living: Andean Mortuary Practices, a Symposium at Dumbarton Oaks, 12th and 13th October, 1991*, ed. Tom D. Dillehay, 315–53. Washington: Dumbarton Oaks Research Library and Collection, Trustees for Harvard University, 1995.

———. "How the *Huacas* Were." *Res* 33 (1998): 7–17.

———. "Introductory Essay: The Huarochirí Manuscript." In *The Huarochirí Manuscript: A Testament of Ancient and Colonial Andean Religion*, ed. and trans. Frank Salomon and Jorge Urioste, 1–38. Austin: University of Texas Press, 1991.

Salomon, Frank, and Jorge Urioste, eds. and trans. *The Huarochirí Manuscript: A Testament of Ancient and Colonial Andean Religion* (ca. 1608). Austin: University of Texas Press, 1991.

Sancho de la Hoz, Pedro. "Relación para su Majestad" (1534). In *Biblioteca Peruana: El Perú a Través de los Siglos*, series 1, vol. 1, 275–343. Lima: Editores Técnicos Asociados, 1968.

Santa Cruz Pachacuti Yamqui Salcamaygua, Joan de. *Relación de Antigüedades deste Reyno del Pirú* (ca. 1613). Ed. Pierre Duviols and César Itier. Travaux de l'Institut Français d'Études Andines, vol. 74. Cuzco: Institut Français d'Études Andines; Centro de Estudios Regionales Andinos "Bartolomé de Las Casas," 1993.

Santillana, Julian I. "Andenes, Canales y Paisaje." In *Los Incas: Arte y Símbolos*, 61–107. Lima: Banco de Crédito, 2000.

Santo Tomás, Domingo de. *Lexicon ó Vocabulario de la Lengua General del Perú* (1560). A facsimile of the first edition with an introduction by Raúl Porras Barrenechea. Lima: Instituto de Historia Grammática, 1951.

Sarmiento de Gamboa, Pedro. *Historia de los Incas* (1572). 2nd rev. ed. Ed. Angel Rosenblatt. Buenos Aires: Emecé Editorial, 1942.

Sarup, Madan. *An Introductory Guide to Post-Structuralism and Postmodernism*. 2nd ed. Harlow, England: Pearson Education, 1993.

Schama, Simon. *Landscape and Memory*. New York: Alfred A. Knopf, 1995.

Schapiro, Meyer. "Style" (1953). In *The Art of Art History: A Critical An-*

thology, ed. Donald Preziosi, 143–49. Oxford: Oxford University Press, 1998.

Schjellerup, Inge R. *Incas and Spaniards in the Conquest of the Chachapoyas: Archaeological and Ethnohistorical Research in the Northeastern Andes of Peru*. Göteborg, Sweden: Göteborg University, 1997.

Schobinger, Juan. "Sacrifices of the High Andes." *Natural History* 100, no. 4 (1991): 62–69.

Schreiber, Katharina J. "The Inca Occupation of the Province of Andamarca Lucanas, Peru." In *Provincial Inca: Archaeological and Ethnohistorical Assessment of the Impact of the Inca State*, ed. Michael A. Malpass, 77–116. Iowa City: University of Iowa Press, 1993.

Scully, Vincent. *The Earth, the Temple, and the Gods*. New York: Praeger, 1969.

Seibold, Katharine E. "Textiles and Cosmology in Choquecancha, Cuzco, Peru." In *Andean Cosmologies through Time: Persistence and Emergence*, ed. Robert V. H. Dover, Katharine E. Seibold, and John H. McDowell, 166–201. Bloomington: Indiana University Press, 1992.

Shady Solís, Ruth. *Caral, la Ciudad del Fuego Sagrado / Caral, the City of Sacred Fire*. Lima: Interbank, 2004.

———. *Caral Supe, Perú: La Civilización de Caral-Supe, 5000 Años de Identidad en el Perú*. Lima: Instituto Nacional de Cultura, 2005.

Sherbondy, Jeanette. "The Canal Systems of Hanan Cuzco." Ph.D. diss., University of Illinois, Urbana-Champaign, 1982.

———. "Los Ceques: Código de Canales en el Cusco Incaico." *Allpanchis Phuturinqa* 27 (1986): 39–74.

Shiner, Larry. *The Invention of Art: A Cultural History*. Chicago: The University of Chicago Press, 2001.

Silverblatt, Irene. *Moon, Sun, and Witches: Gender Ideologies and Class in Inca and Colonial Peru*. Princeton: Princeton University Press, 1987.

Silverman, Helaine. "Touring Ancient Times: The Present and Presented Past in Contemporary Peru." *American Anthropologist* 104, no. 3 (2002): 881–902.

Spivak, Gayatri. "Can the Subaltern Speak?" In *Marxism and the Interpretation of Culture*, ed. Cary Nelson and Lawrence Grossberg, 217–313. Urbana: University of Illinois Press, 1988.

Starn, Orin. "Missing the Revolution: Anthropologists and the War in Peru." *Cultural Anthropology* 6 (1991): 63–91.

Stone, Peter, and Brian Molyneaux, eds. *The Presented Past: Heritage, Museums, and Education*. London: Routledge, 1994.

Stone-Miller, Rebecca. *Art of the Andes: From Chavín to Inca*. London: Thames and Hudson, 2002.

Stone-Miller, Rebecca, and Gordon McEwan. "The Representation of the Wari State in Stone and Thread." *Res* 19–20 (1990–91): 53–80.

Summers, David. *Real Spaces: World Art History and the Rise of Western Modernism.* New York: Phaidon, 2003.

Taussig, Michael. *Shamanism, Colonialism, and the Wild Man: A Study in Terror and Healing.* Chicago: University of Chicago Press, 1987.

Taylor, Gerald. *"Camay, Camac* et *Camasca* dans le Manuscript Quechua de Huarochirí." *Journal de la Société des Américanistes* (Paris) 63 (1974–76): 231–44.

———. "Introducción." In *Ritos y Tradiciones de Huarochirí del Siglo XVII*, ed. G. Taylor, 15–37. Lima: Instituto de Estudios Peruanos, 1987.

Theodore the Studite. *On the Holy Icons* (759–826 CE). Trans. Catherine P. Roth. Crestwood, N.Y.: St. Vladimir's Seminary Press, 1981.

Thompson, Donald E. "Review of *Inca Architecture* by Graziano Gasparini and Luise Margolies." *Man*, n.s., 17, no. 3 (1982): 585–86.

Titu Cusi Yupanqui, Inga Diego de Castro. *An Inca Account of the Conquest of Peru* (1570). Ed. and trans. Ralph Bauer. Boulder: University Press of Colorado, 2005.

———. *Relación de la Conquista del Perú* (1570). Lima: Ediciones de la Biblioteca Universitaria, 1973.

Toledo, Francisco de. "Carta al Rey" (1571). In *La Imprenta en Lima (1584–1824)*, ed. José Toribio Medina, 174. Santiago de Chile: Casa del Autor, 1904.

Trever, Lisa Senchyshyn. "Slithering Serpents and the Afterlives of Stones: The Role of Ornament in Inka-Style Architecture of Cusco, Peru." M.A. thesis, University of Maryland, College Park, 2005.

Trimborn, Hermann. *Archäologische Studien in den Kordilleren Boliviens.* Baessler-Archiv, zur Völkerkunde, neue folge: Beiheft. Berlin: Reimer, 1959.

Tuan, Yi-Fu. *Man and Nature.* Commission on College Geography Resource Paper no. 10. Washington: Association of American Geographers, 1971.

———. *Space and Place: The Perspective of Experience.* Minneapolis: University of Minnesota Press, 1977.

Ubbelohde-Doering, Heinrich. *On the Royal Highway of the Inca.* New York: Praeger, 1967.

Uhle, Max. "Datos para la Explicación de los Intihuatanas." *Revista Universitaria* (Lima) 5, no. 1 (1910): 325–32.

Upton, Dell. "Architectural History or Landscape History?" *Journal of Architectural Education* 44, no. 4 (1991): 195–99.

Urbano, Henrique O. "Del Sexo, Incesto, y los Ancestros de Inkarrí: Mito,

Utopia e Historia en las Sociedades Andinas." *Allpanchis Phutuinqa* 15, nos. 17–18 (1981): 77–103.

Urry, John. "Sensing the City." In *The Tourist City*, ed. Dennis R. Judd and Susan S. Fainstein, 71–86. New Haven, Conn.: Yale University Press, 1999.

———. *The Tourist Gaze: Leisure and Travel in Contemporary Societies*. London: Sage, 1990.

Urton, Gary. "Animal Metaphors and the Life Cycle in an Andean Community." In *Animal Myths and Metaphors in South America*, ed. Gary Urton, 251–84. Salt Lake City: University of Utah Press, 1985.

———. *At the Crossroads of the Earth and the Sky: An Andean Cosmology*. Latin American Monographs no. 55. Austin: University of Texas Press, 1981.

———. *The History of a Myth: Pacariqtambo and the Origin of the Inkas*. Austin: University of Texas Press, 1990.

Valcárcel, Luís E. "Cuzco Archeology." In *Handbook of South American Indians*, ed. Julian Haynes Steward, vol. 2, 177–82. Smithsonian Institution, Bureau of American Ethnology Bulletin 143. New York: Cooper Square Publishers, 1946.

———. *Machu Picchu, el Más Famoso Monumento Arqueológico del Perú*. Buenos Aires: Editorial Universitaria de Buenos Aires, 1967.

———. "Sajsawaman Redescubierto" (3a entrega). *Revista del Museo Nacional* (Lima) 4, no. 2 (1935): 161–203.

Valencia Espinoza, Abraham. "Inkari Qollari Dramatizado." In *Ideología Mesiánica del Mundo Andino*, ed. Juan M. Ossio A., 281–98. Lima: Ignacio Prado Pastor, 1973.

Valencia Zegarra, Alfredo, and Arminda Gibaja Oviedo. *Machu Picchu: La Investigación y Conservación del Monumento Arqueológico después de Hiram Bingham*. Cuzco: Municipalidad del Qosqo, 1992.

Van de Guchte, Maarten. "'Carving the World': Inca Monumental Sculpture and Landscape." Ph.D. diss., University of Illinois, Urbana-Champaign, 1990.

———. "El Ciclo Mítico de la Piedra Cansada." *Revista Andina* 4, no. 2 (1984): 539–56.

———. "Sculpture and the Concept of the Double among the Inca Kings." *Res* 29–30 (1996): 256–68.

Vázquez, Juan Adolfo. "Reconstruction of the Myth of Inkarri." *Latin American Indian Literatures Journal* 2, no. 2 (1986): 92–109.

———. "Las Versiones del Mito de Inkarrí." *America Indígena* 44, no. 4 (1984): 769–78.

Venuti, Lawrence, ed. *The Translation Studies Reader*. 2nd ed. London: Routledge, 2004.

Vivanco, Alejandro. "Nueva Versión del Mito de Inkarrí." *Anthropológica* 2 (1984): 195–99.

Vocabulario y Phrasis en la Lengua General de los Indios del Perú Llamada Quichua y en la Lengua Española (1586). Ed. Guillermo Escobar Risco. 5th ed. Lima: Edición del Instituto de Historia de la Facultad de Letras, 1951.

Wachtel, Nathan. "Estructuralismo e Historia: A Propósito de la Organización Social del Cuzco." In *Sociedad e Ideología*, ed. Nathan Wachtel, 3–58. Lima: Instituto de Estudios, 1973.

———. *Sociedad e Ideología*. Lima: Instituto de Estudios Peruanos, 1973.

———. *The Vision of the Vanquished: The Spanish Conquest of Peru through Indian Eyes*. New York: Barnes and Noble, 1977.

Watkins, Ivan. "Rock Chips: How Did the Incas Create Such Beautiful Stonemasonry?" *Rocks and Minerals Magazine* 65, no. 6 (1990): 541–44.

Weismantel, M. J. "Maize Beer and Andean Social Transformations: Drunken Indians, Bread Babies, and Chosen Women." *MLN* 106, no. 4 (1991): 861–79.

White, Hayden. "The Politics of Historical Interpretation: Discipline and De-Sublimation." In *The Politics of Interpretation*, ed. W. J. T. Mitchell, 119–43. Chicago: University of Chicago Press, 1983.

Wright, Kenneth R., and Alfredo Valencia Zegarra. *Machu Picchu: A Civil Engineering Marvel*. Reston, Va.: Asce Press, 2000.

Ziólkowski, Mariusz S. *La Guerra de los Wawqi: Los Objetivos y los Mecanismos de la Rivalidad dentro de la Elite Inka, Siglos XV–XVI*. Colección "Biblioteca Abya-Yala" 41. Quito: Abya-Yala, 1996.

Ziólkowski, Mariusz S., and Robert M. Sadowski. *La Arqueoastronomía en la Investigación de las Culturas Andinas*. Colección Pendoneros 9. Quito: Banco Central del Ecuador, 1992.

Zuidema, R. Tom. "Bureaucracy and Systematic Knowledge in Andean Civilization." In *The Inca and Aztec States, 1400–1800: Anthropology and History*, ed. George A. Collier, Renato I. Rosaldo, and John D. Wirth, 419–58. New York: Academic Press, 1982.

———. *The Ceque System of Cuzco: The Social Organization of the Empire of the Inca*. Trans. Eva M. Hooykaas. Leiden: E. J. Brill, 1964.

———. "Hierarchy and Space in Incaic Social Organization." *Ethnohistory* 30 (1983): 49–75.

———. "Inka Dynasty and Irrigation: Another Look at Andean Concepts of History." In *Anthropological History of Andean Politics*, ed. John V. Murra, Nathan Wachtel, and Jacques Revel, 177–200. Cambridge: Cambridge University Press, 1986.

———. "Inka Observations of the Solar and Lunar Passages through Zenith

and Anti-Zenith at Cuzco." In *Archaeoastronomy in the Americas*, ed. Ray A. Williamson, 316–42. Los Altos, Calif.: Ballena Press, 1981.

———. "The Lion in the City: Royal Symbols of Transition in Cuzco" (1983). In *Animal Myths and Metaphors in South America*, ed. Gary Urton, 183–250. Salt Lake City: University of Utah Press, 1985.

———. "The Moieties of Cuzco." In *The Attraction of Opposites: Thought and Society in the Dualistic Mode*, ed. David Maybury-Lewis and Uri Almajor, 255–75. Ann Arbor: University of Michigan Press, 1989.

———. "Myth and History in Ancient Peru." In *The Logic of Culture: Advances in Structural Theory and Methods*, ed. Ino Rossi, 150–75. South Hadley, Mass.: J. F. Bergin, 1982.

———. "The Pillars of Cusco: Which Two Dates of Sunset Did They Define?" In *New Directions in American Archaeoastronomy*, ed. Anthony F. Aveni, BAR International Series 454, 143–69. Oxford: British Archaeological Reports, 1988.

———. "La Relación entre el Patrón de Poblamiento Prehispánico y los Principios Derivados de la Estructura Social Incaica." In *XXXVII Congreso Internacional de Americanistas, República Argentina, 1966, Actas y Memorias*, vol. 1, 45–55. Buenos Aires, 1968.

———. "Shaft-Tombs and the Inca Empire." In *Prehistoric Contact between Mesoamerica and South America, Journal of the Steward Anthropological Society* 9, nos. 1–2 (1977–78): 133–78.

———. "El Ushnu." *Economia y Sociedad en los Andes y Mesoamerica*, ed. José Alcina Franch. *Revista de la Universidad Complutense* (Madrid) 28, no. 117 (1979): 317–62.

·⇄·

Index

Page numbers in italics refer to figures.

CAROLYN DEAN

is a professor in the History of Art and Visual Culture
Department at the University of California, Santa Cruz. She is the author
of *Inka Bodies and the Body of Christ: Corpus Christi in
Colonial Cuzco, Peru* (Duke, 1999).

Library of Congress Cataloging-in-Publication Data
Dean, Carolyn, 1957–
A culture of stone : Inka perspectives on rock /
Carolyn Dean.
p. cm.
Includes bibliographical references and index.
ISBN 978-0-8223-4791-0 (cloth : alk. paper)
ISBN 978-0-8223-4807-8 (pbk. : alk. paper)
1. Inca architecture. 2. Inca sculpture.
3. Andes Region — Antiquities. I. Title.
F3429.3.A65D436 2010
980.'01 — dc22
2010022931